D1207177

Graphis Inc. is committed to celebrating exceptional work in Design, Advertising, Photography & Art/Illustration internationally.

Published by **Graphis** | Publisher & Creative Director: **B. Martin Pedersen** | Designer: **Hee Ra Kim**

Associate Editor: **Angela Sabarese** | Associate Designer: **Hie Won Sohn** | Administrative Assistant: **Patricia Cordero**

Graphis New Talent Annual 2018

Published by:
Graphis Inc.
389 Fifth Avenue, New York, NY 10016
Phone: 212-532-9387
www.graphis.com
help@graphis.com

Distributed by:
National Book Networks, Inc.
15200 NBN Way, Blue Ridge Summit, PA 17214
Toll Free (U.S.): 800-462-6420
Toll Free Fax (U.S.): 800-338-4550
Email orders or Inquires: customercare@nbnbooks.com

Legal Counsel: John M. Roth
3140 Bryant Avenue South, #3, Minneapolis, MN 55408
Phone: 612-360-4054
johnrothattorney@gmail.com

ISBN 13: 978-1-931241-65-6
ISBN 10: 1-931241-65-1

All trademarks and logos depicted in this book belong solely
to the owners of the trademarks and logos. By using the
trademarks and logos in these student projects, neither the
schools nor the faculty and students intend to imply any
sponsorship, affiliation, endorsement or other association with
the trademark and logo owners. The student projects were
executed strictly for noncommercial, educational purposes.

The students whose work includes the logo or trademark of a
company or corporation in this book clearly have passion for that
company. Graphis would therefore encourage the ad agencies
that have these accounts to perhaps connect directly with these
students, and to seriously consider employing them.

We extend our heartfelt thanks to the international
contributors who have made it possible to publish a wide
spectrum of the best work in Design, Advertising,
Photography, and Art/Illustration. Anyone is welcome
to submit work at www.graphis.com.

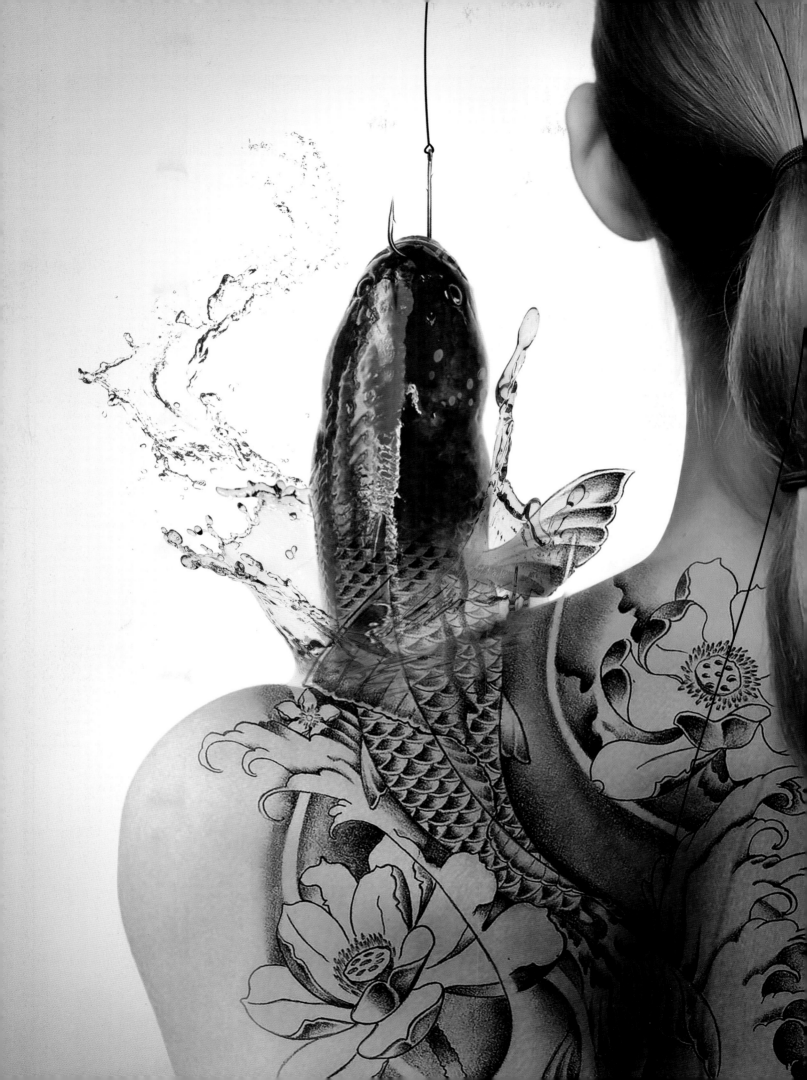

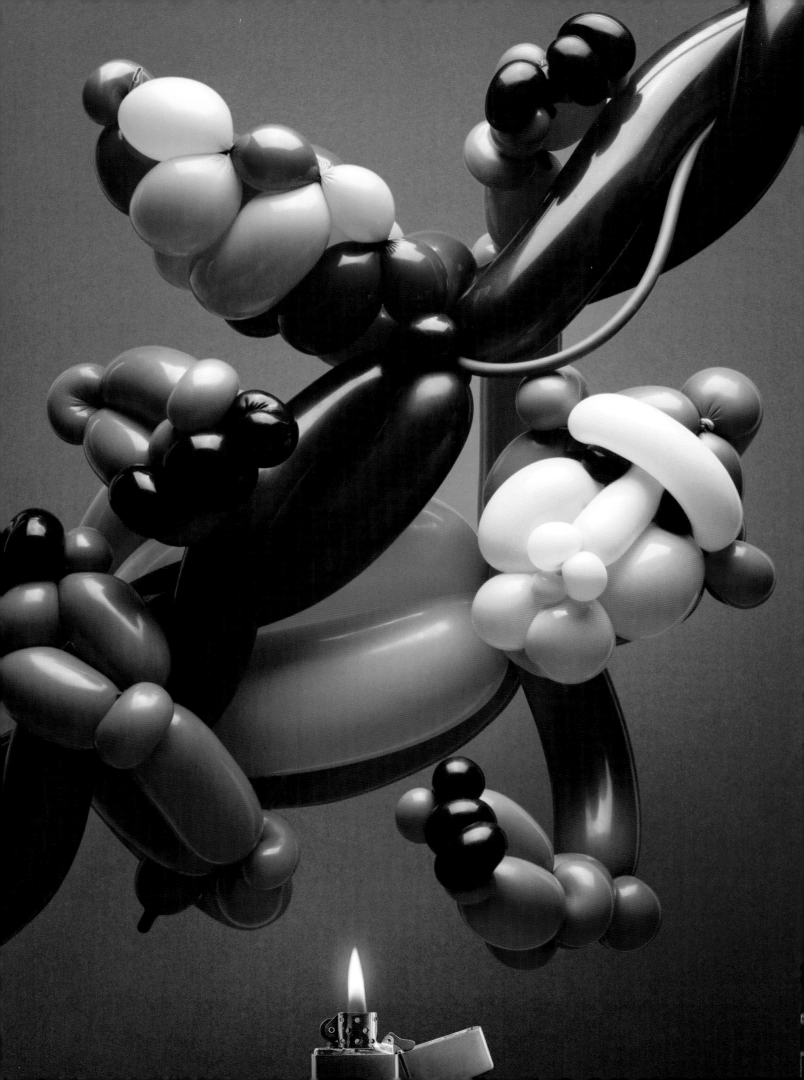

Contents

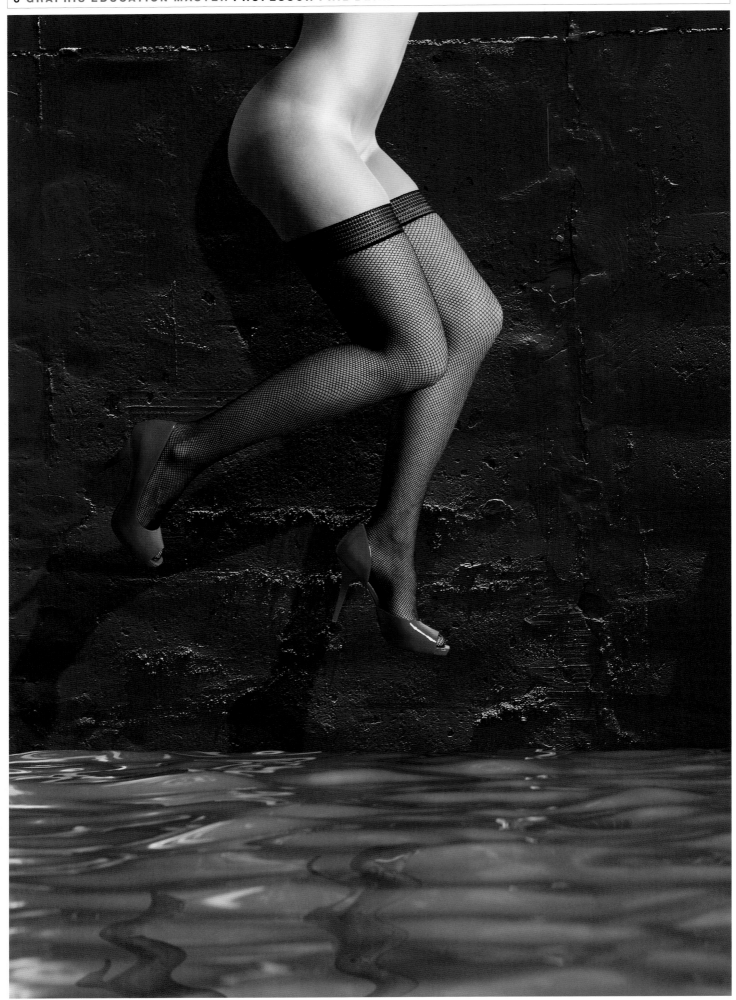

Graduating portfolios should show individual style that reflects the needs of the marketplace. You have to surprise and excite the viewer when you present your work.

Phillip Bekker, *Former Photography Professor, Art Institute of Atlanta*

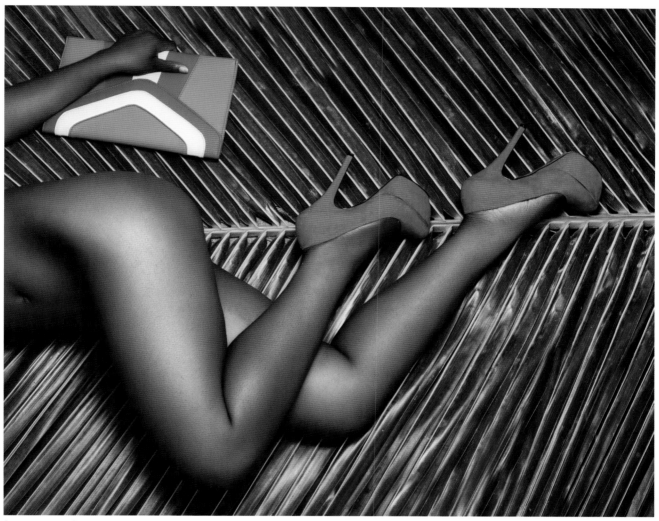

Opposite page: *"Shoes,"* Student: Chad Kelley (2013 Platinum Winner) | **Above:** *"Clutch & Heels,"* Student: Kevon Richardson (2014 Platinum Winner)
Following page: *"Red Trunk,"* Student: Melissa Pierschbacher (2012 Platinum Winner)

After spending over 30 years instructing aspiring Photographers at the Art Institute of Atlanta, Phillip Bekker retired from his positions as Professor and Director of the Photography department. He wrote the first BFA program for the school and primarily taught portfolio and senior courses. Throughout his tenure, he drove his students to create quality images that have won several Platinum and Gold Graphis Awards and earned him a place on our website as a Graphis Master. *Keep an eye out for a Q&A with Phillip Bekker in a future issue of* Graphis Journal.

Phillip Bekker's work is in private and corporate collections worldwide and has appeared in many awards publications, including over 20 of Graphis's 'Photography,' 'Poster,' 'Nudes,' 'Collections,' and 'New Talent' (interviews and cover quotes) Annuals. Born and raised in Rhodesia (Zimbabwe), Phillip studied photography in both South Africa and England and moved to the United States in 1986, where he achieved his MFA. He was on faculty with the commercial photography program at The Art Institute of Atlanta from 1986-2016, heading the program for 6 years in photography for the Art Institutes. He currently practices both commercial and Fine Art photography. (www.bekker.com)

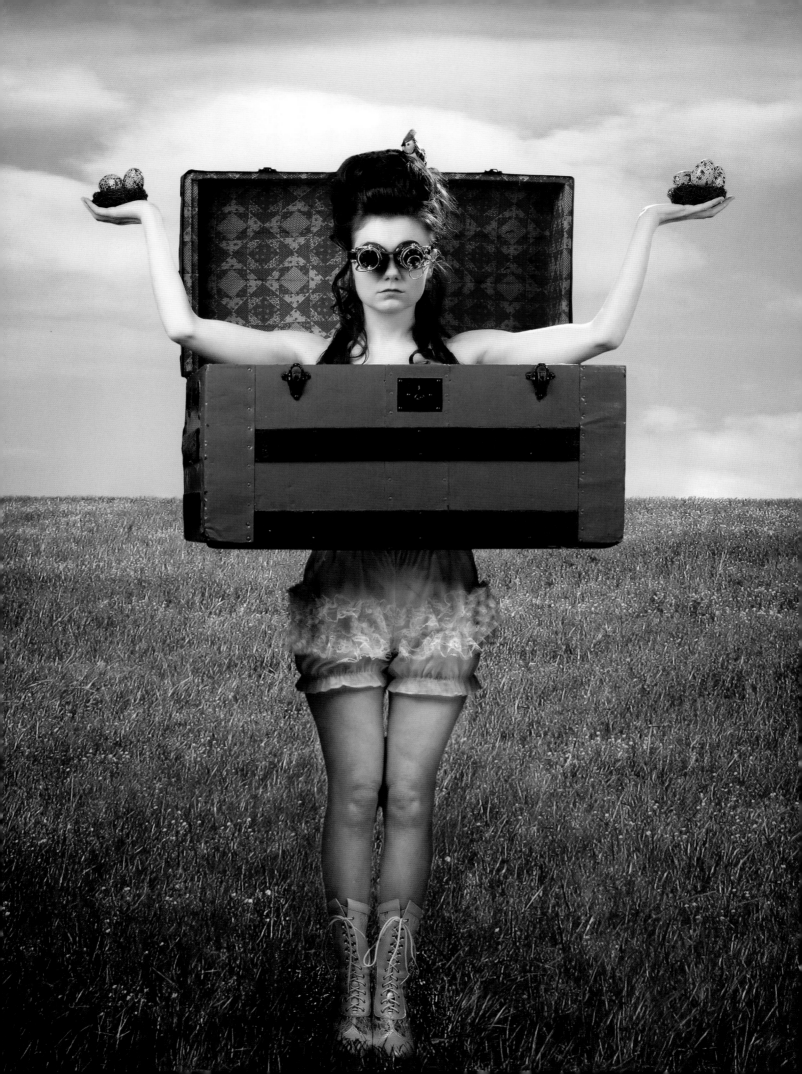

ADVERTISING:

Peter Bell | Executive Creative Director | Traction Factory | Biography: Peter strives to bring strategic and creative ideas to all brands he touches. He has achieved success for such clients as: Harley-Davidson Motor Company, The History Channel, Polaris Snowmobiles, JanSport Daypacks, TaylorMade Golf, Trek Bicycles, Famous Footwear, Snap-on Tools, ALS Association Wisconsin Chapter, and the Madison Museum of Contemporary Art, to name a few. Outside of work—and the occasional surf adventure—he juggles time between his three girls, his dog, as many motorcycle rides as he can fit in, and his own art venture, Strange Compost. **Commentary:** Graphis has always been the bar of excellence that I have strived to soar over. There are students in this Annual who have reached new heights very early on in their careers—congratulations are in order. I look forward to see what is next for you all. ■ I was very taken by several of the campaigns presented—some truly well-thought, well-executed ideas that clearly stood out among the rest. There is definitely a level of creativity that had me thinking "I wish I had done that."

Noah Huber | Associate Creative Director | Designory | Biography: Noah is a graduate of Cal State University Long Beach holding a BFA in Graphic Design. He did his general education, with an emphasis in 3-D animation and modeling, at Fullerton Junior college. Currently he works at the Designory on the Infiniti account. Previous clients include: Honda, Subaru, Lincoln, La-Z- Boy, Mercedes, Mandalay Bay, Outrider Magazine, and California State University Long Beach. **Commentary:** It's fascinating to see how different minds approach creative problem solving; it's one of my favorite things about reviewing creative work. I was very impressed by the quality of the submissions, and I appreciate all of the time and effort that was put into them.

Michael Petersen | Founding Partner | 50,000feet | Biography: Mike is a founding Partner at 50k with more than 20 years of experience overseeing engagements with some of the world's most respected brands. Mike combines his formal education with personal experience as a rider, golfer, and active lifestyler to bring a well-rounded perspective to the work he and the team create. His portfolio covers everything from identity design and packaging to cross-platform campaigns and digital experiences.

Andrew Rubey | Creative Director | Cold Open | Biography: Andrew Rubey is a creative director with Cold Open, an award-winning advertising agency in Venice, CA, specializing in entertainment marketing. Andrew was raised in Los Angeles and received his BFA from Boston University, with a concentration in graphic design. He eventually made his way back to the West Coast to pursue the art of the movie poster business. He calls Los Angeles home and loves the fact that he gets to work with his talented team daily. **Commentary:** I really enjoyed the process of seeing fresh, new talent. The range of smart, unique work was impressive. All the applicants should be very proud of what they presented.

Michael Schillig | Creative Director/Writer | PPK, USA | Biography: Michael has created award-winning campaigns for Circle K, Tires Plus, Pirelli Tires, Sweetbay Supermarket, Tampa Bay Rays, GTE Financial, Big Boy Restaurants, and Touch Vodka. But he has received the most gratification from helping nonprofits gain national creative acclaim, including Big Cat Rescue, Metropolitan Ministries, ASPCA, the National Pediatric Cancer Foundation, Jailhouse Fire Hot Sauce, and the Florida Aquarium. **Commentary:** I've always believed that making the complicated awesomely simple is true creativity. ■ Taking a complex thought and reducing it down to a simple, powerful message is what everyone should strive for. ■ I would tell students that from my many years in this business, I truly believe that passion and hard work trump everything else, even talent. ■ Safety kills. Well, at least in advertising. Since you only have a moment or less to reach consumers, you need a laser beam straight to their hearts and minds. ■ You can never rest on your laurels. Every day there's a new assignment that demands a new idea. That's part of the excitement of this business, but also part of the challenge. ■ My advice is to keep working hard and never stop learning and growing. These times are a changin' and you must constantly keep evolving your skills and adapting to the current market.

Ron Smrczek | Executive Creative Director | The&Partnership | Biography: Ron got his start in advertising a little earlier than most, starring in a Mr. Christie cookie commercial at the age of 5. But it would take nearly twenty years before he would be on the other side of the camera as an Art Director in Toronto. ■ He's led regional and international clients like Chevrolet, Coca-Cola, Kraft, MolsonCoors, Nike, Unilever, and Viagra.

DESIGN:

Chris Braden | Creative Director | Bruce Mau Design | Biography: As Creative Director, Chris leads a team specializing in strategy, communications, and brand development. Since joining BMD as an intern in 2008 he has worked on, among other projects, the visual identity system & website for OCAD University, ASICS and ASICS Tiger, Metrolinx, Harvard University Graduate School of Design, and Sonos. ■ He holds a BDes with a specialization in Advertising from OCAD University. ■ Chris maintains a connection to the OCAD community as a guest lecturer, critic and an Instructor in the Faculty of Design.

Melchior Imboden | Graphic Designer | Biography: Melchior Imboden lives and works in Buochs in Central Switzerland. ■ Since 1992 he has worked as an independent artist, graphic designer, and photographer. ■ Melchior Imboden teaches in arts, graphic design, and photography. For years he has taught at Universities in Switzerland, and he has been invited to give guest lectures abroad. In addition, he taught as a substitute and guest professor in graphic design and photography for three years in Karlsruhe. From 2004 to 2007 Melchior Imboden taught graphic design and photography as a guest professor at the Berlin University of the Arts. **Commentary:** This year's New Talent Annual Competition has convinced the design world of the young talents in its freshness and surprising innovation. ■ Particularly in the categories Music, Vinyl, CD / DVD, I was surprised with particularly outstanding design solutions. Likewise, the poster design category has produced a variety of surprising high quality typography, illustartion, and photography solutions.

Chemi Montes | Director of the Graphic Design Program | American University | Biography: Chemi Montes was born in Spain, where he studied fine arts and graphic design at the University of Salamanca, later completing his MFA in graphic design at Pennsylvania State University. His design career includes professional practice and a long-term dedication to higher education. He is currently head of the Graphic Design Program at American University. He has published writing about semiotics in relation to design and advertising. **Commentary:** The struggle between conventional industry expectations and energetic experimentation is at its most salient at this stage in a designer's career. A number of the product and furniture entries revealed the degree to which the artifact aims to become precious even if it sacrifices function. This search for formal distinctiveness, the eagerness to create memorable objects—to seduce— was also noticeable in some of the best graphic design entries; the most interesting work engaged in image making, in fleshing out ideas within the realm of their own creative logic, not merely exploring aesthetic embellishments. In sum, judging by what this annual has to offer, and loosely paraphrasing Mark Twain, rumors of the demise of print have been greatly exaggerated.

Chikako Oguma | Art Director, Graphic Designer | Biography: She has worked on graphic designs such as VI, CI, and Book design based on print media. She also presided over a Little book label titled YOU ARE HERE.

Michael Pantuso | Graphic Designer and Fine Art Illustrator | Biography: Michael Pantuso is a Graphic Designer and Fine Art Illustrator based in Chicago and works part-time in New York and London. After graduating from Flagler College in 1986, Michael relocated to Chicago and began his career working for a design and marketing agency servicing large retail and corporate clients. Eventually, he decided to go on his own which developed into a rewarding career and close alliances with advertising and branding agencies, corporate clients, and business entrepreneurs. Michael thrives at the intersection of design, artistry, and creatively-inspired ideas.
Commentary: Congratulations to all of the talented creative designers, thinkers, and amplifiers of ideas. To the image makers and image takers. To those that embrace emotion and align themselves with the executional excellence that delivers artistry to the places we touch. And that touch us.

Bud Rodecker | Principal Designer | Thirst | Biography: Bud Rodecker is a principal designer at Thirst, an adjunct professor at DePaul University, and president of the Society of Typographic Arts. His work explores the space between logical constraints and formal play, and balances form with meaning. ■ Outside the studio, Rodecker explores the process of creativity through self-initiated experiments and teaching design at DePaul University.
Commentary: In many cases, the level of concept and craft were at a professional level. The pieces that stood out most were those that demonstrated a strong proficiency in typography, a solid conceptual basis, and were technically well executed. ■ When a creative brief is met with creative solutions that respond visually to the subject matter, the result is always more interesting than when a desired style is applied to a design problem.

FILM/VIDEO:

Silverio Cuellar III | Associate Creative Director | Brunner | Biography: Silver Cuellar III is an Associate Creative Director at Brunner in Atlanta, Georgia. He specializes in strategic brand building, Pokémon Go, and facial hair. Silver has spent the past 15 or so years working at McGarrah Jessee, Mullen, The Richards Group, and BBDO, on everything from fried chicken to ladies underpants. ■ Outside of work you can find Silver teaching a Creative Concepts & Teams Class to the fine young lads and lasses at The Creative Circus and poking around various local barbecue establishments as he is also a self-taught Meat Whisperer. ■ Currently, he resides in Roswell, Georgia with his high school sweetheart Susan, their daughter and future stunt woman Sophia, 3.5-year old Silver the 4th, 21 month-old baby Simon Bear, as well as 65 collective pounds of dog fur known as Lilly Von Pants.
Commentary: I came of age in that MTV sweet spot where they were being weird and different for the sake of being weird and different. You would look forward to every commercial break in anticipation of what visual delights they would put on screen next. Some of the entries in this category felt that way for me and got my Liquid Television spidey sense tingling. My favorite entry, Sonder, was as breathtaking as it was bizarre. Like you had just taken acid and was being abducted by aliens at the Apple store on American Horror Story. Jack of All Trades had a beautiful aesthetic and deliciously big chunky typography. Loved the foreboding glitchy universe the Pixels Opening Titles transported me to. PPAP was a delightfully aloof bag of pop rock candy. Good stuff all around, a lot of entires reminded me of MK12 in their heydey. I'd be proud to have a number of these on my motion reel.

Chad Grandey | Creative Director | Schifino Lee, Tampa | Biography: At Schifino Lee, Chad contributes strong design skills, conceptual thinking and deft leadership to the Tampa Museum of Art account and a broad spectrum of other consumer and B2B clients. His twenty-year career includes top national brands including Pepsi, Best Buy, Corzo Tequila, Delta Airlines, Bank of America, and Fort Lauderdale Tourism.
Commentary: The skillset coming out of the schools today is unbelievable. I was truly impressed by the professionalism of the students' motion graphics, and I look forward to seeing how their talents impact the industry.

Jason Pierce | Creative Director | CP+B BOULDER | Biography: Over the last three years at CP+B Boulder, Jason has served as Creative Director for INFINITI, Otterbox, and was instrumental in winning American Airlines. He also plays a big role in managing INFINITI's partnership with the NCAA's Coaches vs. Cancer campaign. Prior to CP+B, Jason worked with a variety of clients including Ford, GM, Chrysler, Walmart, Gatorade, and State Farm. Jason is originally from Detroit and received his BFA at the Cleveland Institute of Art. Afterwards, he lived in Germany while studying design and music. Jason grew up playing basketball and baseball since the age of 5 and entered every league, tourney, and camp the city had. His TV only has two channels: Sports and Sports news.

Dave Roberts | Associate Creative Director | Greenhaus | Biography: Dave Roberts is an associate creative director at Greenhaus, a 35-person destination advertising agency in San Diego, California. There, Dave has spent the better part of a dozen years working on his craft for brands like W Hollywood, Visit Newport Beach, and San Diego International Airport. In past lives, Dave did stints at Mires Design (now MiresBall) and Vitro Robertson (now Vitro), working on Asics, Taylor Guitars, Newcastle Brown Ale, Yamaha Watersports, Cobra Golf, Kyocera Wireless, and Intel.
Commentary: In judging the student work, I was reminded of the absolute joy and relentless passion in searching for a voice as an artist—looking for inspiration in every living thing, place, and moment. The purity and strength of the ideas, the inventive typographic treatments, and the remarkable production value in the student work was both inspiring and intimidating. Collaboration was evident in many pieces—an invaluable skill to learn so early on. Seeing it all made me want to teach, simply to be around this sort of energy again. Cheers to all who entered.

Travis Robertson | Executive Creative Director | MMB | Biography: Travis holds a Bachelor of Arts in Film Production from Emerson College, with graduate studies in Art Direction and Design from Portfolio Center. Aside from his roles in advertising and the design community, he has also worked as an actor, cable guy, professional fighter, cook, bartender, vespa mechanic, and reggae DJ. All of which inform his design aesthetic and means of visual communication. ■ Travis joined MMB in Boston in 2015 where he now oversees the integrated creative product for all clients.
Commentary: It's exciting to see the next wave of design talent step up to the plate. Overall, the entries were very good, with a lot of attention paid to seamless transitional movements and fluid storytelling. The wide range of artistic techniques was fascinating to observe as well—from tactile art-forms like chalk and watercolor to the colder, more polished CG approach. ■ As a trend, I did notice that the vast majority of the entries were incredibly emotional, cerebral, and even downright dark at times. I love seeing animated elements that grab hold of something visceral and evocative, but I do hope that students don't shy away from the more fun and whimsical approach, wherever appropriate. It's an incredibly flexible medium and 'fun' should not be ignored or neglected—even in high design. It would have been great to see more of that.

ADVERTISING INSTRUCTORS

An award communicates that the advertising industry has validated your creative work as being great.
Mel White, *Instructor, Syracuse University*

Create the kind of advertising that will make a Creative Director say, "Wish I'd done that!
Mel White, *Instructor, Syracuse University*

Big ideas and visual solutions transcend languages and cultures, which is essential for advertising in a world that becomes increasingly global with each day.
Mel White, *Instructor, Syracuse University*

Anyone can teach. But to truly inspire young talent, it's crucial that teachers find ways to awaken their souls. Only then will famous work be born.
Frank Anselmo, *Instructor, School of Visual Arts*

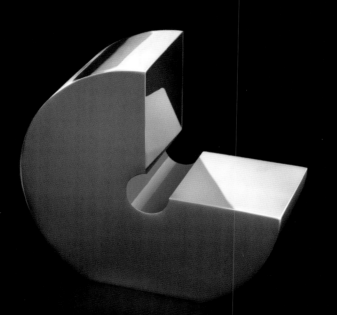

Dong-Joo Park & Seung-Min Han | Hansung Univ. of Design & Art Institute | Dean: Helen Haeryon Han | Page: 16 | Biographies:
Dong-Joo Park: Dong-Joo Park was born in Korea in 1979. Graphic designer based in Seoul. ■ Professor of Hansung University Design & Arts Institute. ■ Received an MFA in Visual Communication Design at Ewha Womans University in Korea. ■ Worked as a marketing director for KT & G affiliate Youngjin Corporation and Ilshin New Drug Corporation Advertising Department.
Seung-Min Han: Seung-Min Han was born in Korea in 1976. Graphic designer and Fine Art Illustrator based in Seoul. ■ Professor of Hansung University Design & Arts Institute. Received an MFA in Visual Communication Design at Kookmin University in Korea and a BFA in Visual Communication Design, Digital Media at Raffles College of Design and Commerce in Sydney (Australia).
Advice: Combining the fluid three-dimensional brush line with the roller symbolizing the art, it symbolically expresses the 'Moving Art Exhibition Tour'. It is also placed at the center of the screen, and the gaze is strongly attracted by the neon yellow color contrasted with the background.

Mel White | Syracuse University | Dean of School of Visual and Performing Arts: Michael S. Tick | Page: 17
Biography: Mel White is currently an Assistant Professor of Advertising-Creative at Syracuse University's S. I. Newhouse School of Public Communications. Since Mel's arrival at Syracuse University in Fall 2015, there has been a significant increase in the number of creative students winning awards and in the overall number of awards being won. Prior to her foray into advertising academia, Mel put in more than 25 years of advertising experience – the last 17 of those years in New York City as a Creative Director/Art Director at Young & Rubicam, Ogilvy, Publicis, and DMB&B. She has worked on a range of accounts such as Microsoft, Land Rover, MINI Cooper, Sony, Crest, Dannon, and American Express.
Advice: 1) Since awards catapult creative careers, enter as many student award shows as possible and catapult your own career. An award communicates that the advertising industry has validated your creative work as being great. And the more female creative students win awards, the more likely these women will parlay that recognition into better opportunities for themselves in the industry – joining their mostly male creative colleagues on that upward spiral towards greater recognition, success, and promotion into agency creative leadership positions. ■ 2) Eat, sleep, and breathe unexpected and groundbreaking ideas – even on fall, winter, spring, and summer breaks. Create the kind of advertising that will make a Creative Director say, "Wish I'd done that!" ■ 3) Ads need tension. If everything is happy in the ad, no one will care. ■ 4) Focus on creating visual solution advertising based on a big idea that's insightful – it interacts and connects with consumers, and dominates the award shows. Big idea visual solution advertising also transcends languages and cultures, which is essential for advertising in a world that is becoming increasingly global with each passing day.

Patrik Hartmann | Miami Ad School Europe | Chair and Founder: Niklas Frings-Rupp | Page: 18
Biography: After graduating at the University of East London with a 1st Class Degree in BA(Hons) in Graphic Design in 2004, Patrik moved back to Germany and started his career at JUNG von MATT Hamburg where he stayed till 2010. He worked on clients such as BMW Motorsport F1, BMW Mini, Konzerthaus Dortmund, Bosch, and MTU. His next stop took him to Leagas Delaney Hamburg, working on clients like SKODA, SKODA Motorsport, Parship, Schauspielhaus Hamburg. Since 2012 he joined the global network agency FCB at the Hamburg office where he continues his passion for advertising, working as a Creative Director on global and national clients like NIVEA, NIVEA MEN, Henkel, tesa, WWF, and hummel.
Advice: Always ask yourself: does the core of your idea come from a really good insight that people can rely on, and is it unique to the product? Make it relevant and don't bore your audience. If you are stuck in your thoughts, don't get stressed; get inspired. The inspiration is all around you: go out, talk to people, visit galleries, go to a cinema, read a book or a magazine, listen to music, go cycling, surfing, skiing, skateboarding, or try something new. Once you have fun again, the ideas and joy will come back. And don't take critique too personally. Stay professional, no matter how good or bad the situation. Most importantly: stay true to yourself. This always was my best advice.

Jack Mariucci & Robert Mackall | School of Visual Arts | Dean: Richard Wilde | Pages: 19, 21, 22, 23 | Biographies:
Jack Mariucci: Early in his career, Mariucci worked with the men and women who changed the face of advertising. Hal Riney. Bob Gage. Phyllis Robinson. Helmut Krone. Bill Bernbach. In 1986, he was elected as a director of DDB Needham Worldwide and held the top creative post in the flagship New York office until his retirement in 1994. His personal campaign credits include American Tourister Luggage, Volkswagen, Polaroid, Avis, Clairol, Hershey, Nabisco, Sony, IBM, Citicorp and the famous Michelin baby commercials. He's won hundreds of awards for creative excellence and marketing effectiveness.
Robert Mackall: Bob Mackall wrote Doing What We Do Best. And Have You Played Atari Today? And All You Need Is a Dollar and a Dream. But the most significant thing he ever wrote was the letter that got him hired at DDB in 1966 and launched a Madison Avenue copywriting career that spanned three decades. The agency hired him again in 1973 to single-handedly write eight years of advertising for American Airlines. And again in 1986, to head up its creative department until his retirement in 1994.
Advice: During the filming of the 1976 movie Marathon Man, Dustin Hoffman complained to his co-star that he was having trouble finding the necessary inspiration for a scene, to which Laurence Olivier replied, "Have you tried acting?" ■ Similarly, to students who search for creative ideas by looking at pictures on their computers, I ask: "Have you tried thinking?"

Frank Anselmo | School of Visual Arts | Dean: Richard Wilde | Page: 20
Biography: What separates Anselmo's accomplishments is that he may be the only advertising creative to ever win coveted One Show Pencils wearing 4 different hats: as a Staff Creative, Freelance Creative, ECD of his company, and as Founding Professor of his own advertising college program that's earned global status as "The Most Awarded Advertising Class In History" for the past 12 years. ■ Anselmo began his career at BBDO New York where he spent 10 years working with creative luminaries: Gerry Graf, Eric Silver and David Lubars. Frank is credited for winning BBDO's 1st One Show Gold Pencil in history for an unconventional media concept. For the past 9 years, Anselmo has been a full-time gun-for-hire freelancer at over 50 companies including Apple headquarters in Cupertino. ■ Frank's Unconventional Advertising class he founded in 2006 at SVA has won more One Show, ADC & Clio awards than any entire ad school in the world.
Advice: Students need more than just teachers to achieve superhuman success. ■ They need a concentrated dose of passionate energy injected into them regularly. ■ Anyone can teach. But to truly inspire young talent it's crucial that teachers find ways to awaken their souls. Only then will famous work be born.

Indrajeet Chandrachud | Miami Ad School | Dean: Zorayma Guevara | Page: 24
Biography: Indrajeet Chandrachud is a freelance creative director currently working at Havas. Indrajeet completed his MFA in ad design at Syracuse University. He has also worked at Grey, JWT, Wunderman, and FCB. Indrajeet is also a product designer and a fine artist having shown his paintings across the globe.
Advice: Make something that will make everyone else go "Damn, I wish I had thought of that." Try to do this with every ad you make.

Hyuk-jun Jang | Hansung University of Design & Art Institute | Dean: Hye-Ryeon Han | Page: 16
Biography: Jang Hyuk-jun attends the Visual Design Department of Hansung University. ■ He is 28 years old and lives in Seoul, Korea. His hobby is football. ■ He started design because he was interested in advertising design. ■ That's why he's now studying the subject. ■ This will be his first award so far. ■ He made four mobile music album covers for his work, and also made a cafe logo design at the request of his friends. ■ In the future, he will study deeply into sports advertising.

Nicole Framm | Syracuse University | Page: 17
Biography: Born and raised in Charlotte, North Carolina, Nicole Framm is currently a Junior at Syracuse University's S.I. Newhouse School of Public Communications. She is pursuing her Bachelor's Degree in Advertising with an emphasis in Art Direction. At any given moment you will most likely find her doodling on the closest blank surface. Nicole considers herself a hot sauce enthusiast and strongly believes that everything in life, including advertising, should have a kick to it.

Tania Shevereva | Miami Ad School Europe | Page: 18
Biography: Her journey began as a copywriter in Ukraine but she switched to art direction and came to study in MASE. Having experience in the top agencies like Leo Burnett, Havas Worldwide Digital, Ogilvy&Mather and Facebook, she knows how to win awards. One Show, D&AD, Vega Digital Awards and Lurzer's archive have witnessed her ideas and work in a very short span. On the lighter side, her life circles around street photography, karaoke bars, and friends all over the world.

Steven Guas | School of Visual Arts | Dean: Richard Wilde | Page: 19
Biography: I am a 20 year old, third-year design and motion graphics student (previously an advertising major) at the School of Visual Arts in New York City. ■ I have been creating designs and animations for the past 9-10 years, since my start in middle school. www.stevenguas.com - I love this stuff.

Cindy Hernandez | School of Visual Arts | Dean: Richard Wilde | Page: 19
Biography: Cindy Hernandez is a Junior Advertising major at School of Visual Arts. Born into a culturally rich Dominican family, Cindy's background has shaped her into the artist she is today. She has always been a visual person, drawing random people on the bus while commuting to New York City. Cindy was drawn to advertising because of its flexibility and wide range of different challenges. Furthermore, she enjoys the collaborative process of working with her peers and friends.

Tamara Yakov | School of Visual Arts | Dean: Richard Wilde | Page: 19
Biography: Tamara Yakov is a Junior at the School of Visual Arts in New York City. She is set to graduate in May of 2019 with a BFA in Advertising. Her passion for art grew from a young age as she has a number of accomplished artists in her family. Determined to find solutions in a creative way, Tamara has always looked for the most effective yet surprising ways to accomplish a task. Her work exemplifies her determination and passion for the field of advertising.

Ha Jung Song | School of Visual Arts | Dean: Richard Wilde | Pages: 21, 23
Biography: Ha Jung is a junior in BFA Advertising Major at School of Visual Arts in NYC. She was born and grew up in Seoul until 2009. When she was 16, her family moved to Calgary, Canada, so she spent her high school years in Canada. After she graduated from high school, her family moved to the United States again. She had a passion for fine arts and designs since she was a little girl. Growing up, she discovered her fascination with advertising that catches people's eyes. She is still challenging herself, figuring out her way. "Though she be but little, she is fierce!"

Bowook Yoon | School of Visual Arts | Dean: Richard Wilde | Pages: 21, 23
Biography: Bowook Yoon is a Junior BFA advertising student at School of Visual Arts. He was born and raised in South Korea as an art kid who loved to create. After he graduated from high school, he became an art student at Gachon University in South Korea as a major of Visual Communication Design, and two years later transferred to SVA, New York. He finds satisfaction in expressing and challenging himself as he has studied and worked in New York. He works to come up with ideas regardless of the field, and strives for a level of quality that is better than yesterday's.

Woo Jae Yoon | School of Visual Arts | Dean: Richard Wilde | Page: 21
Biography: Woo Jae Yoon is a student art director based in New York City. He is originally from Seoul, Korea and spent most of his youth years there. Woo Jae is currently majoring in BFA Advertising at School of Visual Arts. He also has various professional experiences in the field of advertising and graphic design and is always a full-time creative thinker looking for ideas that are bold, scary and original.

Hunwoo Choi | School of Visual Arts | Dean: Richard Wilde | Page: 20
Biography: Hunwoo Choi is an art director and visual designer focusing on advertising based in New York. He is majoring in advertising design and interaction design as a senior at School of Visual Art. ■ He applies conceptual ideas to each project with foundation of graphic design. ■ Also he always works on personal project which contains his self-motivated interests.

Ein Jung | School of Visual Arts | Dean: Richard Wilde | Page: 20
Biography: Ein (rhymes with fine) is a creative thinker and maker based in New York City. Her focuses lie in developing strong ideas and creating well-rounded work that touches different disciplines in an intriguing manner. Her upbringing in the Himalayan mountains has influenced her love for anything that pushes her to think in different perspectives. Naturally, she was drawn to the field of advertising and design. When she is not immersed in her work, she is quite fond of café-hopping and reading psychological thriller books.

Han Sol Ryoo | School of Visual Arts | Dean: Richard Wilde | Page: 22
Biography: Hansol Ryoo is a Graphic Designer based in New York who was born and raised in South Korea. She received a Bachelor of Fine Arts in Graphic Design at the School of Visual Arts and she is currently studying for a Master of Fine Arts in Computer Arts, especially in Motion Graphics, at the same college.

Shinyee Seet | Miami Ad School | Page: 24
Biography: Shinyee Seet, or Seet Shin Yee, as used in Malaysia, is an Art Director, but most of the time she lets art direct her. A psychic that she went to in Chicago foresaw her in New York pursuing the dream and voilà, he was right! She loves going to contemporary art museums and her favorite artist is Magritte. She has a tattoo of him at the back of her left arm, above her elbow.

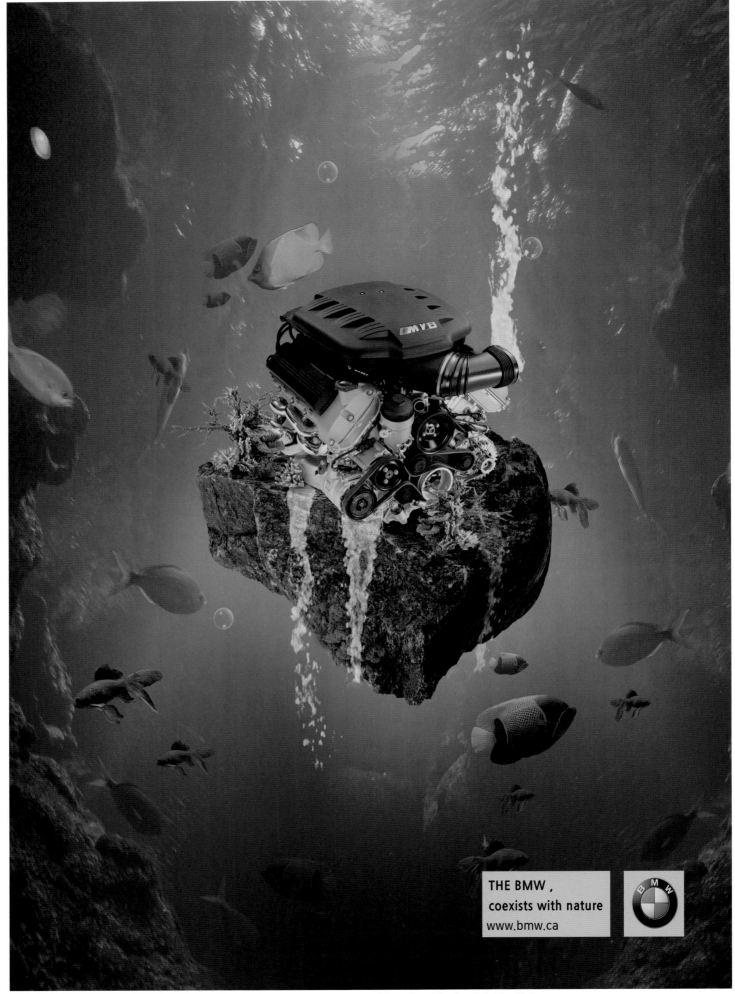

THE BMW ,
coexists with nature
www.bmw.ca

Student: Hyuk-June Jang | Hansung University of Design & Art Institute

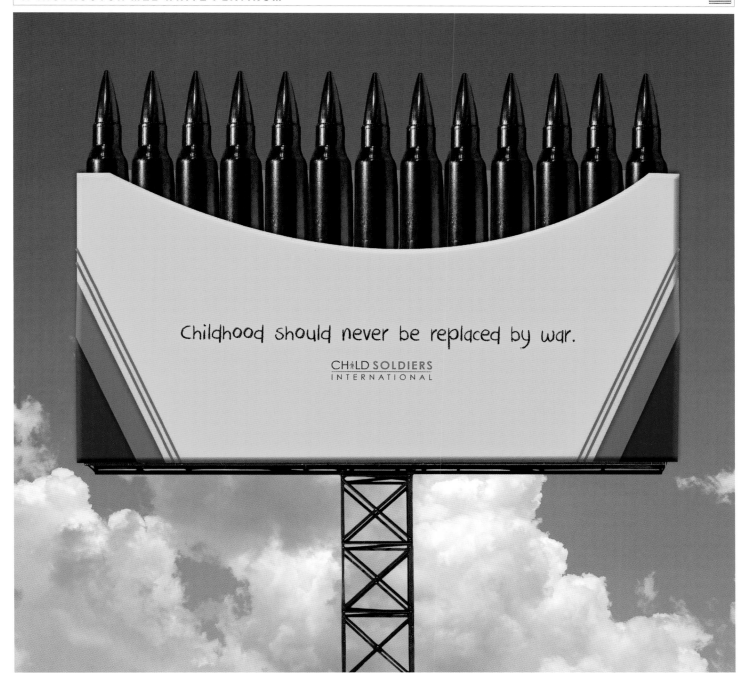

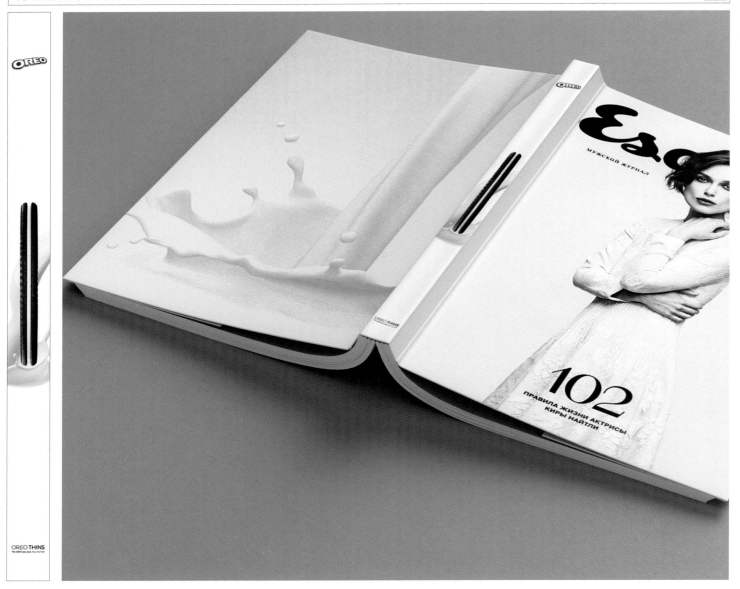

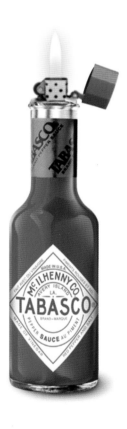

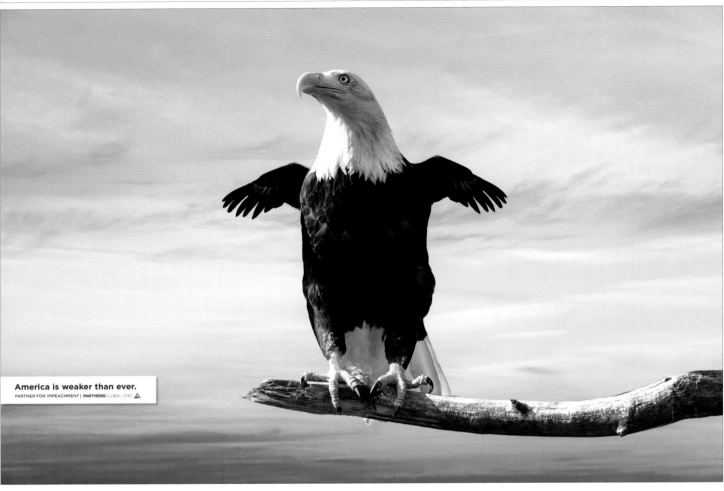

America is weaker than ever.
PARTNER FOR IMPEACHMENT | **PARTNERS**GLOBAL.ORG

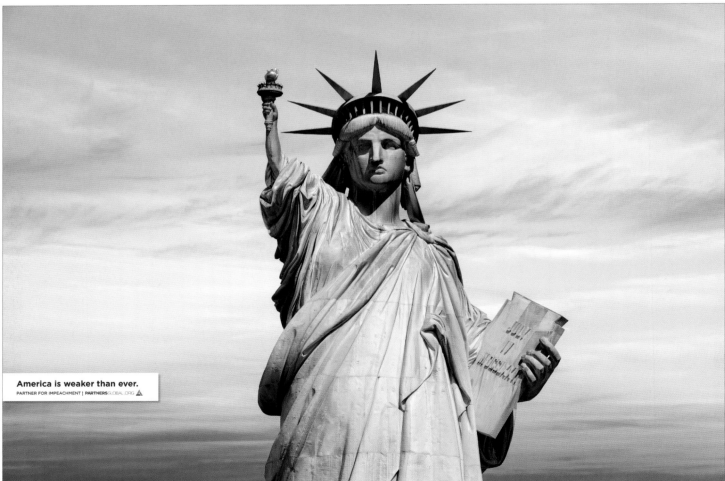

America is weaker than ever.
PARTNER FOR IMPEACHMENT | **PARTNERS**GLOBAL.ORG

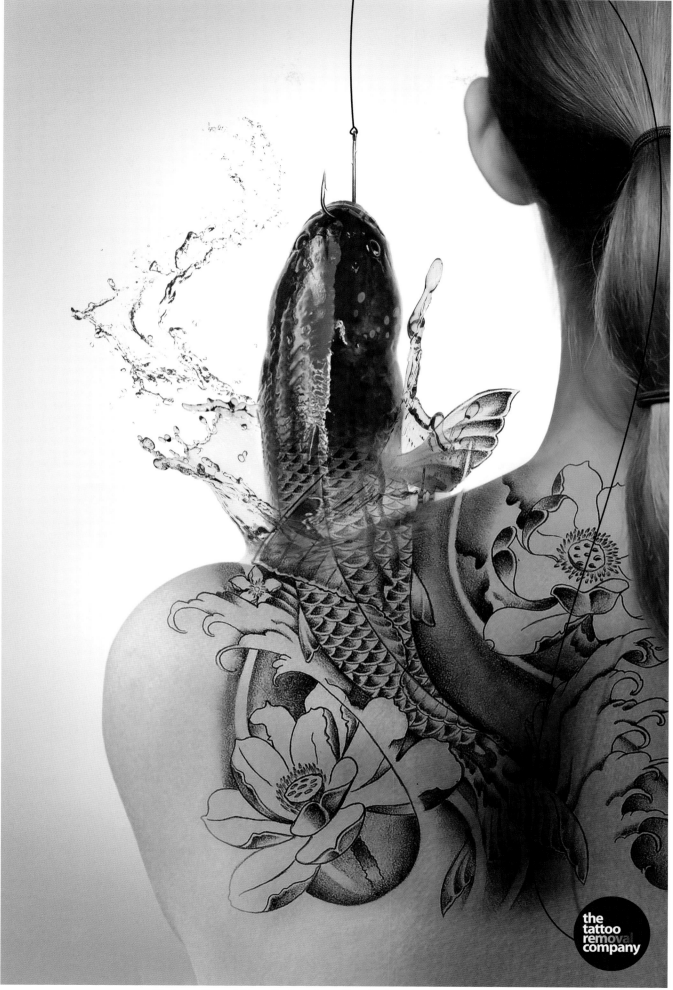

the tattoo removal company

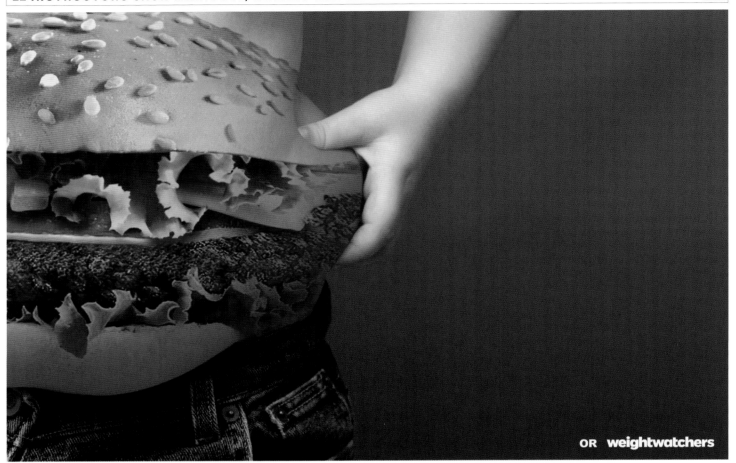

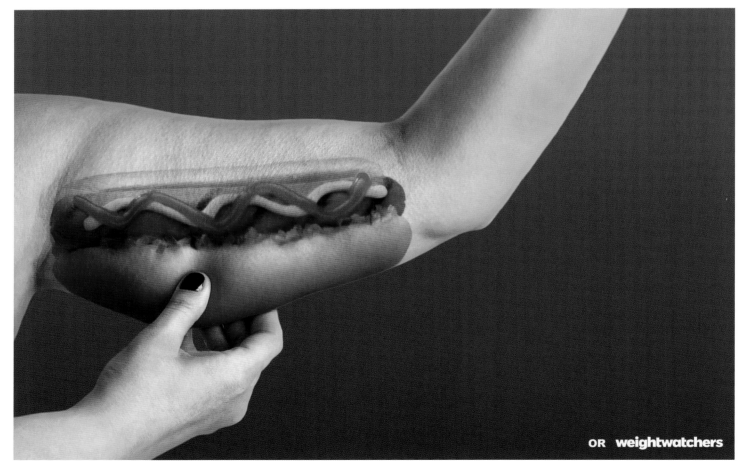

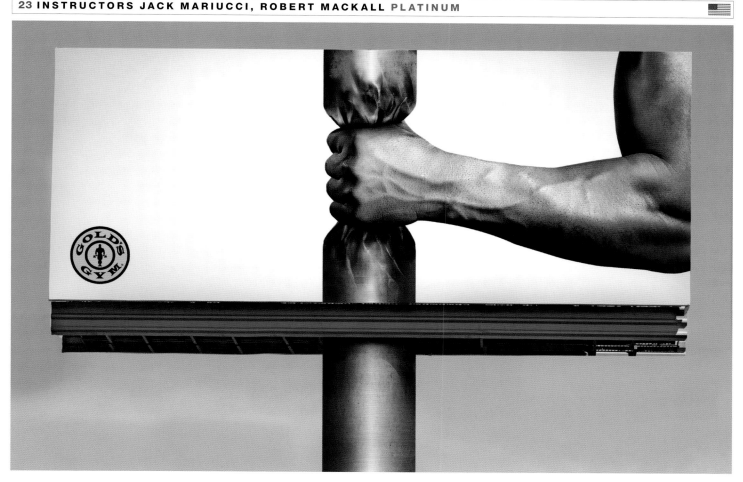

INSTRUCTOR MEL WHITE

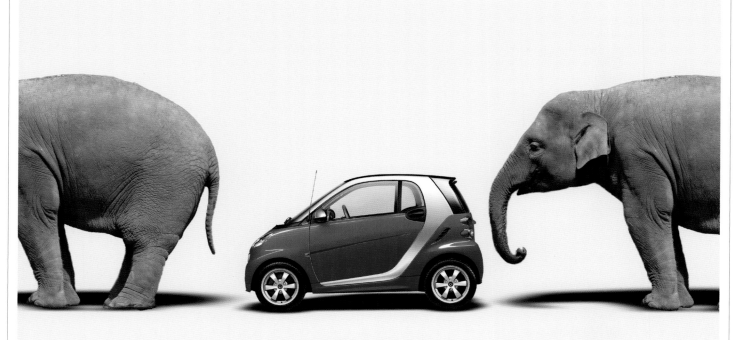

no obnoxious trunk.

Student: **Alexis Watson** | Syracuse University

INSTRUCTORS JACK MARIUCCI, ROBERT MACKALL

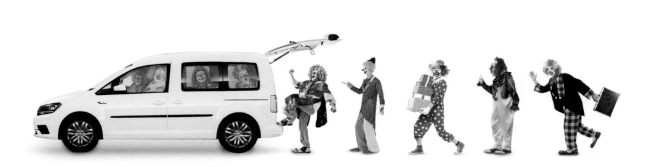

So roomy it's scary.

Students: **Tamara Yakov, Cindy Hernandez, Steven Guas** | School of Visual Arts

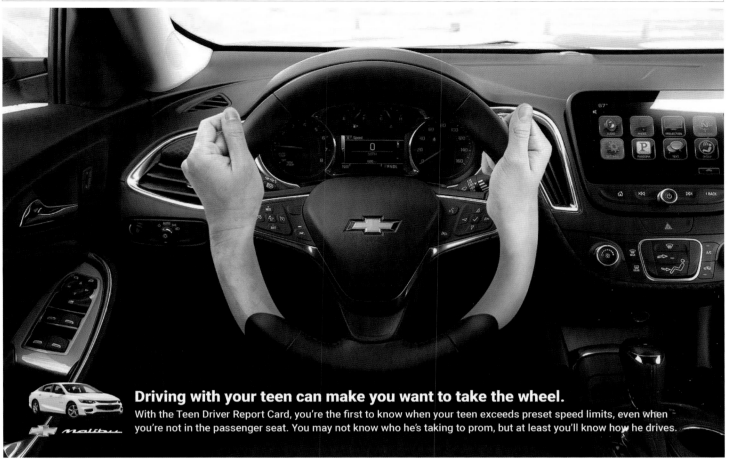

Driving with your teen can make you want to take the wheel.

With the Teen Driver Report Card, you're the first to know when your teen exceeds preset speed limits, even when you're not in the passenger seat. You may not know who he's taking to prom, but at least you'll know how he drives.

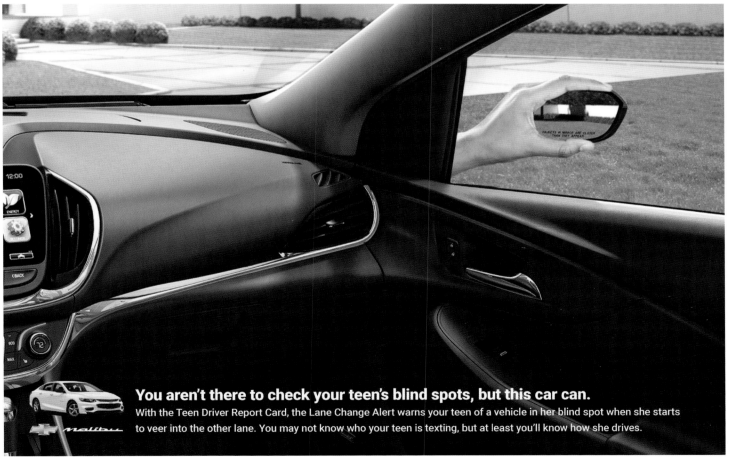

You aren't there to check your teen's blind spots, but this car can.

With the Teen Driver Report Card, the Lane Change Alert warns your teen of a vehicle in her blind spot when she starts to veer into the other lane. You may not know who your teen is texting, but at least you'll know how she drives.

Students: Lan Zhang, Mikaela Thomas | Syracuse University

Automotive | Advertising

THE
— TINIEST —
OF EMISSIONS

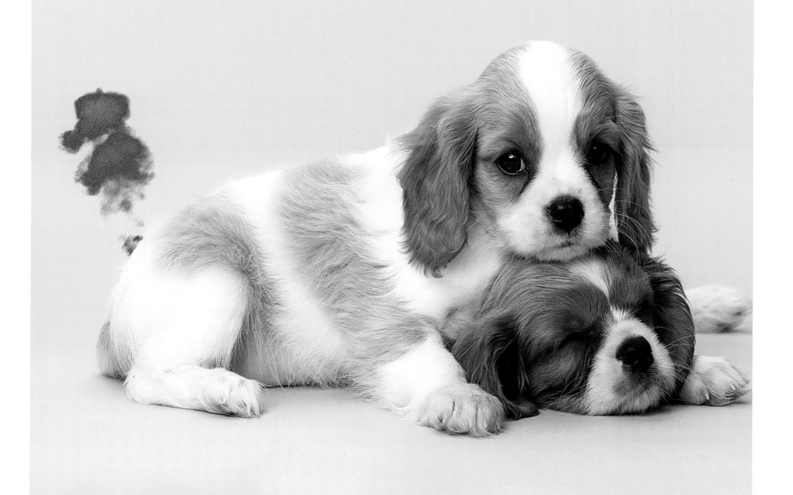

Student: Emily Kaufman | Miami Ad School

INSTRUCTORS JACK MARIUCCI, ROBERT MACKALL

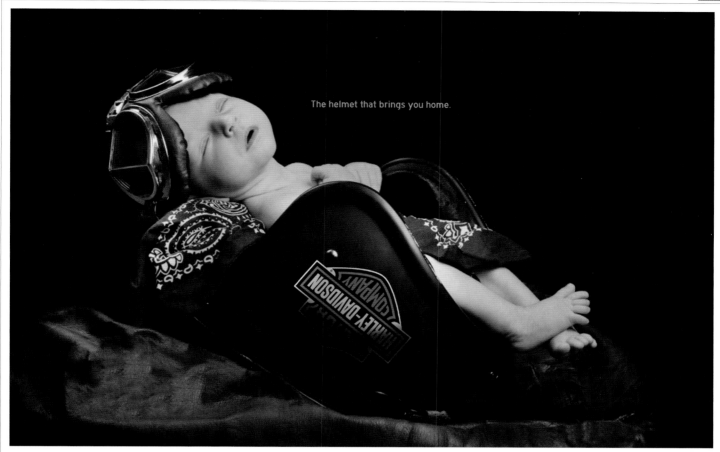

The helmet that brings you home.

Student: Tamara Yakov | School of Visual Arts

INSTRUCTORS JACK MARIUCCI, ROBERT MACKALL

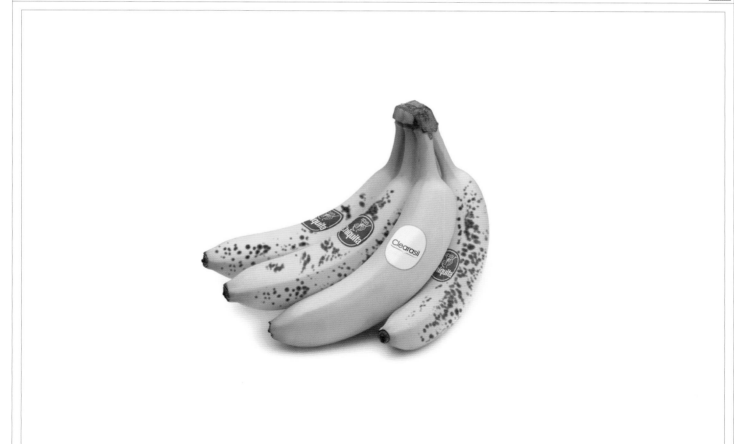

Students: Tamara Yakov, Steven Guas | School of Visual Arts

Clearasil

Students: Han Sol Ryoo, Yae Nah Oh | School of Visual Arts

INSTRUCTOR MEL WHITE

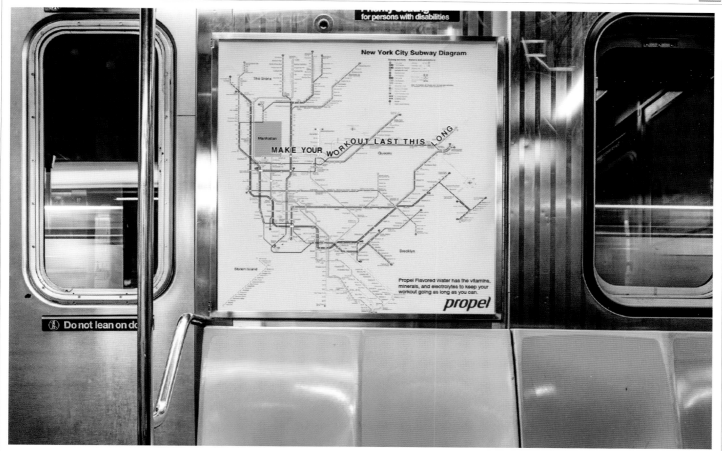

Student: Emily McMurray | Syracuse University

INSTRUCTOR ANNA XIQUES

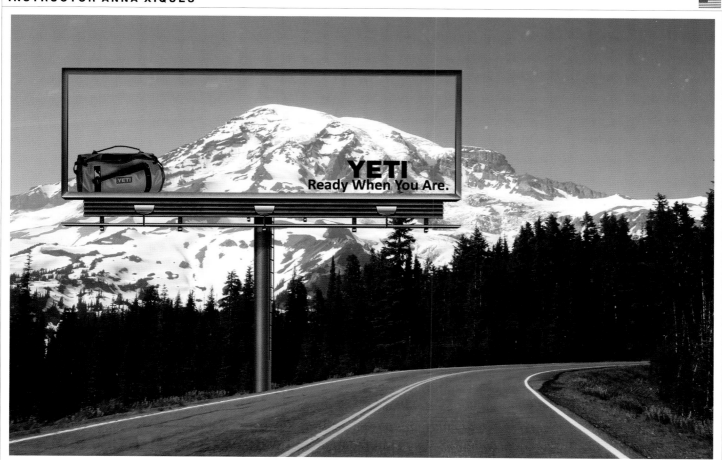

Student: Sean Rowland | Miami Ad School

INSTRUCTORS JACK MARIUCCI, ROBERT MACKALL

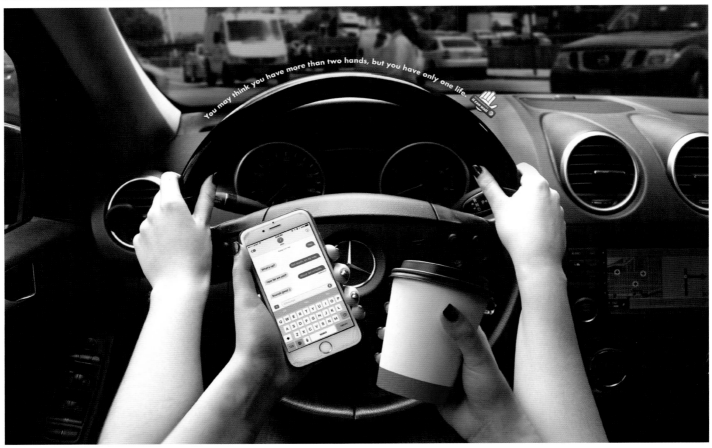

You may think you have more than two hands, but you have only one life.

Students: **Tamara Yakov, Cindy Hernandez** | School of Visual Arts

INSTRUCTOR BILL MEEK

AVAAZ.org // **Proceeds** go to help art and design schools' recovery after **Hurricane Maria** and **The Earthquake in Mexico**

Student: **Salena Hu** | Texas State University

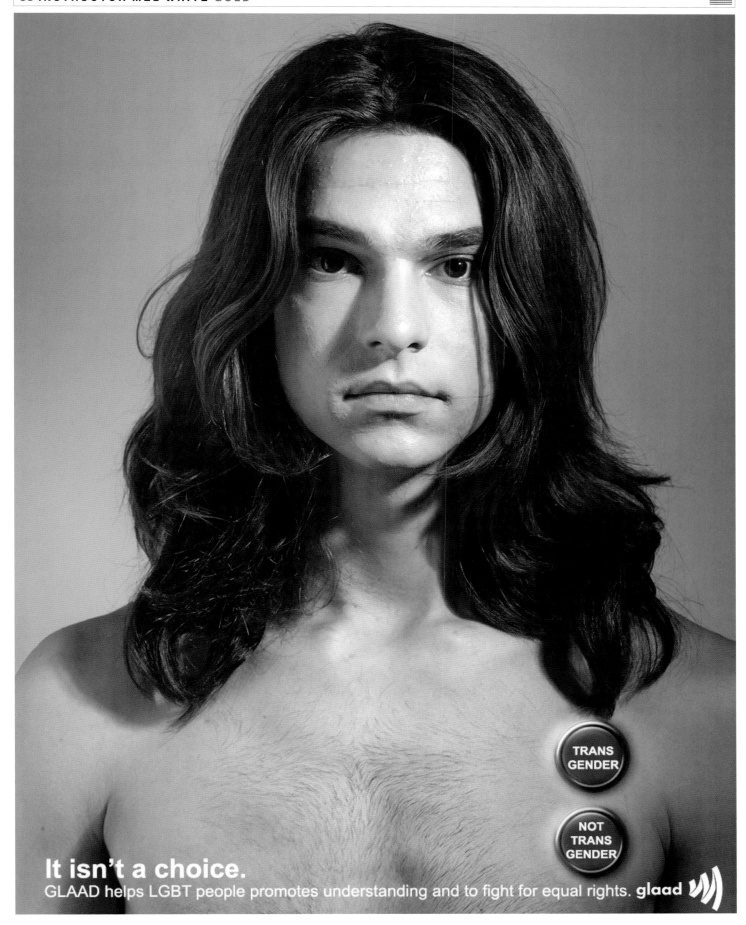

INSTRUCTOR MEL WHITE

BE WHO YOU WANNA BE. PlayStation.VR

Student: Ting Peng | Syracuse University

INSTRUCTOR MEL WHITE

Your grandchildren may not see what you see today.
The African forest elephant is endangered due to the poaching for the international ivory trade.

AWF

Student: Jingpo Li | Syracuse University

Entertainment (Top), Environmental (Bottom) | Advertising

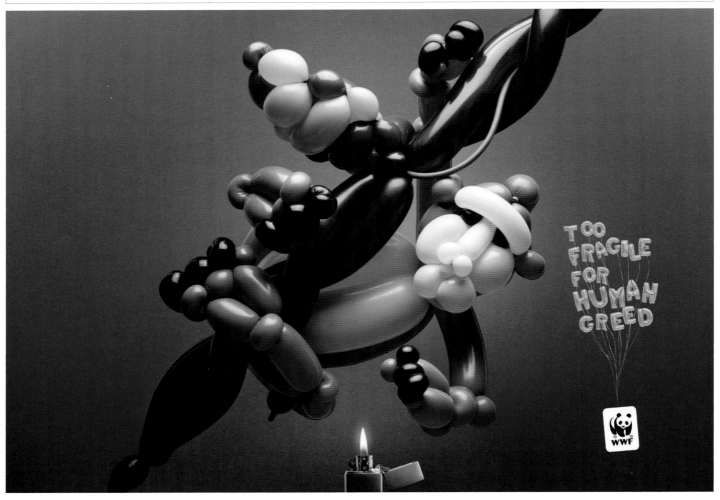

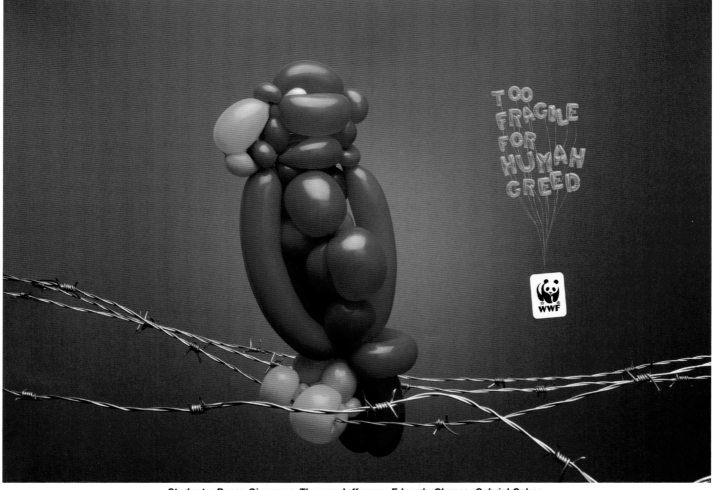

Students: Bruno Giuseppe, Thomaz Jefferson, Eduardo Chaves, Gabriel Gakas, Lorran Schoechet Gurman, Adriano Tozin | Miami Ad School São Paulo / New York

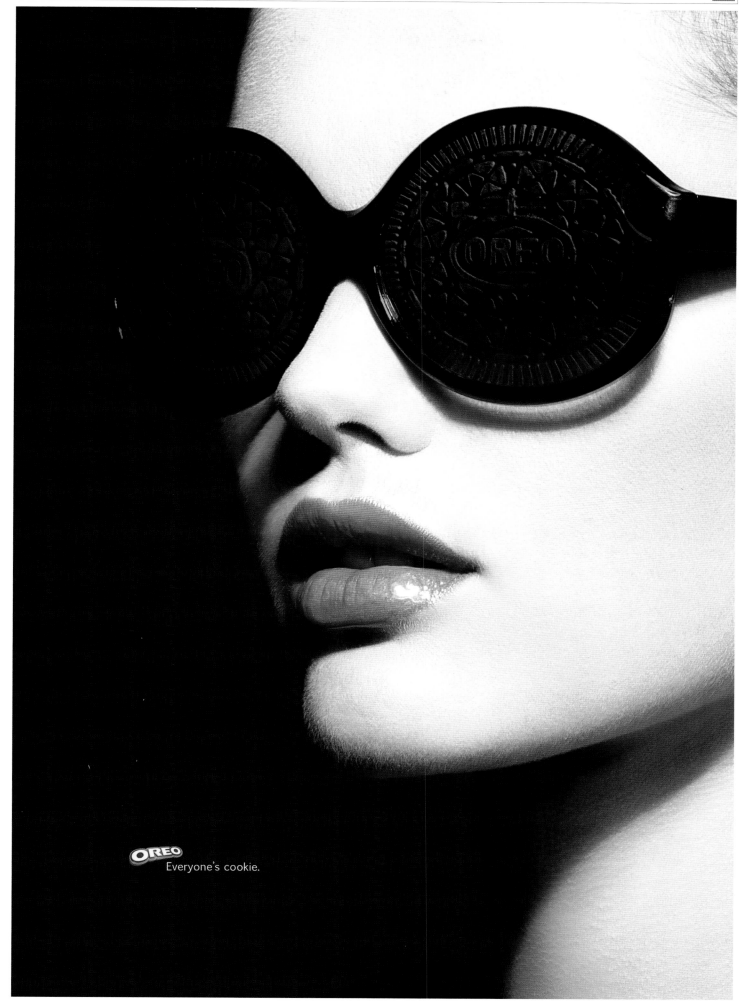

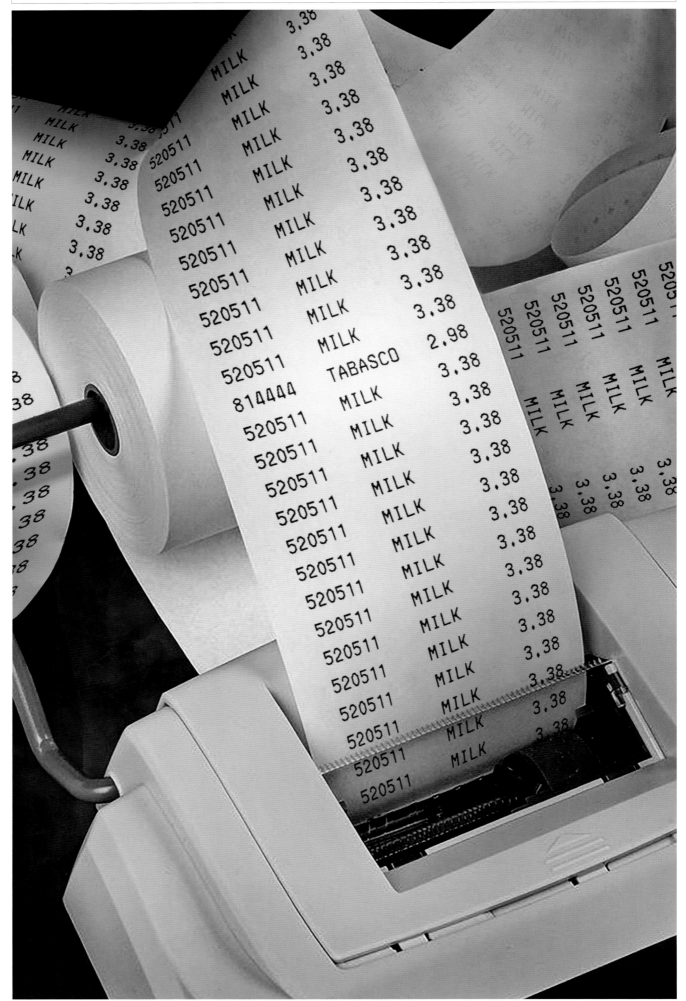

Students: Bowook Yoon, Ha Jung Song | School of Visual Arts

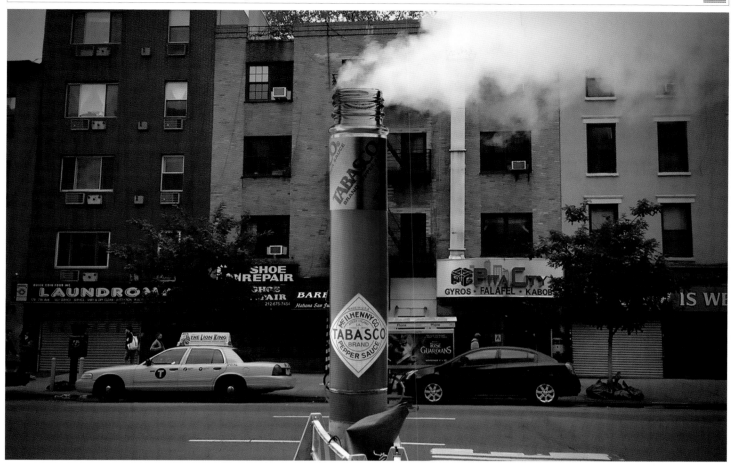

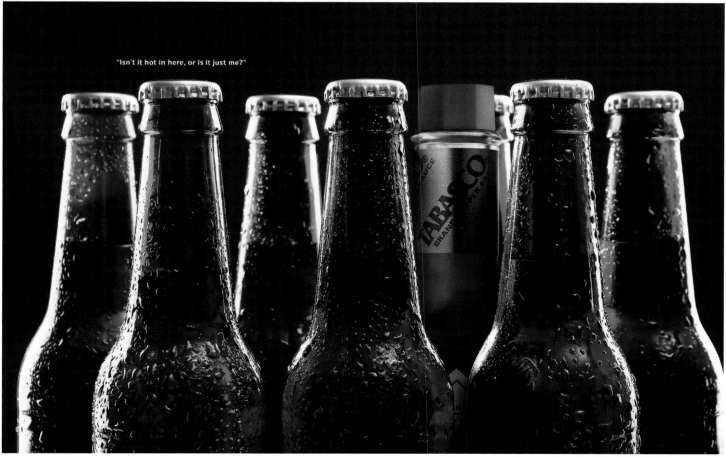

"Isn't it hot in here, or is it just me?"

Students: Bowook Yoon, Ha Jung Song | School of Visual Arts Food | Advertising

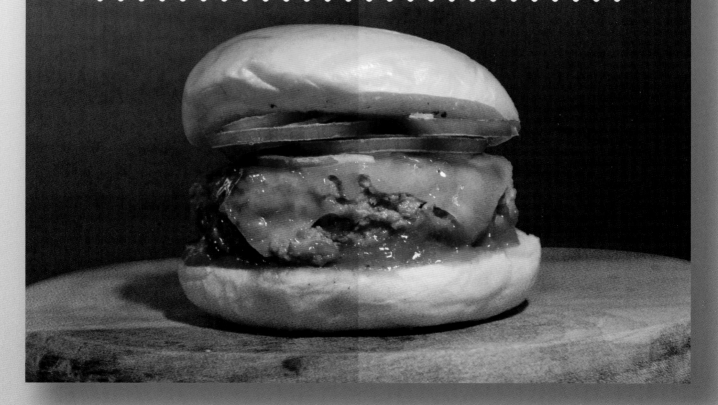

4Brothers

Carolina

Pão de Hamburger Molho Carolina

Hamburger Artesanal

Cheddar Inglês Cebola Roxa Crua

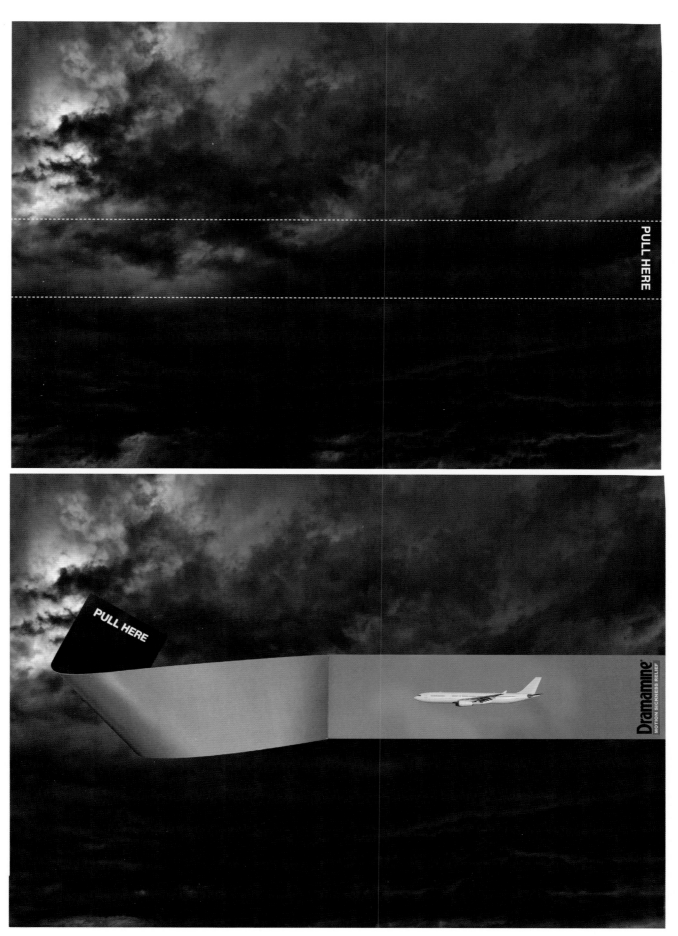

PULL THE TAB OVER THE ALARMING SPREAD TO REVEAL A SMOOTH PATH OF TRAVEL.

INSTRUCTORS JACK MARIUCCI, ROBERT MACKALL

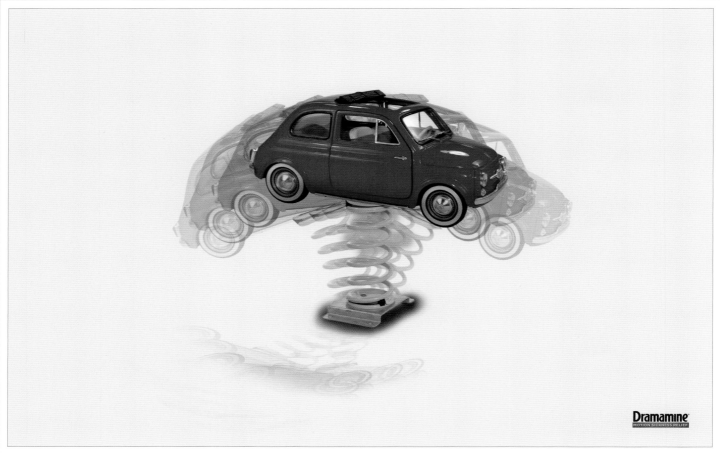

Students: Sujin Lim, Taekyoung Debbie Park | School of Visual Arts

INSTRUCTORS JACK MARIUCCI, ROBERT MACKALL

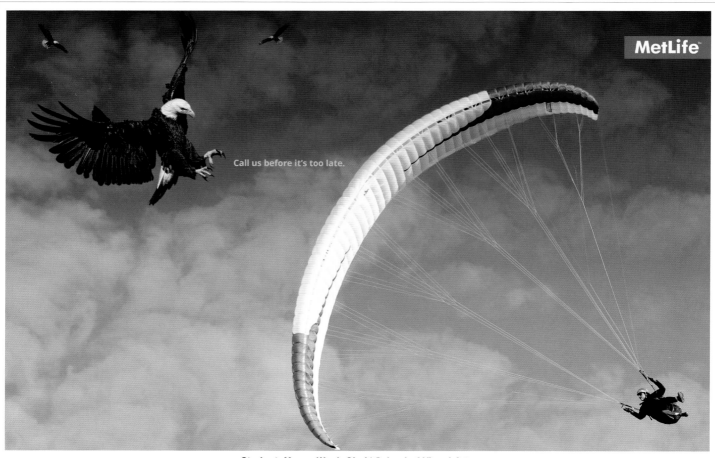

Student: Young Wook Choi | School of Visual Arts

Advertising | Healthcare (Top), Insurance (Bottom)

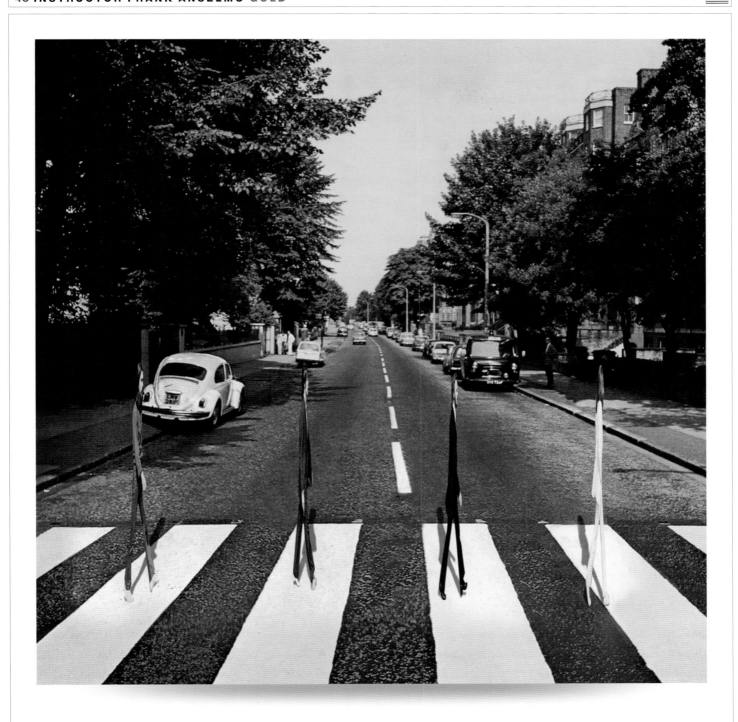

UNCOMPRESS YOUR MUSIC.
CHOOSE VINYL.

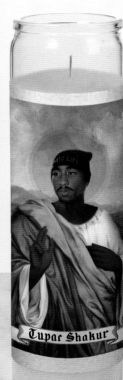
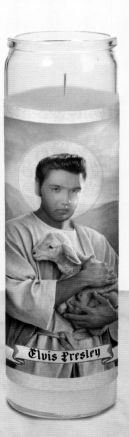

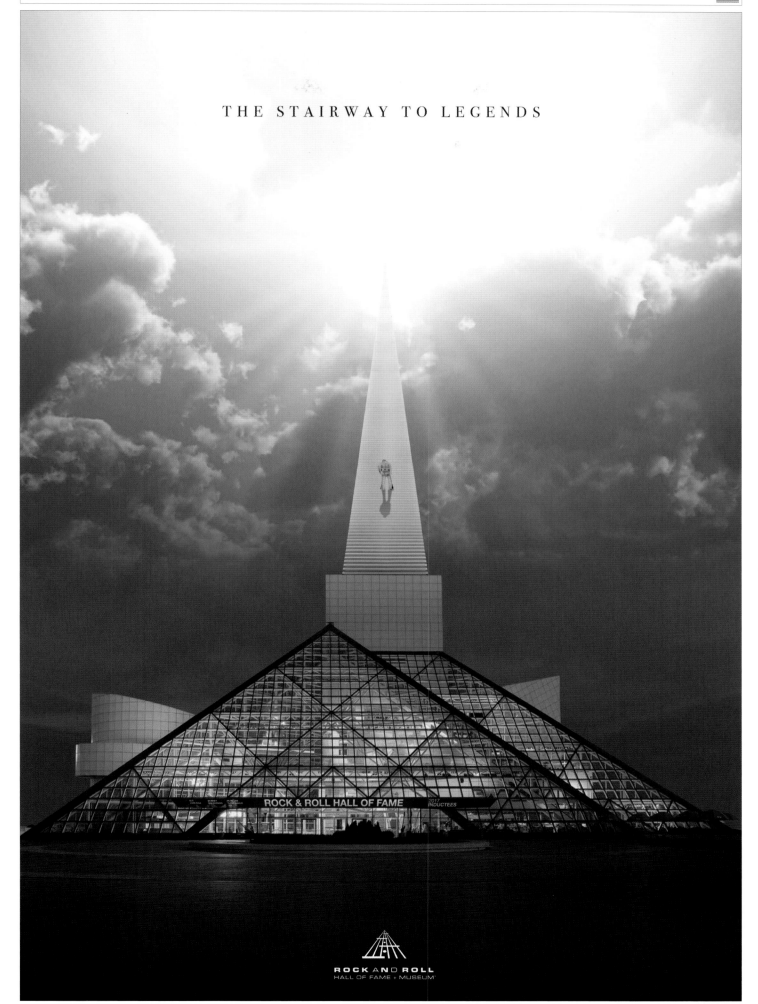

THE STAIRWAY TO LEGENDS

ROCK & ROLL HALL OF FAME

ROCK AND ROLL
HALL OF FAME + MUSEUM

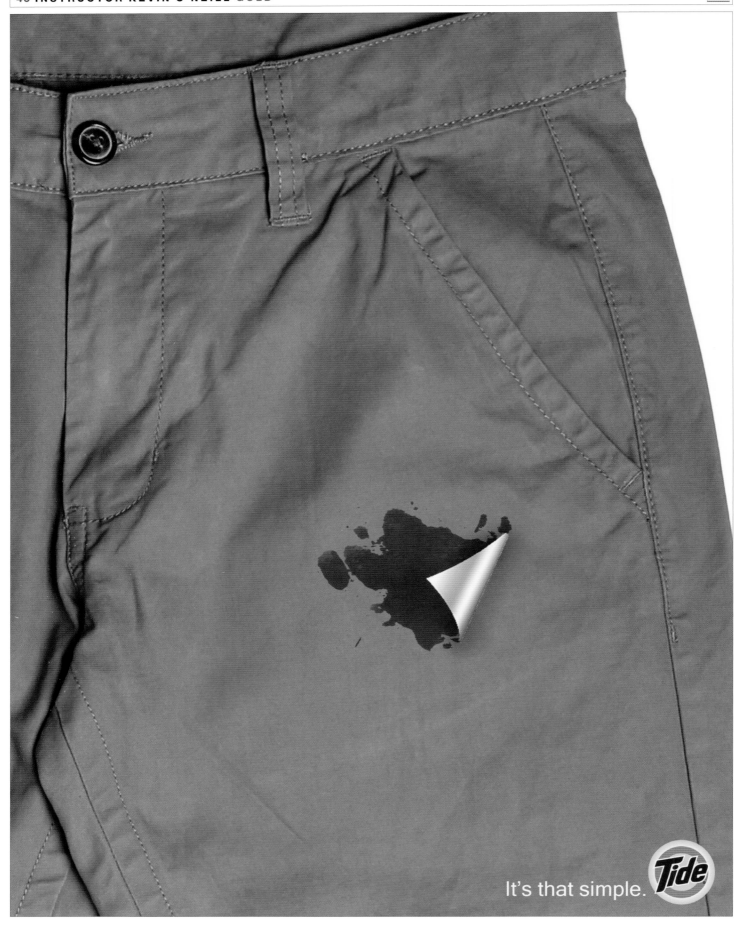

It's that simple.

Advertising | Product

Student: Yunxuan Wu | Syracuse University

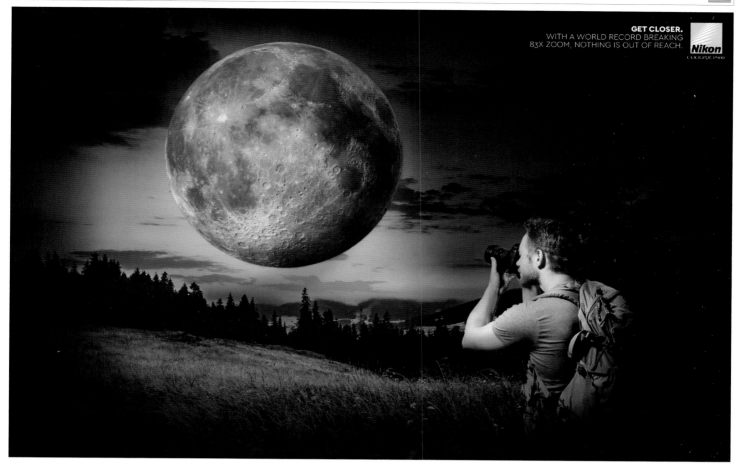

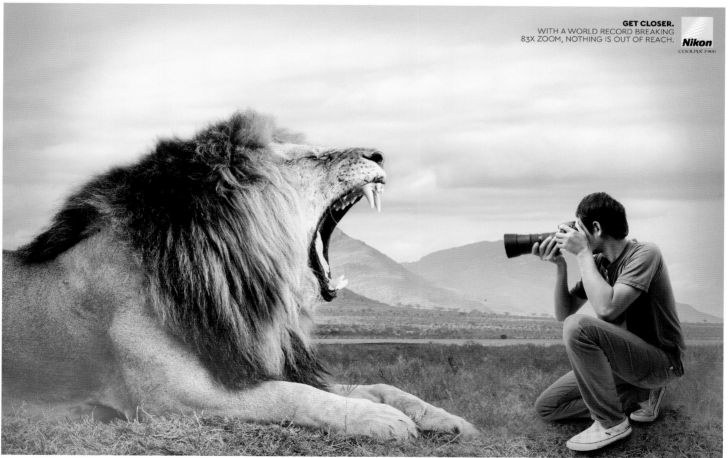

INSTRUCTOR MEL WHITE

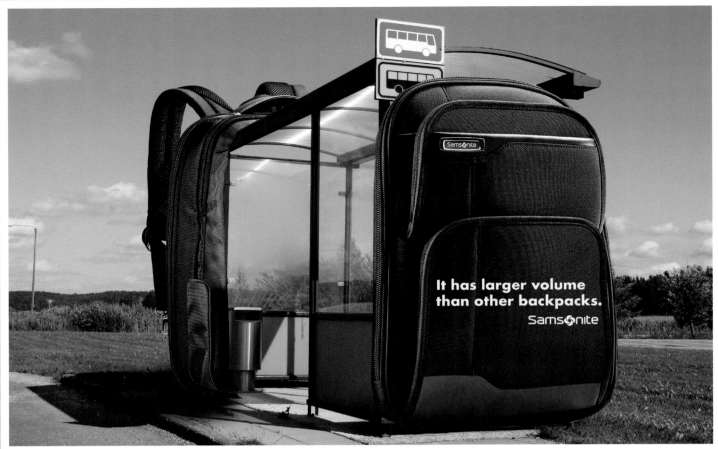

Student: Ting Peng | Syracuse University

INSTRUCTOR LARRY GORDON

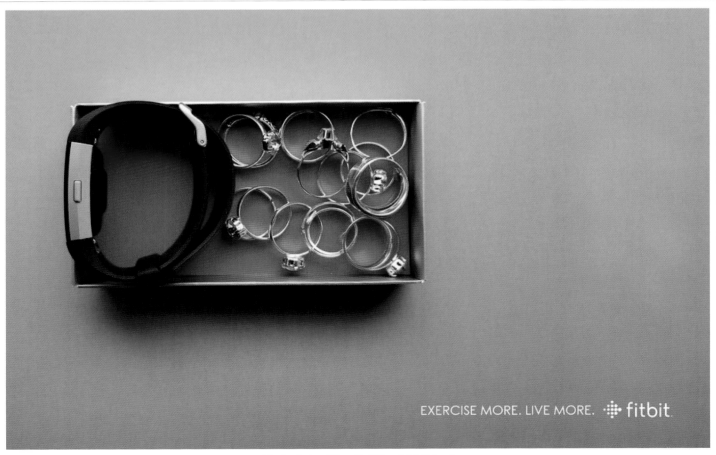

Student: Ana Miraglia | Miami Ad School

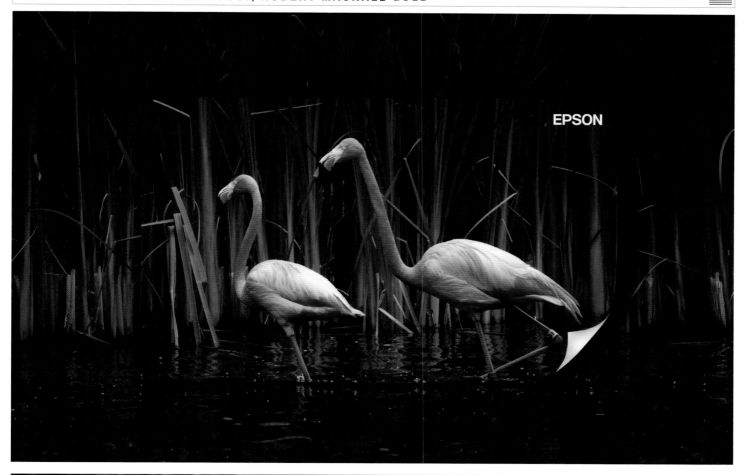

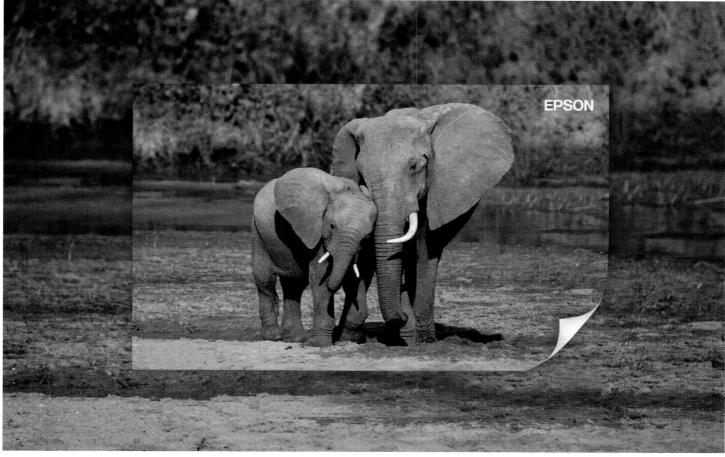

INSTRUCTOR MARK SMITH

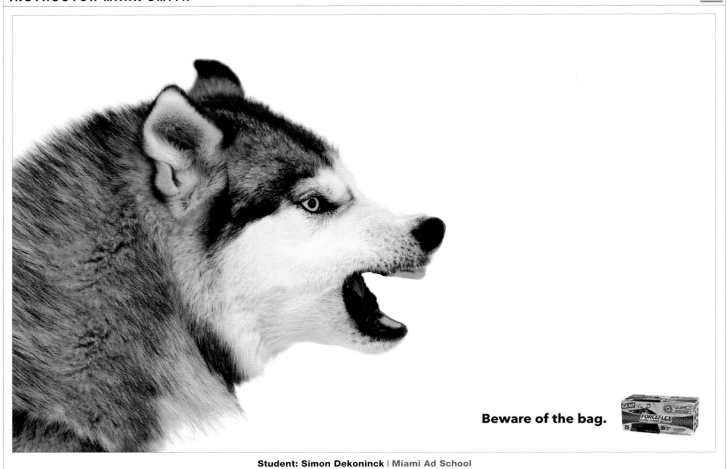

Beware of the bag.

Student: **Simon Dekoninck** | Miami Ad School

INSTRUCTOR MEL WHITE

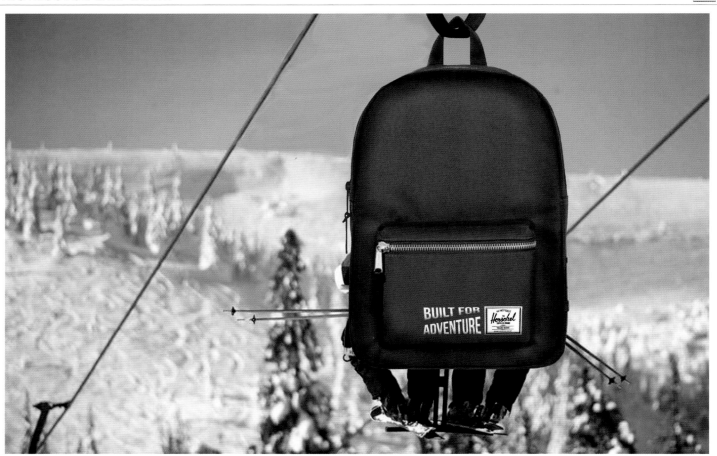

Student: **Kylie Chase Packer** | Syracuse University

INSTRUCTORS JACK MARIUCCI, ROBERT MACKALL

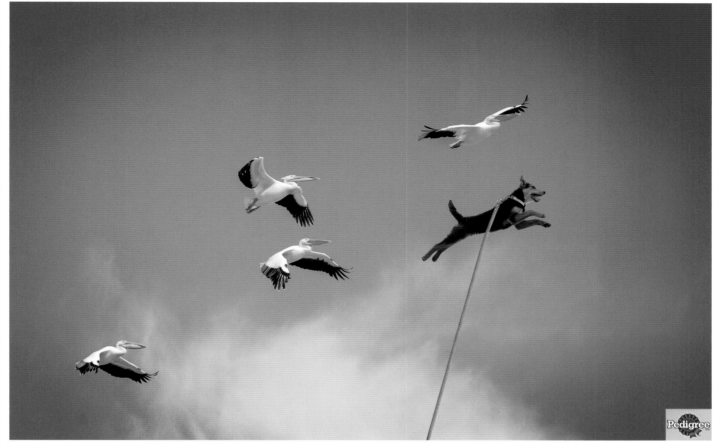

Student: Sewon Park | School of Visual Arts

INSTRUCTORS JACK MARIUCCI, ROBERT MACKALL

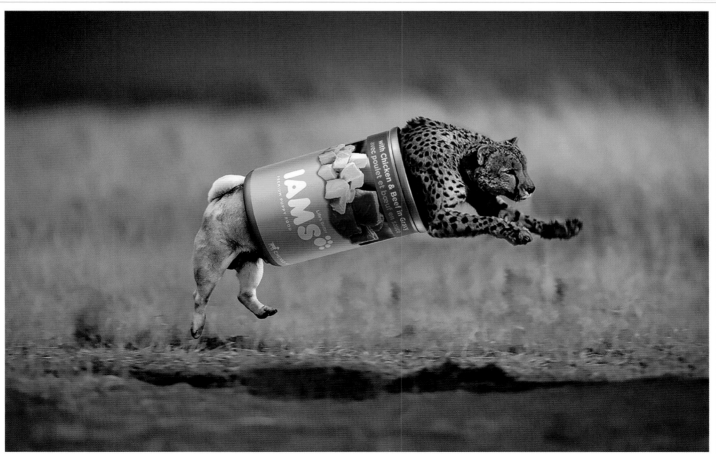

Students: Bowook Yoon, Ha Jung Song | School of Visual Arts

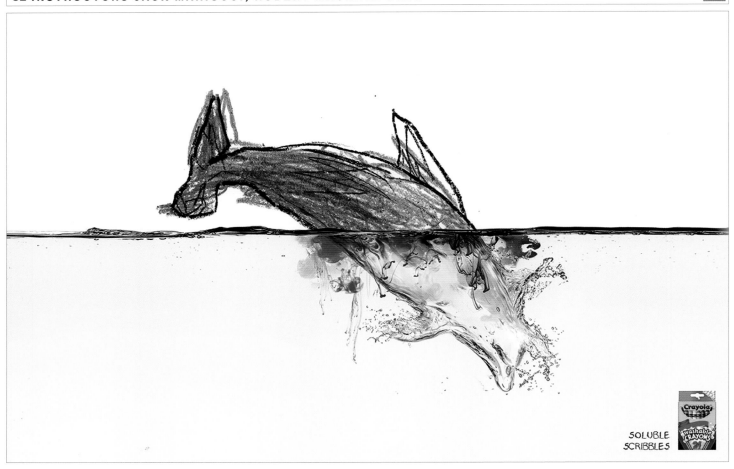

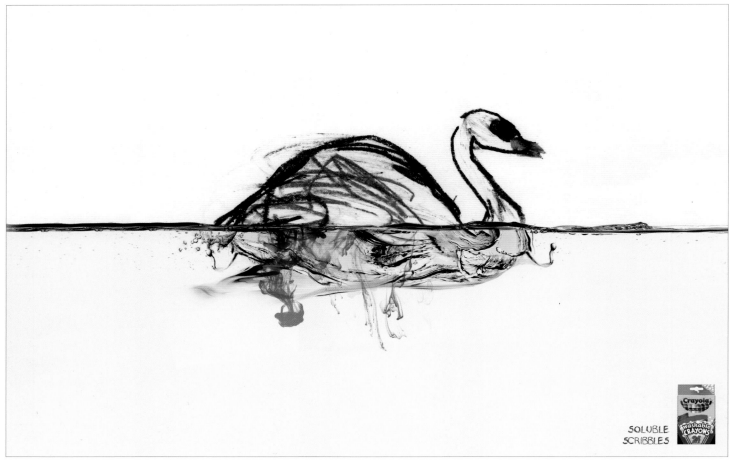

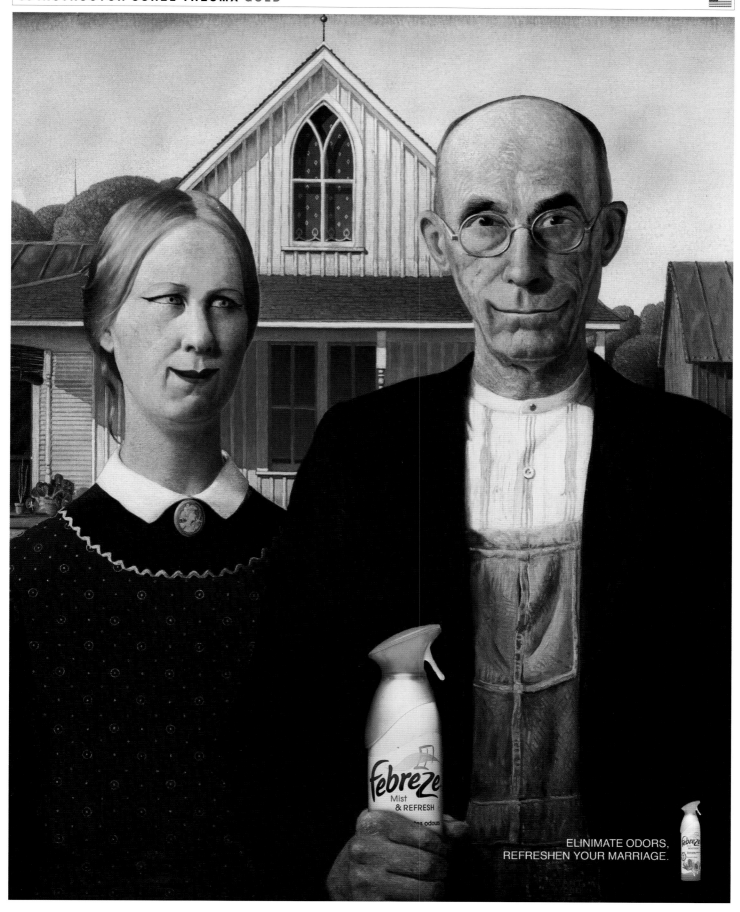

ELINIMATE ODORS,
REFRESHEN YOUR MARRIAGE.

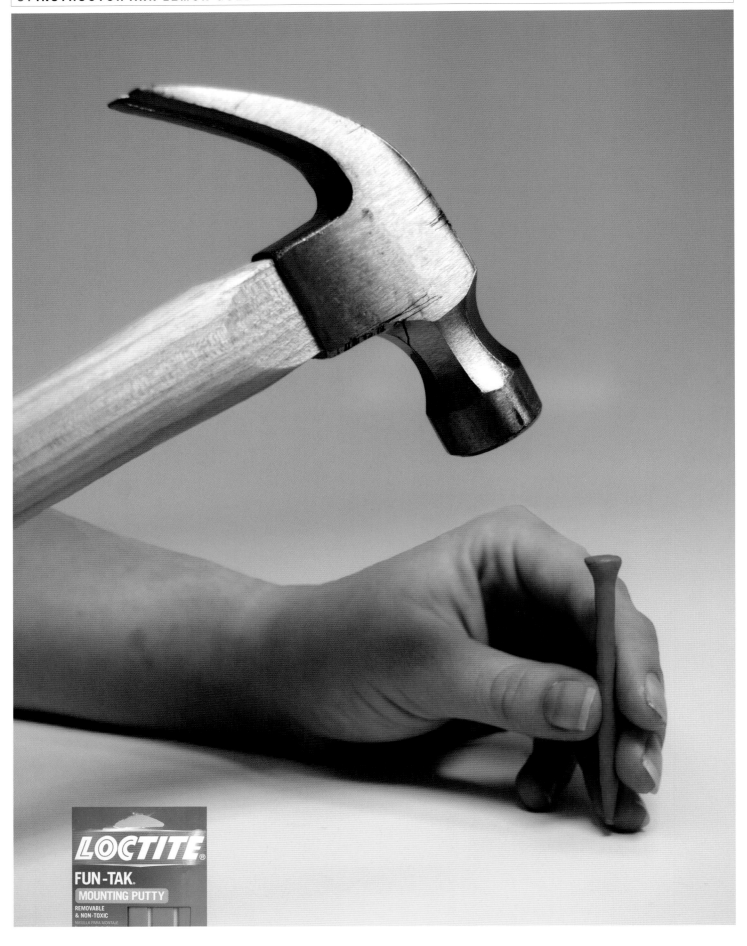

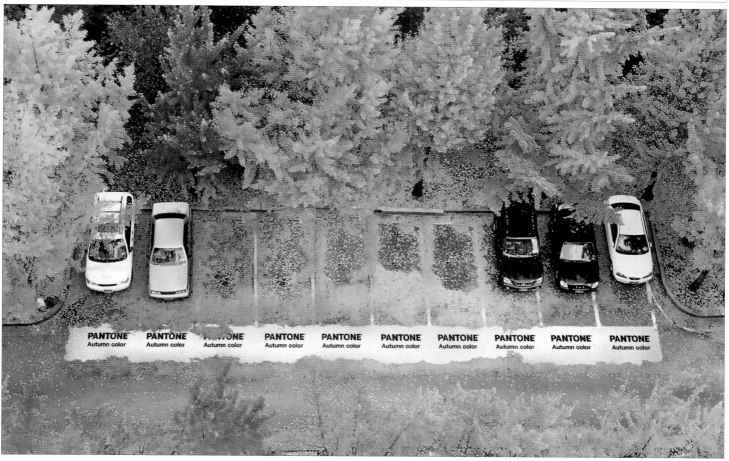

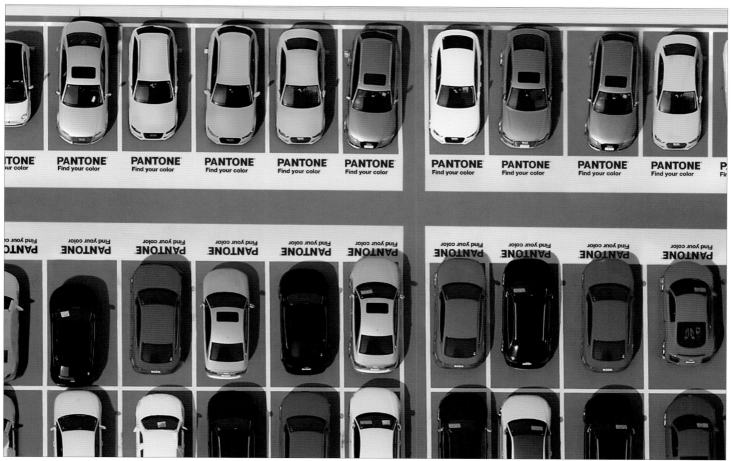

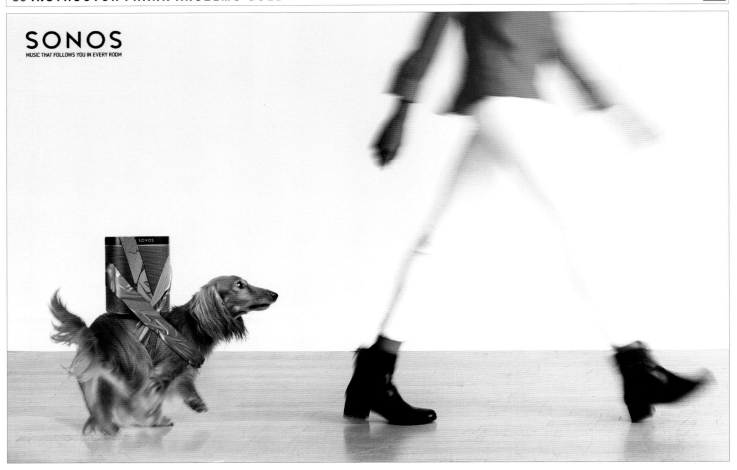

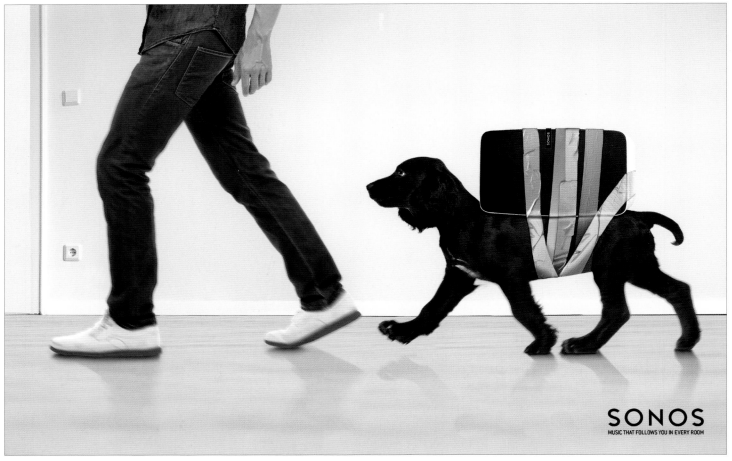

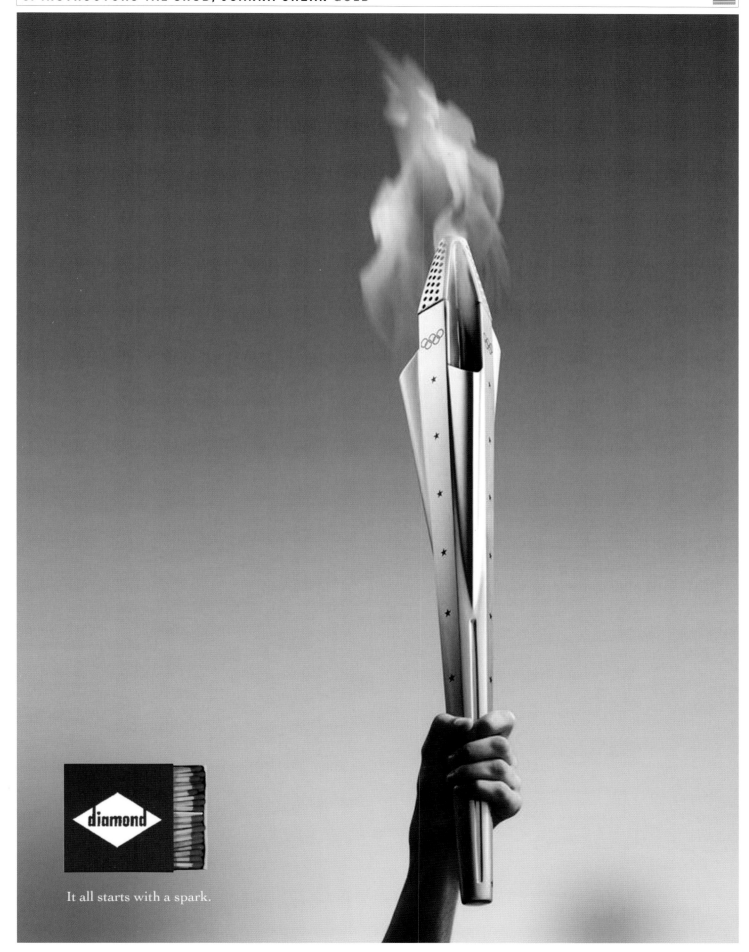

It all starts with a spark.

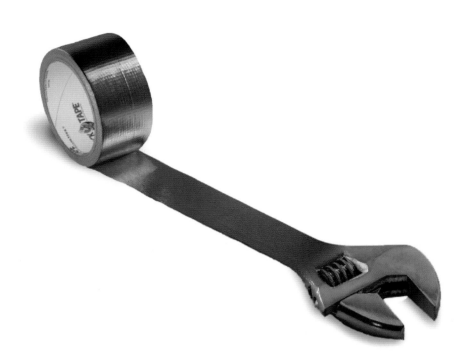

The perfect tool for every project. Duck Duct Tape.

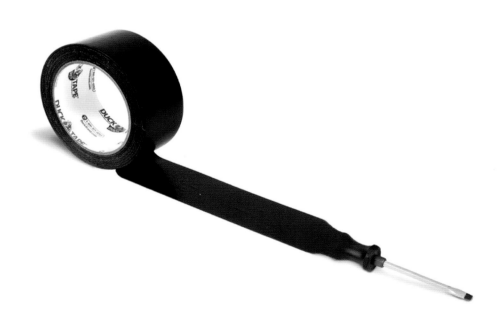

The perfect tool for every project. Duck Duct Tape.

Student: Nicole Framm | Syracuse University

INSTRUCTORS JACK MARIUCCI, ROBERT MACKALL

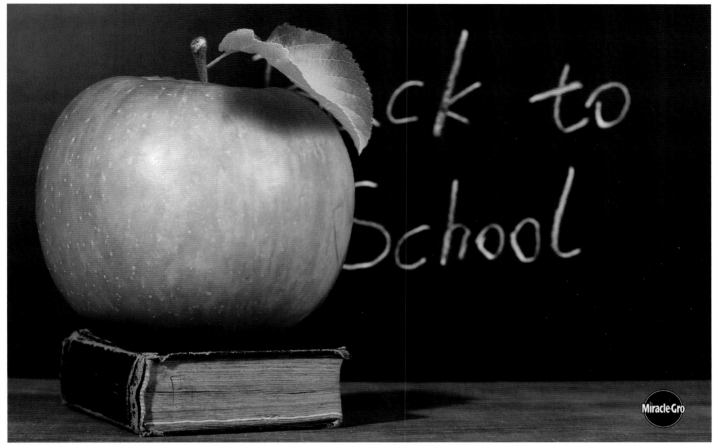

Student: Tamara Yakov | School of Visual Arts

INSTRUCTORS JACK MARIUCCI, ROBERT MACKALL

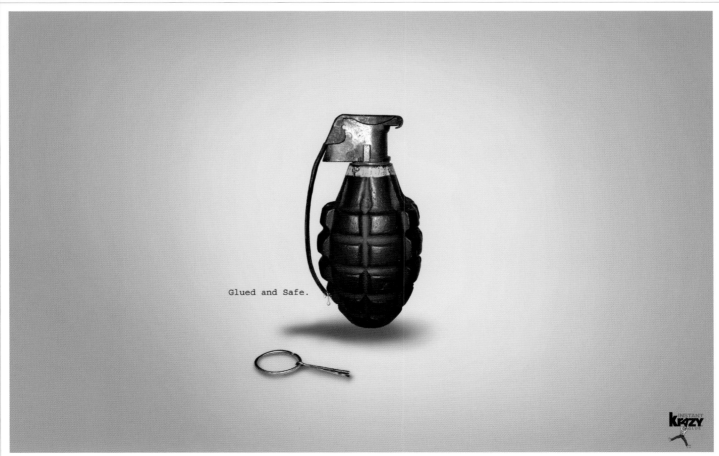

Student: Yoonseo Chang | School of Visual Arts

Product | Advertising

ALL THE COLORS IN NATURE.

PANTONE®

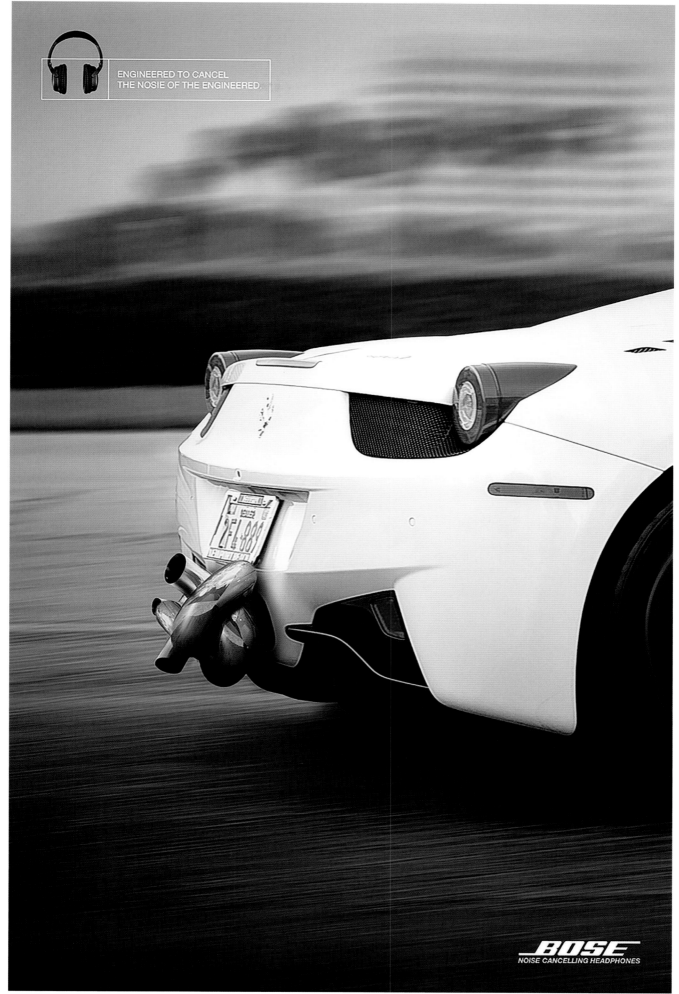

ENGINEERED TO CANCEL
THE NOSIE OF THE ENGINEERED.

BOSE
NOISE CANCELLING HEADPHONES

INSTRUCTOR EILEEN HEDY SCHULTZ

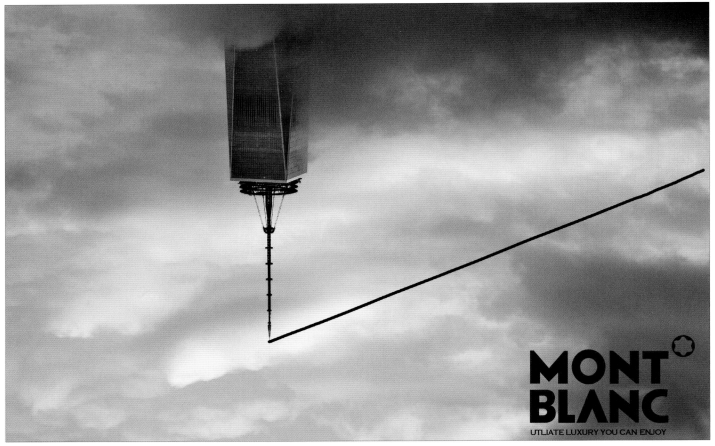

Student: Jae Wook Baik | School of Visual Arts

INSTRUCTORS JACK MARIUCCI, ROBERT MACKALL

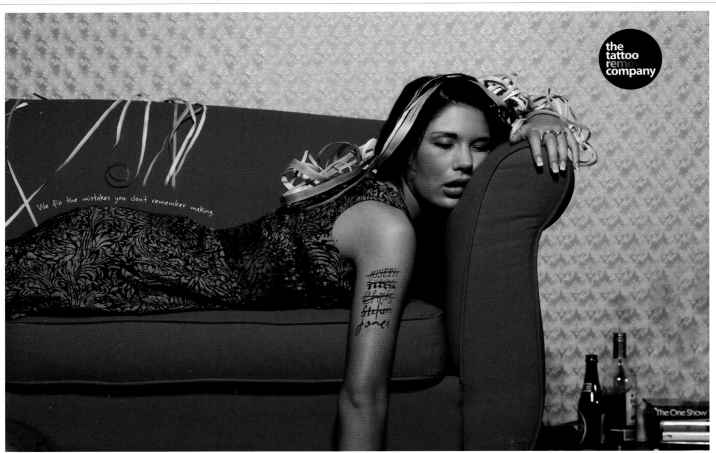

Student: Tamara Yakov | School of Visual Arts

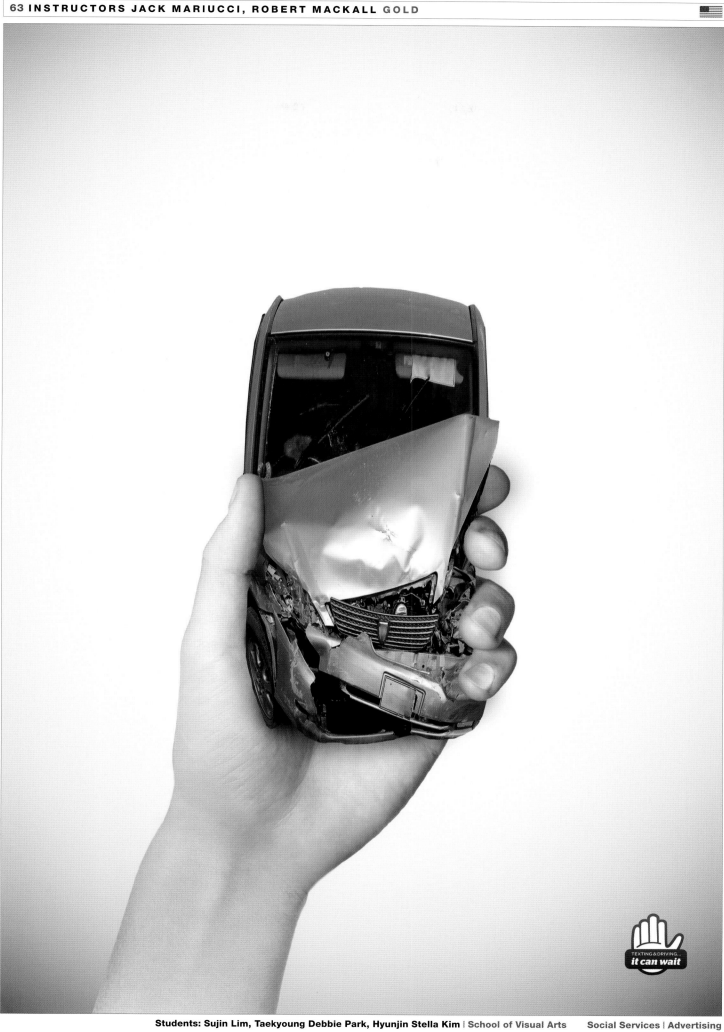

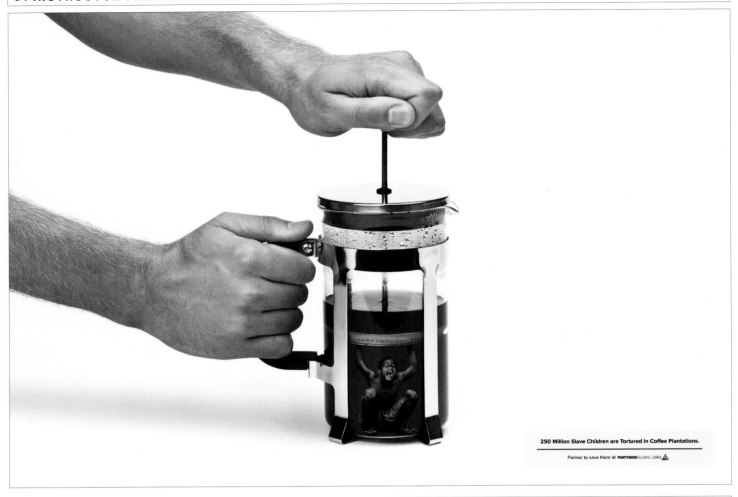

250 Million Slave Children are Tortured in Coffee Plantations.

Partner to save them at **PARTNERS**GLOBAL.ORG

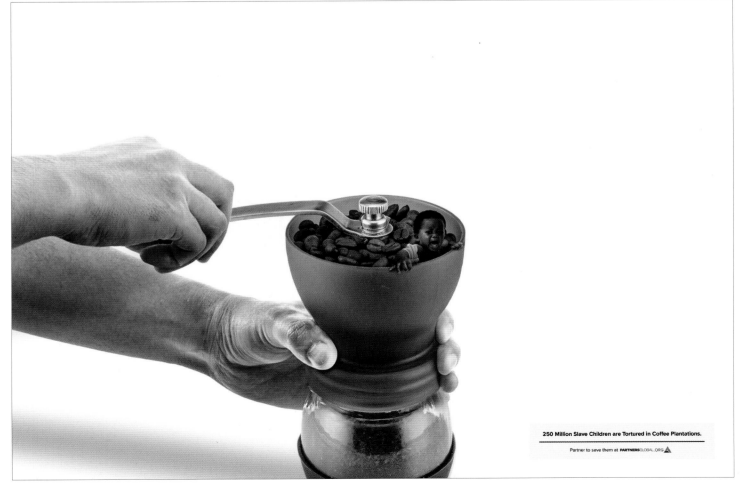

250 Million Slave Children are Tortured in Coffee Plantations.

Partner to save them at **PARTNERS**GLOBAL.ORG

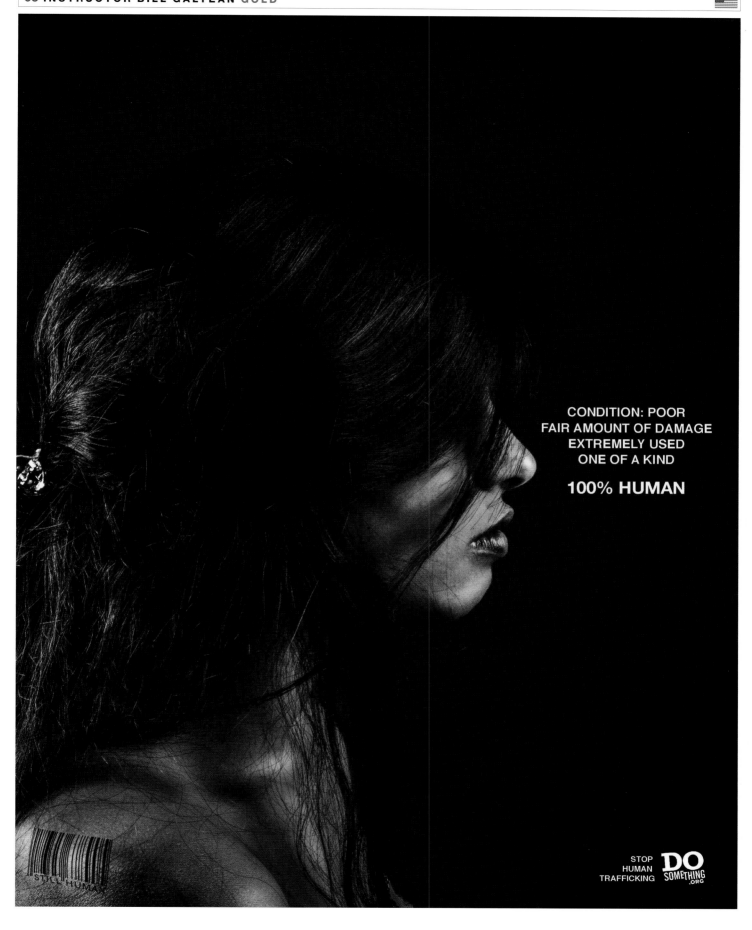

CONDITION: POOR
FAIR AMOUNT OF DAMAGE
EXTREMELY USED
ONE OF A KIND

100% HUMAN

STOP
HUMAN
TRAFFICKING **DO** SOMETHING .ORG

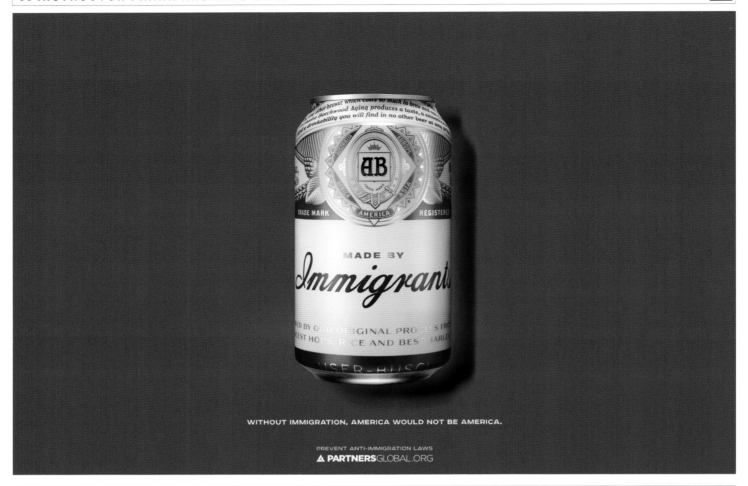

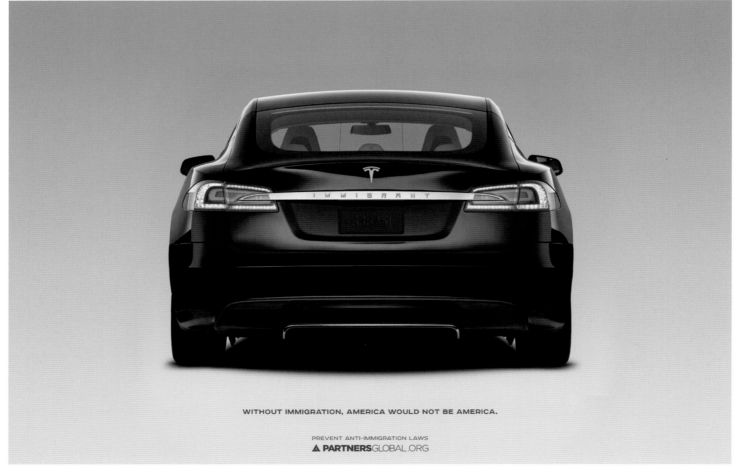

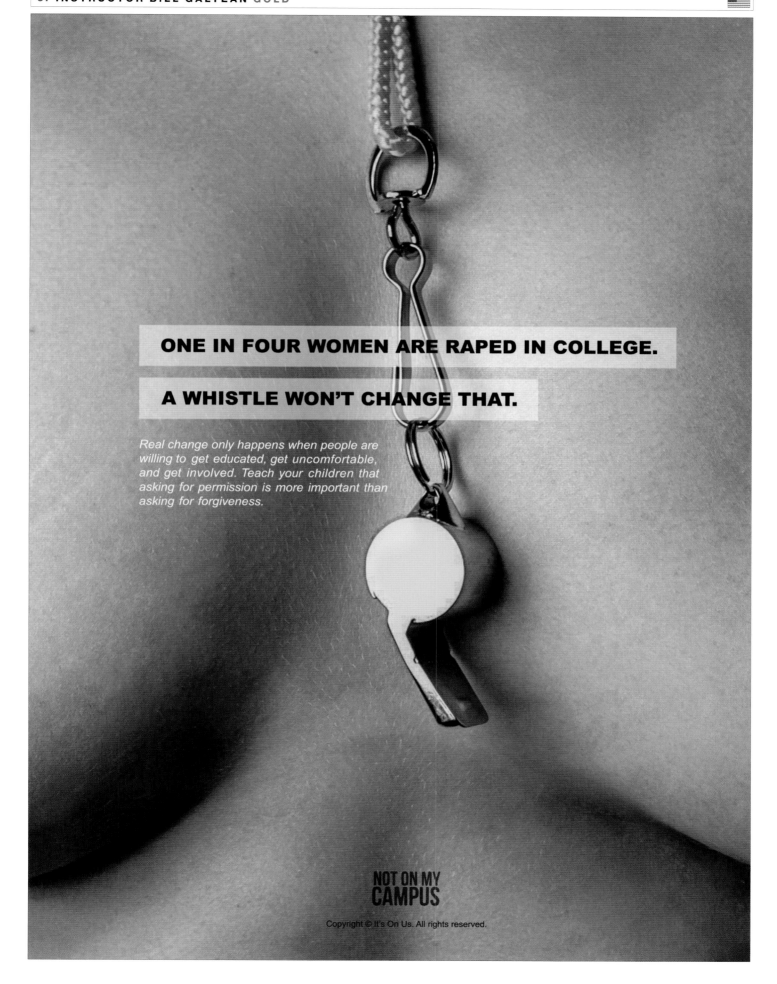

ONE IN FOUR WOMEN ARE RAPED IN COLLEGE.

A WHISTLE WON'T CHANGE THAT.

Real change only happens when people are willing to get educated, get uncomfortable, and get involved. Teach your children that asking for permission is more important than asking for forgiveness.

NOT ON MY CAMPUS

Student: Justine Rendl | Texas Christian University

Social Services | Advertising

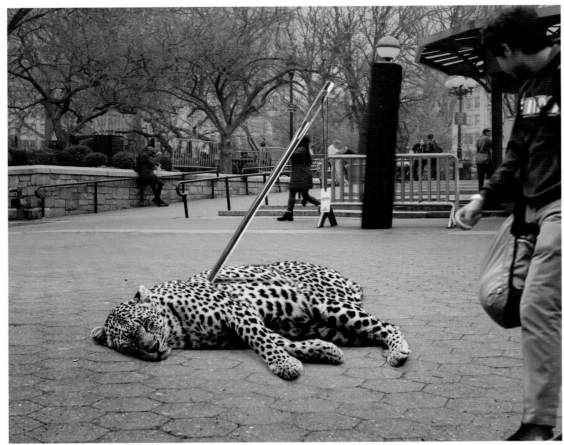

ACTUAL TAXIDERMIED ANIMALS WITH OVERSIZED SEWING NEEDLES ARE INSTALLED IN HIGH-TRAFFIC LOCATIONS.

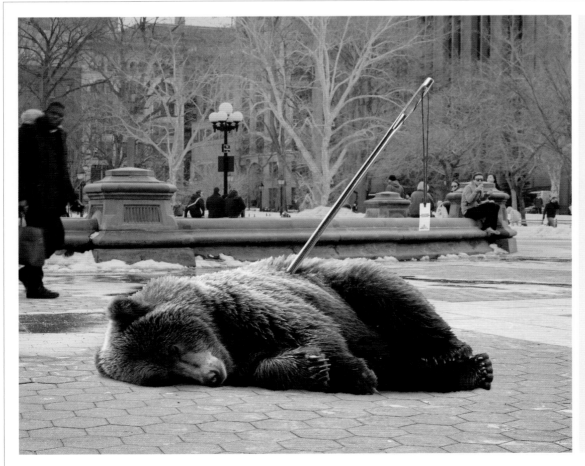

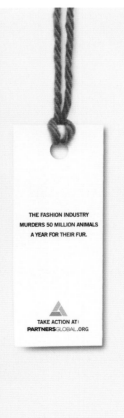

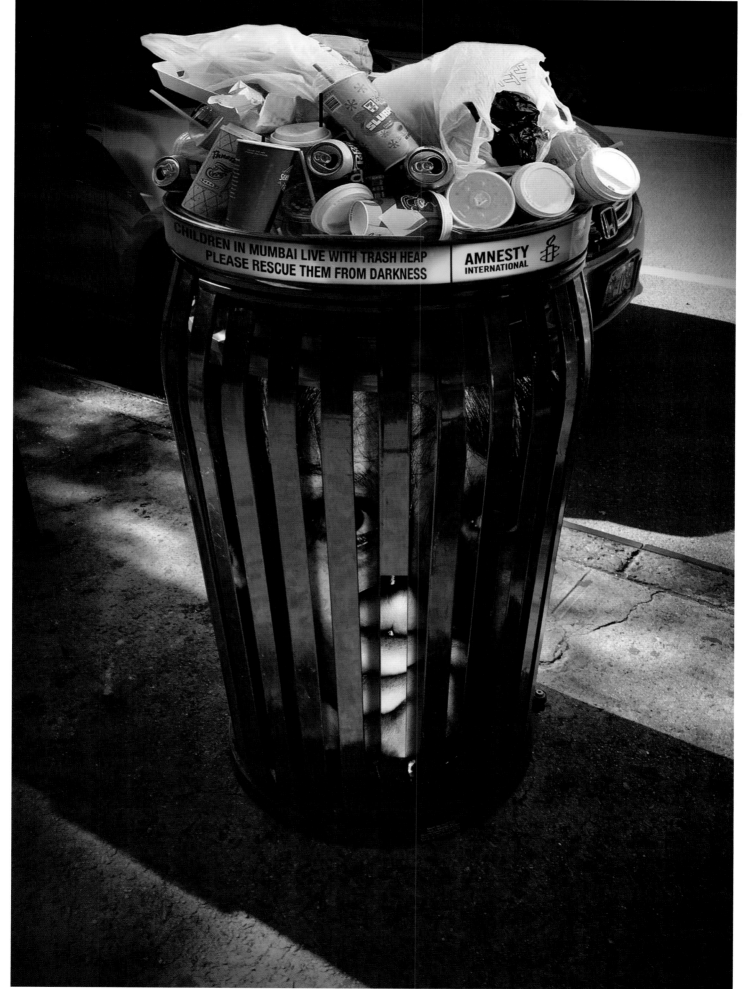

CHILDREN IN MUMBAI LIVE WITH TRASH HEAP
PLEASE RESCUE THEM FROM DARKNESS

AMNESTY
INTERNATIONAL

Students: Bowook Yoon, Ha Jung Song | School of Visual Arts Social Services | Advertising

INSTRUCTORS JACK MARIUCCI, ROBERT MACKALL

UNTIE HUMAN TRAFFICKING

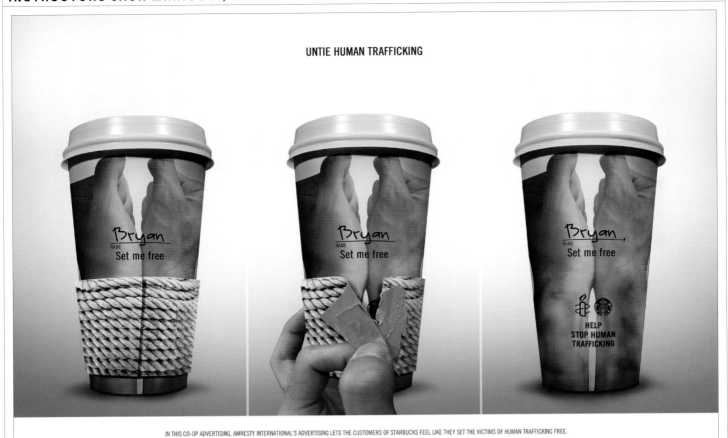

IN THIS CO-OP ADVERTISING, AMNESTY INTERNATIONAL'S ADVERTISING LETS THE CUSTOMERS OF STARBUCKS FEEL LIKE THEY SET THE VICTIMS OF HUMAN TRAFFICKING FREE.

Students: Bowook Yoon, Ha Jung Song | School of Visual Arts

INSTRUCTOR FRANK ANSELMO

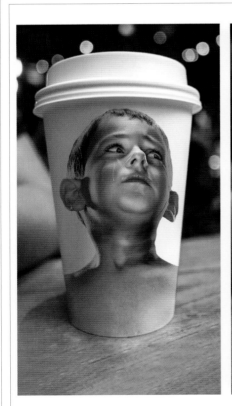
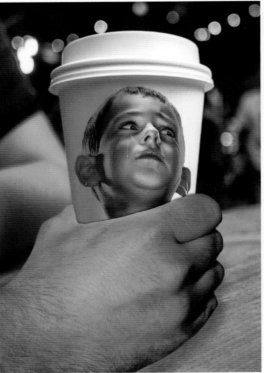
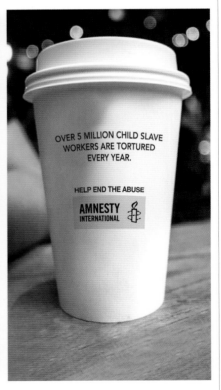

TO DEMONSTRATE THE ABUSE CHILD SLAVE WORKERS ENDURE, THE ILLUSION OF A CHILD BEING CHOKED IS CREATED WHILE SIMPLY HOLDING THE COFFEE CUP.

Students: Jake Blankenship, Yifei You | School of Visual Arts

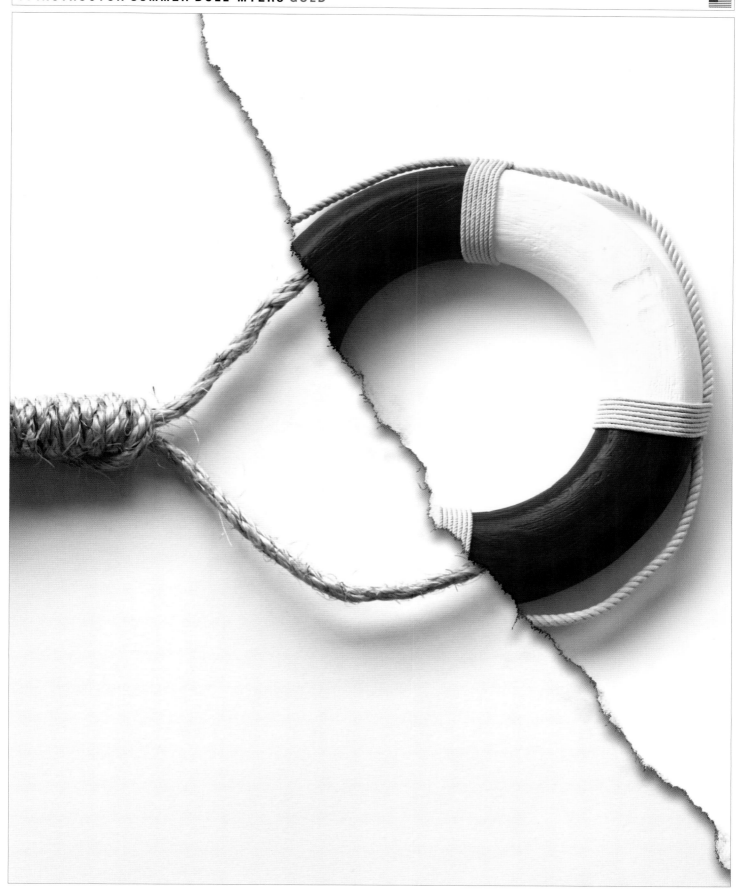

The spiritual journey

PURE
MEDITATION & YOGA

Students: Bowook Yoon, Ha Jung Song | School of Visual Arts

INSTRUCTORS JACK MARIUCCI, ROBERT MACKALL

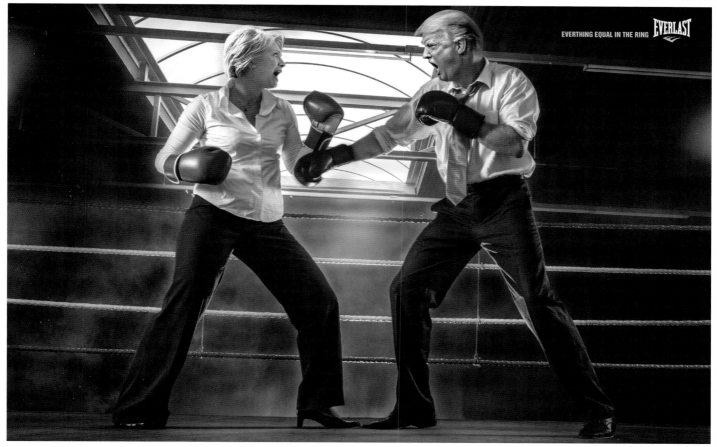

Student: **Young Wook Choi** | School of Visual Arts

INSTRUCTORS JACK MARIUCCI, ROBERT MACKALL

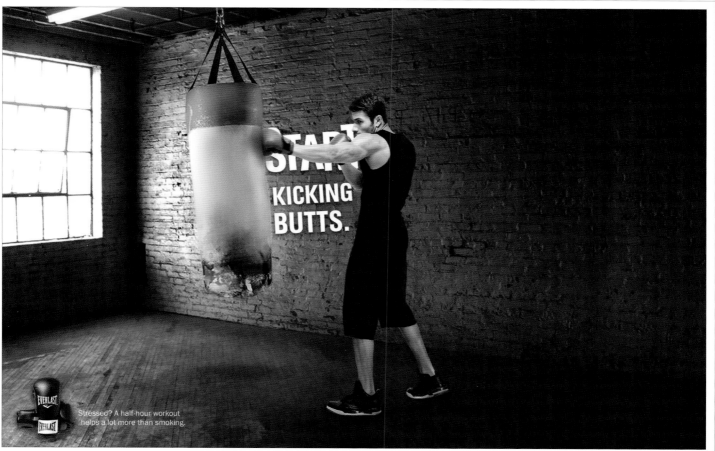

Students: **Sheung Cho, Bernise Wong, Joanna Yoon** | School of Visual Arts

INSTRUCTORS JACK MARIUCCI, ROBERT MACKALL

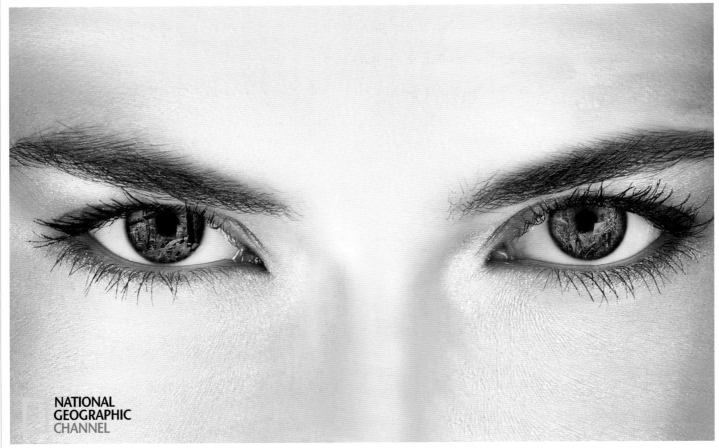

Student: Tamara Yakov | School of Visual Arts

INSTRUCTORS JACK MARIUCCI, ROBERT MACKALL

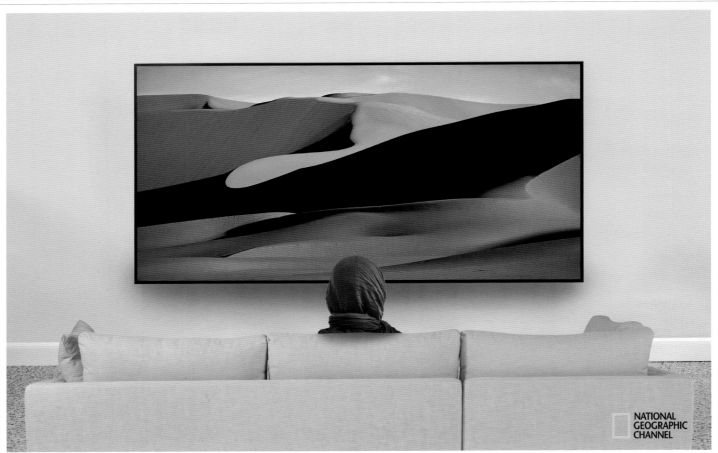

Student: Sujin Lim | School of Visual Arts

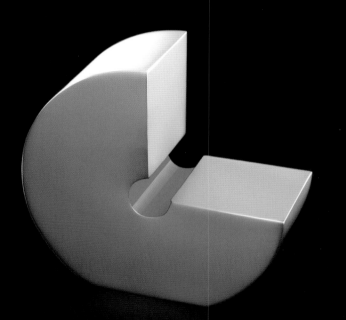

INSTRUCTOR MEL WHITE

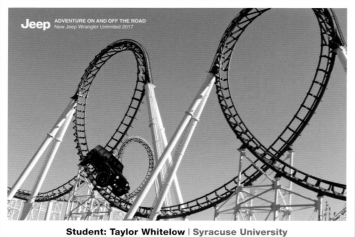

Student: Taylor Whitelow | Syracuse University

INSTRUCTORS JACK MARIUCCI, ROBERT MACKALL

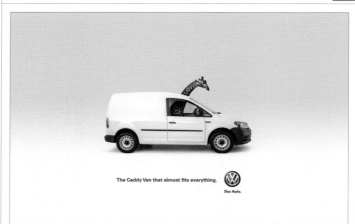

Student: HyeonA Kim | School of Visual Arts

INSTRUCTORS JACK MARIUCCI, ROBERT MACKALL

Students: Bowook Yoon, Ha Jung Song | School of Visual Arts

INSTRUCTOR FRANK ANSELMO

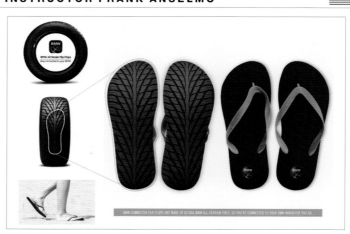

Students: Junho Lee, Evan Choi | School of Visual Arts

INSTRUCTORS JACK MARIUCCI, ROBERT MACKALL

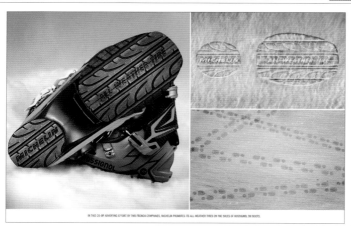

Students: Bowook Yoon, Ha Jung Song | School of Visual Arts

INSTRUCTOR MEL WHITE

Student: Alanna Quinlan | Syracuse University

INSTRUCTOR MEL WHITE

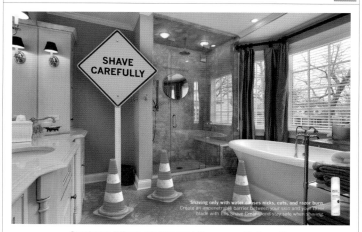

Student: Elizabeth Young | Syracuse University

INSTRUCTORS JACK MARIUCCI, ROBERT MACKALL

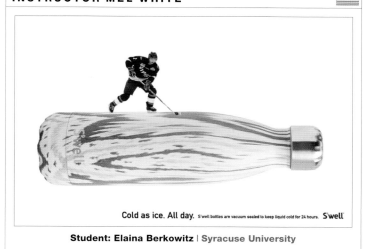

Students: Bowook Yoon, Ha Jung Song | School of Visual Arts

INSTRUCTOR MEL WHITE

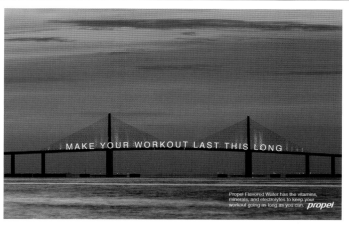

Student: Emily McMurray | Syracuse University

INSTRUCTOR MEL WHITE

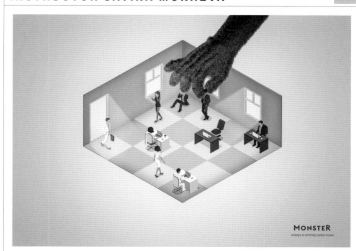

Student: Elaina Berkowitz | Syracuse University

INSTRUCTOR MEL WHITE

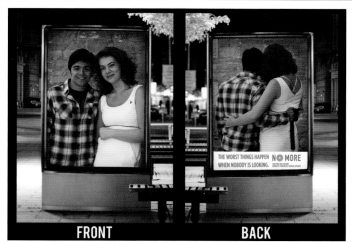

Student: Bryan Allman | Syracuse University

INSTRUCTOR SAVINA MOKREVA

Student: Alexandru Lungu | Miami Ad School Europe

INSTRUCTOR MEL WHITE

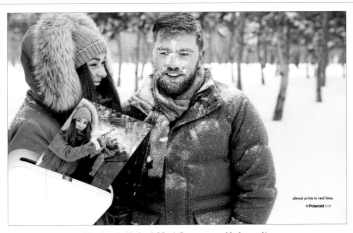

Student: **Hairol Ma** | Syracuse University

INSTRUCTORS JACK MARIUCCI, ROBERT MACKALL

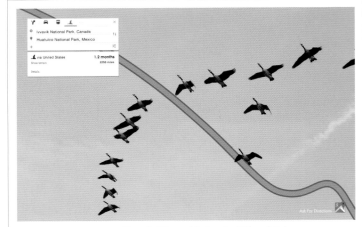

Student: **Han Sol Ryoo** | School of Visual Arts

INSTRUCTOR EILEEN HEDY SCHULTZ

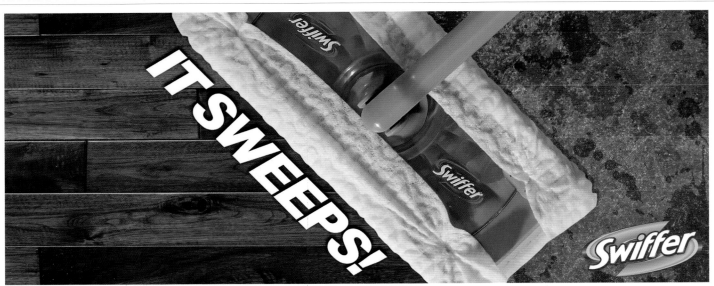

Student: **Yun Lee** | School of Visual Arts

INSTRUCTORS JACK MARIUCCI, ROBERT MACKALL

Students: **Bowook Yoon, Ha Jung Song** | School of Visual Arts

INSTRUCTOR MEL WHITE

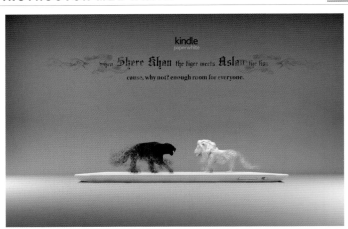

Student: **Estella Huixin Xian** | Syracuse University

INSTRUCTOR KEVIN O'NEILL

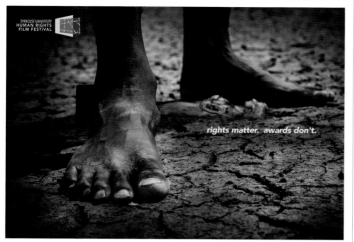

Student: Joshua Race | Syracuse University

INSTRUCTOR MEL WHITE

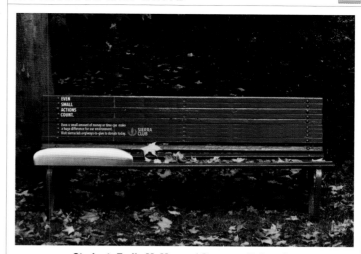

Student: Emily McMurray | Syracuse University

INSTRUCTORS JACK MARIUCCI, ROBERT MACKALL

Students: Tamara Yakov, Ha Eun Kim | School of Visual Arts

INSTRUCTORS JACK MARIUCCI, ROBERT MACKALL

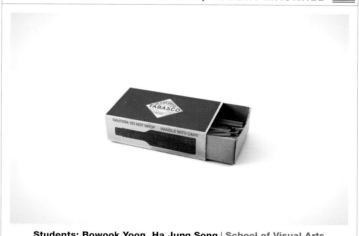

Students: Bowook Yoon, Ha Jung Song | School of Visual Arts

INSTRUCTOR MEL WHITE

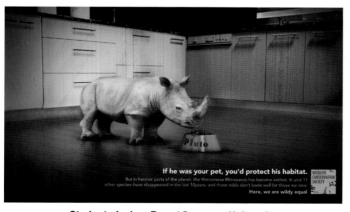

Student: Joshua Race | Syracuse University

INSTRUCTOR MEL WHITE

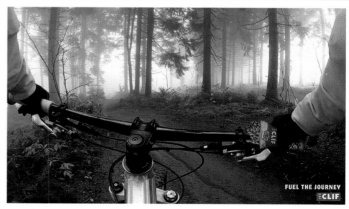

Students: Sarah Togni, Chase Condrone | Syracuse University

MARLON VON FRANQUEMONT

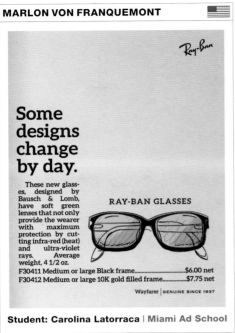

Student: Carolina Latorraca | Miami Ad School

INSTRUCTOR FRANK ANSELMO

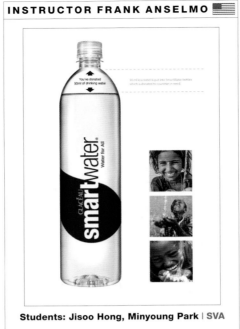

Students: Jisoo Hong, Minyoung Park | SVA

INSTRUCTOR HOON-DONG CHUNG

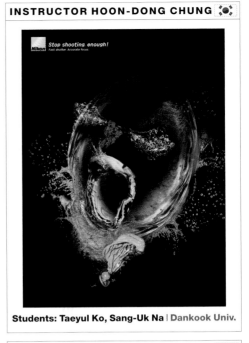

Students: Taeyul Ko, Sang-Uk Na | Dankook Univ.

INSTRUCTOR MICHAEL DOOLEY

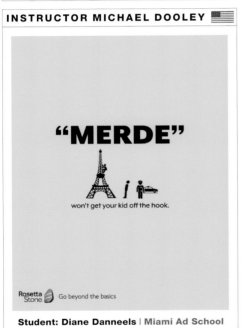

Student: Diane Danneels | Miami Ad School

INSTRUCTOR NIKLAS FRINGS-RUPP

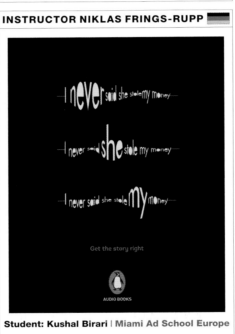

Student: Kushal Birari | Miami Ad School Europe

FLORIAN WEITZEL, DAVID HERRMANN

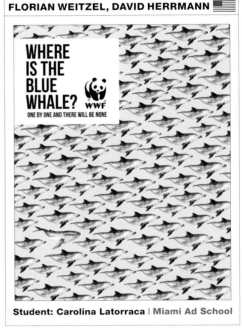

Student: Carolina Latorraca | Miami Ad School

INSTRUCTOR MELISSA WITHORN

NEVER HIDE

Student: Anthony Crisa
Portfolio Center

INSTRUCTOR PIPPA SEICHRIST

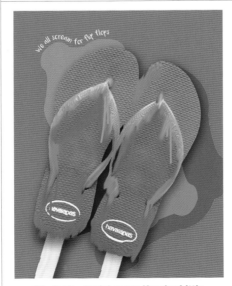

Students: Jack Lester, Kendra Little
Portfolio Center

INSTRUCTOR CARLOS RONCAJOLO

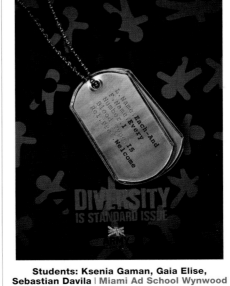

Students: Ksenia Gaman, Gaia Elise,
Sebastian Davila | Miami Ad School Wynwood

INSTRUCTORS JACK MARIUCCI, ROBERT MACKALL

Student: Woo Jae Yoon | School of Visual Arts

INSTRUCTOR FRANK ANSELMO

Students: Joe Chong, Mo Ku | School of Visual Arts

INSTRUCTORS JACK MARIUCCI, ROBERT MACKALL

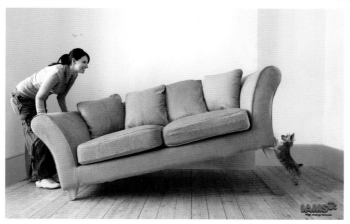

Student: Sujin Lim | School of Visual Arts

INSTRUCTOR HOON-DONG CHUNG

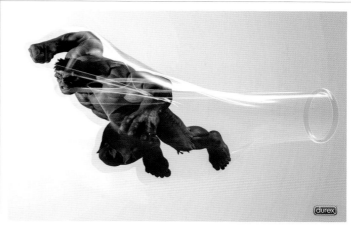

Students: Jonghoon Kim, Taeyul Ko | Dankook University

INSTRUCTOR JOSH EGE

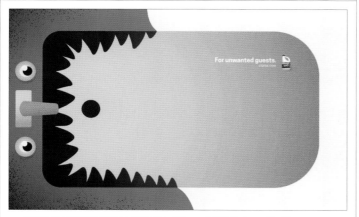

Student: Karina Pérez-Fajardo | Texas A&M University Commerce

INSTRUCTORS JACK MARIUCCI, ROBERT MACKALL

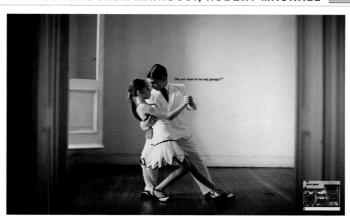

Students: Bowook Yoon, Ha Jung Song | School of Visual Arts

INSTRUCTOR UNATTRIBUTED

The only formula that provides the same benefits as breast feeding

Student: Carolina Latorraca | Miami Ad School

JACK MARIUCCI & ROBERT MACKALL

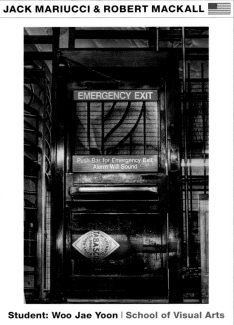

EMERGENCY EXIT

Push Bar for Emergency Exit
Alarm Will Sound

Student: Woo Jae Yoon | School of Visual Arts

JACK MARIUCCI & ROBERT MACKALL

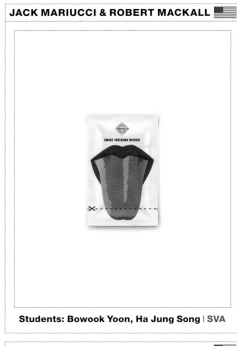

Students: Bowook Yoon, Ha Jung Song | SVA

INSTRUCTOR ANN LEMON

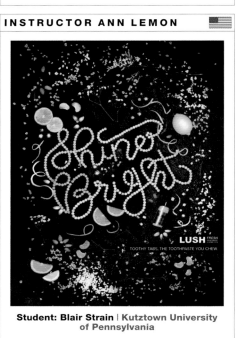

LUSH FRESH
TOOTHY TABS, THE TOOTHPASTE YOU CHEW

**Student: Blair Strain | Kutztown University
of Pennsylvania**

INSTRUCTOR ZORAYMA GUEVARA

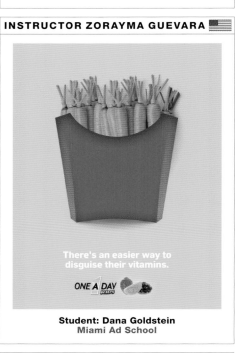

There's an easier way to
disguise their vitamins.

ONE A DAY KIDS

**Student: Dana Goldstein
Miami Ad School**

INSTRUCTOR FRANK ANSELMO

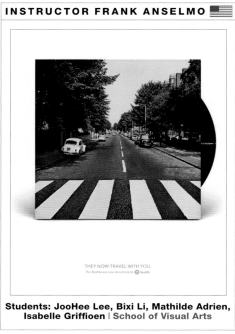

THEY NOW TRAVEL WITH YOU.
The Beatles are now streaming on Spotify

**Students: JooHee Lee, Bixi Li, Mathilde Adrien,
Isabelle Griffioen | School of Visual Arts**

JACK MARIUCCI & ROBERT MACKALL

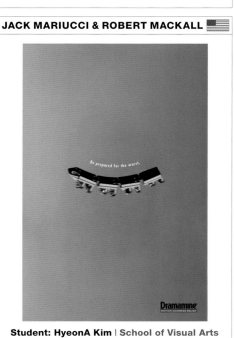

Be prepared for the worst.

Dramamine
MOTION SICKNESS RELIEF

Student: HyeonA Kim | School of Visual Arts

JACK MARIUCCI & ROBERT MACKALL

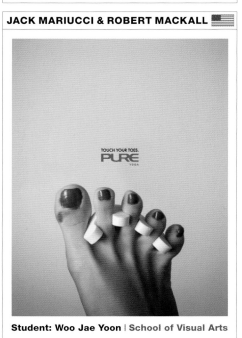

TOUCH YOUR TOES.
PURE YOGA

Student: Woo Jae Yoon | School of Visual Arts

INSTRUCTOR MEL WHITE

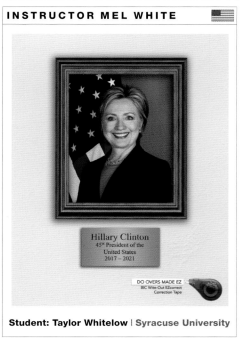

Hillary Clinton
45th President of the
United States
2017 – 2021

DO OVERS MADE EZ
BIC Wite-Out EZcorrect
Correction Tape

Student: Taylor Whitelow | Syracuse University

INSTRUCTOR PIPPA SEICHRIST

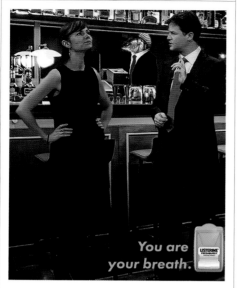

Student: Mark Hyde | **Portfolio Center**

JACK MARIUCCI & ROBERT MACKALL

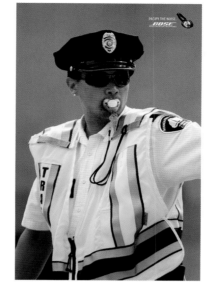

Student: Woo Jae Yoon | **School of Visual Arts**

INSTRUCTOR MARK SMITH

Student: Jon Gruber | **Miami Ad School**

INSTRUCTOR MEL WHITE

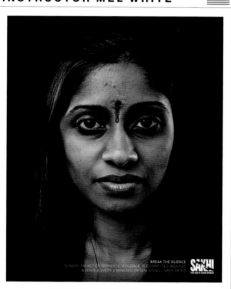

Student: Justina Hnatowicz
Syracuse University

JACK MARIUCCI & ROBERT MACKALL

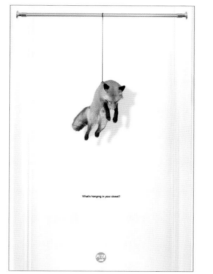

Students: Han Sol Ryoo, Yae Nah Oh
School of Visual Arts

INSTRUCTOR MARK SMITH

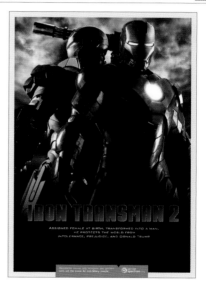

Students: Hampus Elfström, Thomas Nguyen
Miami Ad School

INSTRUCTOR FRANK ANSELMO

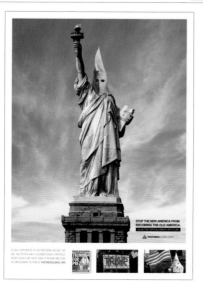

Students: Junho Lee, Evan Choi
School of Visual Arts

INSTRUCTOR BILL GALYEAN

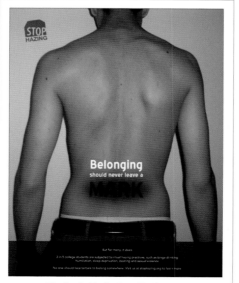

Student: Emily Ann Hathaway
Texas Christian University

FLORIAN WEITZEL, DAVID HERRMANN

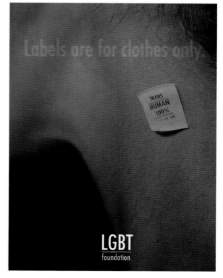

Student: Carolina Latorraca
Miami Ad School

INSTRUCTOR MEL WHITE

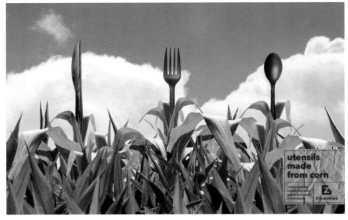

Student: Audra Linsner | Syracuse University

INSTRUCTOR MEL WHITE

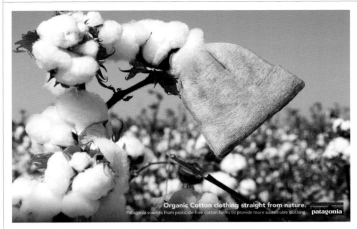

Student: Jacob Marcus | Syracuse University

INSTRUCTOR MEL WHITE

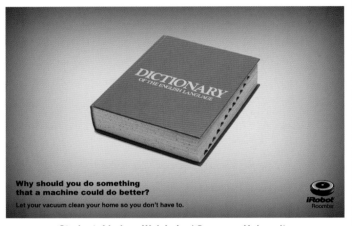

Student: Lindsay Weisleder | Syracuse University

INSTRUCTORS JACK MARIUCCI, ROBERT MACKALL

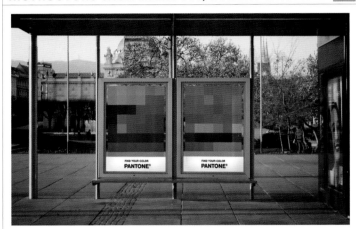

Students: Bowook Yoon, Ha Jung Song | School of Visual Arts

INSTRUCTOR MEL WHITE

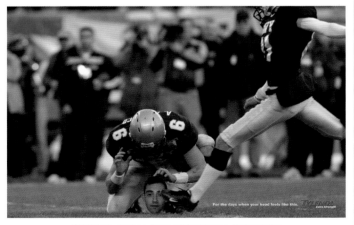

Student: James Baras | Syracuse University

INSTRUCTOR MEL WHITE

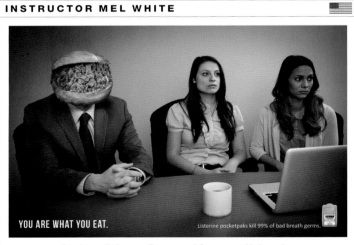

Student: Rebecca Bregman | Syracuse University

INSTRUCTORS JACK MARIUCCI, ROBERT MACKALL

Student: Woo Jae Yoon | School of Visual Arts

INSTRUCTORS JACK MARIUCCI, ROBERT MACKALL

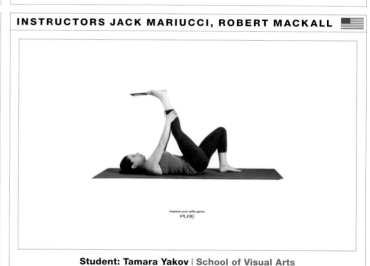

Student: Woo Jae Yoon | School of Visual Arts

INSTRUCTORS JACK MARIUCCI, ROBERT MACKALL

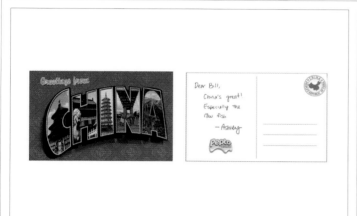

Student: Tamara Yakov | School of Visual Arts

INSTRUCTORS JACK MARIUCCI, ROBERT MACKALL

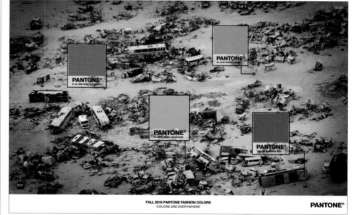

Student: Tamara Yakov | School of Visual Arts

INSTRUCTORS JACK MARIUCCI, ROBERT MACKALL

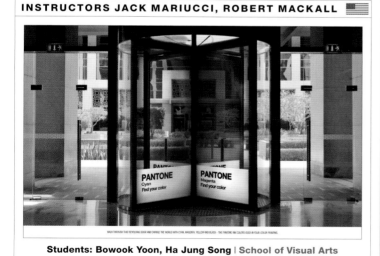

Students: Bowook Yoon, Ha Jung Song | School of Visual Arts

INSTRUCTORS JACK MARIUCCI, ROBERT MACKALL

Students: Bowook Yoon, Ha Jung Song | School of Visual Arts

INSTRUCTOR RACHEL DIESEL

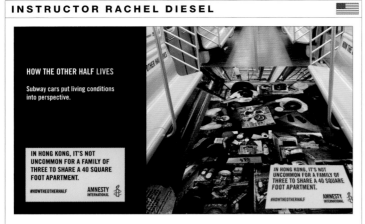

Students: Caitlin Hickey, Matt Tennenbaum | Miami Ad School

INSTRUCTOR FRANK ANSELMO

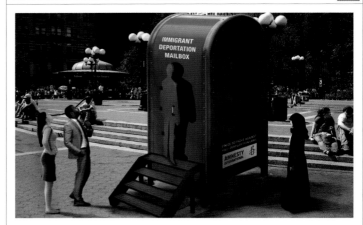

Students: Jisoo Hong, Minyoung Park | School of Visual Arts

INSTRUCTOR NIKLAS FRINGS-RUPP

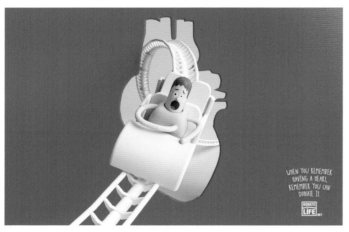

Student: Shao Tsai
Miami Ad School Europe

INSTRUCTOR FRANK ANSELMO

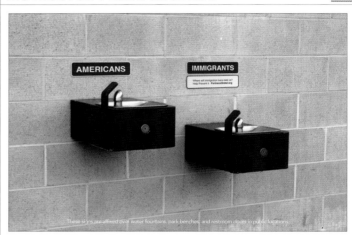

Students: Jack Jungho Hwang, Han Meng, Junho Lee, Evan Choi,
Garret Wheeler, Michelle Sadler | School of Visual Arts

INSTRUCTORS JACK MARIUCCI, ROBERT MACKALL

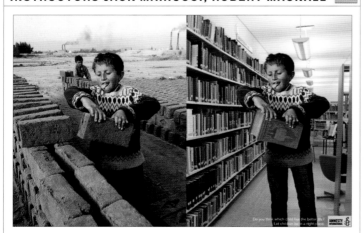

Student: Sewon Park | School of Visual Arts

INSTRUCTOR FRANK ANSELMO

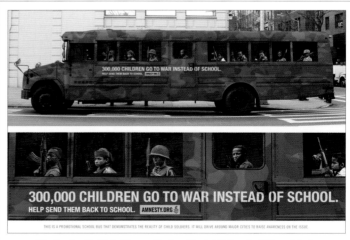

Students: Delilah Kimm, Taejun Park | School of Visual Arts

INSTRUCTORS JACK MARIUCCI, ROBERT MACKALL

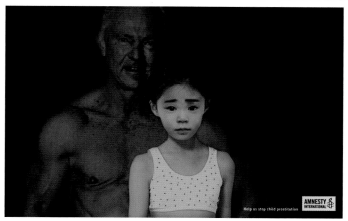

Student: Sujin Lim | School of Visual Arts

INSTRUCTOR MEL WHITE

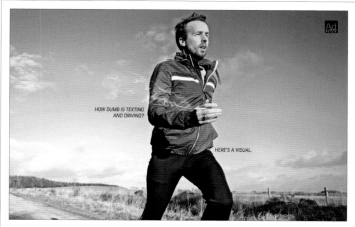

Student: Alexis Watson | Syracuse University

INSTRUCTOR FRANK ANSELMO

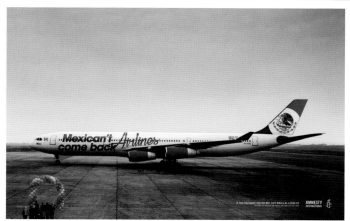

Students: Rogier van der Galiën, Robin van Eijk | School of Visual Arts

INSTRUCTOR MEL WHITE

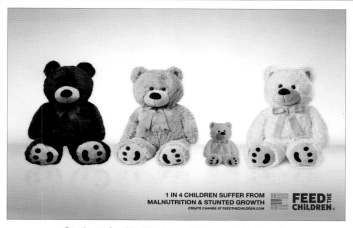

Student: Sophia Kardaras | Syracuse University

INSTRUCTOR MEL WHITE

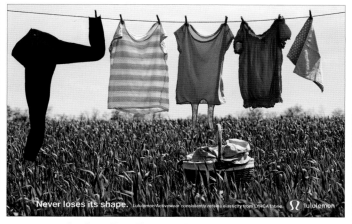

Student: Kate Fitzgerald | Syracuse University

INSTRUCTORS JACK MARIUCCI, ROBERT MACKALL

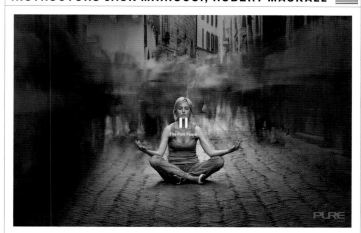

Students: Bowook Yoon, Ha Jung song | School of Visual Arts

DESIGN INSTRUCTORS

Be open to new ways of thinking, ideas, perspectives, different cultures, and things you think are plain whacko.

Sean Adams, *Instructor, Art Center College of Design*

Be passionate about what you do. It will see you through your most difficult hours.

Eileen Hedy Schultz, *Instructor, School of Visual Arts*

Being happy in your profession is more important than pursuing fame or wealth (not that these can't be wonderful by-products).

Chris Austopchuk, *Instructor, School of Visual Arts*

No one will be impressed by your work unless you are.

Tyler Hopf, *Instructor, School of Visual Arts*

If you want to compete against the best talent for the best jobs, you have to become the best. End of story.

Adrian Pulfer, *Instructor, Brigham Young University*

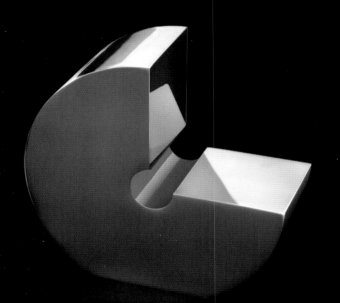

Chris Austopchuk | **School of Visual Arts** | **Dean: Richard Wilde** | **Page: 92**
Biography: Christopher Austopchuk is the Senior VP & Creative Director of Sony Music, co-founder of Spirit & Flesh magazine, and a professor with the School of Visual Arts. He has been practicing his craft in the industry for over 40 years in various disciplines, including branding, editorial design, book design, advertising, online design, digital design, and content creation.
Advice: My advice to students is that while there is a chorus of voices in school who will offer their advice, it is MOST important to find your OWN voice, and that being happy in what you do in your profession is more important than pursuing fame or wealth (not that these can't be wonderful bi-products).

Peter Ahlberg | **School of Visual Arts** | **Dean: Richard Wilde** | **Page: 93**
Biography: Peter Ahlberg is a designer and principal of AHL&CO and teaches graphic design and typography at the School of Visual Arts in New York City. He is the author of Please Make This Look Nice: The Graphic Design Process and co-author of Diary of Your Home.
Advice: My advice to students is best captured in the two quotes below:
[On the design process] "Everyone has a plan 'till they get punched in the mouth." —Mike Tyson
[On the finished work] "Good art should elicit a response of 'Huh? Wow!' as opposed to 'Wow! Huh?'" —Ed Ruscha

Adrian Pulfer | **Brigham Young University** | **College of Fine Arts and Communication: Ed Adams** | **Page: 94**
Biography: Adrian has created textiles and wallpapers for Knoll International and F. Schumacher, New York. As an art director, he has produced advertising for American Express' "Are You A Cardmember?" and "Make Life Rewarding" campaigns. Adrian art directed campaigns for Crate & Barrel and launched their CB2 stores. He has created the graphic standards for a number of corporations from Georgia-Pacific's Hopper Papers to Sundance. Adrian designed the Salt Lake Winter Olympic Bid Books, toasted by the IOC as the finest in the history of the Games. For thirty years, Adrian served as head of the Graphic Design Department at Brigham Young University.
Advice: I tell my students that if you want to compete against the best talent in the country for the best jobs, you have to become the best. End of story.

Eileen Hedy Schultz | **School of Visual Arts** | **Dean: Richard Wilde** | **Page: 95**
Biography: Eileen Hedy Schultz is President and Creative Director, Design International; Creative Director, The Depository Trust Company; Formerly Creative Director, Hearst Promotions; Creative Director, Advertising and Sales Promotion, Good Housekeeping. B.F.A., School of Visual Arts; Art Students League; Columbia University. President, Society of Illustrators. Past Chairman, The Joint Ethics Committee. Past President: Art Directors Club (Only woman President). The School of Visual Arts Alumni Society. Board of Trustees, School Art League. Board of Directors, School of Visual Arts; Advisory Board, F.I.T.; Advisory Commission, New York Community College. Former Columnist, Art Direction. Art Director, Designer, Editor, The 50th Art Directors Club Annual. National and international lecturer. Awards: Outstanding Achiever Award, School of Visual Arts Alumni Society; innumerable professional awards and honors. Currently Graphic, Interior, and Fashion Designer and Photographer.
Advice: Do what you love. Stay motivated, stay dedicated, and stay focused. Believe in yourself and chase your dreams. And most important, be passionate about what you do. It will see you through your most difficult hours.

Dong-Joo Park & Seung-Min Han | **Hansung University of Design & Art Institute Page: 96**
See page 14 for their biographies and advice.

Tyler Hopf | **School of Visual Arts** | **Dean: Richard Wilde** | **Page: 97**
Biography: Tyler Hopf is the Creative Director at IrisVR. He also serves as Adjunct Faculty at the School of Visual Arts. Tyler graduated from Princeton University with a Masters in Architecture and has worked across architecture, technology, and visual effects at Diller Scofidio, Samsung Research, and Framestore.
Advice: No one will be impressed by your work unless you are. What you have done is incredible, unique and powerful. Own it. Believe in yourself. Others will follow.

Sean Adams & Chris Hacker | **Art Center College of Design**
Associate Provost for Student Affairs & Dean of Students: Ray Quirolgico | **Page: 98** | **Biographies:**
Sean Adams: Sean Adams is the Executive Director of the Graphic Design Graduate Program at ArtCenter College of Design, founder of Burning Settlers Cabin, author of multiple books, and on-screen author for LinkedIn Learning. He is the only two-term AIGA national president in AIGA's 100-year history. In 2014, Adams was awarded the AIGA Medal, the highest honor in the profession. He currently is on the editorial board and writes for Design Observer. ■ Adams is an AIGA and Aspen Design Fellow. He has been widely recognized by every major competition and publication, including a solo exhibition at SFMOMA. Adams has been cited as one of the forty most important people shaping design internationally, and one of the top ten influential designers in the United States. Previously, Adams was a founding partner of AdamsMorioka.
Advice: Sean Adams: The most important aspect of design education is the willingness to be open. Be open to new ways of thinking, ideas, different perspectives, different cultures, and things you think are just plain whacko. I tell my students that they can get constipated later in life and hate everything that's new, but not now. ■ Also, Talk, talk, and talk more. 80% of the job is discussion, persuasion, and dialogue. The more you discuss your work and others in crits, the more comfortable you become when it's time to face a client or boss. If you sit in the back of the room silently fuming, you cheat yourself. It's good to have opinions and voice them. Just don't go for the personal. It's not ok in a crit to say, "You have no friend, nobody loves you, you're ugly." Stick with a conversation about the work.

Chris Hacker: Chris Hacker is Chief Design Officer of Hacker Design Group, a design consultancy specializing in Product, Brand, Experience Design, Design Management, and Sustainability Design. He is also a Professor in the Graphic Design Graduate Program at Art Center College of Design. He brings Design management and mutli-disiciplinary training to the program. Previously, Chris was Vice President of Marketing and Design at Herman Miller and was Creative Director of Herman Miller Collection and Consumer businesses. Prior to HM, Chris was the Chief Design Officer for Johnson & Johnson Consumer Companies, where he built an internal design team. ■ Chris was Senior Vice President of Global Marketing and Design for Aveda™ prior to joining Johnson & Johnson. Under his leadership, Aveda was awarded the 2004 National Design Award for Corporate Achievement from the Smithsonian Cooper-Hewitt National Design Museum. ■ Chris received his Bachelor of Science in Industrial Design from the University of Cincinnati College of Design Architecture and Art.

What you have done is incredible, unique and powerful. Own it. Believe in yourself. Others will follow.

Tyler Hopf, *Instructor, School of Visual Arts*

Talk, talk, and talk more. The more you discuss your work in crits, the more comfortable you'll be when it's time to face a client or boss.

Sean Adams, *Instructor, Art Center College of Design*

Anne Zeygerman | School of Visual Arts | Dean: Richard Wilde | Page: 92
Biography: Anne Zeygerman is a multidisciplinary visual designer who creates strong imagery using Adobe Creative Suite, motion graphics, styling, photography, freehand illustration, and typography. Born in the Philippines and raised by two high ranking military officers in Manila, Anne developed a sense of rebellion, hunger for perfection, and the spirit that always seeks things that excite and entice all five senses. She moved from Manila to New York in 2011 and received a Silas Rhodes scholarship in The School of Visual Arts, graduating with high honors in 2017. She enjoys traveling, photography, making music, and hosting dinner parties at her home.

Yoonseo Chang | School of Visual Arts | Dean: Richard Wilde | Page: 93
Biography: Born in South Korea, Yoonseo Chang is a graphic design student at School of Visual Arts (SVA), based in New York City. His works now mostly focus on digital design and UI/UX. He is passionate about both technology and health. His goal is to create experiences that can give people a better life. During his spare time, he often learns to code or watches movies. His motto is "Always move forward, whether you are crawling or running."

Haley Stoneking | Brigham Young University | Dean, College of Fine Arts and Communication: Ed Adams | Page: 94
Biography: Haley Stoneking is a passionate graphic designer from Orem, Utah. She received a BFA in Graphic Design from Brigham Young University in 2017. When she's not designing, she enjoys road tripping with her husband, cooking healthy, delicious food, rocking out at concerts, and looking at pictures of Bernese Mountain dogs.

Sean Dong | School of Visual Arts | Dean: Richard Wilde | Page: 95
Biography: Sean has been interested in design since moving to the United States from China at the age of 8, and discovered his talent for design during high school when he took his first "Computer Art" class. His attention to detail and passion for design grew through coursework and internships, ultimately helping him to earn an Alexander Medal for Visual Arts upon graduation and a second Alexander Medal from The School Art League of New York. As a sophomore in Advertising and Design at the School of Visual Arts, he looks forward to learning and growing more as a designer in the future.

Dan Bi Kim | Hansung University of Design & Art Institute | Dean: Sang Hyun Jee | Page: 96
Biography: She is studying at Hansung University of Design&Art Institute and is a designer who learns about advertising design as a major. ■ The theme of the poster is one of her projects. The exhibition truck is a different exhibition project that was planned on the basis of the Korean food truck trend. Other projects include the Jagermeister Urban Art Project. After designing her own personal character, she got a good reputation and proceeded to exhibit twice. She also exhibited her own poster in Jeju Beer Gallery. ■ She likes to touch upon various branches of design, so she is trying to meet the desire for design while touching various designs.

Joe Haddad | School of Visual Arts | Dean: Richard Wilde | Page: 97
Biography: Joe Haddad is a multidisciplinary designer and artist based in New York. He received his BFA from the School of Visual Arts in 2017. He currently works as a designer at GrandArmy. Prior to this he interned at Chermayeff, Geismar, and Haviv, Mother NY, and Deutsch inc.

Moonyong Ro | Art Center College of Design | Associate Provost for Student Affairs & Dean of Students: Ray Quirolgico | Page: 98
Biography: She is from South Korea and now lives in Pasedena. She went to Academy of Art for undergrad in graphic design. From her experience at Academy of Art, she is knowledgable about the printing process for books and also did a few interaction/app projects. She did a spring internship as a visual designer at Monster Product. She is currently pursuing her Masters in Graphic Design at Art Center to further extend her graphic design knowledge and learn about user experience design and emerging technologies.

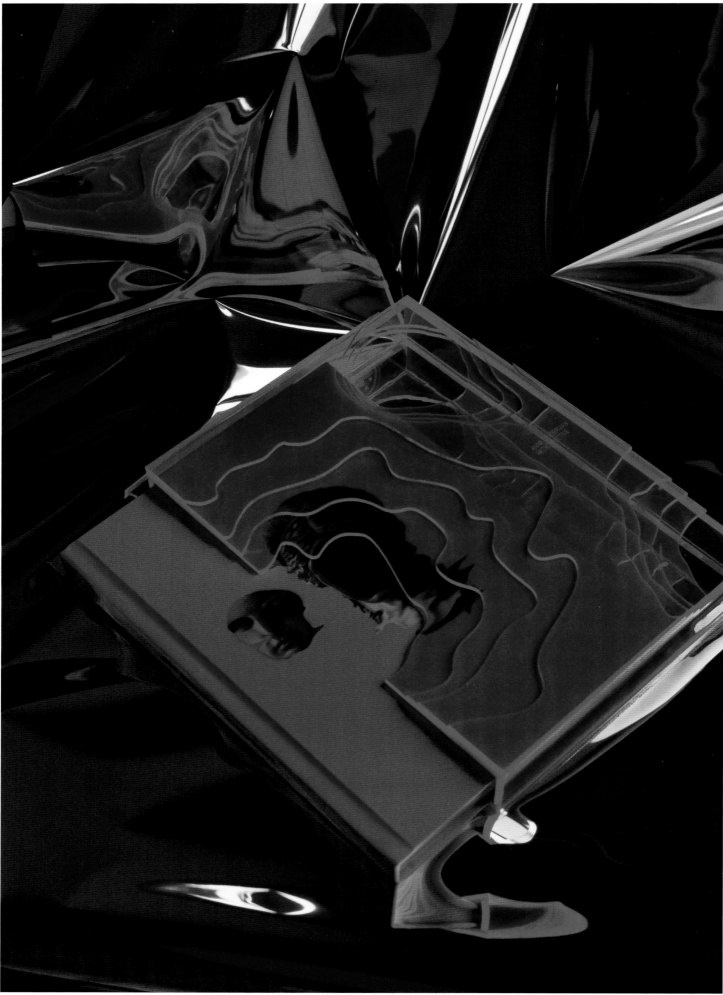

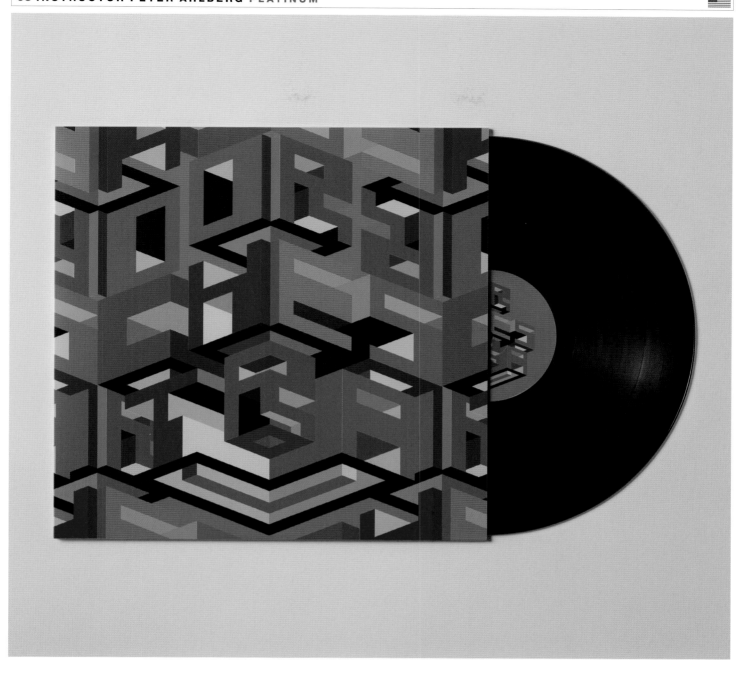

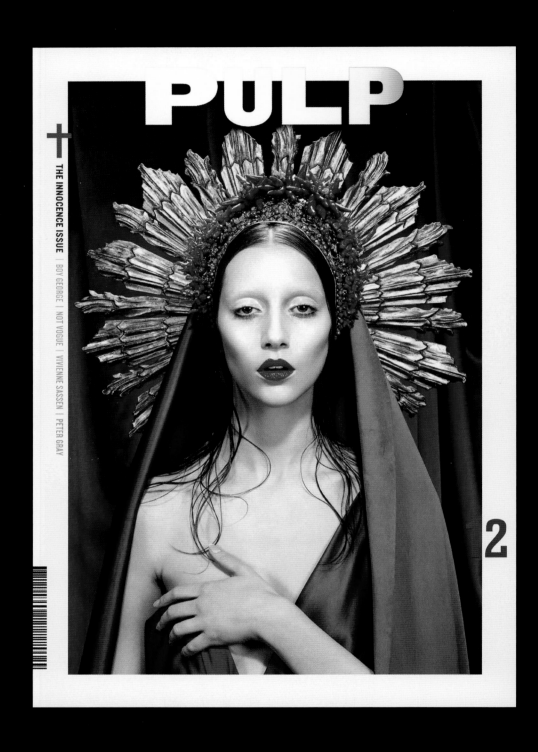

Student: Haley Stoneking | Brigham Young University

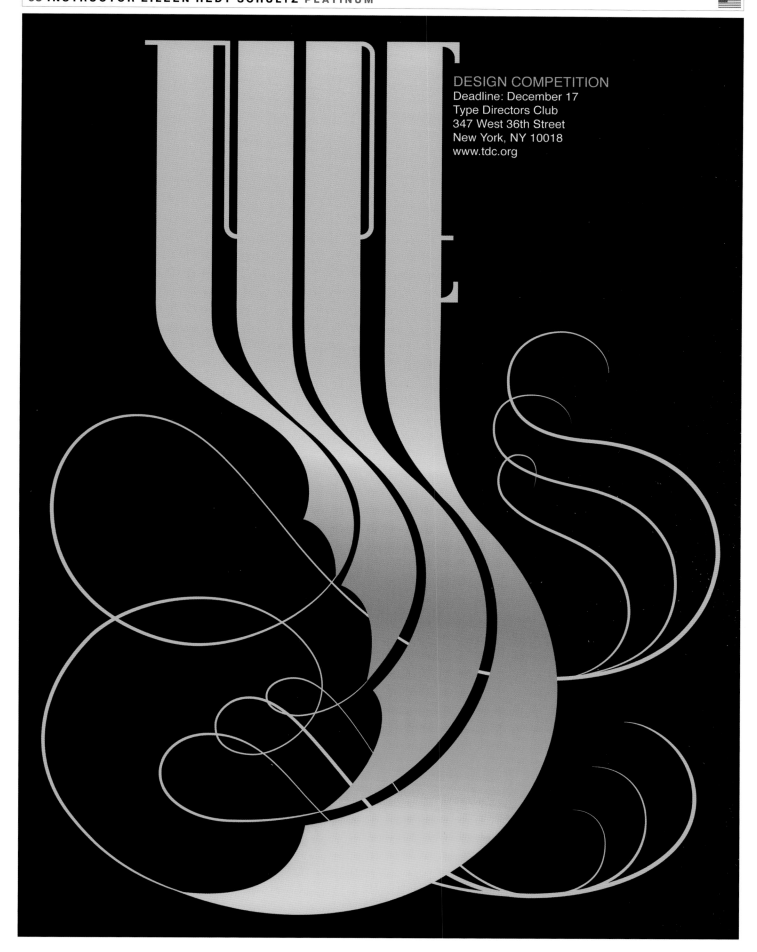

DESIGN COMPETITION
Deadline: December 17
Type Directors Club
347 West 36th Street
New York, NY 10018
www.tdc.org

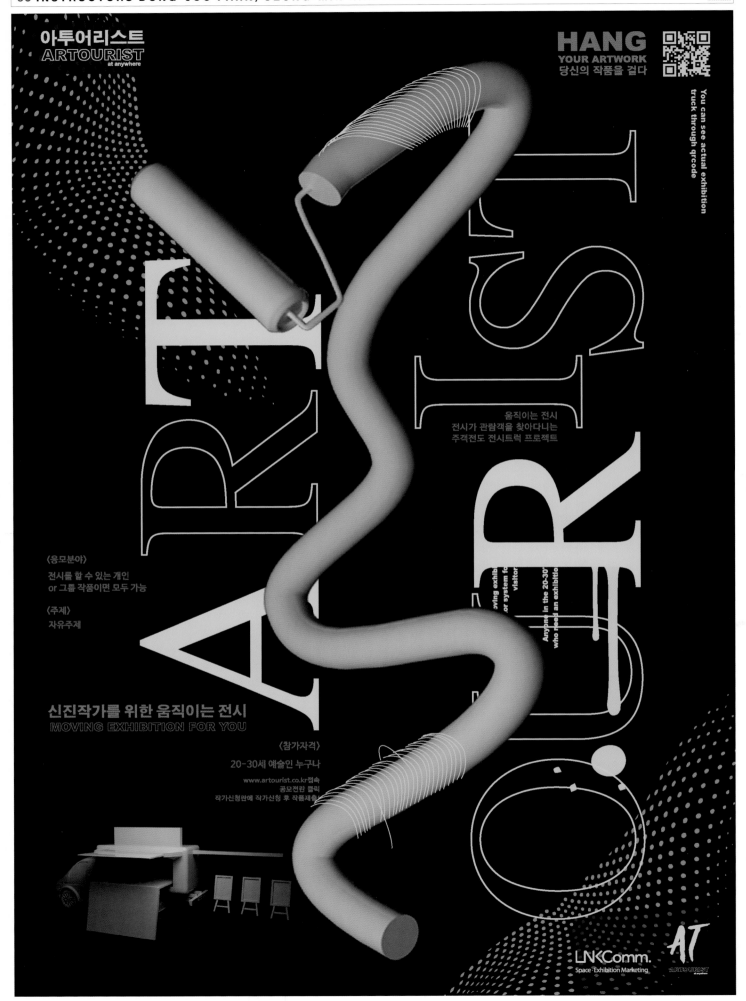

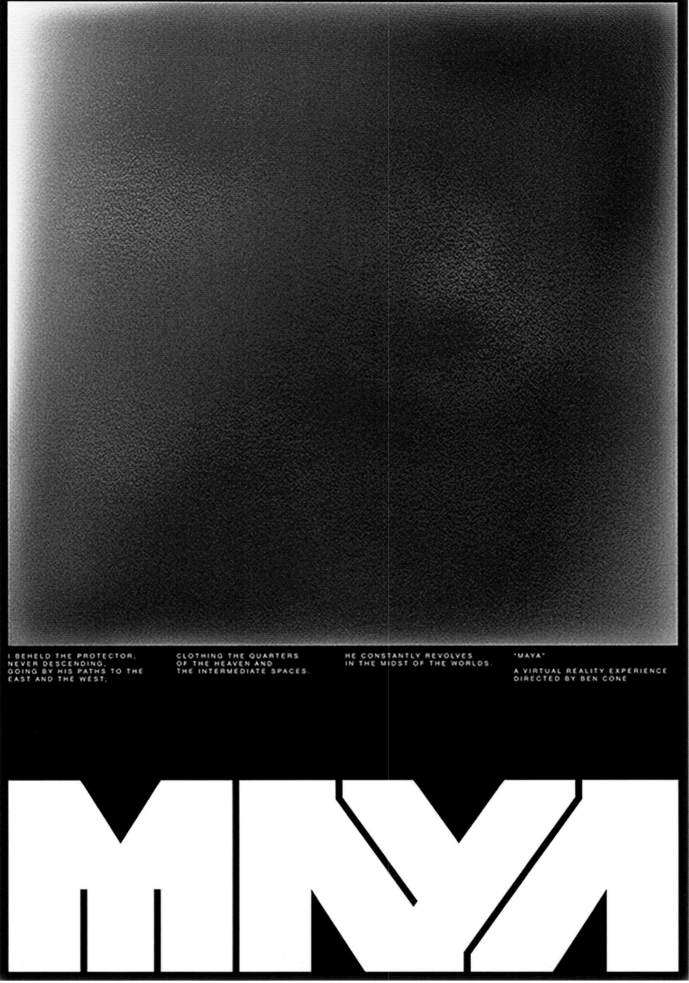

I BEHELD THE PROTECTOR, NEVER DESCENDING, GOING BY HIS PATHS TO THE EAST AND THE WEST;

CLOTHING THE QUARTERS OF THE HEAVEN AND THE INTERMEDIATE SPACES.

HE CONSTANTLY REVOLVES IN THE MIDST OF THE WORLDS.

"MAYA"

A VIRTUAL REALITY EXPERIENCE DIRECTED BY BEN CONE

Student: Joe Haddad | School of Visual Arts

Poster | Design

CATERPILLAR

CATERPILLAR

Design | Poster **Student: Moonyong Ro** | Art Center College of Design

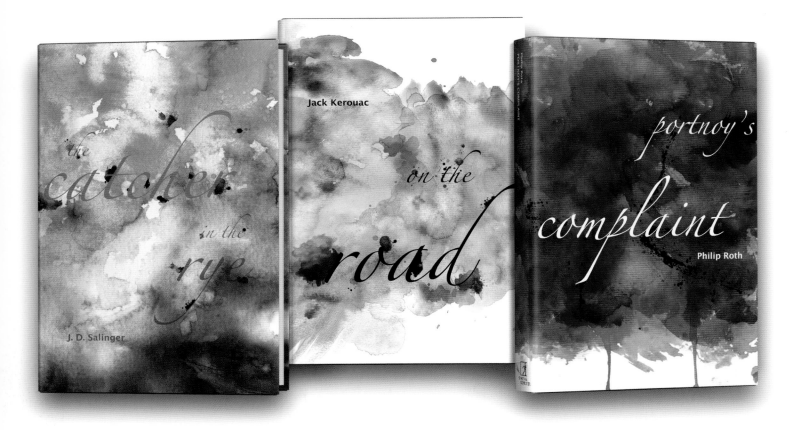

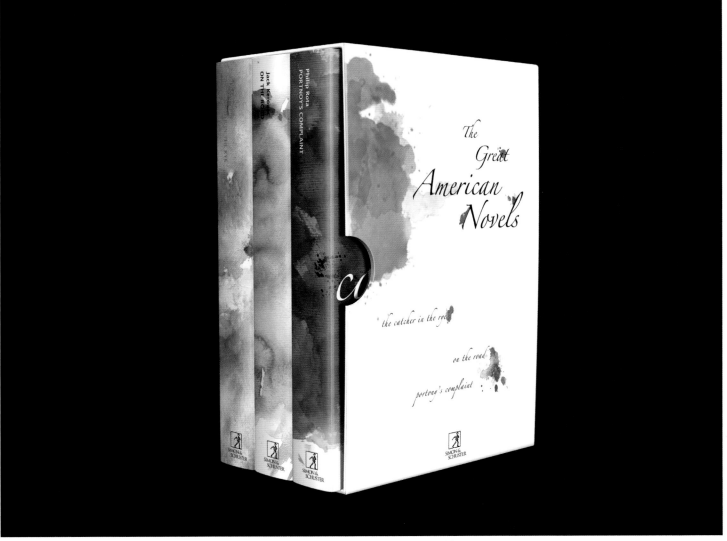

Student: Hie Won Sohn | School of Visual Arts

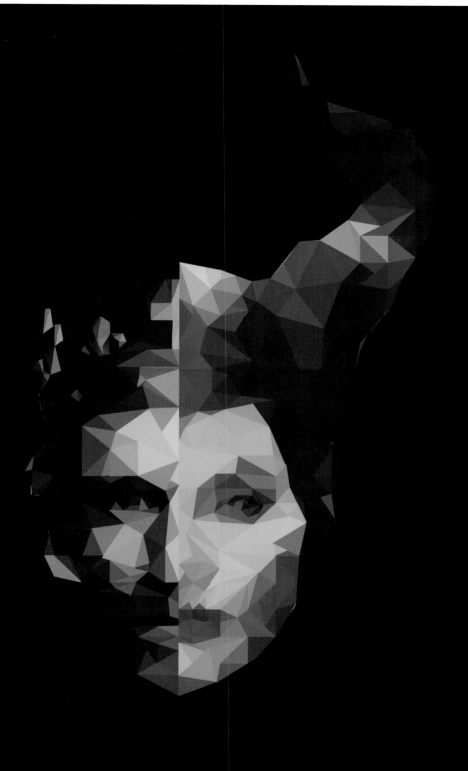

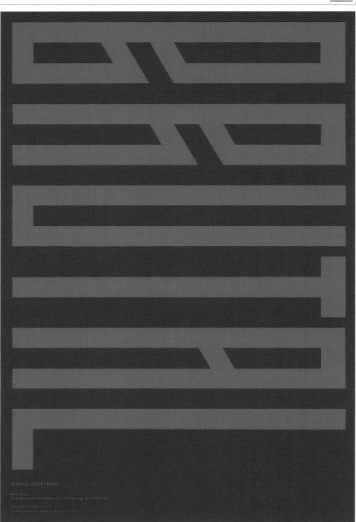

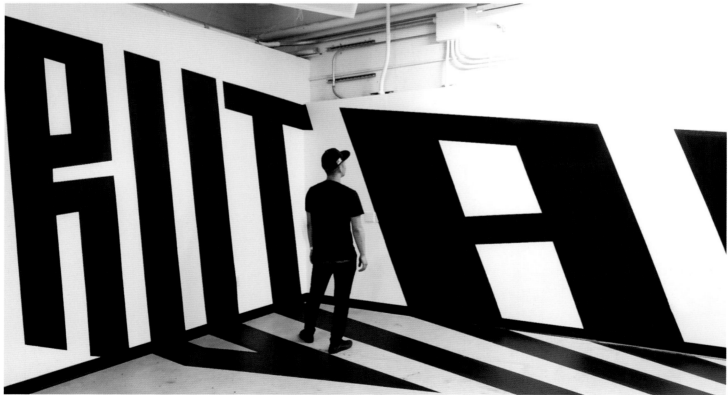

Design | Branding **Student: Tais Ghelli** | Art Center College of Design

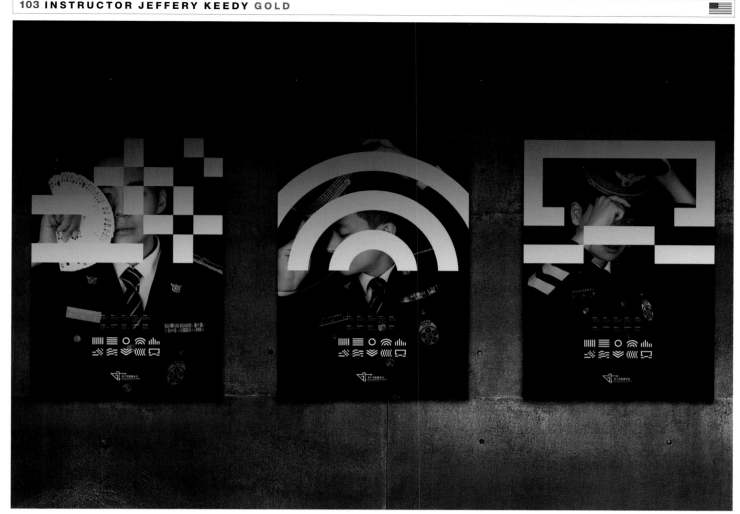

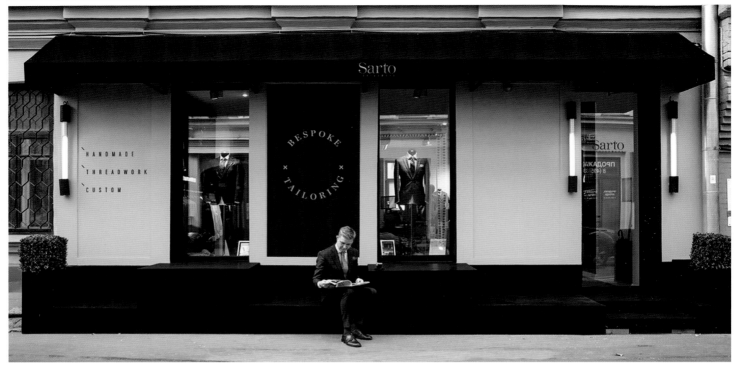

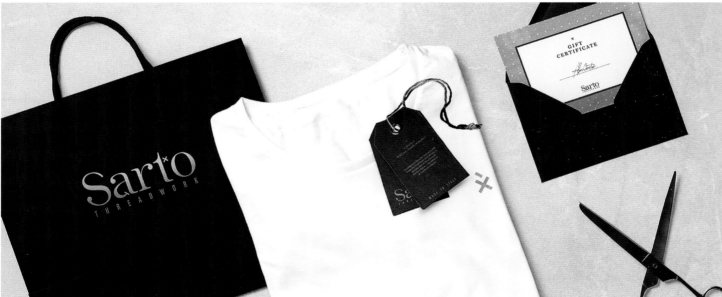

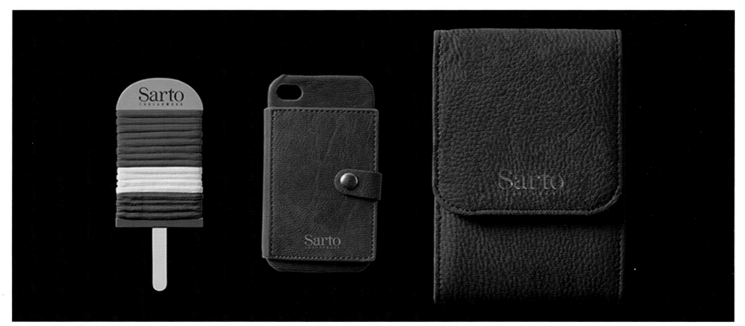

Student: Grina Choi | School of Visual Arts

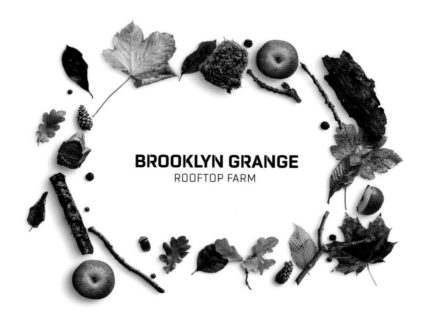

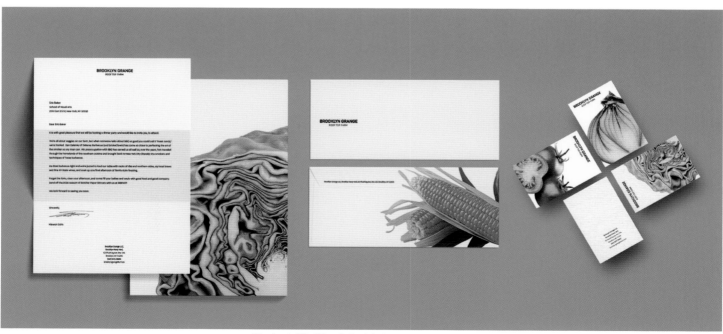

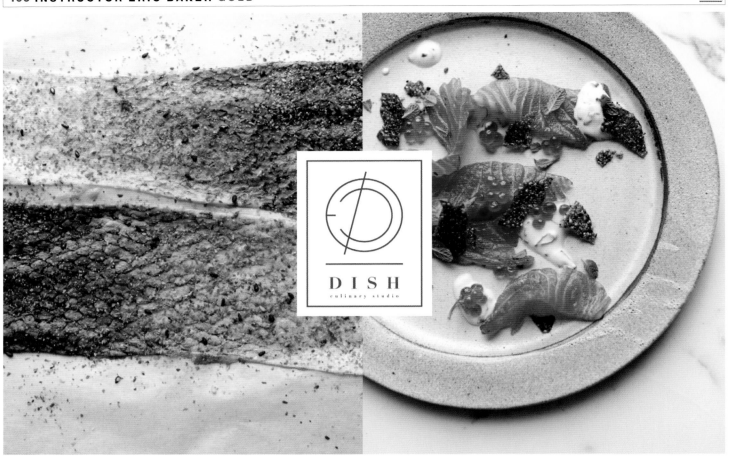

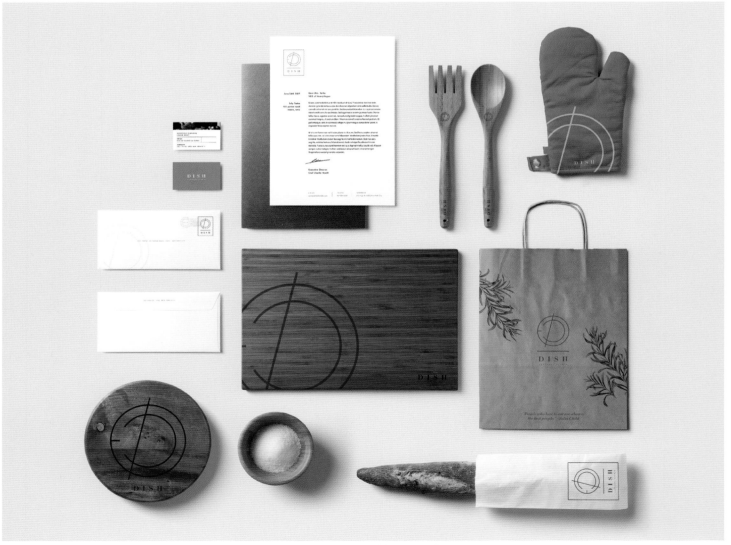

Design | Branding **Student: Madeleine Arnould | School of Visual Arts**

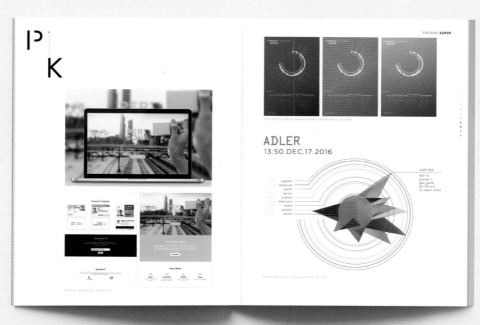

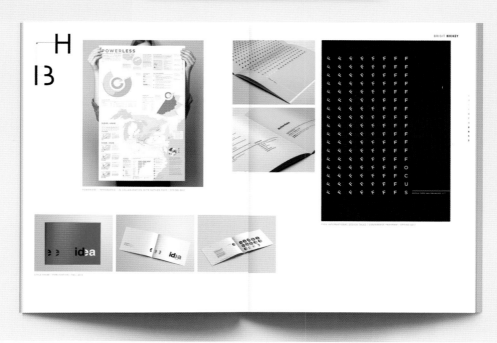

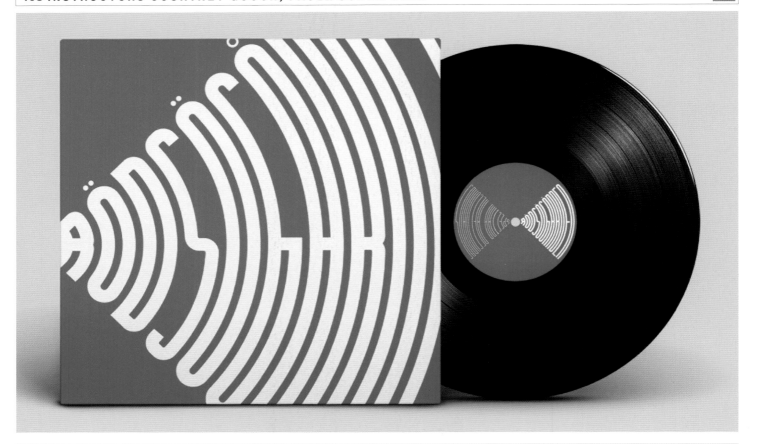

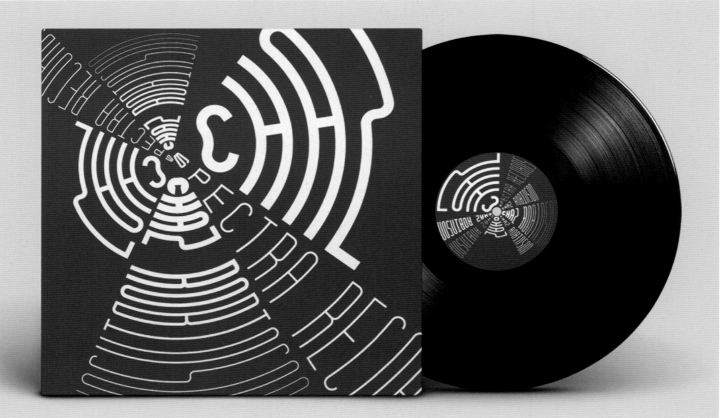

In this volume we visit the iconic CHATSWORTH HOUSE, where we will see there wealth of SIR THOMAS after the MORTENSEN, tour the cities of LONDON and the amazing EDINBURGH and SHETLAND ISLANDS where questions that we all wonder, while deepening the SCOTT CLIFFORD DANCE, speak of the lost art of the speak of the LOST ART OF THE PEOPLE in ruraling areas.

03

In this volume we visit the iconic CHATSWORTH HOUSE, where we will see there wealth of SIR THOMAS after the MORTENSEN, tour the cities of LONDON and the amazing EDINBURGH and SHETLAND ISLANDS where questions that we all wonder, while deepening the SCOTT CLIFFORD DANCE, speak of the lost art of the speak of the LOST ART OF THE PEOPLE in refreshing areas.

03

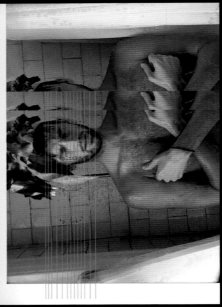

plick

plick

plick

plick

fig.1

a cloud

a true cloud

a splenid cloud/

this
is
trash

but
you
know

deconceptualize
yourself
and don
bother me no more
bitch

deviant
monster
freak
goon
worm
enemy
cancer
go
away
away
/
and
never
come
back

I hate you
I love
you
you
p
pl
pli
plic
plick
*
*

Anna Never ft. Timo
Timo ft. Anna Never
2016
Inter disci plinary des ign

it's raining

someone slit cloud's throat

Plick *Plick*

Plick *Plick*

Plick *Plick*

Plick *Plick* *Plick* *Plick*

Plick
Plick
Plick

Plick

I

IMOGEN CUNNINGHAM

1883 - 1976

Magnolia Seed Pod

1920

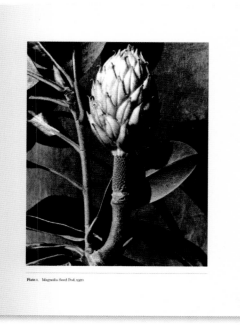

Plate 1. Magnolia Seed Pod, 1920

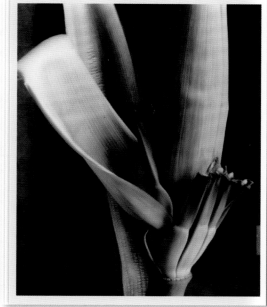

III

Pitcher Plant

1920

From 1910 to 1917, Cunningham spent her formative years in Seattle where she operated a successful portrait studio and created exquisite pictorialist images. From 1917 to 1920, she lived with her artist husband, Roi Partridge, and her three sons, Gryffyd, Rondal, and Padraic, in San Francisco. In 1920, the family moved to Oakland, California, where Roi began teaching at Mills College[2], a liberal arts school for women. Although Cunningham was geographically restricted

[2] A liberal arts and sciences college located in the San Francisco Bay Area.

IV

Magnolia Blossom

1920

to the West Coast, information about new tendencies in art and photography was hardly inaccessible. She was exposed to avant-garde[III] aesthetic ideology through Alfred Stieglitz's periodical, Camera Work. She was particularly interested in the work of the Italian futurists exhibited at the Panama-Pacific International Exposition in San Francisco in 1915. Frederic C. Torrey, the San Francisco collector and art dealer, who purchased Marcel Duchamp's cube-futurist masterpiece Nude Descending a Staircase [No. 2] from the Armory Show in 1913, also collected Roi

[III] People or works that are experimental, radical, or unorthodox, with respect to art, culture, and society.

Plate 3. Pitcher Plant, 1920
Plate 4. Magnolia Blossom, 1920

RELEVANT, FAITH, CULTURE, & INTENTIONAL LIVING

RLVN†

JAN / FEB 17

CHRISTIANS IN FASHION

FLOURESCENT ADOLESCENT / THE SPACE BETWEEN / THE RISE OF UNIVERSALISM

Student: Jason Rall | Portland Community College

Student: Ryan Bunao | Portland Community College

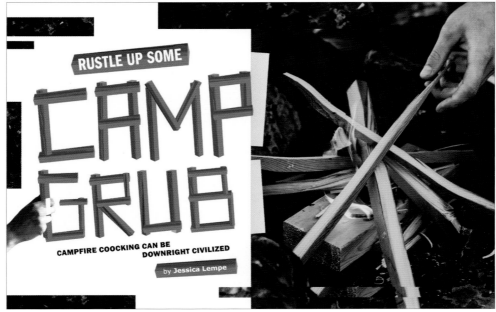

Student: Angela Moreno | Portland Community College

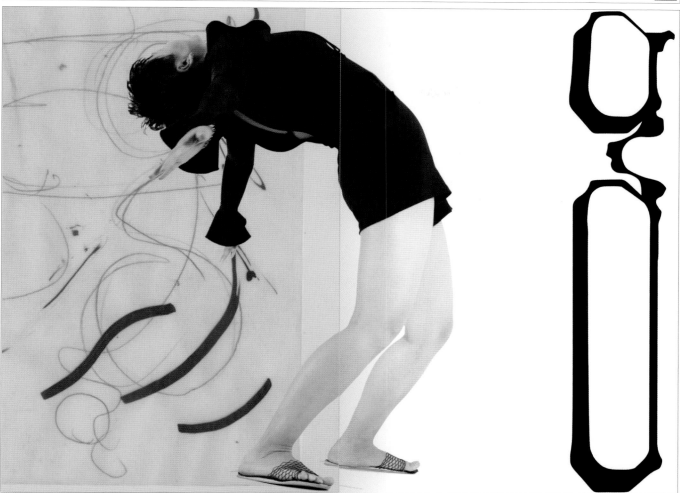

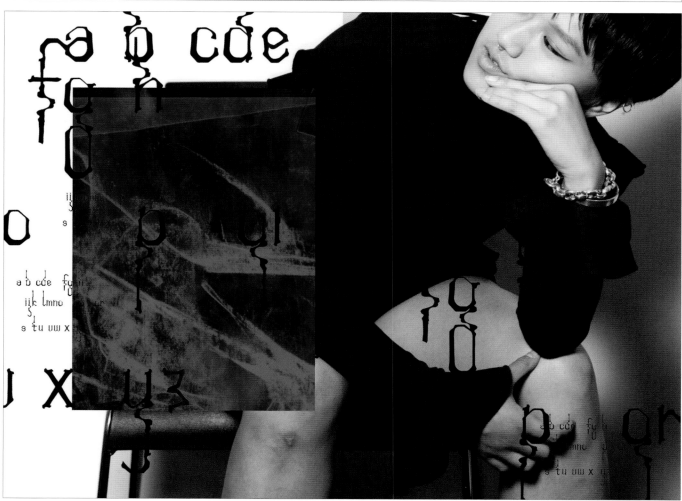

Student: Ashley Law | School of Visual Arts

Editorial | Design

LA FORME L'ASPECT VISUEL OU LA CONFIGURATION D'UN OBJET, DANS UN SENS PLUS LARGE, LA FORME

NO. 406 | FÉVRIER 2017

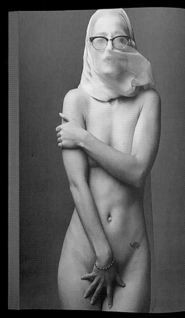

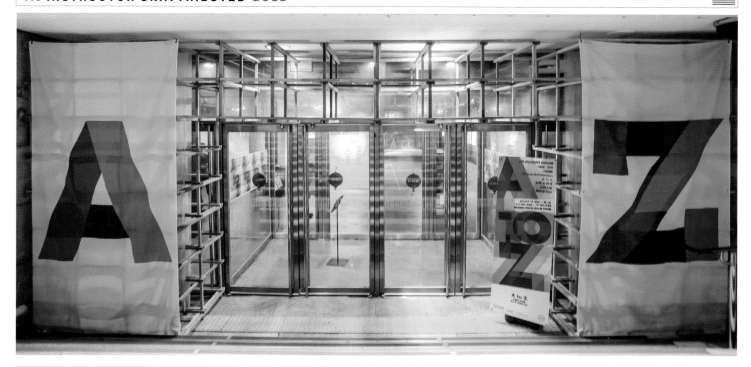

Student: Dongkyu Lee

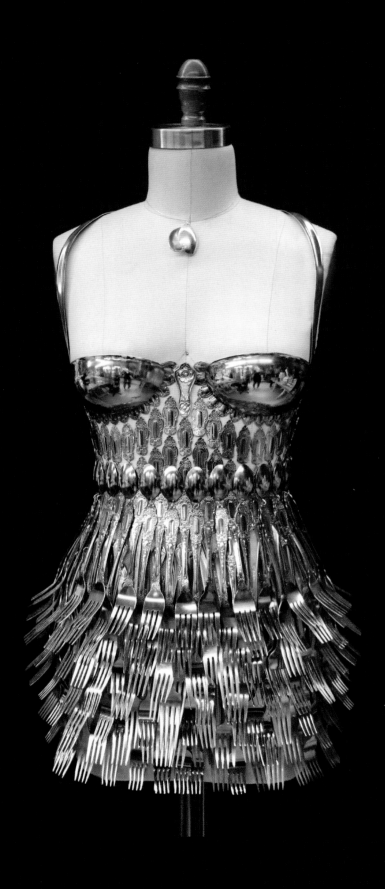

Student: Filipa Mota | School of Visual Arts

INSTRUCTOR MARVIN LEE

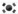

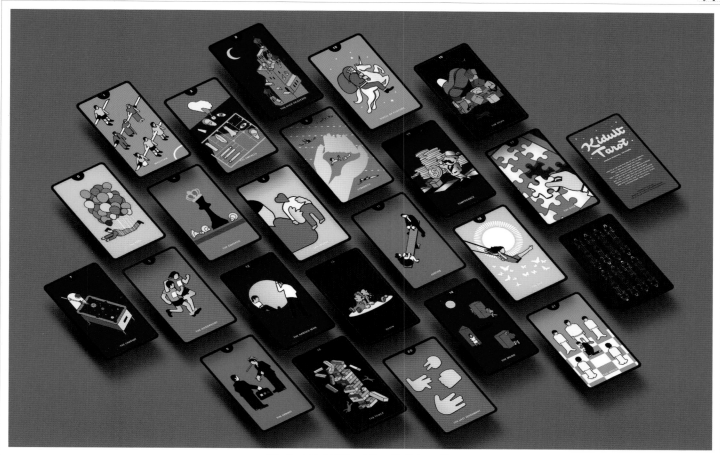

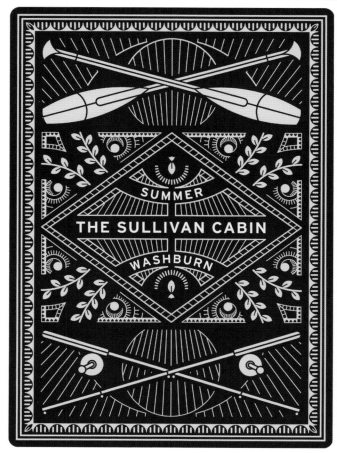

Student: Sol Bi Doo | Hongik University

INSTRUCTOR JOHN DUFRESNE

Student: Matthew Sullivan | Concordia University

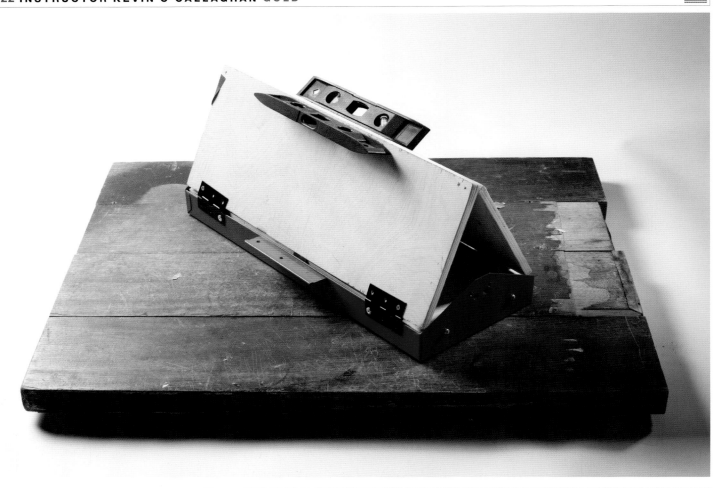

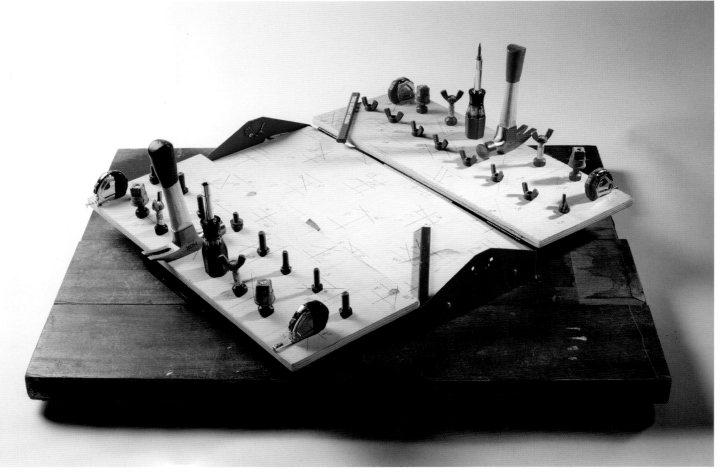

Student: Christopher Mourato | School of Visual Arts

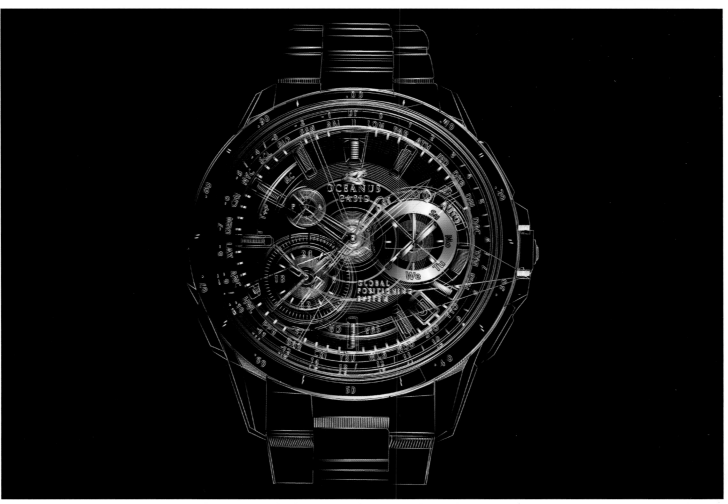

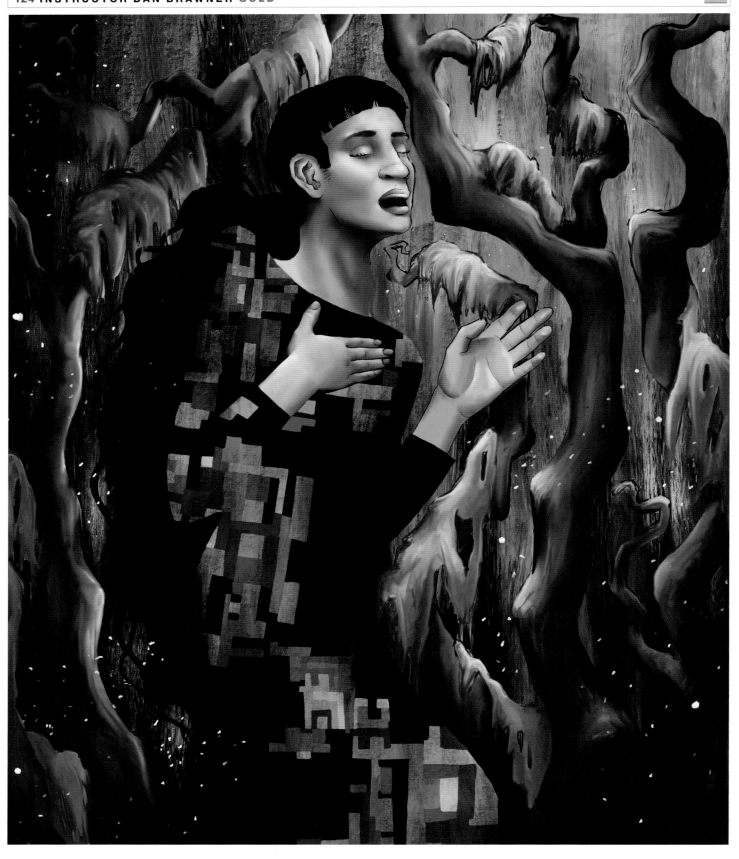

Student: Natalie Briscoe | Watkins College of Art

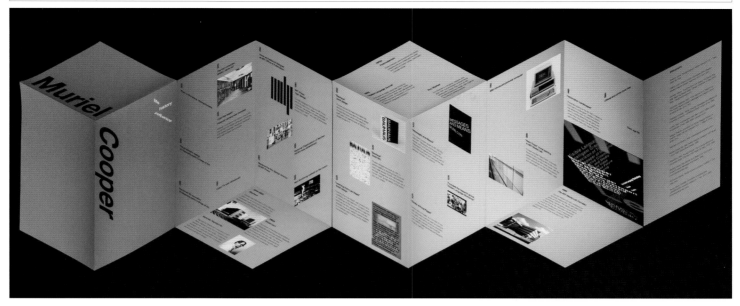

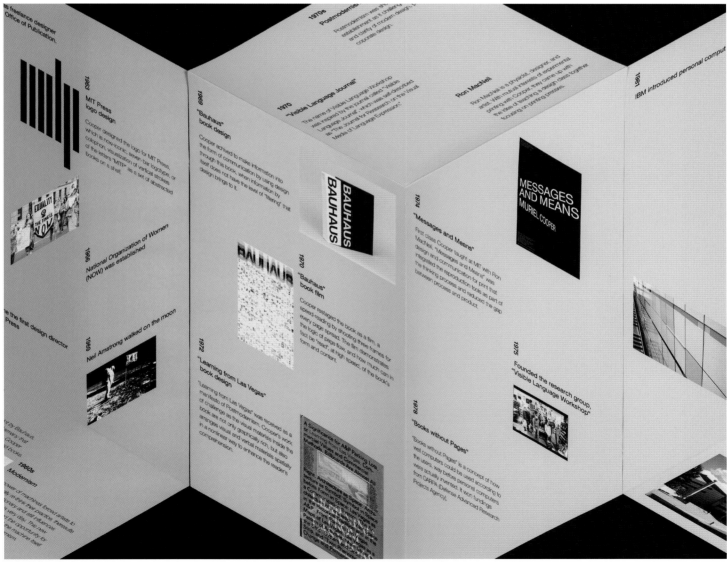

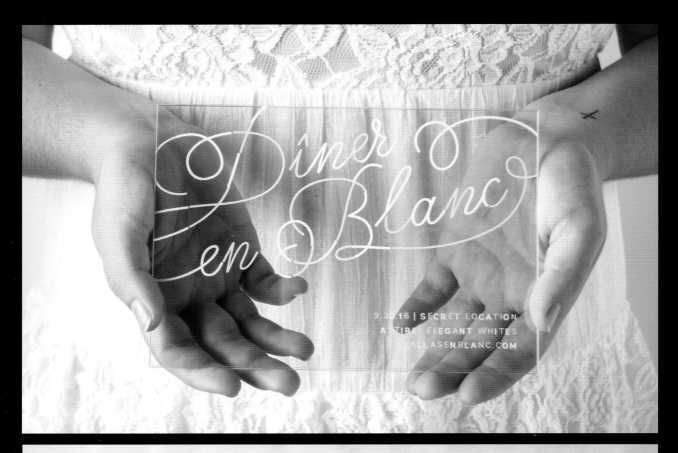

INSTRUCTOR M.C. COPPAGE

OCEANIC INSTITUTE

Student: Alex Minkin | Portfolio Center

INSTRUCTOR MARK STAMMERS

Student: Stephanie Yueyang Wang | School of the Art Institute of Chicago

INSTRUCTOR HANK RICHARDSON

Student: Luke Romig | Portfolio Center

INSTRUCTOR BEHNOUSH MCKAY

SYDNEY 2020

Student: Galia Gharabeg | Woodbury University

INSTRUCTOR ANAIS SÁNCHEZ MOSQUERA

BEAR

Stud.: Eduardo Piedra Quiroz | Universidad Católica de Santiago de Guayaquil

INSTRUCTOR HANK RICHARDSON

Student: Luke Romig | Portfolio Center

INSTRUCTOR JOSH EGE

Student: Solbinna Choi | Texas A&M University Commerce

INSTRUCTOR DAVID ELIZALDE

Student: Emma Holland | Texas Christian University

Logo | Design

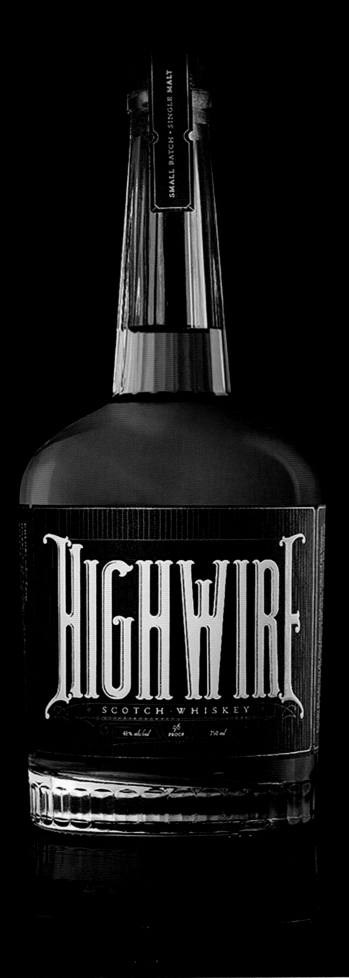

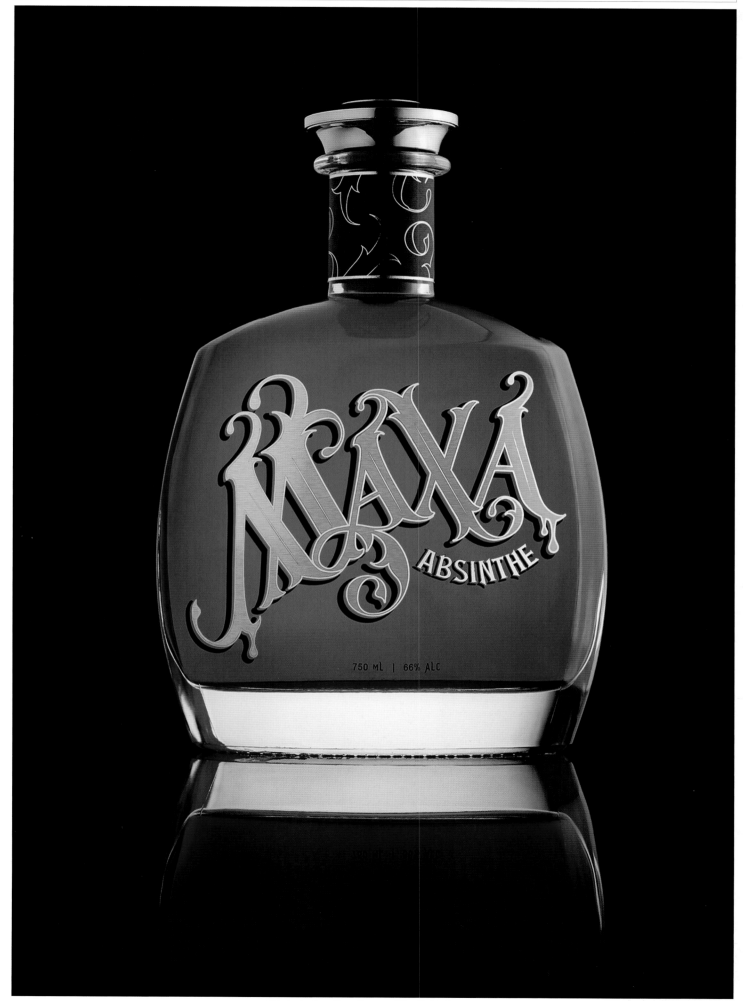

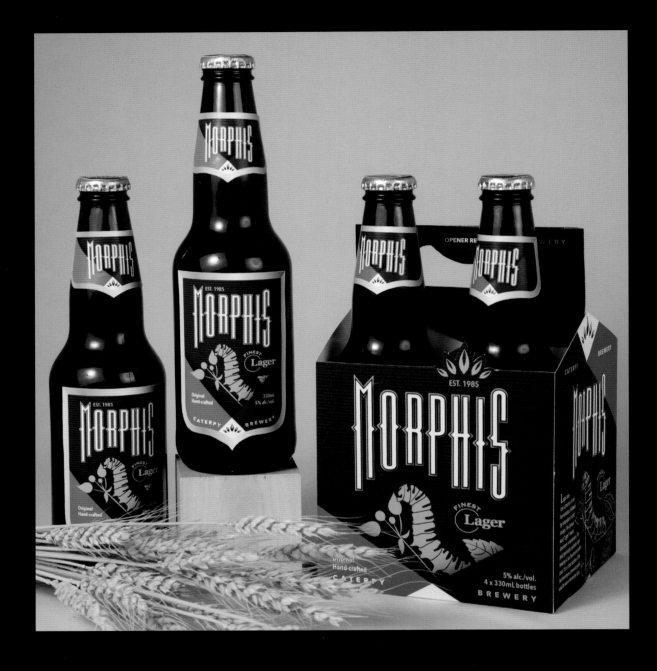

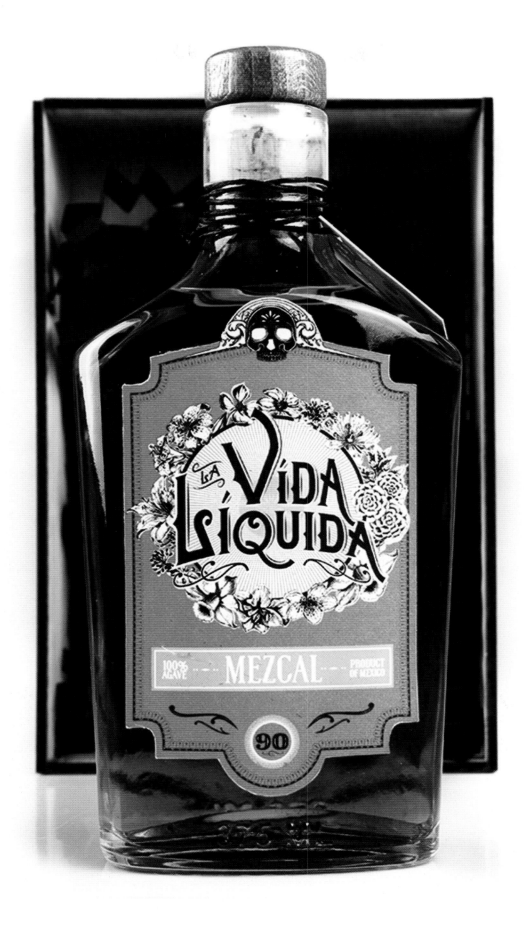

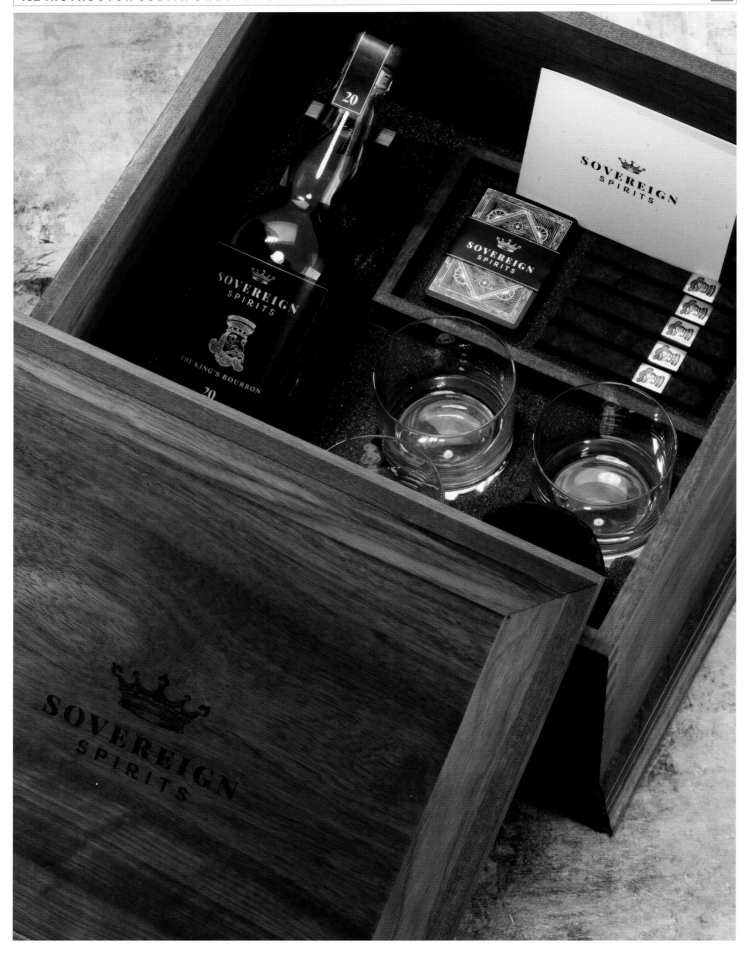

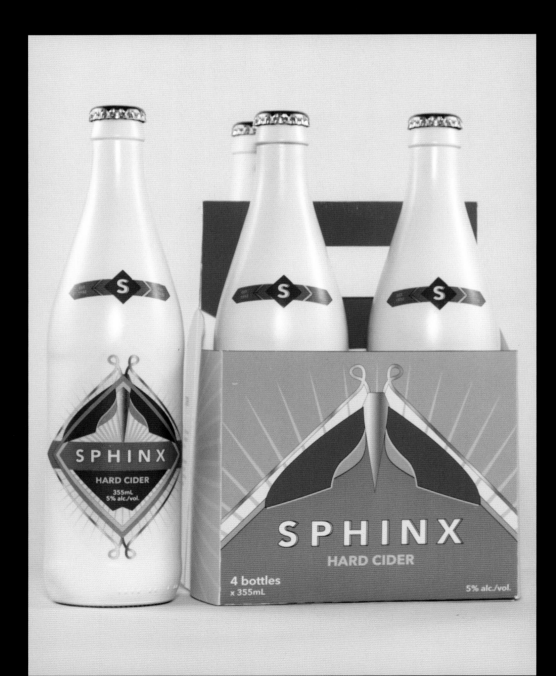

INSTRUCTOR MICHELE DAMATO

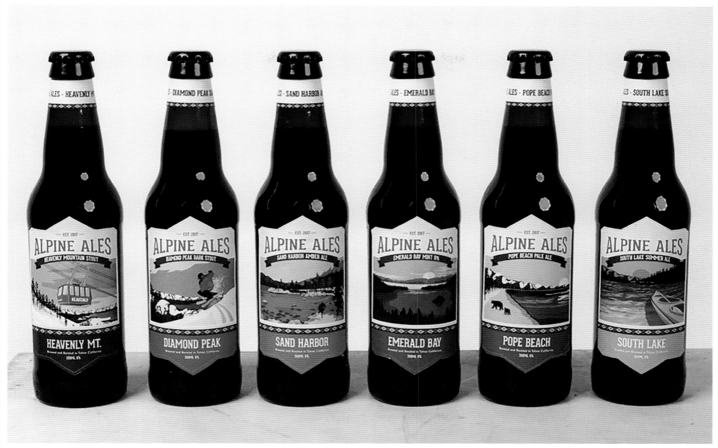

Student: Jacqueline Akerley | Syracuse University

INSTRUCTOR THOMAS MCNULTY

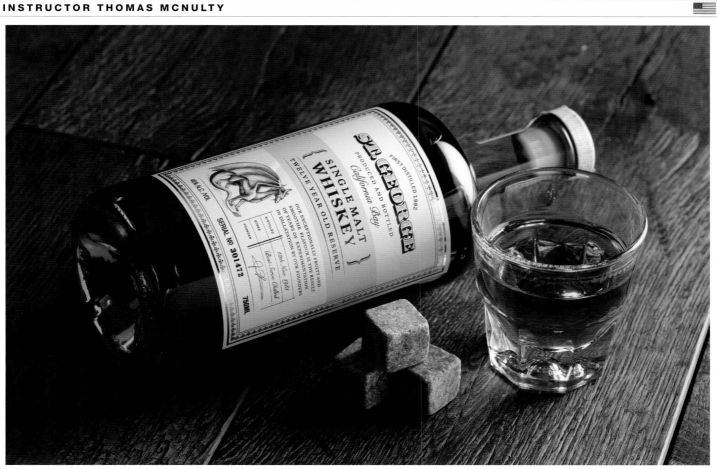

Student: Zahra Ilyas | Academy of Art University

INSTRUCTOR ABBY GUIDO

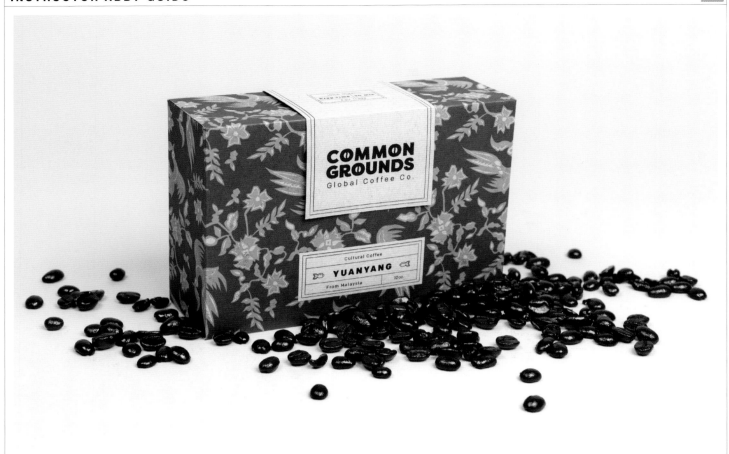

Student: Brandon Whirley | Temple University

INSTRUCTOR ERIC BAKER

Student: Park JooHyun | School of Visual Arts

INSTRUCTOR MARGARET RYNNING

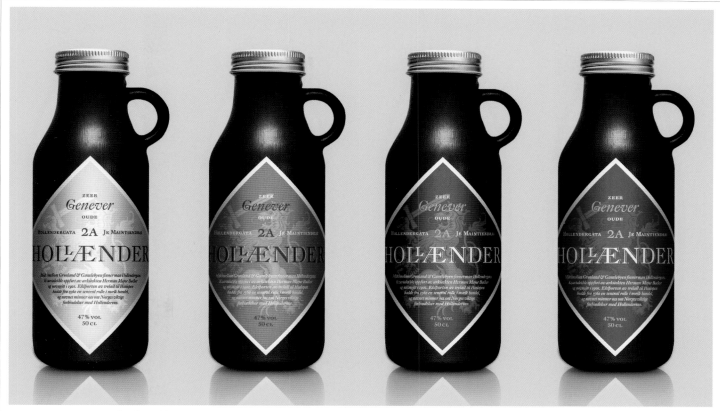

Student: Kristofer Hoffmann Schärer | Westerdals Oslo School of Arts, Communication and Technology

INSTRUCTOR GERARDO HERRERA

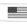

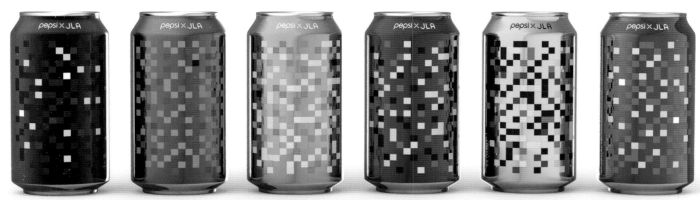

Student: Jenny Joe | Art Center College of Design

INSTRUCTOR KRISTIN SOMMESE

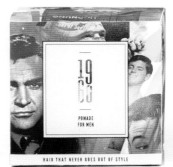

Student: Brandon Rittenhouse | Pennsylvania State University

INSTRUCTOR MICHAEL OSBORNE

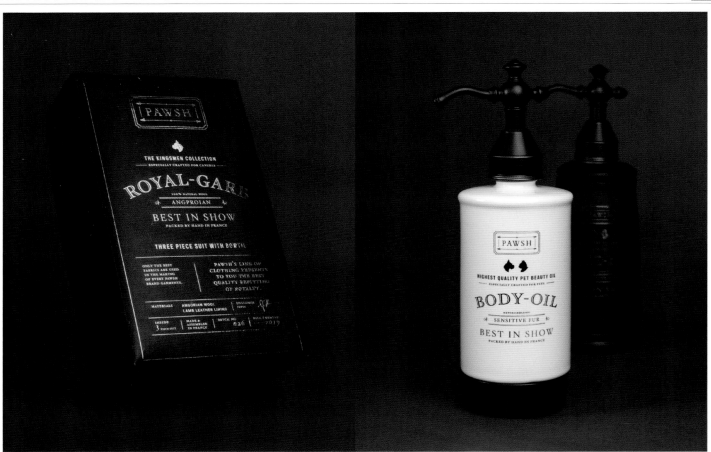

Students: Nathania Frandinata, Carrisa The, Nicola Crossley, Seen Rongkapan | Academy of Art University

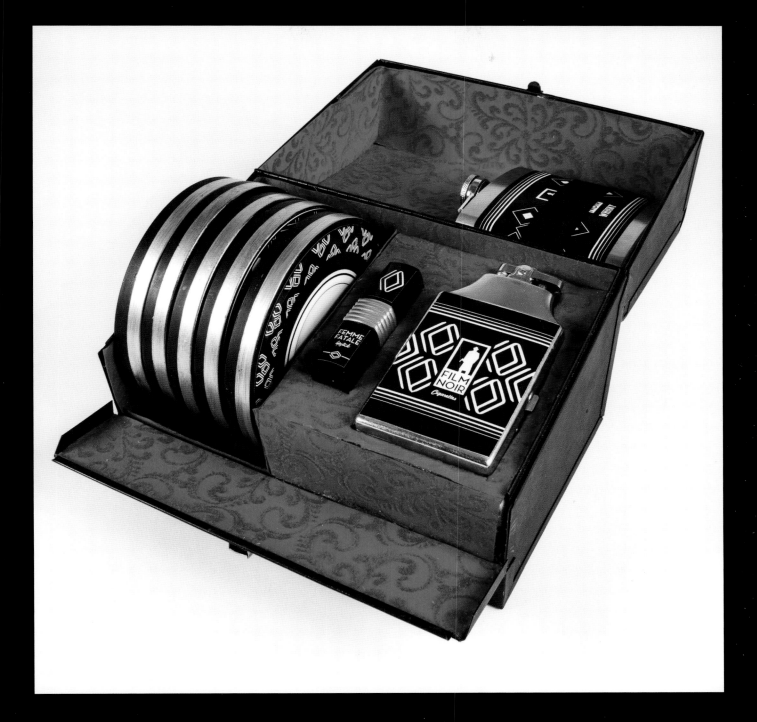

INSTRUCTOR THOMAS MCNULTY

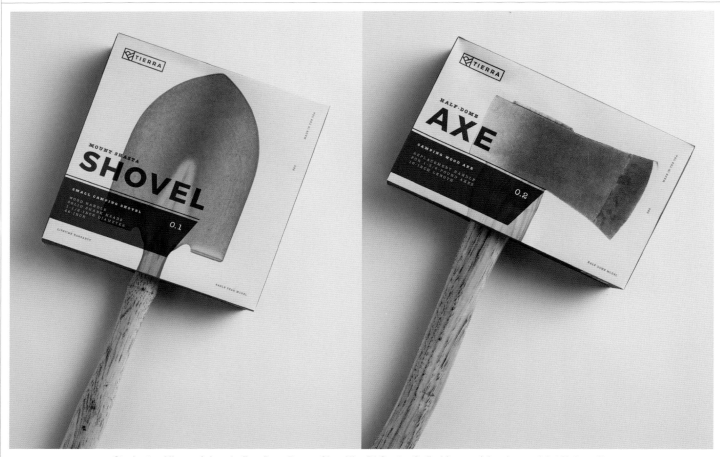

Students: Alireza Jajarmi, Ray Dao, Peggy Chu, Kim Di Santo, Sofia Llaguno | Academy of Art University

INSTRUCTOR BRETT PLAYER

Student: Melanie Maynard | Portfolio Center

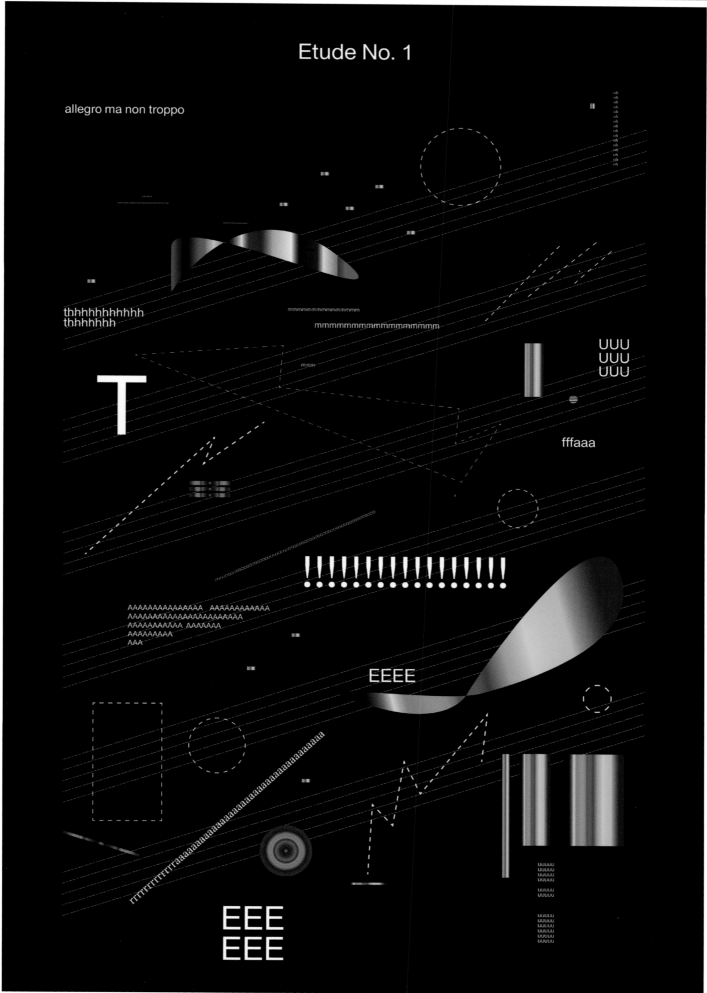

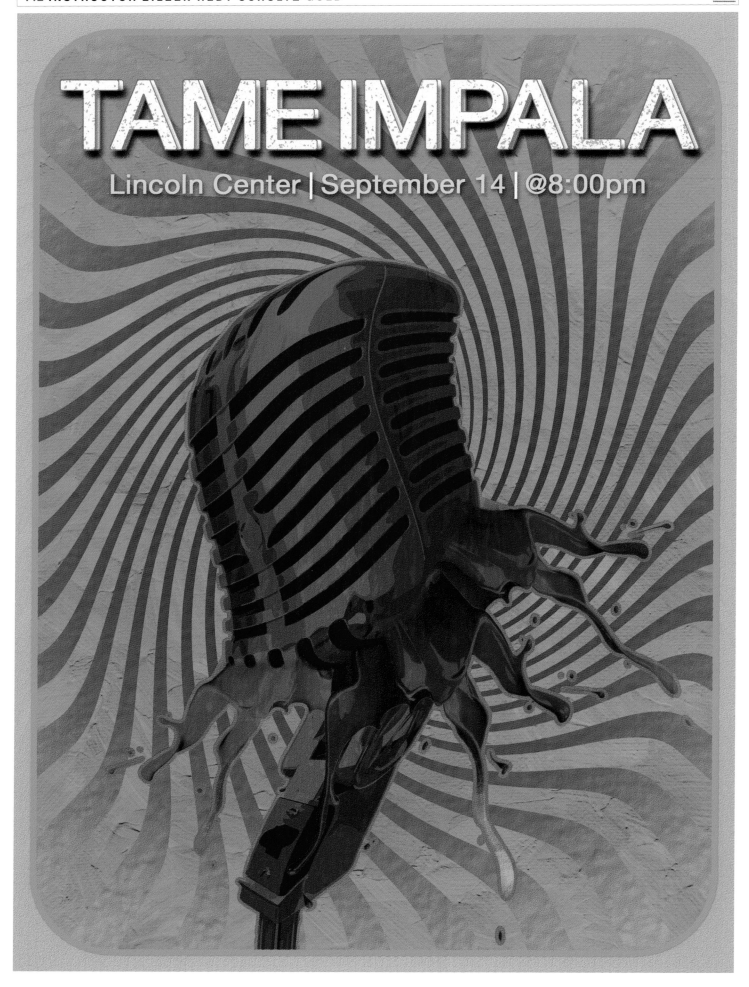

samuel morse
jan 3 – feb 9

nikola tesla
feb 14 – mar 17

elon musk
mar 21 – apr 30

b o l t futurists:
3 technical pioneers

Join us at the Museum of Science and Industry to experience the influential contributions by visionary technologists Morse, Tesla, and Musk. This interactive science exhibition will explore the influential works of some of the greatest thinkers of all time. You are sure to experience an educational display of the exciting cutting-edge science and technology in the United States history.

SAMUEL MORSE

january 3 – february 9

museum of

science & industry

5700 South Lakeshore Drive

Chicago, IL 60637

(773) 684-1414

www.msichicago.org

museum

admission

Adults: $10

Students: $5

Children: Free

museum

hours

Mon: Closed

Tues - Fri: 11:00 a.m. - 8:00 p.m.

Sat: 10:00 a.m. to 5:00 p.m.

Sun: Noon to 5:00 p.m.

CHARLIE

MAY 1 –
JUNE 30
2014

BIRD

Ferdinand J E L L Y R O L L Morton
MAY 1–MAY 19

Mary L O U Williams
MAY 22–JUNE 9

Charlie B I R D Parker
MAY 12–JUNE 30

PARKER

PRESERVATION HALL
New Orleans Jazz
726 St. Peter Street
New Orleans, LA 70116

(504) 522-2841 www.preservationhall.com

Join us at New Orleans' famous
Preservation Hall to hear a
special performance series,
SOUND ASSERTIONS:
3 JAZZ PIONEERS.
These live performances will
demonstrate the intoxicating
power of the jazz musical genre.

Playing the
REVOLUTIONARY
music of three pioneers by our
own Preservation Hall Jazz Band,
you are sure to recognize why
this unique American genre of
music infectiously captured the
WORLD'S EAR.

All music performed by our own
Preservation Hall Jazz Band
Showtimes: 8 9 & 10 pm.

General Admission:
Stand in line in front of the
Hall before the show you
would like to attend. Tickets
are $15-$20 at the door.

SOUND ASSERTIONS:
3 JAZZ PIONEERS

Student: Kayla Stellwagen | University of Cincinnati DAAP

Type Design Competition
Deadline: December 17
Type Directors Club
347 West 36th Street
New York, NYC 10018
www.tdc.org

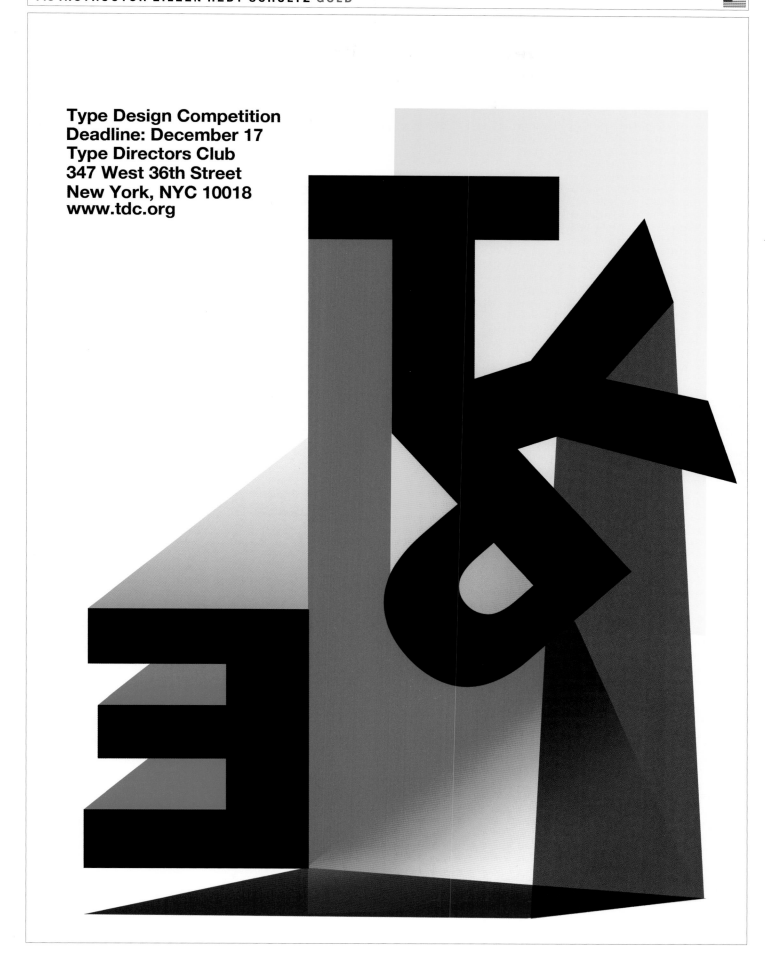

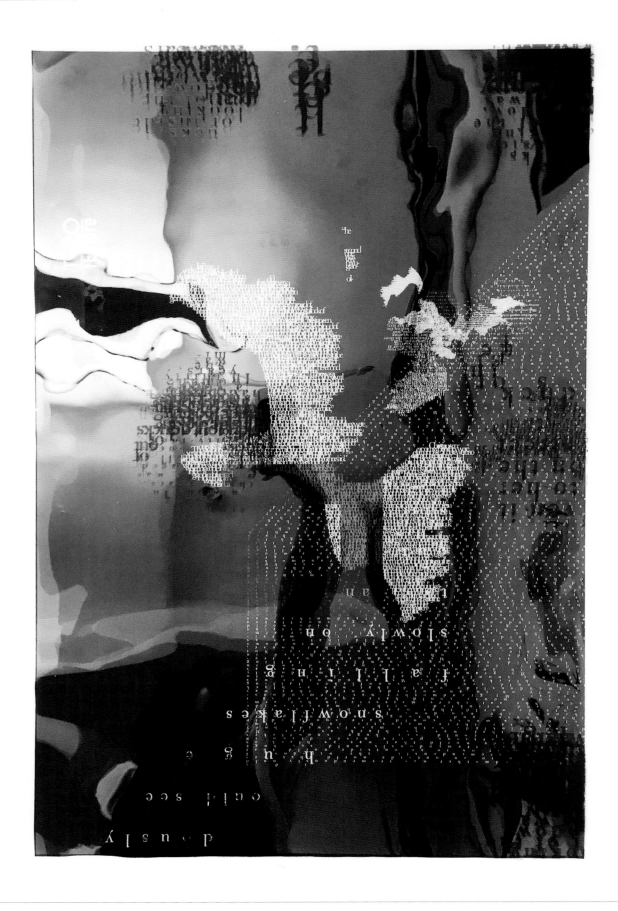

Student: Davina Hwang | School of Visual Arts

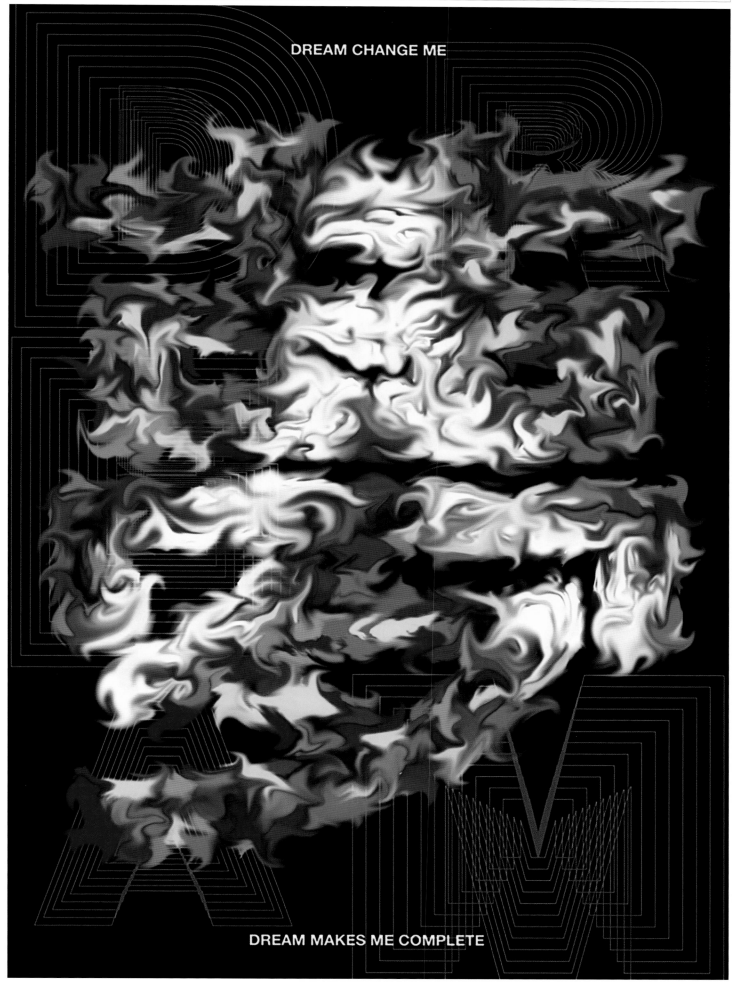

DREAM CHANGE ME

DREAM MAKES ME COMPLETE

Student: Sung Hyun Ha | Hansung University of Design & Art Institute

Poster | Design

IDEA COMETS: 3 SOCIAL PIONEERS
MARTIN LUTHER KING, JR.
February 14 – March 17

MAHATMA GANDHI
January 3–February 9

MARTIN LUTHER KING, JR.
February 14–March 17

MALALA YOUSAFZAI
March 21–April 30

VISIT THE FREEDOM CENTER FOR IDEA COMETS: 3 SOCIAL PIONEERS.
These interactive exhibitions will explore thevdevelopment and historical
perspectives of these three extraordinary world social leaders. Along with
many important historical artifacts, papers, photographs, films and audios,
visitors will experience the inspirational power that led thousands seeking
social justice and change through non-violent means.

NATIONAL UNDERGROUND RAILROAD FREEDOM CENTER
50 East Freedom Way, Cincinnati, OH 45202

ADMISSION
Adults: $10
Students: $5
Children (under 10): Free

CENTER HOURS
Monday: Closed
Tuesday–Sunday: 11-8
(513) 333-7739 www.ugrrf.org

Student: Codie Chang | University of Cincinnati DAAP

INSTRUCTOR RICHARD POULIN

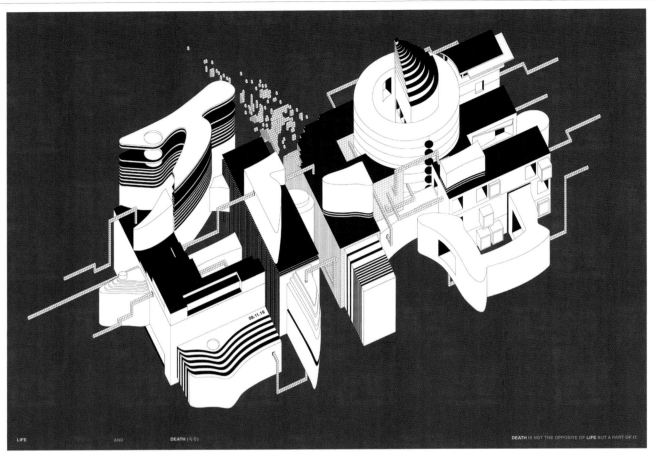

Student: Kyu Jin Hwang | School of Visual Arts

INSTRUCTORS DONG-JOO PARK, SEUNG-MIN HAN

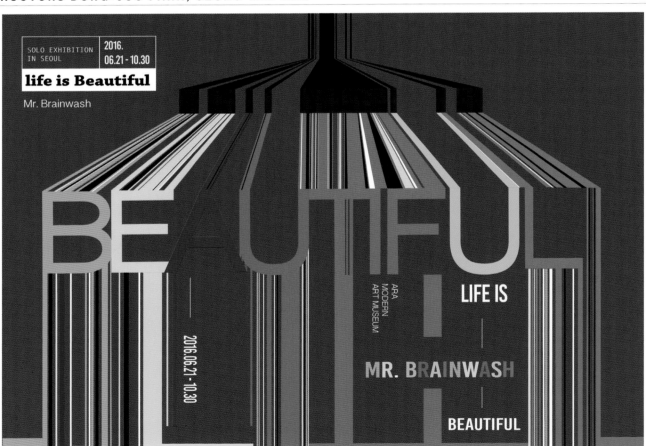

Student: Chaewon Lee | Hansung University of Design & Art Institute

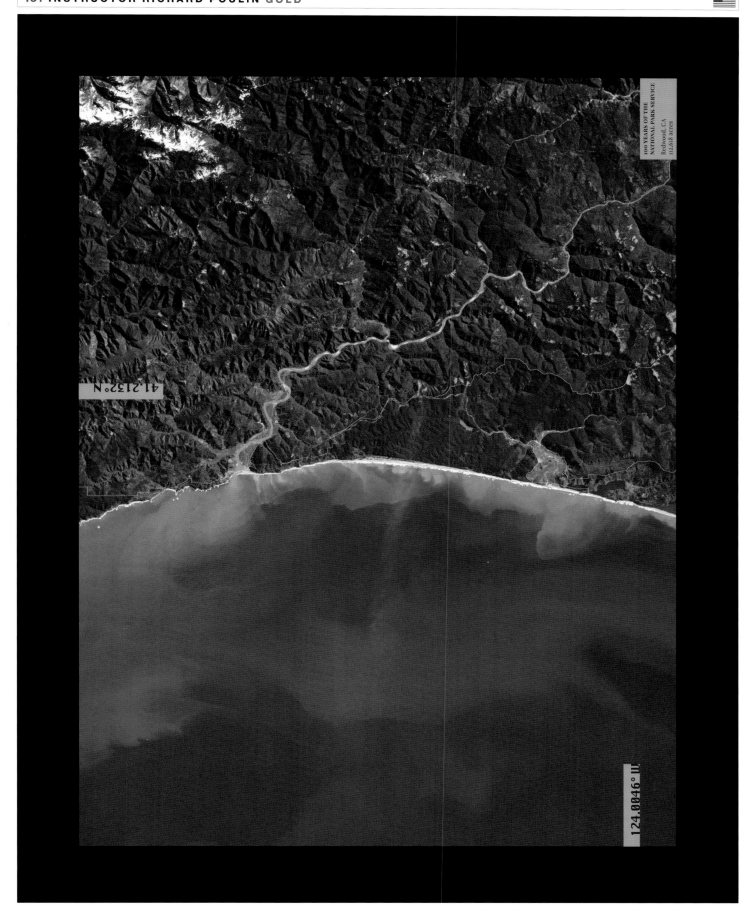

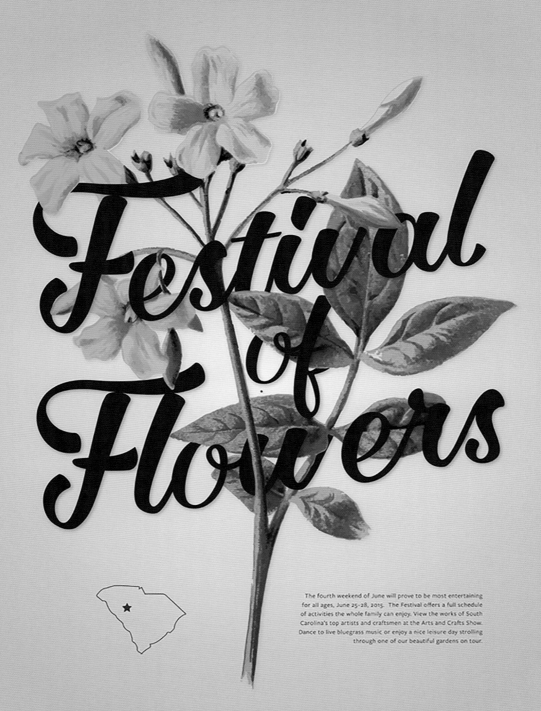

Student: Caroline Skarupa | Portfolio Center

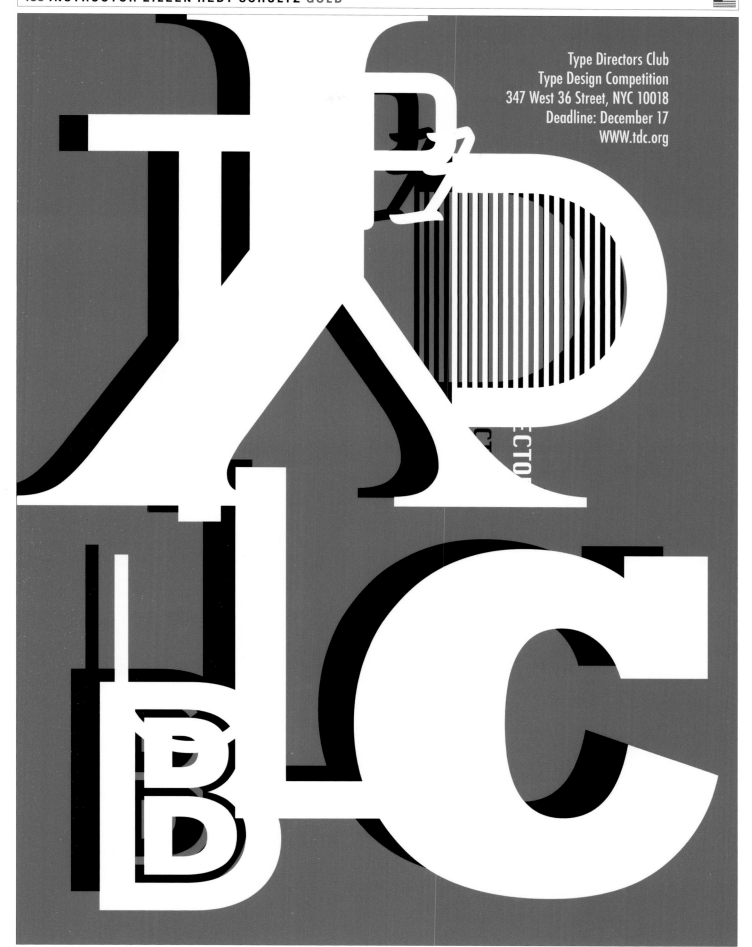

Type Directors Club
Type Design Competition
347 West 36 Street, NYC 10018
Deadline: December 17
WWW.tdc.org

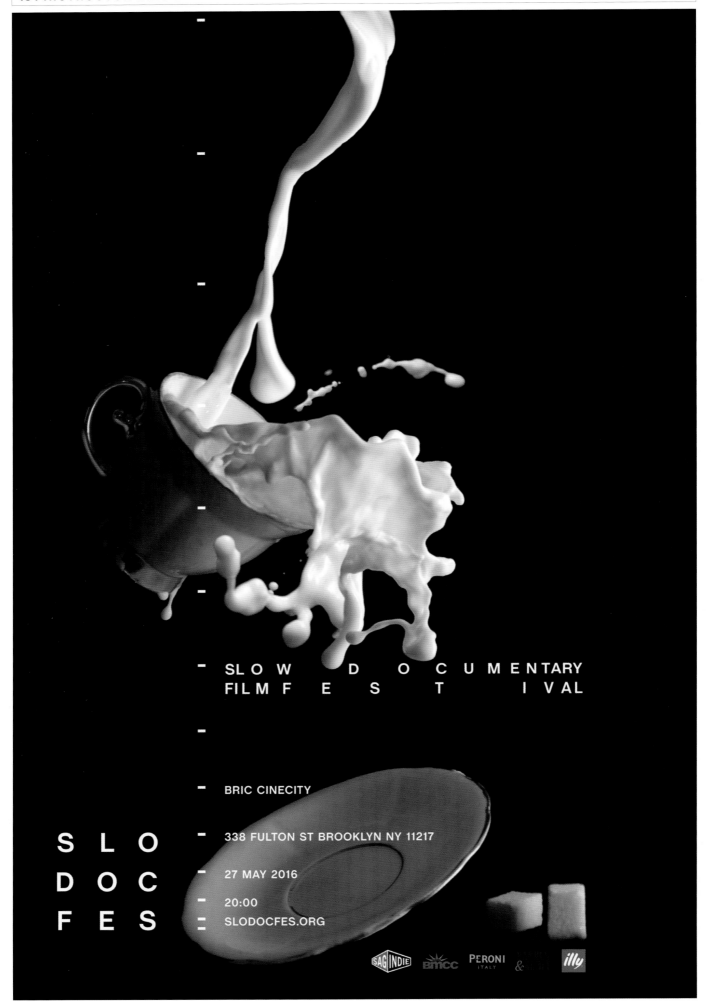

SLOW DOCUMENTARY
FILM FESTIVAL

BRIC CINECITY

338 FULTON ST BROOKLYN NY 11217

27 MAY 2016

20:00

SLODOCFES.ORG

SLO
DOC
FES

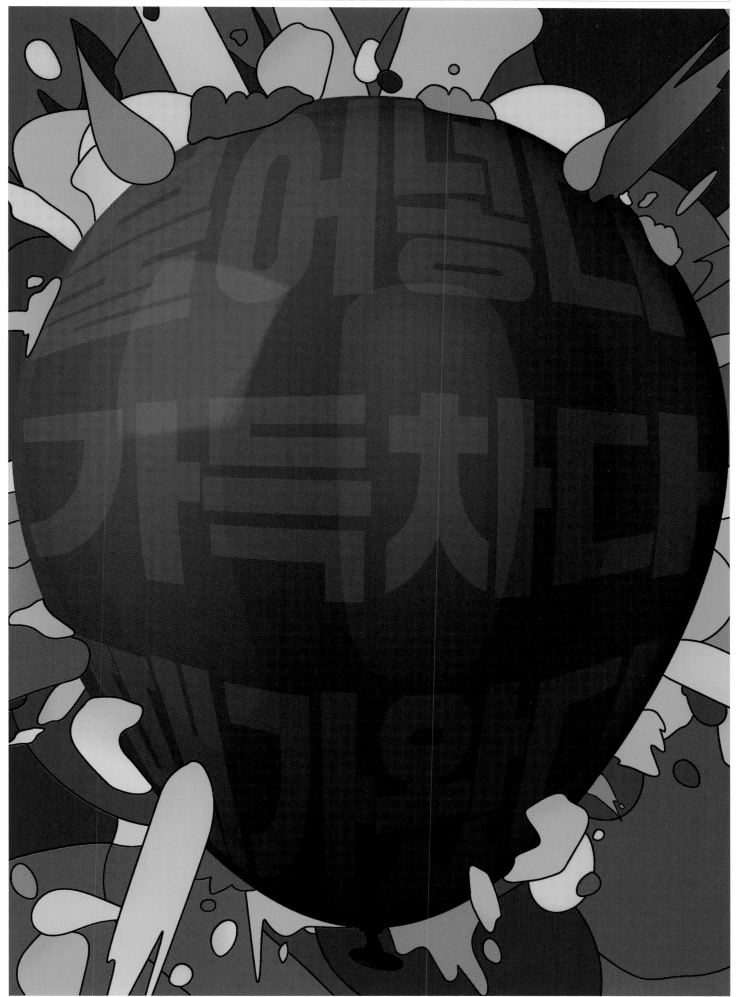

Students: Chan Kyu Lee, Min Gi An, Bong Hee Park, Min Soo Kim | Hansung University of Design & Art Institute Poster | Design

SEOUL
JAZZ FESTIVAL

MAY 28 Sat - MAY 29 Sun 2016

27 SPECIAL OPENING NIGHT
28 SOUL JAZZ FESTIVAL
29 SOUL JAZZ FESTIVAL

AT OLYMPIC PARK

http://www.seouljazz.co.kr/
info@privatecurve.c02)563-0595

PRODUCED BY PRIVATE CURVE

We are back & a Very Welcome to Seoul Jazz Festival 2014

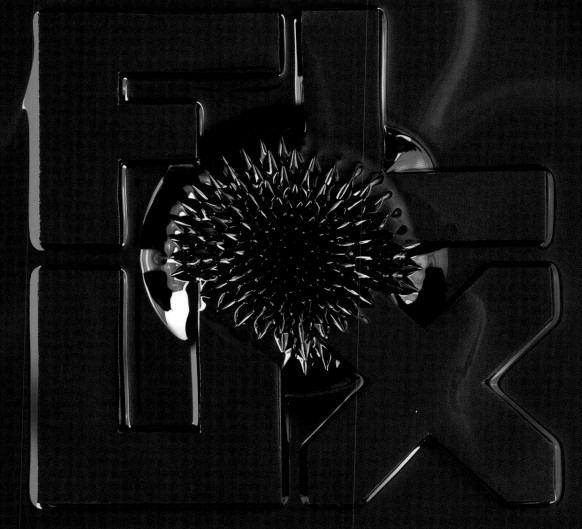

WATKINS COLLEGE OF ART
PRESENTS

GRAPHIC DESIGN SENIOR SHOW

LYDIA JARVI. ELLIOT HAY. CHRIS FORNAL. LAUREN VANSICKLE
DEREK ANDERSON. MELINA OLIVERA. MARLON MALBROUGH

4.27.17

5:30-8:30 PM AT ST8MNT - 822 3rd Ave. S.
fluxdesignshow.com

Watkins receives funding from the Metro Nashville Arts Commission and Tennessee Arts Commission.

Students: Derek Anderson, Chris Fornal, Elliot Hay | Watkins College of Art

Poster | Design

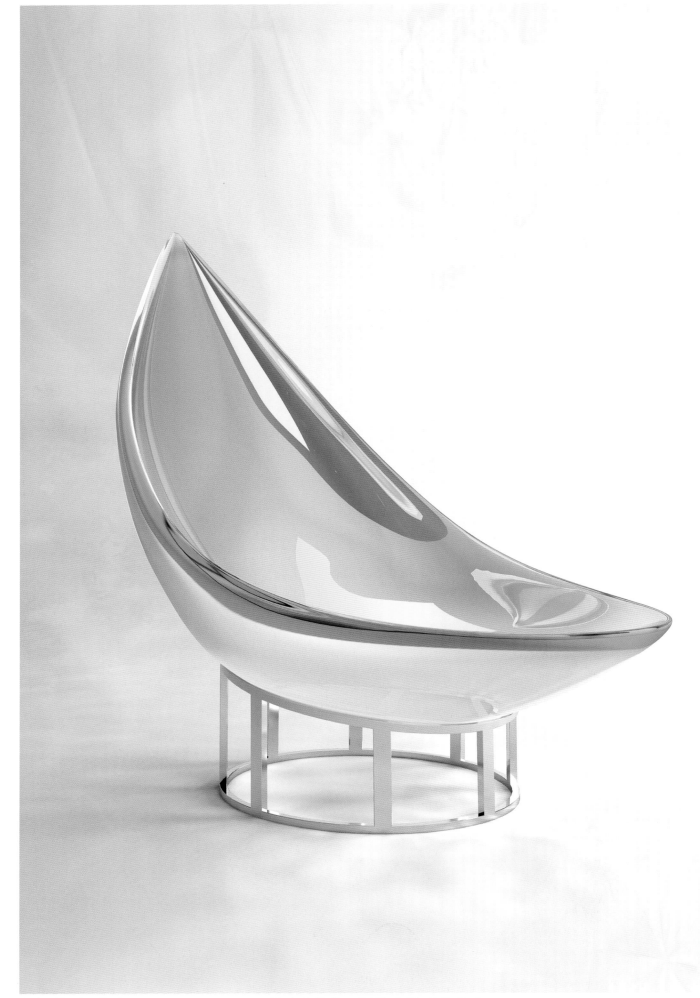

INSTRUCTOR HANK RICHARDSON

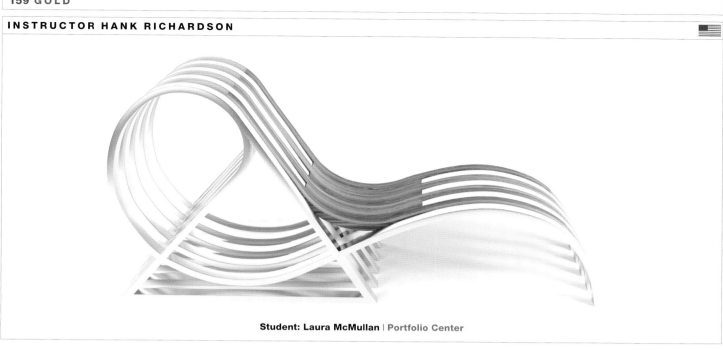

Student: Laura McMullan | Portfolio Center

INSTRUCTOR HANK RICHARDSON

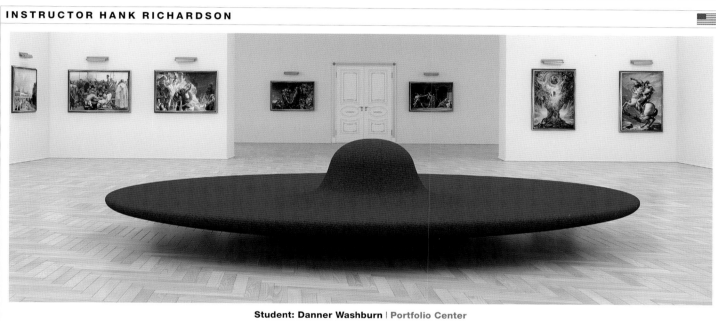

Student: Danner Washburn | Portfolio Center

INSTRUCTOR HANK RICHARDSON

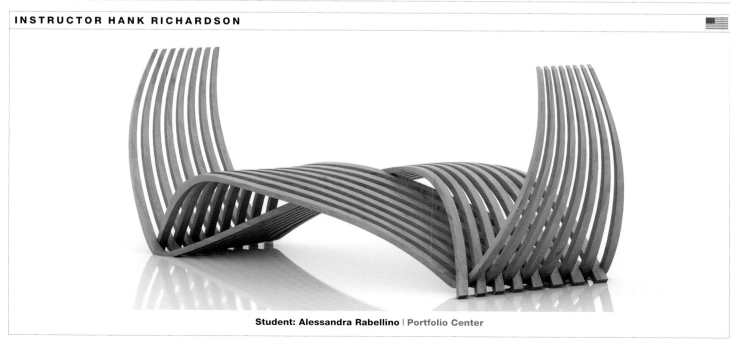

Student: Alessandra Rabellino | Portfolio Center

Product Design | Design

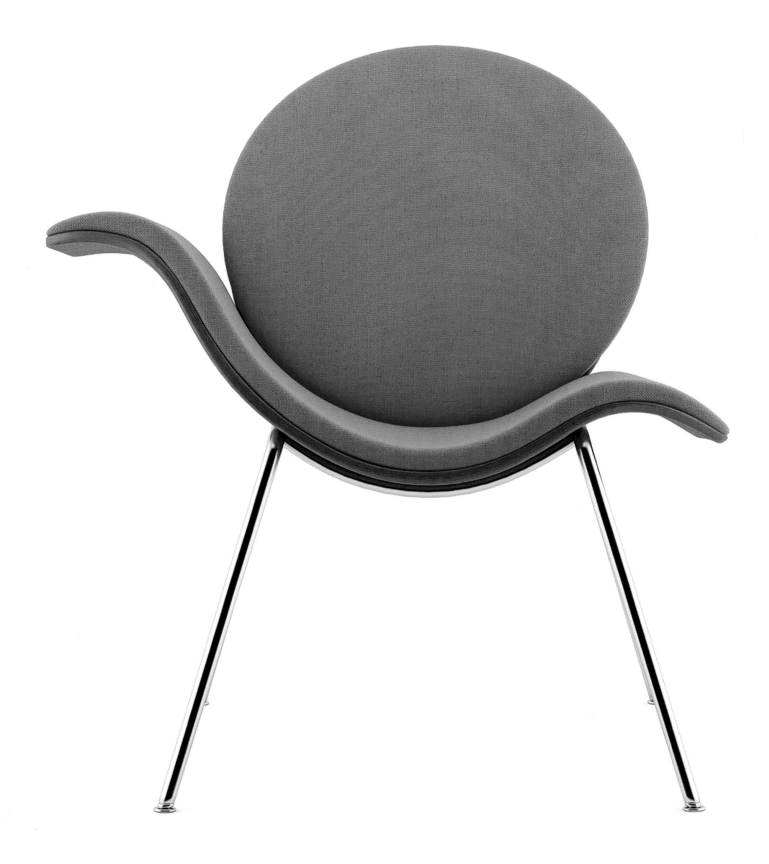

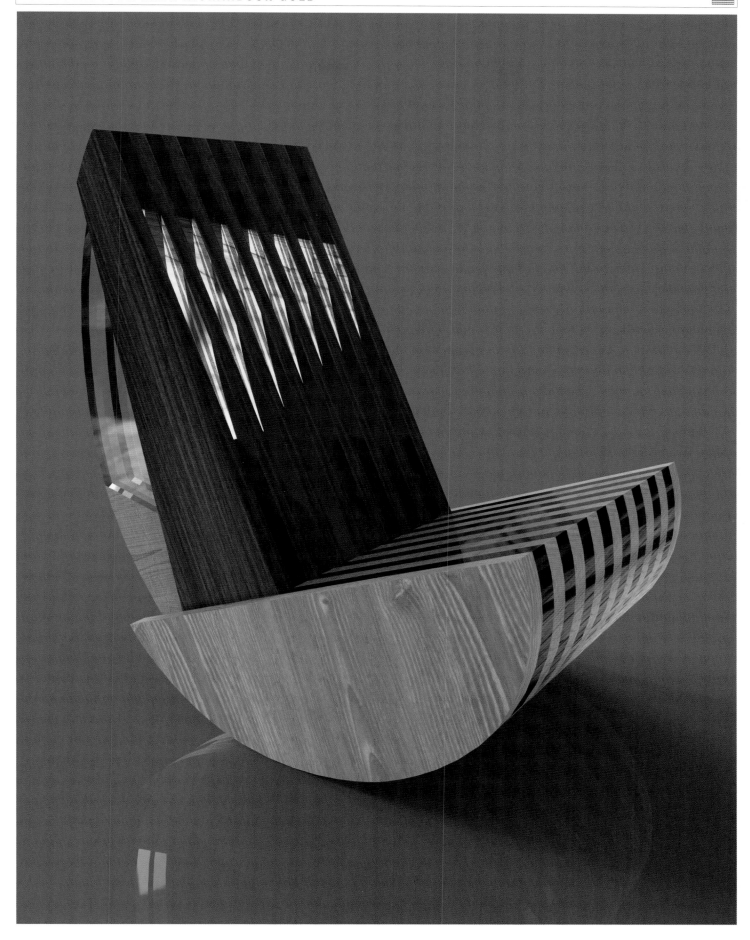

Student: Alex Cohen | Portfolio Center

Product Design | Design

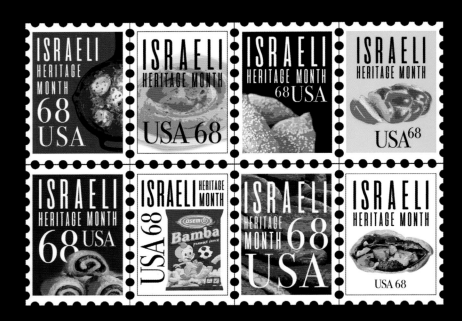

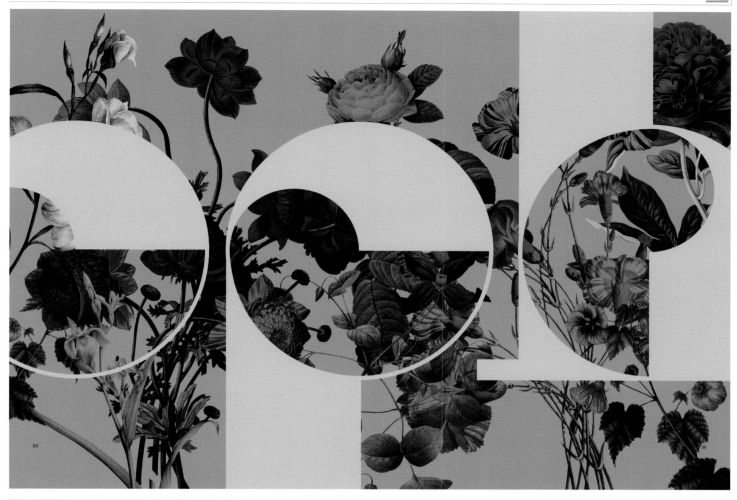

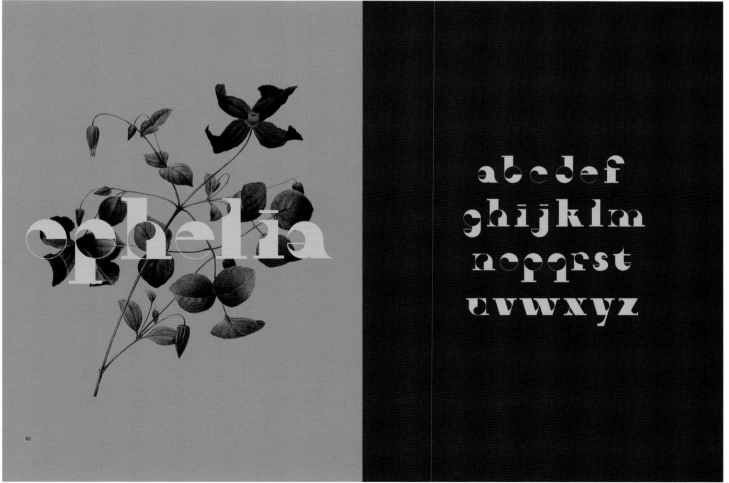

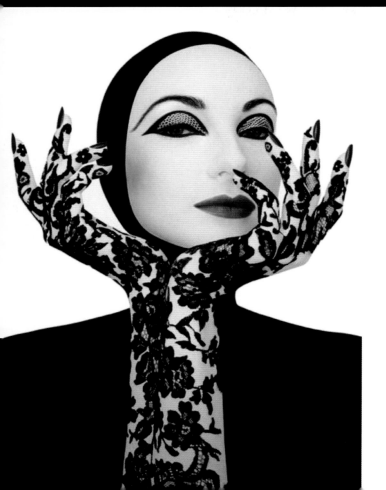

things base and vile folding no quantity

love can transpose to form and dignity

love looks with no eyes but with the mind

and therefore is wingd cupid painted blind

nor hath loves mind of any judgement taste

wings and no eyes figure unheedy haste

and therefore is love said to be a child

because in choice he is so oft beguiled

as waggish boys in game themseleves forswear

so the boy love is perjured every where

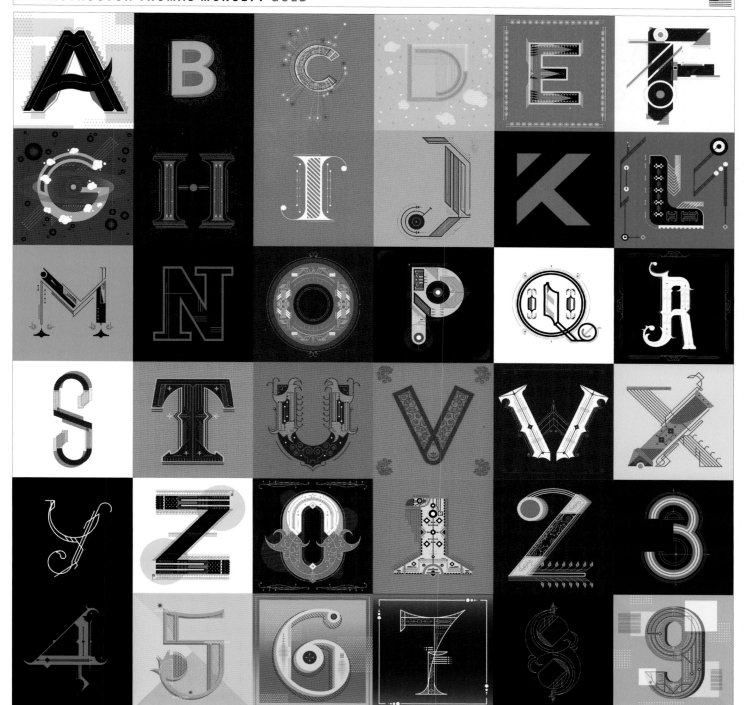

INSTRUCTOR EILEEN HEDY SCHULTZ

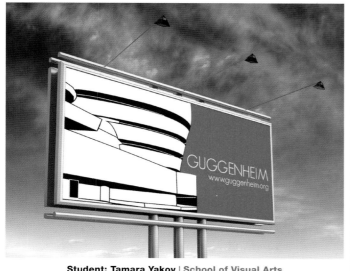

Student: Tamara Yakov | School of Visual Arts

INSTRUCTOR DAN CASSARO

Student: Hanbyul Park | School of Visual Arts

INSTRUCTOR KRISTIN SOMMESE

Student: William King | Pennsylvania State University

INSTRUCTOR CAROLINA DE BARTOLO

Student: Juan Manuel Corredor | Academy of Art University

INSTRUCTOR STANLEY ZIENKA

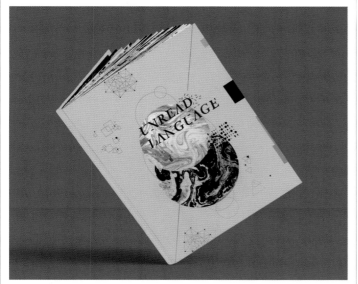

Student: Hsuan-Yun Huang | Academy of Art University

INSTRUCTOR THOMAS MCNULTY

Student: Juan Manuel Corredor | Academy of Art University

INSTRUCTOR OLGA MEZHIBOVSKAYA

Student: Ti Tung Wang
School of Visual Arts

INSTRUCTOR OLGA MEZHIBOVSKAYA

Student: Huiwen Tan
School of Visual Arts

INSTRUCTOR TRACEY SHIFFMAN

Student: Ricardo Imperial
Art Center College of Design

INSTRUCTOR SANDY STEWART

Student: Max Kahn
Drexel University

INSTRUCTOR EDUARD CEHOVIN

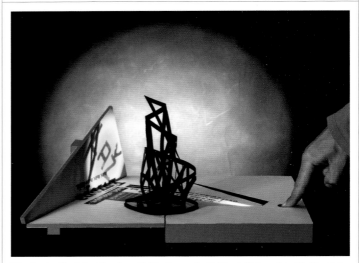

Students: S. Arko Strojan, P. Kostevc, A. R. Tomšič Jacobs, M. Kladnik,
V. Stojanovski, D. Kocijancic | Academy of Fine Arts and Design

INSTRUCTOR DR. ALAN YOUNG

Student: Phoebe Ellis | Auckland University of Technology

INSTRUCTOR UNATTRIBUTED

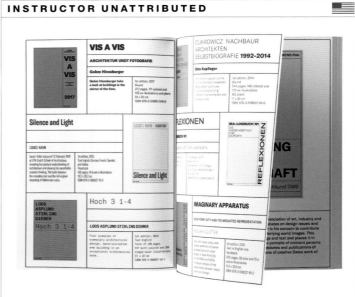

Student: Rose Maria Sofie | School of Visual Arts

INSTRUCTOR CARIN GOLDBERG

Student: Misha Hunt | School of Visual Arts

INSTRUCTOR ADRIAN PULFER

Blink | Tipping Point | Outliers

Student: Tyler Watson | Brigham Young University

INSTRUCTOR HANK RICHARDSON

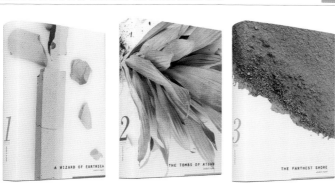

Student: Brendan Brines | Portfolio Center

INSTRUCTORS HANK RICHARDSON, MELISSA KUPERMINC

THE GIRL WITH THE DRAGON TATTOO

THE GIRL WHO PLAYED WITH FIRE

THE GIRL WHO KICKED THE HORNET'S NEST

Student: Brennan Holloway | Portfolio Center

INSTRUCTOR EILEEN HEDY SCHULTZ

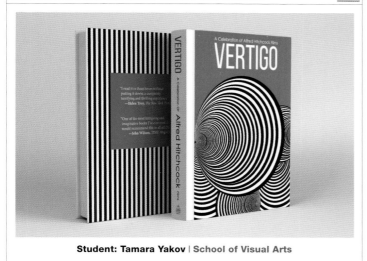

VERTIGO
A Celebration of Alfred Hitchcock Films

Student: Tamara Yakov | School of Visual Arts

INSTRUCTOR JERROD NEW

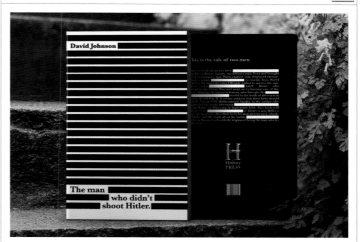

David Johnson

The man who didn't shoot Hitler.

History PRESS

Student: Marcelo Shalders | Miami Ad School

INSTRUCTOR ERIC BAKER

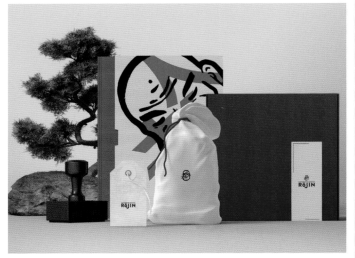

Student: Erik Campay | School of Visual Arts

INSTRUCTOR HANK RICHARDSON

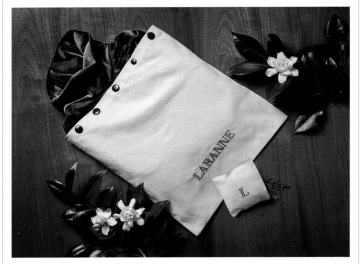

Student: Elle Oser | Portfolio Center

INSTRUCTORS COURTNEY GOOCH, PAULA SCHER

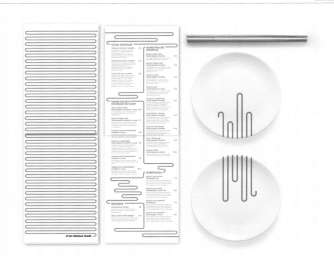

Student: Ho Seok Lee | School of Visual Arts

INSTRUCTOR EILEEN HEDY SCHULTZ

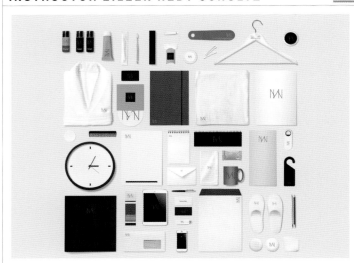

Student: Tamara Yakov | School of Visual Arts

INSTRUCTOR DAN CASSARO

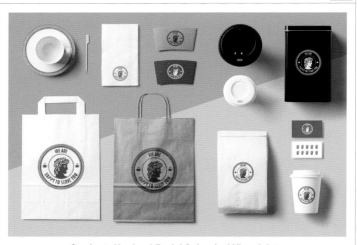

Student: Hanbyul Park | School of Visual Arts

INSTRUCTOR INYOUNG CHOI

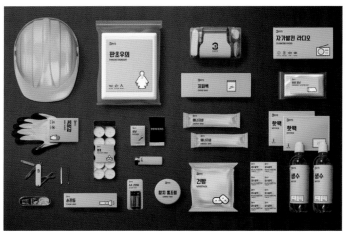

Student: Bokyung Ku | Hanyang University

INSTRUCTOR ADRIAN PULFER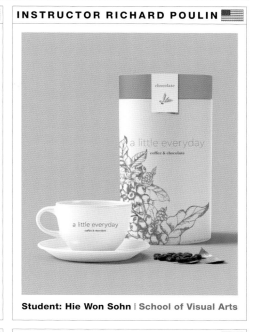

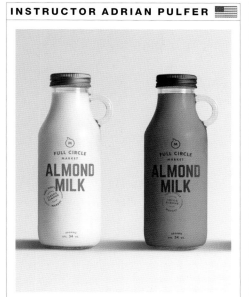

Student: Gunnar Harrison | **Brigham Young Univ.**

INSTRUCTOR HANK RICHARDSON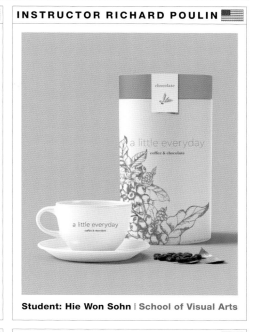

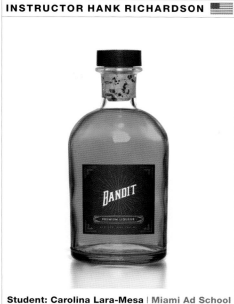

Student: Carolina Lara-Mesa | **Miami Ad School**

INSTRUCTOR RICHARD POULIN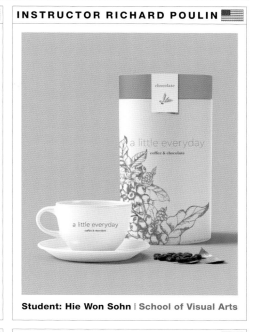

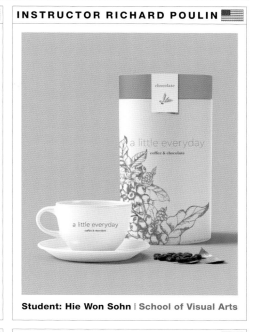

Student: Hie Won Sohn | **School of Visual Arts**

INSTS. SEAN ADAMS, CHRIS HACKER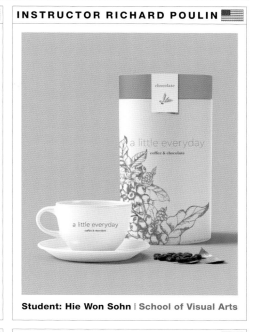

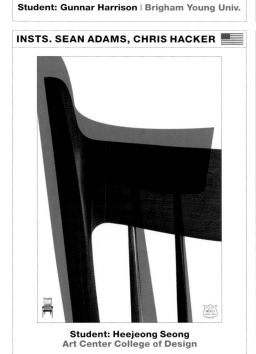

Student: Heejeong Seong
Art Center College of Design

INSTRUCTOR CARIN GOLDBERG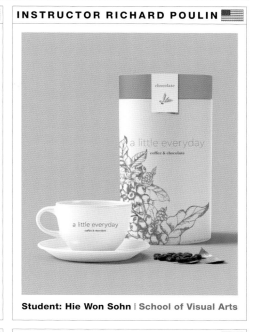

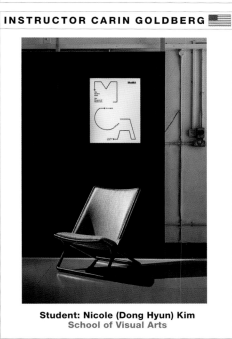

Student: Nicole (Dong Hyun) Kim
School of Visual Arts

INSTRUCTOR UNATTRIBUTED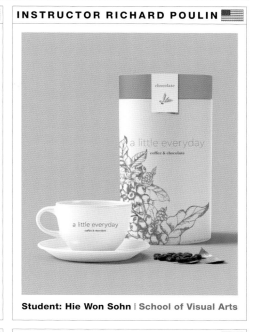

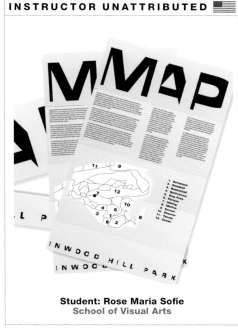

Student: Rose Maria Sofie
School of Visual Arts

INSTS. ELLEN LUPTON, JASON M. GOTTLIEB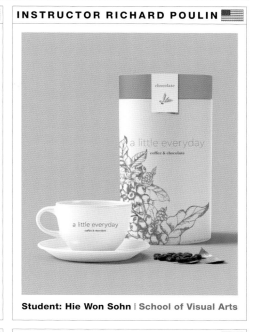

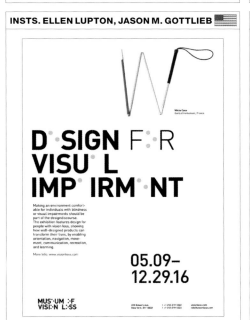

Stud.: Ze Wang | **Maryland Institute College of Art**

INSTS. PAULA SCHER, COURTNEY GOOCH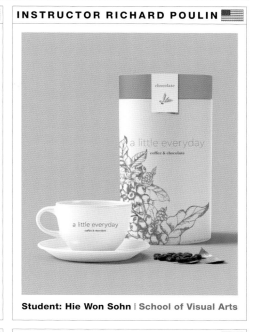

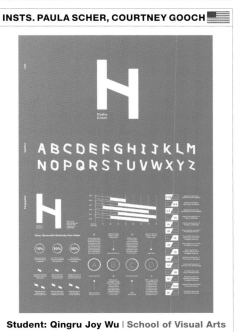

Student: Qingru Joy Wu | **School of Visual Arts**

INSTS. PAULA SCHER, COURTNEY GOOCH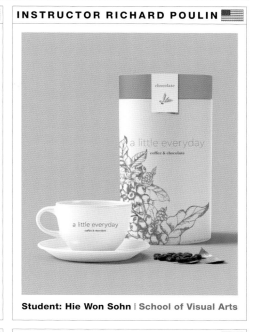

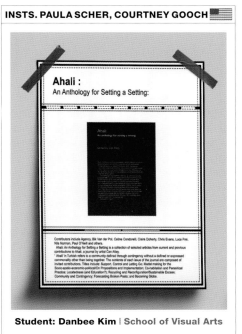

Student: Danbee Kim | **School of Visual Arts**

INSTRUCTORS PAULA SCHER, COURTNEY GOOCH

Student: Grina Choi | School of Visual Arts

INSTRUCTORS HOLLY STERLING, TANYA FREACH

Student: Lauren Godwin | Texas State University

INSTRUCTOR SE RA YOON

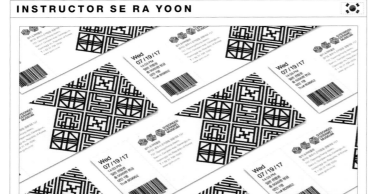

Student: Min Kyeung Kim | Chung-Ang University

INSTRUCTOR ADRIAN PULFER

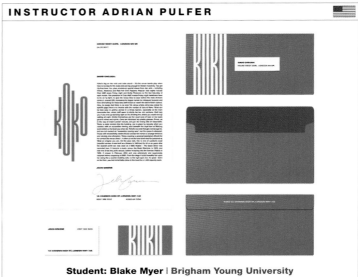

Student: Blake Myer | Brigham Young University

INSTRUCTOR WITT LANGSTAFF

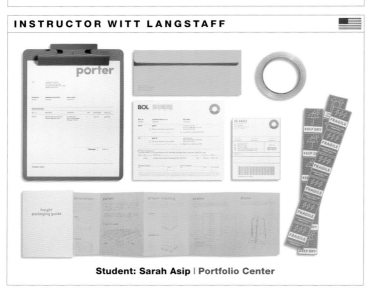

Student: Sarah Asip | Portfolio Center

INSTRUCTOR BRAD BARTLETT

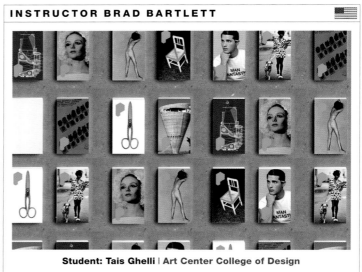

Student: Tais Ghelli | Art Center College of Design

INSTRUCTOR HUNTER WIMMER

Student: Hugo Ugaz | **Academy of Art University**

INSTRUCTOR DEVAN CARTER

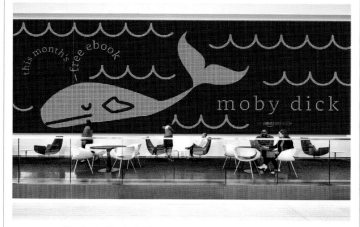

Student: Rachel Eleanor Phillips | **Portfolio Center**

INSTRUCTOR DEVAN CARTER

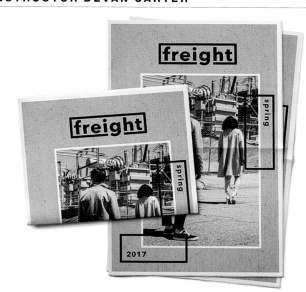

Student: Brennan Holloway | **Portfolio Center**

INSTRUCTORS PAULA SCHER, COURTNEY GOOCH

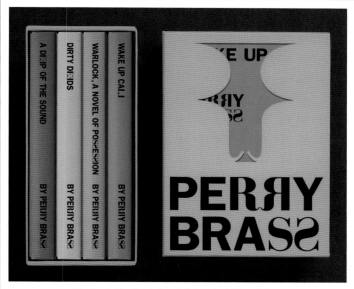

Student: Ho Seok Lee | **School of Visual Arts**

INSTRUCTOR MELISSA KUPERMINC

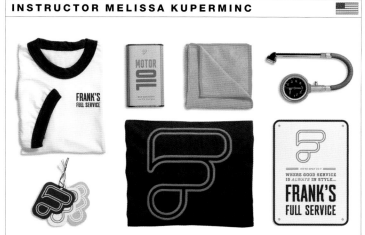

Student: Carter Tindall | **Portfolio Center**

INSTRUCTOR MELISSA KUPERMINC

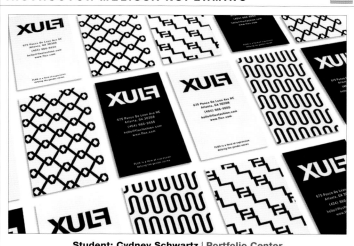

Student: Cydney Schwartz | **Portfolio Center**

INSTRUCTOR BRAD BARTLETT

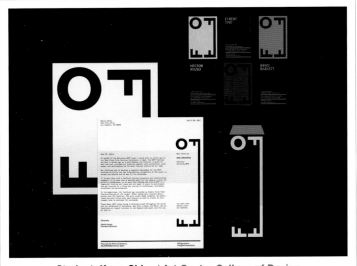

Student: Kuan Chiou | Art Center College of Design

INSTRUCTOR SCOTT BUSCHKUHL

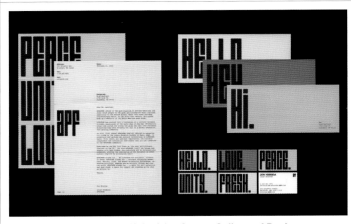

Student: Hyunkyung Koh | School of Visual Arts

INSTRUCTORS PAULA SCHER, COURTNEY GOOCH

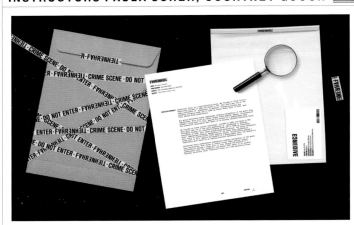

Student: HyeRi Hyun | School of Visual Arts

INSTRUCTOR BRAD BARTLETT

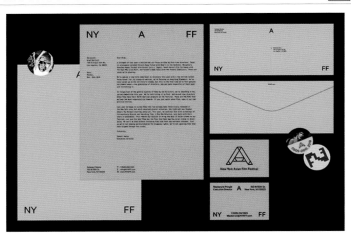

Student: Yuma Naito | Art Center College of Design

INSTRUCTOR STEPHEN SERRATO

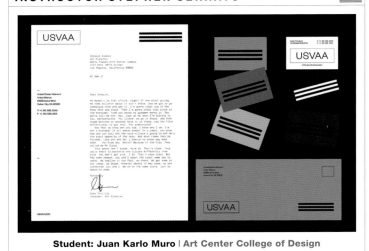

Student: Juan Karlo Muro | Art Center College of Design

INSTRUCTOR BRAD BARTLETT

Student: Brian Liu | Art Center College of Design

INSTRUCTOR EILEEN HEDY SCHULTZ

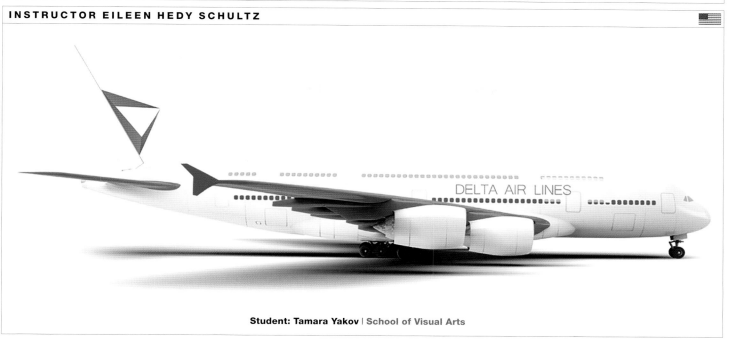

DELTA AIR LINES

Student: Tamara Yakov | School of Visual Arts

INSTRUCTOR UNATTRIBUTED

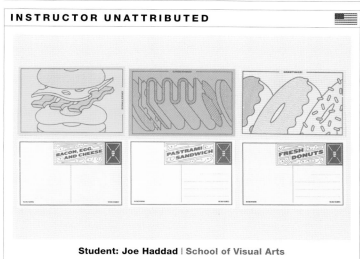

Student: Joe Haddad | School of Visual Arts

INSTRUCTOR JON NEWMAN

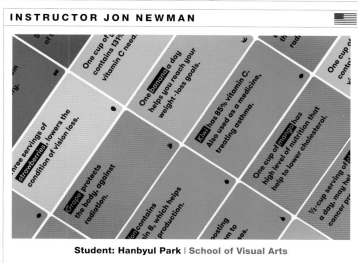

Student: Hanbyul Park | School of Visual Arts

INSTRUCTOR RICHARD MEHL

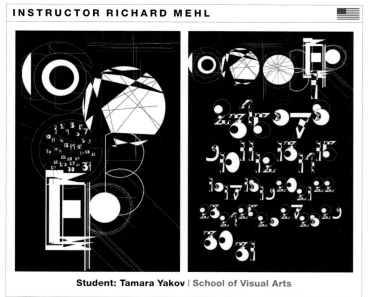

Student: Tamara Yakov | School of Visual Arts

INSTRUCTOR BRITTANY BAUM

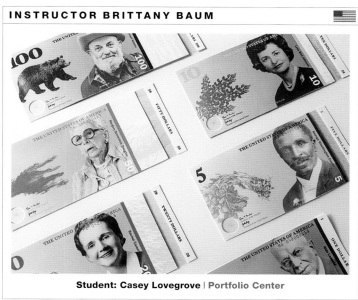

Student: Casey Lovegrove | Portfolio Center

INSTRUCTOR CARIN GOLDBERG 🇺🇸

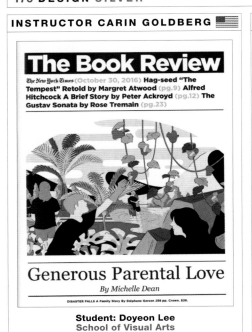

Student: Doyeon Lee
School of Visual Arts

INSTRUCTOR ADRIAN PULFER 🇺🇸

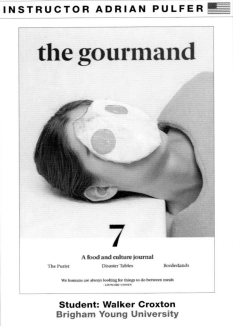

Student: Walker Croxton
Brigham Young University

INSTRUCTOR MICHAEL WORTHINGTON 🇺🇸

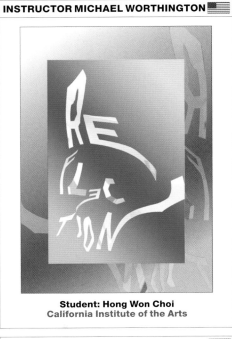

Student: Hong Won Choi
California Institute of the Arts

INSTRUCTOR BARBARA DEWILDE 🇺🇸

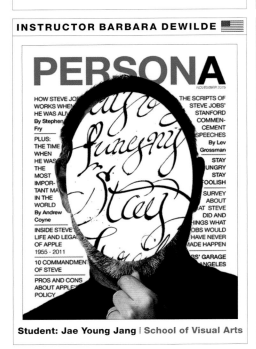

Student: Jae Young Jang | School of Visual Arts

INSTRUCTOR SHAWN HASTO 🇺🇸

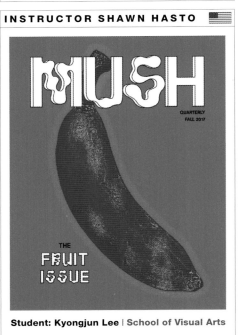

Student: Kyongjun Lee | School of Visual Arts

INSTRUCTOR ADRIAN PULFER 🇺🇸

Student: Brooke Pathakis | Brigham Young Univ.

INSTRUCTOR JERRI JOHNSON 🇨🇦

Student: Sanja Pavlovic | George Brown College

INSTRUCTOR OLGA MEZHIBOVSKAYA 🇺🇸

Student: Sihao Sun | School of Visual Arts

INSTRUCTOR JERRI JOHNSON 🇨🇦

Stud.: Yusuke Yamazaki | George Brown College

INSTRUCTOR MICHELE DAMATO

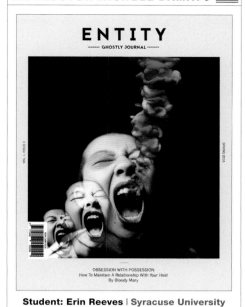

Student: **Erin Reeves** | **Syracuse University**

INST. EILEEN HEDY SCHULTZ

Student: **Tamara Yakov** | **School of Visual Arts**

INSTRUCTOR LANNY SOMMESE

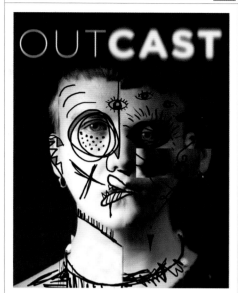

Stud.: **Kyle Cernicky** | **Pennsylvania State Univ.**

INSTRUCTOR ADRIAN PULFER

Student: **Megan Eckersley** | **Brigham Young University**

INSTRUCTOR ABBY GUIDO

Student: **Julie Lam** | **Temple University**

INSTRUCTOR CARIN GOLDBERG

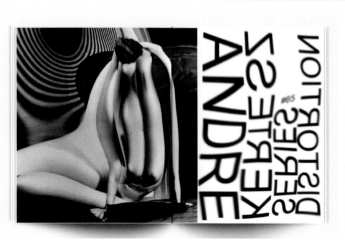

Student: **Soojin Hong** | **School of Visual Arts**

INSTRUCTOR CARIN GOLDBERG

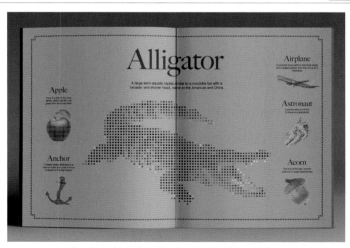

Student: **Han Jun Kim** | **School of Visual Arts**

INSTRUCTOR CARIN GOLDBERG

Student: Hyejin Lee | School of Visual Arts

INSTRUCTOR THERON MOORE

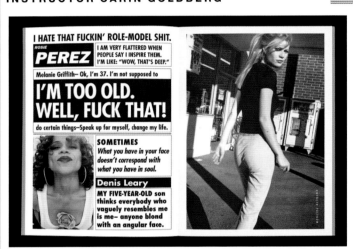

Student: Marshall Dahlin | California State University, Fullerton

INSTRUCTOR CARIN GOLDBERG

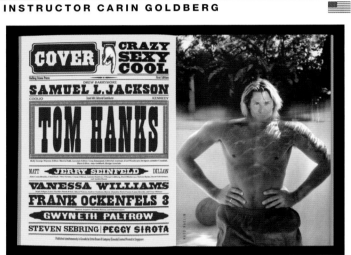

Student: Doyeon Lee | School of Visual Arts

INSTRUCTOR CARIN GOLDBERG

Student: Doyeon Lee | School of Visual Arts

INSTRUCTOR CARIN GOLDBERG

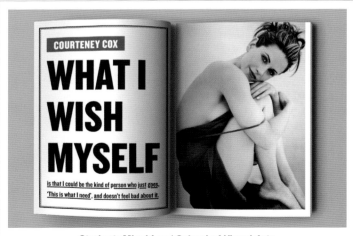

Student: Minzi Lee | School of Visual Arts

INSTRUCTORS JESSICA WALSH, TIMOTHY GOODMAN

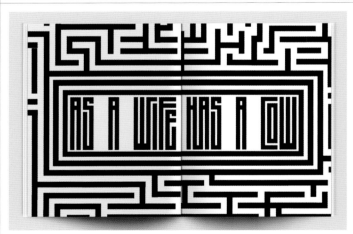

Student: Soojin Hong | School of Visual Arts

INSTRUCTOR DEVAN CARTER

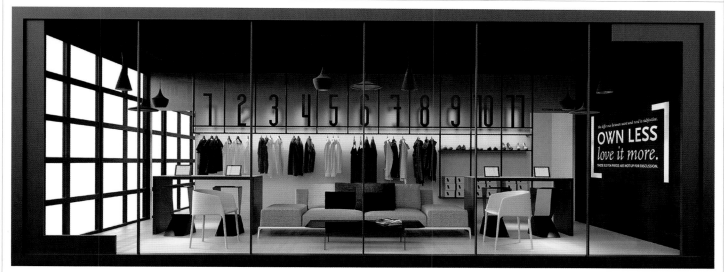

Student: Carter Tindall | Portfolio Center

INSTRUCTOR KELLY HOLOHAN

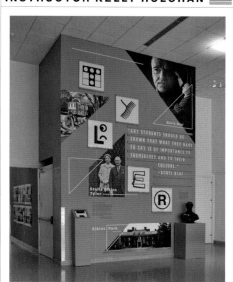

**Students: Krissy Beck, Laura Sutphen,
Ryan Hewlett** | Temple University

INSTRUCTOR RICHARD POULIN

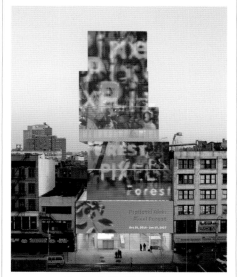

Student: Hie Won Sohn
School of Visual Arts

INSTRUCTOR UNATTRIBUTED

Student: Seungeun Heo
School of Visual Arts

INSTRUCTOR HANK RICHARDSON

Students: Laura Capps, Elle Oser | Portfolio Center

INSTRUCTOR SHUSHI YOSHINAGA

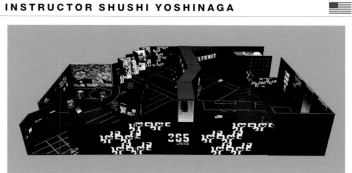

Student: June Lee | Drexel University

INSTRUCTOR JOE SCORSONE

Student: Krissy Beck | Temple University

INSTRUCTORS DONG-JOO PARK, SEUNG-MIN HAN

COEXISTENCE

Student: Min Gyong Park | Hansung University of Design & Art Institute

INSTRUCTOR UNATTRIBUTED

Student: Harlan Ballogg | School of Visual Arts

INSTRUCTOR DAN BRAWNER

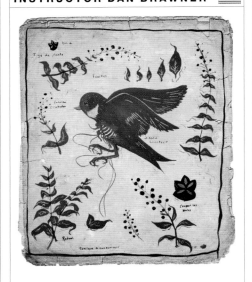

Stud.: Katherine Hansen | Watkins College of Art

INSTRUCTOR MELISSA MCFEETERS

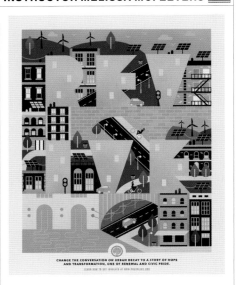

Student: Jacqueline Jensen | Temple University

INSTRUCTOR YVONNE CAO

Student: Marissa Merrill | Texas Christian University

INSTS. THOMAS SHIM, RICHARD POULIN, WILLY WONG, SHANNAN COGHILL

Student: Jun Yong Choi | School of Visual Arts

INSTRUCTOR RYAN RUSSELL

Students: Rob Pitrovich, Deric Silva | Pennsylvania State University

INSTRUCTOR MELISSA KUPERMINC

Student: Laura Capps | Portfolio Center

INSTRUCTOR RYAN SCOTT TANDY

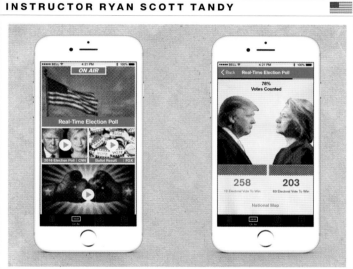

Student: Han Jun Kim | School of Visual Arts

INSTRUCTOR WIOLETA KAMINSKA

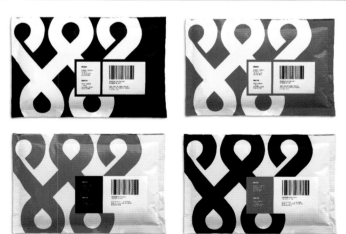

Student: Emilie Garnier | Academy of Art University

INSTRUCTOR KATIE KITCHENS

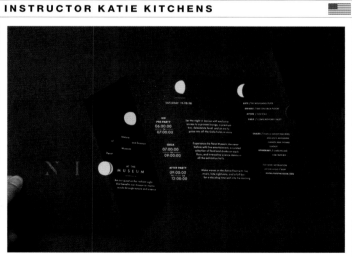

Student: Alex Flores | Texas A&M University Commerce

INSTRUCTOR ADRIAN PULFER

Student: Camilla Aubrey | Brigham Young University

INST. ANAIS SÁNCHEZ MOSQUERA

Student: Eduardo Piedra Quiroz | **Universidad Católica de Santiago de Guayaquil**

INST. JOHN HARTWELL

Student: Alex Cohen
Portfolio Center

INST. BEHNOUSH MCKAY

Student: Samantha Deboda
Woodbury University

INST. HOLLY STERLING

Students: Callie Gabbert, Angela Rhys, Courtney Whitehouse, Randy Gaytan | **Texas State Univ.**

INST. BILL GALYEAN

Student: Marissa Merrill
Texas Christian University

INST. JOHN HARTWELL

Student: Caroline Skarupa
Portfolio Center

INST. JOHN HARTWELL

Student: Laura Capps
Portfolio Center

INST. JOHN HARTWELL

Student: Laura Capps
Portfolio Center

INST. JOHN HARTWELL

Student: Caroline Skarupa
Portfolio Center

INST. HANK RICHARDSON

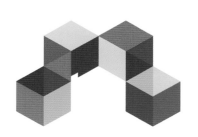

Student: Katie Tynes
Portfolio Center

INSTRUCTOR UNATTRIBUTED

Student: Lysander Romero
Metropolitan State University of Denver

INST. GAIL ANDERSON

Student: Youn Jae Lee
School of Visual Arts

INST. STEFAN KJARTANSSON

Student: Laura McMullan
Portfolio Center

INST. JOSHUA EGE

Student: Kelsey Paine
Texas A&M University Commerce

INSTS. OLGA MEZHIBOVSKAYA, NADA RAY

Student: Nubia Jay Giraldo
School of Visual Arts

INST. GERALD SOTO

FRANCISCO SERRANO

Student: Francisco Serrano
School of Visual Arts

INST. HANK RICHARDSON

Student: Katie Tynes
Portfolio Center

INST. PAUL BOOTH

Student: Victoria Barber
Fort Lewis College

INST. DAVID BECK

US FOREST SERVICE

Student: Cooper H. Weinstein
Texas A&M University Commerce

INST. STEFAN KJARTANSSON

Student: Madison DeFilippis
Portfolio Center

INST. STEFAN KJARTANSSON

Student: Alex Minkin
Portfolio Center

INST. JOHN HARTWELL

Student: Alex Cohen
Portfolio Center

INST. JOHN HARTWELL

Student: Caroline Skarupa
Portfolio Center

INST. ADRIAN PULFER

Student: Camilla Aubrey
Brigham Young University

INSTRUCTOR BRYAN FAREVAAG

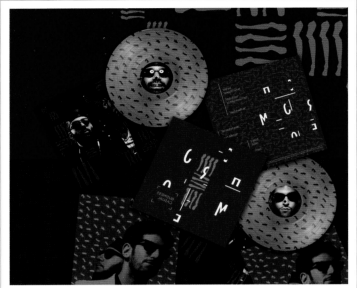

Student: **Shuyue Chen** | School of Visual Arts

INSTRUCTOR MELISSA KUPERMINC

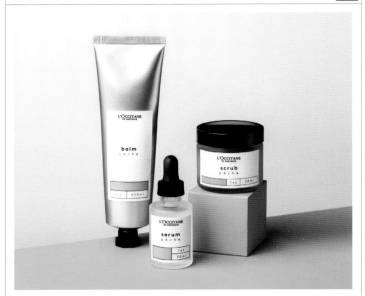

Students: **Elle Oser, Laura Capps, Savannah Colbert** | Portfolio Center

INSTRUCTOR ANN LEMON

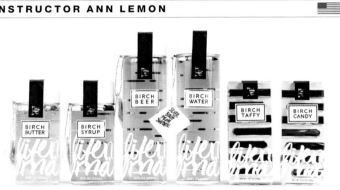

Student: **Christian Weber** | Kutztown University of Pennsylvania

INSTRUCTOR EVANTHIA MILARA

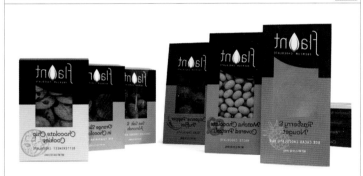

Student: **Leah Stang** | Art Institute of North Hollywood

INSTRUCTOR KRISTIN SOMMESE

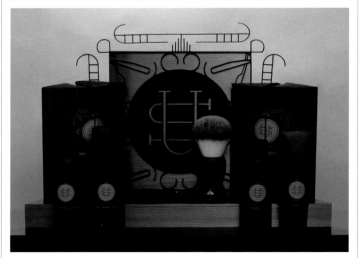

Student: **Hayle Stoner**
Pennsylvania State University

INSTRUCTOR HANK RICHARDSON

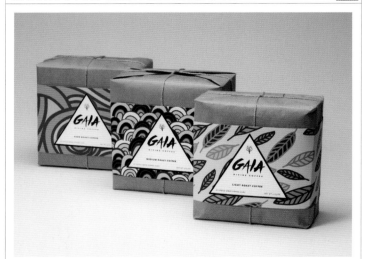

Students: **Elliot Cohen, Rachel Eleanor Phillips, Anna Riethman, Sarah Asip, Cydney Schwartz** | Portfolio Center

INSTRUCTOR LEWIS GLASER

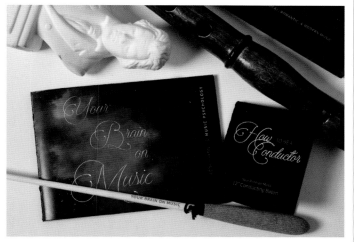

Student: Michele Farren | Texas Christian University

INSTRUCTOR KRISTIN SOMMESE

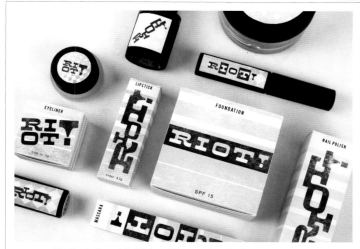

Student: Cassidy Walter | Pennsylvania State University

INSTRUCTORS ANDREW GIBBS, JESSICA DESEO

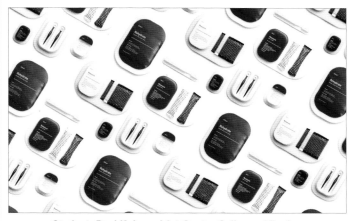

Student: Paul Knipper | Art Center College of Design

INSTRUCTOR KRISTIN SOMMESE

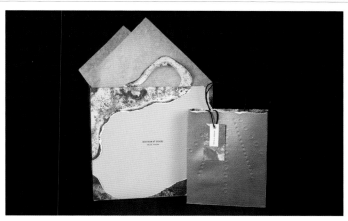

Student: Katelyn Nellis | Pennsylvania State University

INSTRUCTOR THOMAS MCNULTY

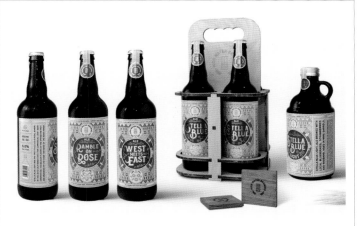

Student: Hsuan-Yun Huang | Academy of Art University

INSTRUCTOR OLGA MEZHIBOVSKAYA

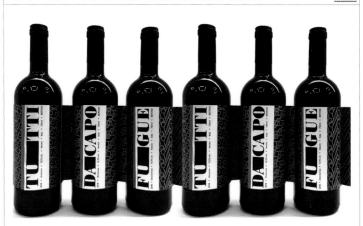

Student: Sou Young Ji | School of Visual Arts

INSTRUCTOR HANK RICHARDSON

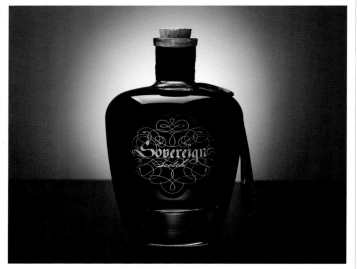

Student: Mary Elizabeth Morse | Portfolio Center

INSTRUCTOR ADRIAN PULFER

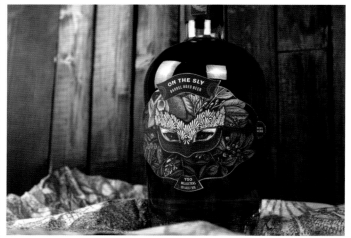

Student: Dallin Diehl | Brigham Young University

INSTRUCTOR THOMAS MCNULTY

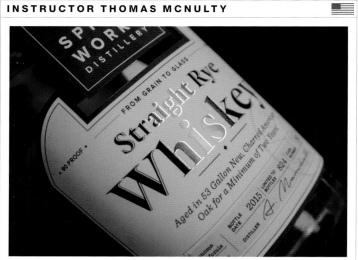

Student: Cory Shigeta | Academy of Art University

INSTRUCTOR KRISTIN SOMMESE

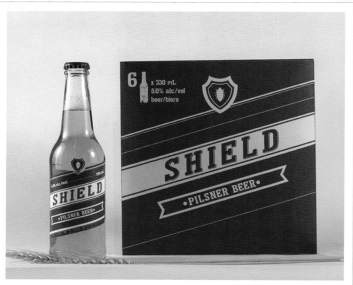

Student: Cassidy Walter | Pennsylvania State University

INSTRUCTOR JERRI JOHNSON

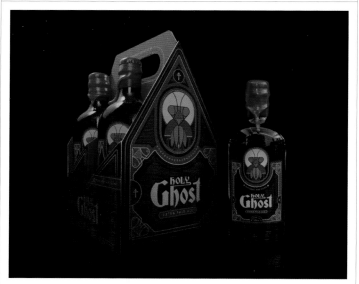

Student: Eunice Joaquin | George Brown College

INSTRUCTOR JERRI JOHNSON

Student: Nancy Gioffre | George Brown College

INST. JERROD NEW

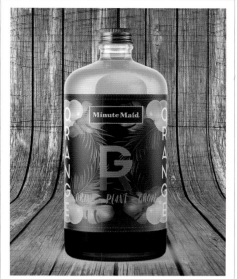

**Students: Marcelo Shalders,
Christian Napolitano** | Miami Ad School

INST. HANK RICHARDSON

Student: Brennan Holloway
Portfolio Center

INST. HANK RICHARDSON

Student: Dan King
Portfolio Center

INST. ADRIAN PULFER

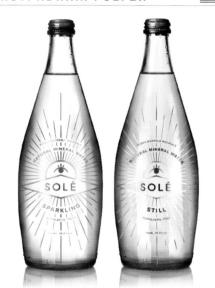

Student: Alex Pynes | Brigham Young Univ.

INST. EILEEN HEDY SCHULTZ

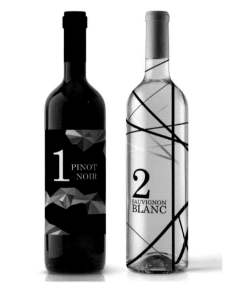

Student: Tamara Yakov | School of Visual Arts

INST. DAVID ELIZALDE

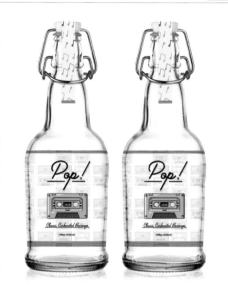

Student: Reo Nathan | Texas Christian University

INST. JULIET D'AMBROSIO

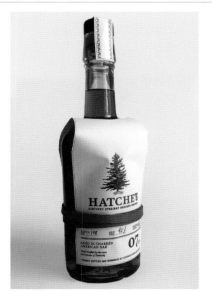

Student: Averil Eagle Brannen | Portfolio Center

INST. THOMAS MCNULTY

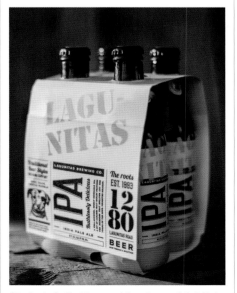

Student: Sofia Llaguno | Academy of Art Univ.

INST. THOMAS MCNULTY

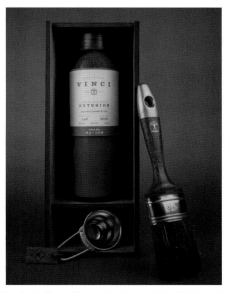

Student: Hugo Ugaz | Academy of Art University

INSTRUCTOR MICHAEL OSBORNE

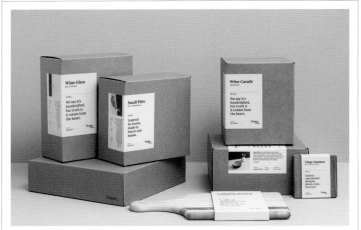

Students: Brandi Steele, Jay Jeon, Jessica Sanjaya Wonomihardjo, Lisa Lindh | **Academy of Art University**

INSTRUCTOR SCOTT BUSCHKUHL

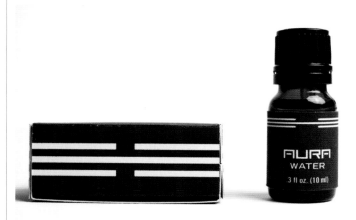

Student: Klever D. Alvarado
School of Visual Arts

INSTRUCTOR THERON MOORE

Student: Angela Godoy | **California State University, Fullerton**

INSTRUCTOR JUDITH SWEENEY O'BRYAN

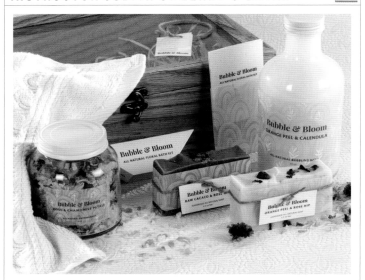

Student: Natalie Miles | **Watkins College of Art**

INSTRUCTORS NIC TAYLOR, BRETT KILROE

Student: Ho Seok Lee | **School of Visual Arts**

INSTRUCTOR THOMAS MCNULTY

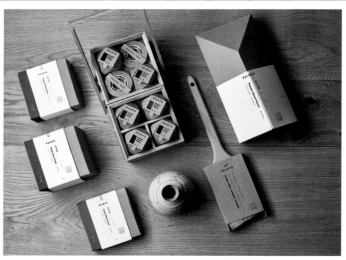

Student: Zihang Jiao | **Academy of Art University**

INSTRUCTOR NAGESH SHINDE

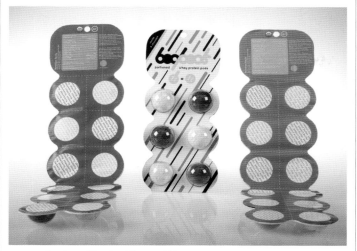

Student: Kendra Wagner | University of Wisconsin–Stout

INSTRUCTOR KRISTIN SOMMESE

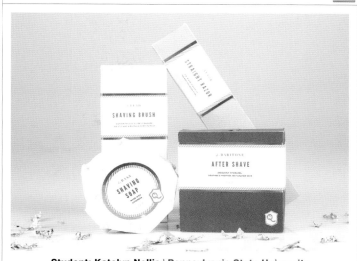

Student: Katelyn Nellis | Pennsylvania State University

INST. RICK GAVOS

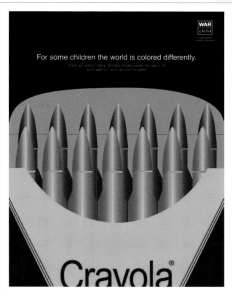

Student: Brandi Hamilton
Texas A&M University Commerce

INST. THERON MOORE

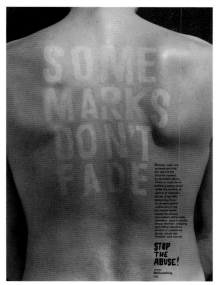

Student: Marshall Dahlin
California State University, Fullerton

INST. MELISSA KUPERMINC

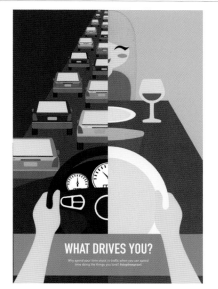

Student: Caroline Skarupa
Portfolio Center

INSTS. HANK RICHARDSON, ADRIANA PELLEGRINI

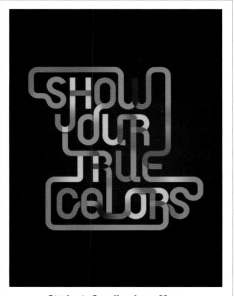

Student: Carolina Lara-Mesa
Miami Ad School

INST. THERON MOORE

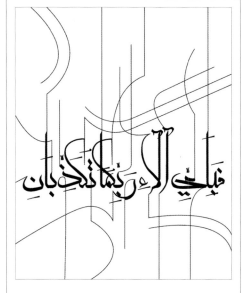

Student: Maaheen Malik
California State University, Fullerton

INST. PETER AHLBERG

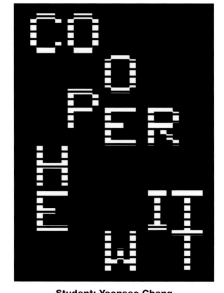

Student: Yoonseo Chang
School of Visual Arts

INSTS. DONG-JOO PARK, SEUNG-MIN HAN

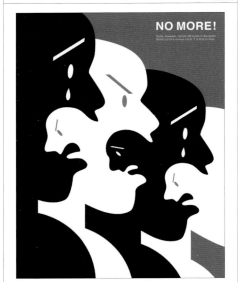

Student: Jinah Yu
Hansung University of Design & Art Institute

INST. RICHARD POULIN

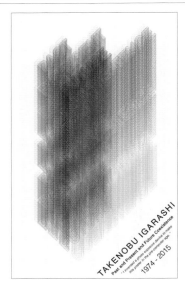

Student: Kyu Jin Hwang
School of Visual Arts

INST. ERIC BAKER

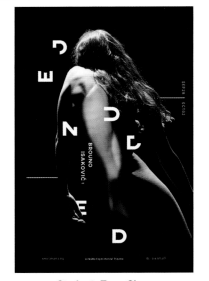

Student: Tung Chou
School of Visual Arts

INST. OLGA MEZHIBOVSKAYA

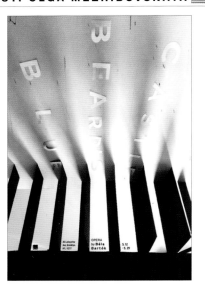

Student: Jiwon Yu
School of Visual Arts

INSTS. DONG-JOO PARK, SEUNG-MIN HAN

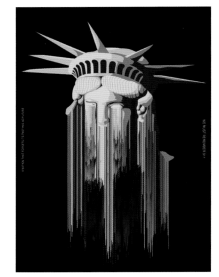

Student: Kyung Hwan An
Hansung University of Design & Art Institute

INST. JOHN NETTLETON

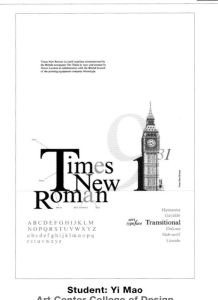

Student: Yi Mao
Art Center College of Design

INST. DAN BRAWNER

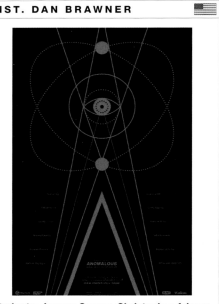

Students: Jeremy Searcy, Christopher Adams,
Natalie Miles | Watkins College of Art

INST. TRAN THANH BINH

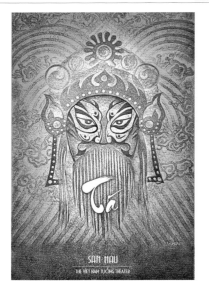

Student: Dang Thi Bich Ngoc
Da Nang Architecture University

INST. PETER AHLBERG

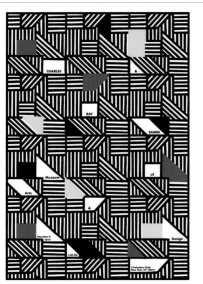

Student: Klara Kovac
School of Visual Arts

INSTRUCTOR INYOUNG CHOI

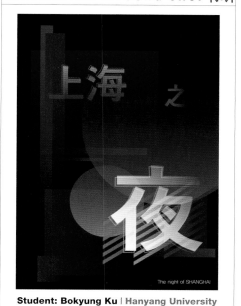

Student: Bokyung Ku | **Hanyang University**

INSTRUCTOR UNATTRIBUTED

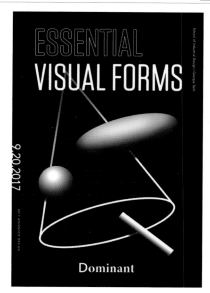

Student: Do Hee Park | Georgia Institute of Tech.

INST. PIPPA SEICHRIST

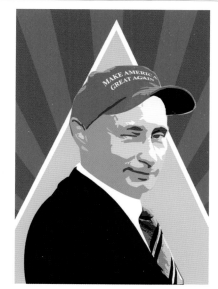

Student: Laura McMullan | **Portfolio Center**

INST. DAVID TILLINGHAST

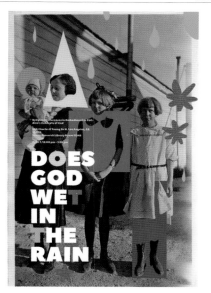

Student: Ying Siu | Art Center College of Design

INST. KIMBERLY CAPRON GONZALEZ

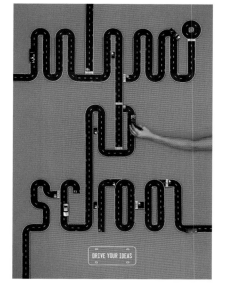

Student: Sofia Soldevila | Miami Ad School

INST. RENEÉ SEWARD

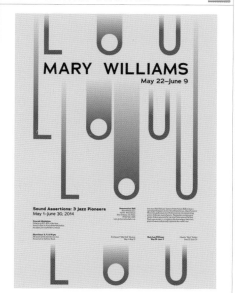

Student: Morgan Smith | Univ. of Cincinnati DAAP

INST. HOON-DONG CHUNG

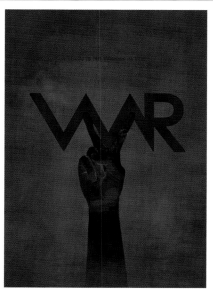

Student: Soobin Yeo | **Dankook University**

INST. CARIN GOLDBERG

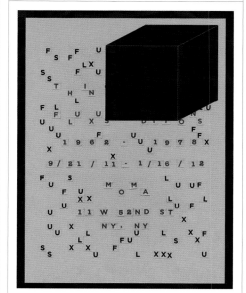

Student: Seoyoung Lee | School of Visual Arts

INST. SCOTT BUSCHKUHL

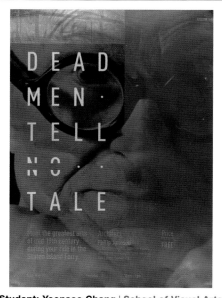

Student: Yoonseo Chang | School of Visual Arts

INST. EILEEN HEDY SCHULTZ

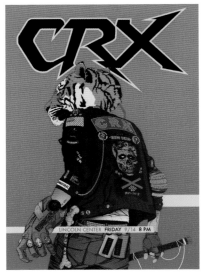

Student: Sean Dong
School of Visual Arts

INST. JERROD NEW

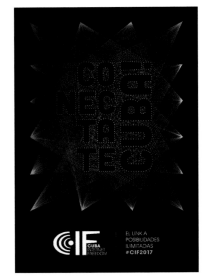

Students: Carolina Lara-Mesa, Carolina Rabago
Miami Ad School

INST. RENEÉ SEWARD

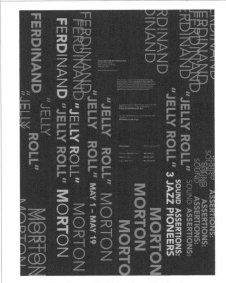

Student: Christopher Enderle
University of Cincinnati DAAP

INST. IVAN CHERMAYEFF

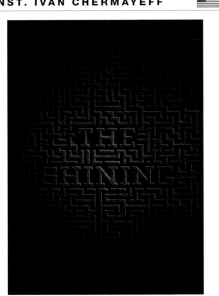

Student: Han Jun Kim | School of Visual Arts

INST. CARIN GOLDBERG

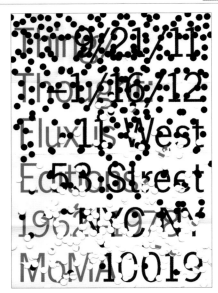

Student: Axel Lindmarker | School of Visual Arts

INST. MARK WILLIE

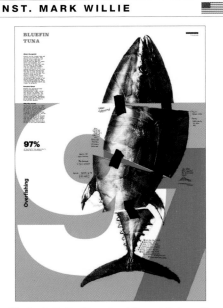

Student: Emily Charniga | Drexel University

INST. EILEEN HEDY SCHULTZ

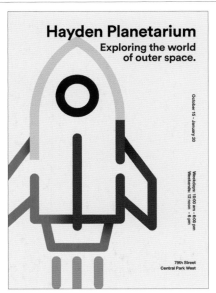

Student: Panini Pandey | School of Visual Arts

INST. DENNIS Y. ICHIYAMA

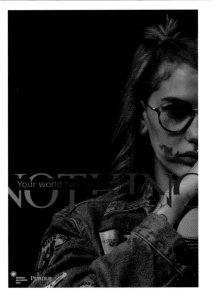

Student: Nancy Sells | Purdue University

INST. LETA SOBIERAJSKI

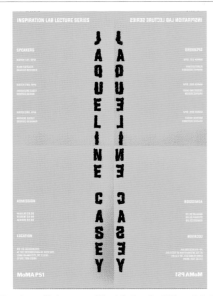

Student: Bokyoung Kim | School of Visual Arts

INST. HANK RICHARDSON

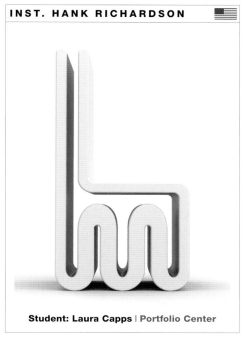

Student: Laura Capps | **Portfolio Center**

INST. HANK RICHARDSON

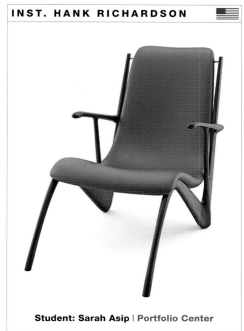

Student: Sarah Asip | **Portfolio Center**

INST. HANK RICHARDSON

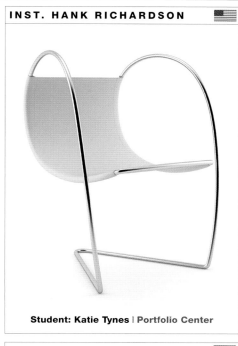

Student: Katie Tynes | **Portfolio Center**

INST. HANK RICHARDSON

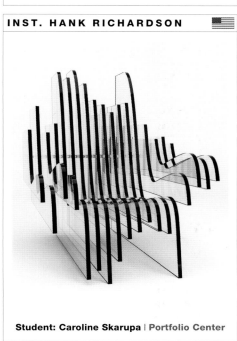

Student: Caroline Skarupa | **Portfolio Center**

INST. HANK RICHARDSON

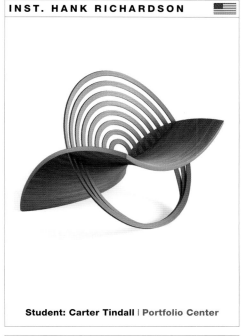

Student: Carter Tindall | **Portfolio Center**

INST. HANK RICHARDSON

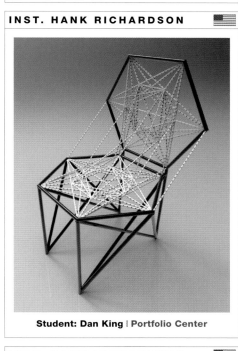

Student: Dan King | **Portfolio Center**

INST. HANK RICHARDSON

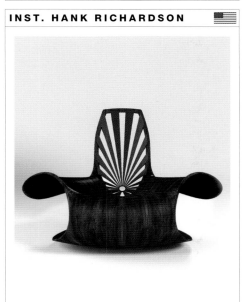

Student: Mary Elizabeth Morse | **Portfolio Center**

INST. HANK RICHARDSON

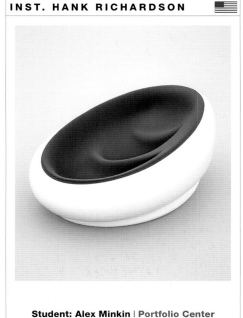

Student: Alex Minkin | **Portfolio Center**

INST. HANK RICHARDSON

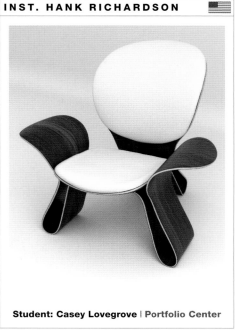

Student: Casey Lovegrove | **Portfolio Center**

INSTRUCTOR RUTH FOWLER

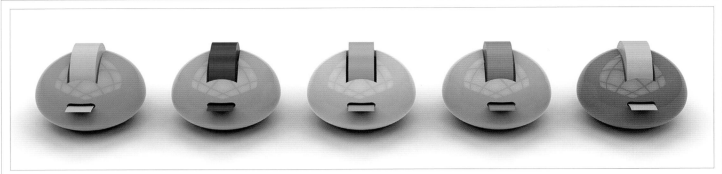

Student: Savannah Colbert | Portfolio Center

INST. HANK RICHARDSON

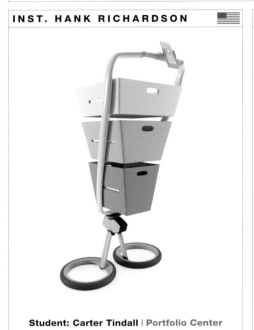

Student: Carter Tindall | Portfolio Center

INST. RUTH FOWLER

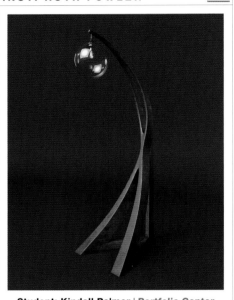

Student: Kindall Palmer | Portfolio Center

INST. HANK RICHARDSON

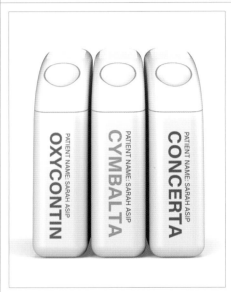

Student: Sarah Asip | Portfolio Center

INSTRUCTOR MAJA MILINIC BOGDANOVIC

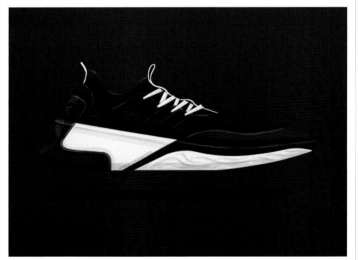

Student: Strahinja Spasic | Belgrade's Polytechnic

INSTRUCTOR LAIN GREENWAY

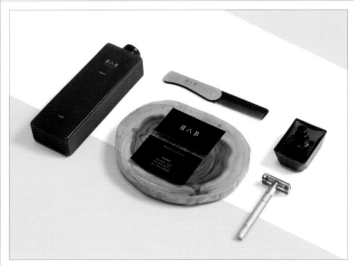

Student: An Cho | School of Visual Arts

INSTRUCTOR NATHAN SAVAGE

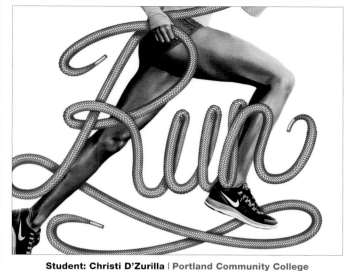

Student: Christi D'Zurilla | Portland Community College

INSTRUCTOR EZSTER CLARK

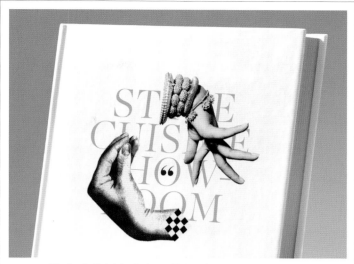

Student: Patricia Catangui | Academy of Art University

INSTRUCTORS DONG-JOO PARK, SEUNG-MIN HAN

Student: So Ra Jeong | Hansung University of Design & Art Institute

INSTRUCTOR HANK RICHARDSON

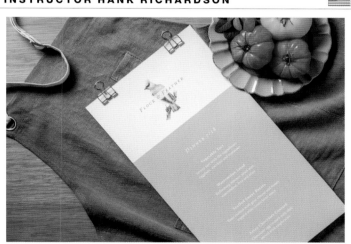

Student: Savannah Colbert | Portfolio Center

INSTRUCTOR HANK RICHARDSON

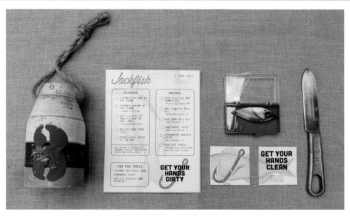

Student: Laura Capps | Portfolio Center

INSTRUCTOR HANK RICHARDSON

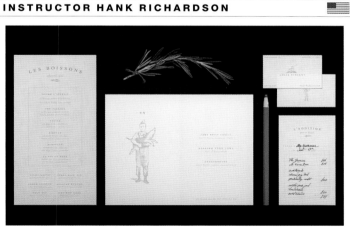

Student: Carter Tindall | Portfolio Center

INST. JON NEWMAN

A B C D E F
G H I J K L
M N O P Q
R S T U V
W X Y Z

Student: Zuheng Yin
School of Visual Arts

INSTS. FELICIA FERRONE, SHARON OIGA

graph

a b c d e f g h i j
k l m n o p q r s t
u v w x y z

**Students: Jennifer Brott, William Dutton,
Hyunji Kim, Kenneth Randall, Judith Pauly, Diana
Mazurok, Elissa Lepoire, Christopher Fanelli**
University of Illinois at Chicago

INST. OLGA MEZHIBOVSKAYA

abcdefg
hijklmn
oprqstu
vwxyz

Student: Natalia Drobinina
School of Visual Arts

INST. RICHARD POULIN

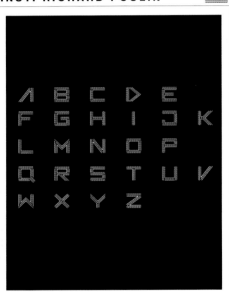

Student: Elaine Chng | School of Visual Arts

INST. IRINA LEE

BASTION

ABCDEFGH
IJKLMNOPQ
RSTUVWXYZ

Student: Joe Haddad | School of Visual Arts

INST. OLGA MEZHIBOVSKAYA

abcdef
ghijklm
nopqrst
uvwxyz

ophelia Typeface designed by *darius wang*

Student: Darius Wang Dazhi | SVA

INST. OLGA MEZHIBOVSKAYA

abcde
fghijk
lmnop
qrstu
vwxyz

Student: Dongjun Choi | School of Visual Arts

INST. OLGA MEZHIBOVSKAYA

abcdefg
hijklmn
opqrstu
vwxyz

Student: Uchan Kim | School of Visual Arts

INST. OLGA MEZHIBOVSKAYA

abcde
fghijk
lmnop
qrstu
vwxyz

Student: Daye Kim | School of Visual Arts

Instructor: Lynda Green | **Art Institute of Atlanta** | **Provost & Dean of Academic Affairs: Dr. Linda Wood** | **Page: 199**

Biography: Lynda Green is an Atlanta-based advertising photographer specializing in people, locations, digital, infrared, and underwater. Lynda has a BS degree in Photography from Sam Houston State University, and a BS degree in Zoology from The University of Georgia. She is an adventurer and an explorer whether it is a shark dive, an international location, or shooting out of a helicopter. Being a photographer allows Lynda the opportunity of meeting new and interesting people and to gain knowledge about some of the most unusual things. Her clients include BP Oil, BellSouth, Coca Cola, Delta Airlines, Georgia Pacific, Hilton Hotels, Home Depot, Ritz Carlton, UPS.

Advice: My advice to students is to always follow your heart and passions. If you do not love what you do, you will never be successful. Always look for things that inspire you and the wings of creativity will make you soar.

Student: KaTiah Byrd | **Art Institute of Atlanta** | **Dean: Dr. Linda Wood, Provost & Dean of Academic Affairs:** | **Page: 199**

Biography: KaTiah Byrd is currently working on her Bachelor's degree in Photography at The Art Institute of Atlanta. While the approach to her education is a commercial one, she has a love for the fine art aspect as well and tries to practice it whenever possible. Working in either approach, she tries to make her focus one of true emotion, enhancing feelings of sadness, gloom, or even excitement. Her goal is to make the viewer identify or question the feelings that are being presented to them. When not photographing KaTiah reads obsessively, writes, and enjoys mediation. She is a proud mother and wife.

PHOTOGRAPHY INSTRUCTOR

Always follow your heart and passions. Look for things that inspire you and the wings of creativity will make you soar.

Lynda Green, *Instructor, Art Institute of Atlanta*

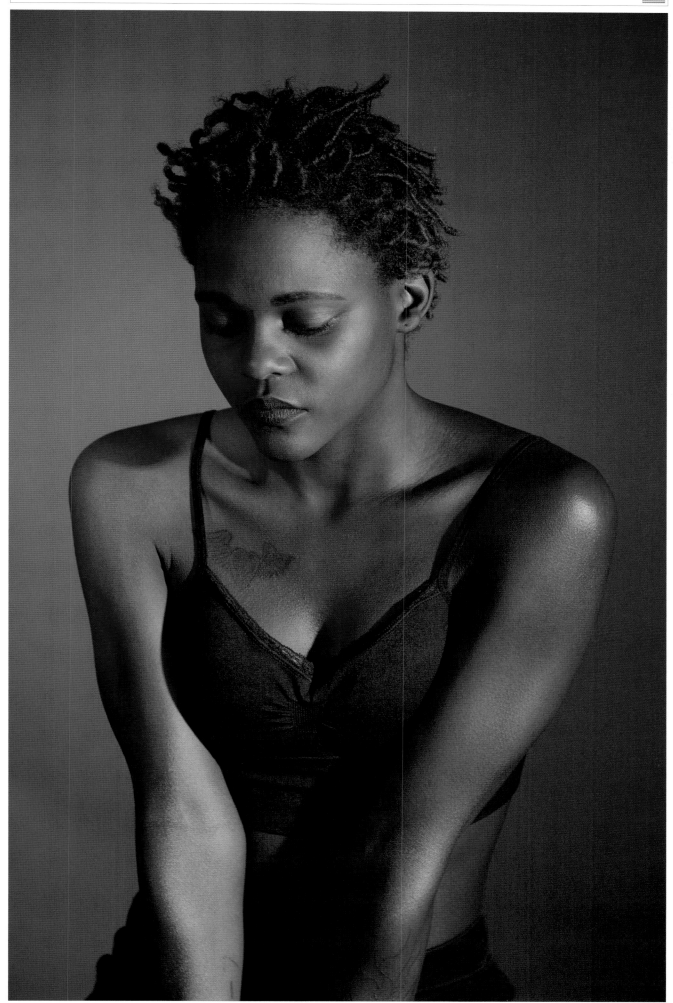

Student: KaTiah Byrd | Art Institute of Atlanta Portraits | Photography

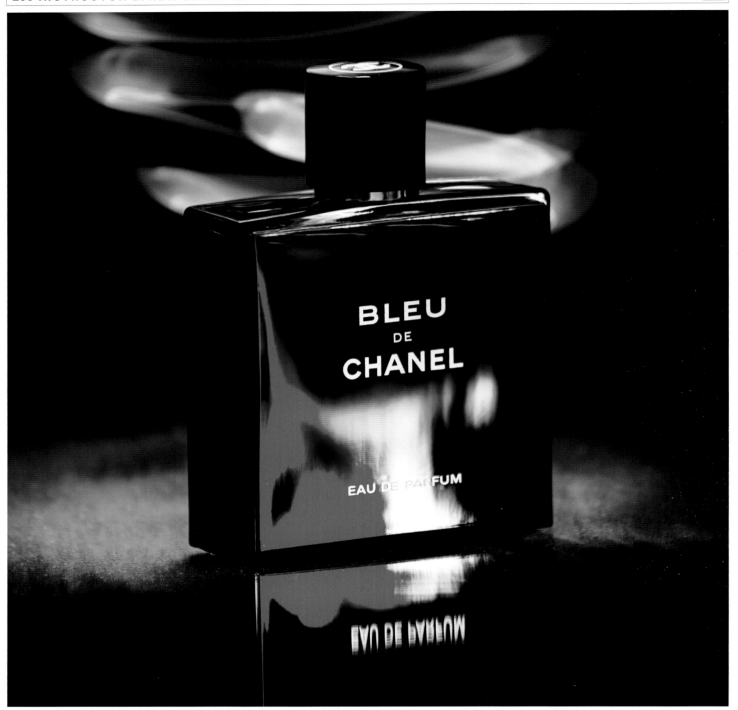

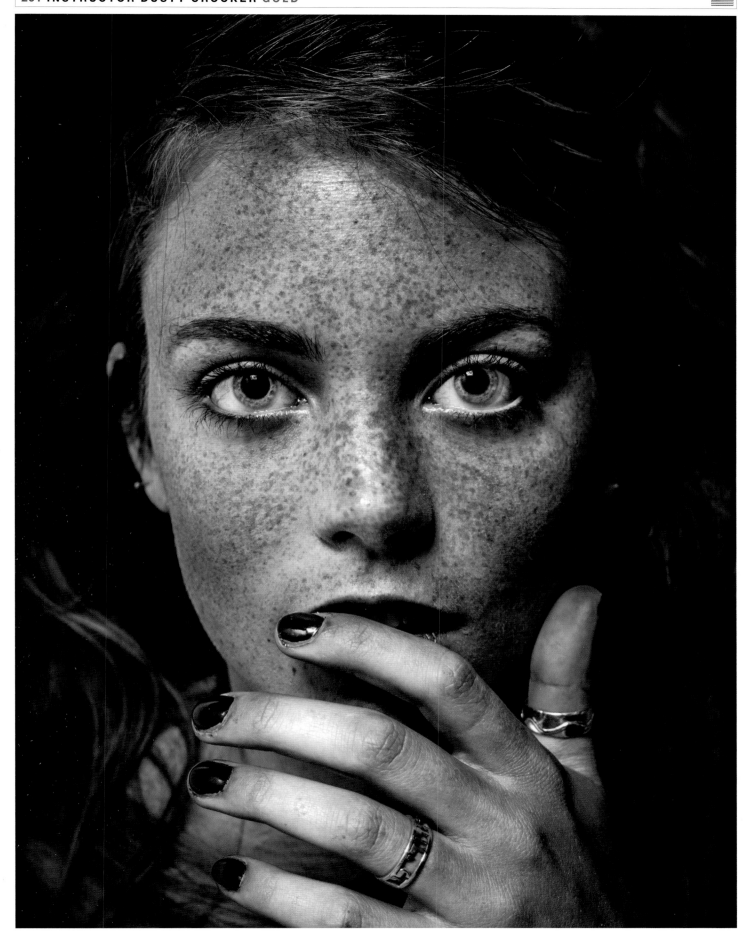

Student: Claire Hargis | Texas Christian University Portraits | Photography

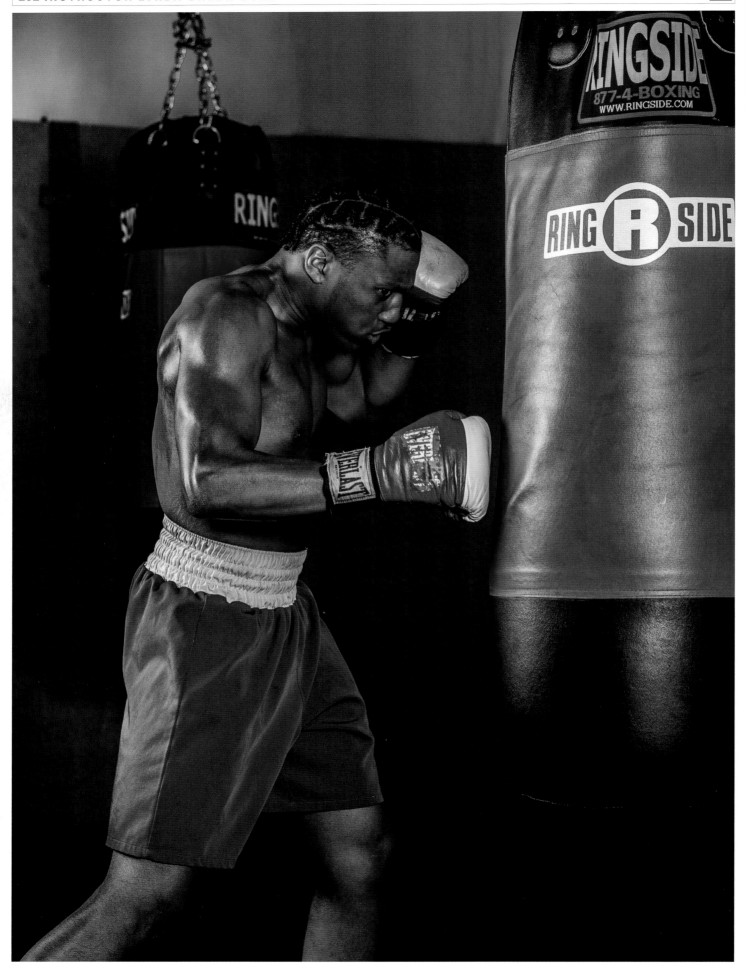

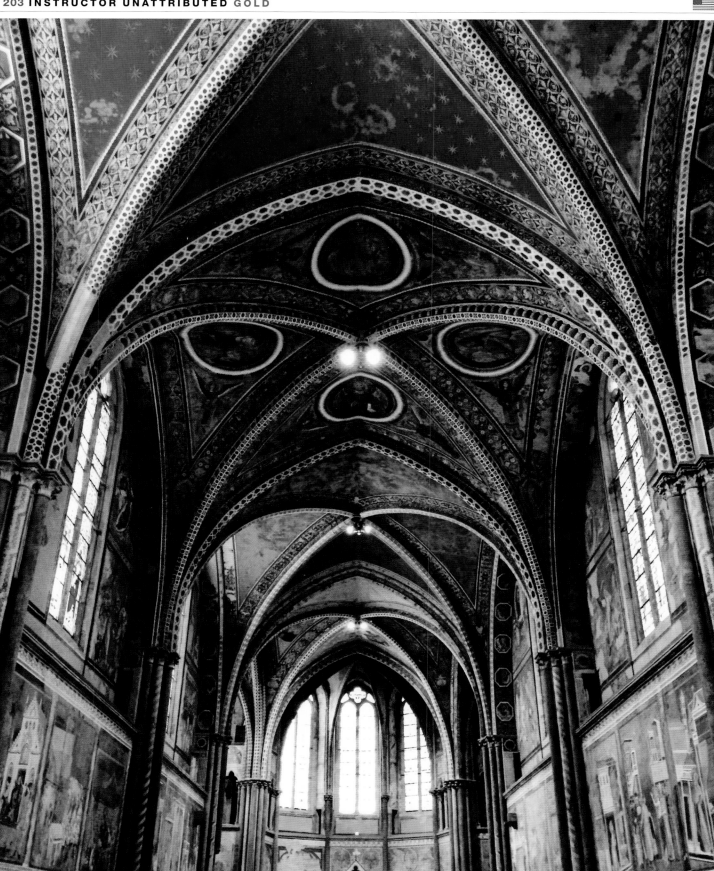

Student: Hridaynag Kooretti | Miami Ad School San Francisco Promotion (Photographers) | Photography

INSTRUCTOR TAYLOR BAREFORD

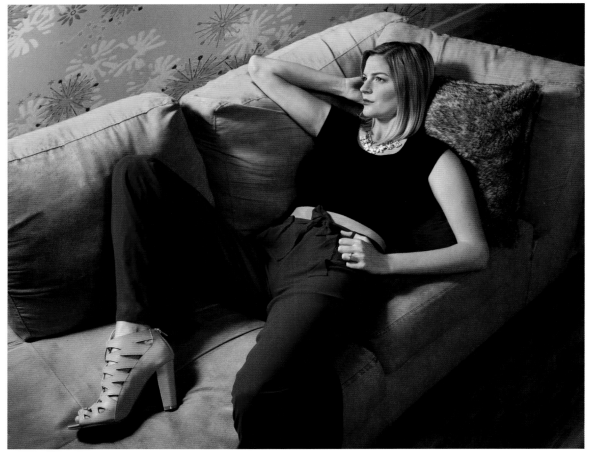

Student: Cassandra Davis | Art Institute of Atlanta

INSTRUCTOR LYNDA GREEN

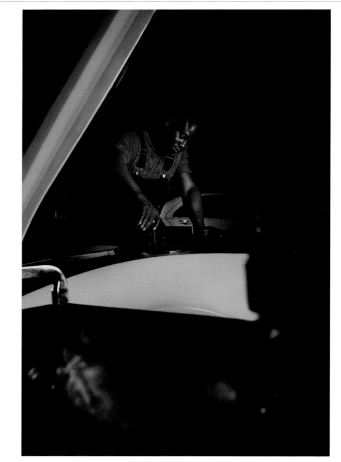

Student: Curtisey Liggins | Art Institute of Atlanta

INSTRUCTOR LYNDA GREEN

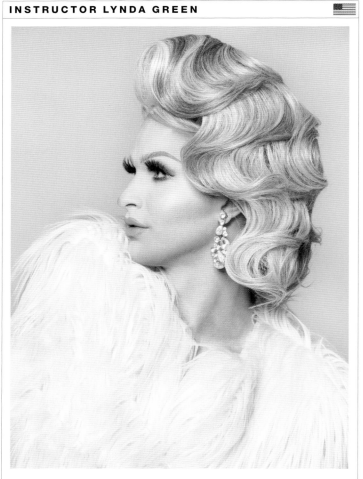

Student: Aboubacar Kante | Art Institute of Atlanta

INSTRUCTOR GINNY DIXON

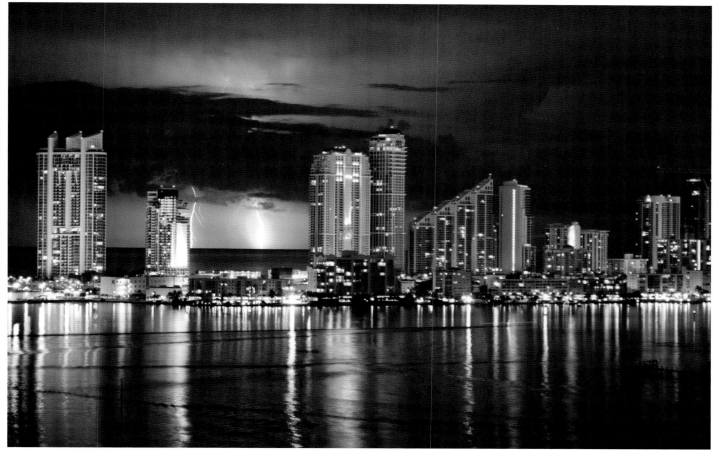

Student: **Ksenia Gaman** | Miami Ad School

INSTRUCTOR DUSTY CROCKER

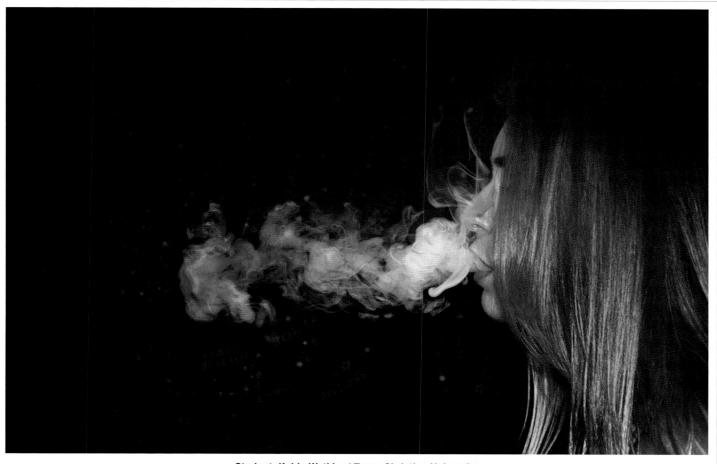

Student: **Kahla Watkins** | Texas Christian University

INSTRUCTOR NICOLE HA JACOBS-LICHT

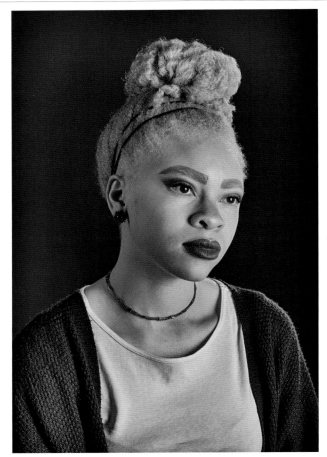

Student: KaTiah Byrd | Art Institute of Atlanta

INSTRUCTOR LYNDA GREEN

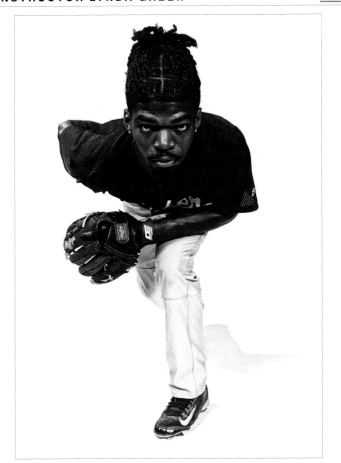

Student: Curtisey Liggins | Art Institute of Atlanta

INSTRUCTOR TAYLOR BAREFORD

Student: Ashley King | Art Institute of Atlanta

FILM INSTRUCTORS

Persevere. Sometimes you need to go back to the research, reframe the questions you are asking, or find new inspiration to rejuvenate your approach. Don't ever give up.

Kelly Holohan, *Instructor, Temple University*

Motion design is the crucial link between graphic design and technology. It can take you wherever you dream.

Ori Kleiner, *Head of Motion Graphics area of study at School of Visual Arts Design and Advertising Departments*

Frank Anselmo | School of Visual Arts | Dean: Richard Wilde | Pages: **210, 215** | See page 14 for his biography and advice.

Ori Kleiner | School of Visual Arts | Dean: Richard Wilde | Pages: **211, 212**
Biography: Ori Kleiner is the head of the Motion Graphics area of study at School of Visual Arts Design and Advertising Departments.
Advice: Motion design is the crucial link between graphic design and technology; it transforms static design into interactive experience. It can take you wherever you dream.

Hye Sung Park | School of Visual Arts | Dean: Richard Wilde | Pages: **213, 214**
Biography: Hye Sung is an international award-winning commercial/film animation director based in New York. For a decade, he has spent his time creating numerous graphic design/motion projects for some of the world's leading brands, such as Nintendo, HTC, Verizon, Fanta, Nestle, Bank of America, McDonald's, and Cartoon Network.
Advice: Everyone has their own strengths. You've learned design principles in school, and now it's time for you to take a journey to find your own specialties. Art is subjective. You don't have to compare yourselves to others. Keep trying to look for your own color, then, you will eventually find yourselves loving what you do."

Myoung Zin Won | Eulji University | Page: **214**
Biography: Professor of Medical Public Visual Design, Eulji University. Bachelor's degree in Visual Design, Hongik University; Master's degree in The Industrial Arts University, Hongik University; Doctor's degree in Visual Design, Hongik University; Creative Direstor's activities for 20 years at CheilWorldwide, Leoburnett, TBWA, Innocean; 2002 Cannes Festival Silver Lions; 2002 New York Festival Gold Medal, Other international and domestic awards; Visual Thinking, Visual Curation research.

Kelly Holohan | Temple University | Dean of Tyler School of Art: Susan E. Cahan | Page: **216**
Biography: Kelly Holohan is the principal of Holohan Design and heads both the BFA and MFA Program in Graphic & Interactive Design at Tyler School of Art, Temple University. Prior to moving to Philadelphia, she worked in NYC as Senior Designer at Bernhardt Fudyma Design Group and taught a class at School of Visual Arts. ■ Her work has been featured in many publications and exhibitions. Her solo exhibition, "Sorry We're Closed" featured posters that address LGBTQ rights around the world. The Herskovits Library of African Studies at Northwestern University includes her work in their collection.
Advice: Extend your research. Move beyond google searches. Go to the library, talk to people, design a survey to collect information, or use empathy to shadow another person's experience. ■ Slow Down. Make sure to build in time to evaluate your work. When you are rushing to complete a project there is not time to reflect and critically evaluate your work. ■ Persevere. Sometimes you need to go back to the research, reframe the questions you are asking, or find new inspiration to rejuvenate your approach. Don't give up.

Mark Smith | Miami Ad School | Page: **217**
Biography: Art, Commerce, and Education. These are the three constant themes in my career. Art has always been the primary driver in my life. From an early age it was the focus of my passion and discipline. I have worked as an Illustrator, an Animator, a Fine Artist, a Designer, Art Director, and Creative Director over the past 20+ years. ■ My passion for the Arts, coupled with a strong natural predisposition toward entrepreneurial activities lead me to start several businesses over my career. I have built several companies from start-up level to multi-million dollar enterprises and overseen the strategic growth of established firms. I have learned over the years that my expertise is best utilized creating new ventures and bringing the full force of innovation practices to bear on older ones. To put it simply, I am an agent of change. ■ The third category of Education has been a constant in my career. Early on, I learned the value of a great teacher or mentor's influence on my life and career. I have always taught or mentored throughout my entire career including institutions such as Parsons School of Design, Pratt Institute, and Miami Ad School.

Jerrod New & Marcos Lawson | Miami Ad School | Page: **218**
Biography: Marcos Lawson draws from a 16-year international career, during which he has worked alongside iconic global brands like Ford, Adidas, Reebok, Johnnie Walker, Smirnoff, Sony, Shell and Coca-Cola, in London, Europe, Latin America, and the USA. In that time, he has created campaigns that have overcome virtually every kind of marketing challenge, built outstanding creative departments, fostered cultures of collaboration and creative excellence, forged enduring client relationships, and won several awards in the process.
Advice: Remember that none of us really know what we're doing––especially Creative Directors.

Jack Mariucci & Robert Mackall | School of Visual Arts | Page: **219** | See page 14 for their biographies and advice.

Ji Yeon Kim | School of Visual Arts | Dean: Richard Wilde | Pages: **210, 215**
Biography: Kate Ji-Yeon Kim is a student in BFA Advertising at SVA since 2013. Born in South Korea and raised in Australia and New Zealand, Kate moved to NY to pursue her dream as a creative director. She has been selected into the "Unconventioanl Advertising" program at SVA, which has earned global status as "The Most Awarded Advertising Class in History" for the past two years.

Sookhyoun Kim | School of Visual Arts | Dean: Richard Wilde | Pages: **210, 215**
Biography: Born in South Korea, Sookhyoun (Hailey) Kim moved to the Philippines and attended International School of Manila, where she got to embrace cultural diversity. She established her foundation of visual arts at Idyllwild Arts Academy in California. From there, she found passion for communication through art and decided to major in Advertising at SVA in NY, building up her portfolio with print and digital ads, commercials, and unconventional ads. She is currently working toward her career path as an art director.

Jin Jeon | School of Visual Arts | Dean: Richard Wilde | Page: **211**
Biography: Jin Jeon is a creative designer and developer with a multidisciplinary role for Branding, Interactive (UX / UI), Motion (2D / 3D), and Front-End Development. After graduating with honors from SVA, Jin has been working on a wide variety of projects with a number of clients like Google, Amazon, Spotify, Viacom, Clio Awards, and more.

Luke Guyer | School of Visual Arts | Dean: Richard Wilde | Page: **212**
Biography: Luke Guyer is a designer and animator focusing on 3D design currently based in New York. A recent graduate from the School of Visual Arts design program, he considers himself a 3D designer and animator that applies a strong foundation of graphic design to each project. Design oriented 3D projects are his focus. He is currently working as the Senior Motion Designer at DE-YAN in New York.

Siling Zhao | School of Visual Arts | Dean: Richard Wilde | Page: **213**
Biography: Siling Zhao moved from China to the US to study at SVA. After two years' education in graphic design, he went on to major in motion graphics. Passionate about film and music, the choice is a natural fit. He now lives in NY, freelancing and working on his personal projects. Before devoting his work to design, Siling tried out different options in life. He graduated from one of China's top ten universities with a degree in Japanese language and literature, played in a band as a drummer, and worked at China Tobacco for two years.

Hyun Cheol An | Eulji University | Pages: **214**
Biography: Multipotentialite, multl-functional human 'Hyun Cheol An.' ■ Originally, he was a student who studied IT. ■ Now, he studies design and marketing with a passion for advertising and ideas, and is about to graduate. He's not at the top of his game yet. ■ However, he can do many things including copywriting, planning, and design. ■ From now on, he will learn more knowledge and skills such as music, carpentry, and others. ■ It's going to be great creativity to bring those things together and make people better.

Sun Young In | Eulji University | Pages: **214**
Biography: Sunyoung In is a senior majoring in 'Public Relationship & Visual Design' so that she could learn both PR and Design. ■ Since she was in high school, she had a lot of interest in minor problems which were very close to her. ■ It was such an excellent experience for her. Because, she thinks that she helped to inform how to recycle 'old clothes' correctly with things that she learned in her major. ■ With this valuable experience, she will try hard to make a better world in the future.

Krissy Beck | Temple University | Dean: Susan E. Cahan, Dean of Tyler School of Art | Pages: **216**
Biography: Krissy Beck's versatile graphic design works narrate stories across a variety of forms, places, and societies. Her personal connections to the development and exploration of each subject is a story of creation unto itself. Anchored in realities that range from playful to emotional, her works are engaging moments of interactivity that are relatable and can be shared. ■ Krissy received a B.S. in Graphic Design from Drexel University in 2013 and an M.F.A. in Graphic and Interactive Design from Tyler School of Art in 2017.

Simon Dekoninck | Miami Ad School | Pages: **217**
Biography: Simon Dekoninck is a creative born and raised in Belgium. After graduating with a Bachelor's degree in Business Management and Marketing, he was determined to pursue a creative career. He moved to Miami, Florida to start the Art Director's program at Miami Ad School. Here he had the opportunity to work at international agencies and compete in several award shows. In his spare time, he shows great interest in anything that involves design and videography.

Mariam Elias | Miami Ad School | Pages: **218**
Biography: Mariam Elias is an art director with a master's degree from Miami AD School. She has previously worked as a copywriter, scriptwriter and an art reviewer before she shifted her role as a creative. Besides advertising, she directed a short film entitled "Drawing On A Nude Body" which was reviewed in Frieze art magazine and won best directing award at Cairo's National Film Festival. She has also self-published a book about young artists entitled "Thawret El Loool."

Nellie Santee | Miami Ad School | Pages: **218**
Biography: She is a copywriter with a passion for disruptive ideas. She has a Bachelor's and Master's in Communications from Brazil, where she grew up, and now she's finishing a Portfolio Degree at Miami Ad School in Miami. What she loves about advertising is being able to combine different insights and give them to an audience in an interesting way. Sometimes it's not about reinventing the wheel, just showing it in a different enough light to spark the interest of people that could benefit from that product, brand, or idea.

Jisoo Hong | School of Visual Arts | Dean: Richard Wilde | Pages: **219**
Biography: Jisoo Hong is an art director based in New York. She has won Future Lions, One Show, and Graphis awards. Jisoo was published in AdAge, Adweek, PSFK, Adobo Magazine, Creativepool, Creativity Online, AKQA, and etc. Jisoo has a BFA in Advertising from School of Visual Arts. Jisoo enjoys being creative and different.

Ji Hoon Kim | School of Visual Arts | Dean: Richard Wilde | Pages: **219**
Biography: He is a a Korean-born creative based in New York, currently finishing his last year at School of Visual Arts. He likes to do art direction, design, and sometimes copywriting. He's had opportunities to work with clients like Samsung Galaxy, Chevrolet, and K-pop boy band 'Winner' when working at agencies in Korea. He's won several awards, such as Cannes Future Lions and One Show.

Minyoung Park | School of Visual Arts | Dean: Richard Wilde | Pages: **219**
Biography: She's a senior student majoring in Advertising at School of Visual Arts in New York. She has internship experience at Y&R New York as a creative intern. She has won Future Lions, two silver pencils, and three merits from One Show Young Ones and honorable mention from One Show Young Ones Client Pitch in 2017. She likes taking photos with her iPhone, digital, film, and instant cameras. I also draw and doodle. I love watching movies, gallery hopping, and traveling around where I find inspiration.

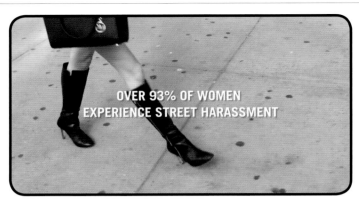

OVER 93% OF WOMEN
EXPERIENCE STREET HARASSMENT

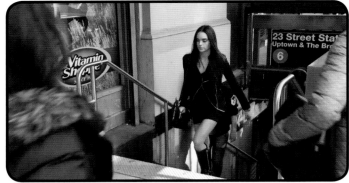

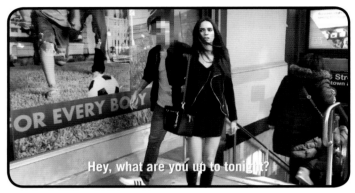

Hey, what are you up to tonight?

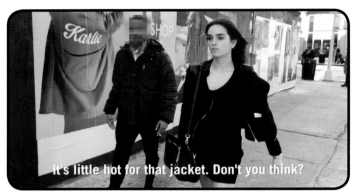

It's little hot for that jacket. Don't you think?

FIGHT BACK AGAINST HARASSMENT.

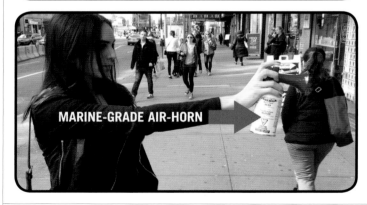

MARINE-GRADE AIR-HORN

hollaback!

www.ihollaback.org

Students: Ji Yeon Kim, Sookhyoun Kim | School of Visual Arts

Student: Jin Jeon | School of Visual Arts

Student: Luke Guyer | School of Visual Arts

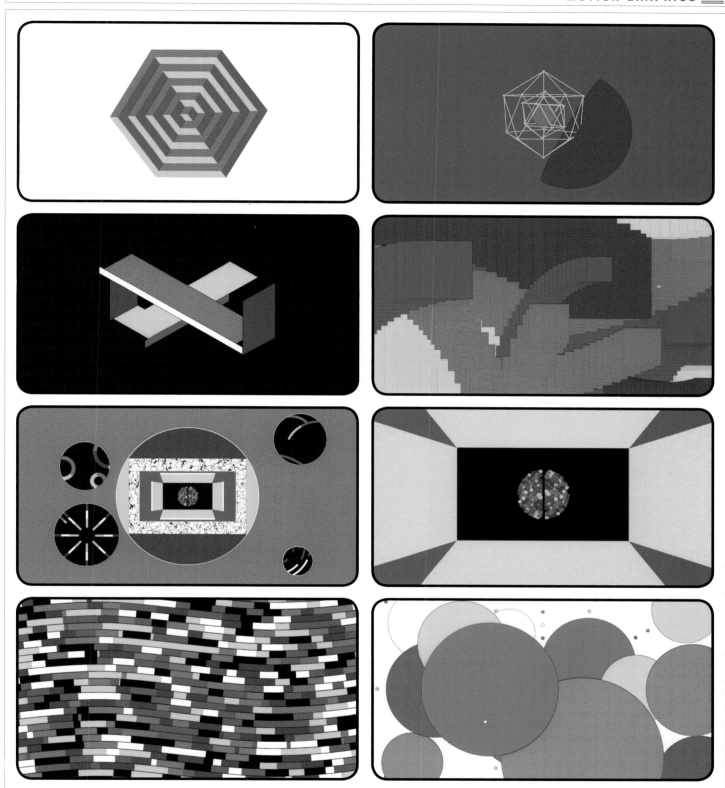

Student: Siling Zhao | School of Visual Arts

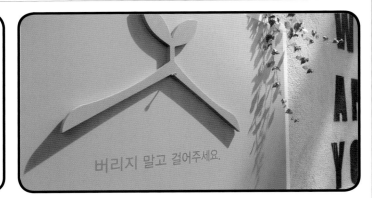

OTCAN
Good Hanger Campaign

버리지 말고 걸어주세요.

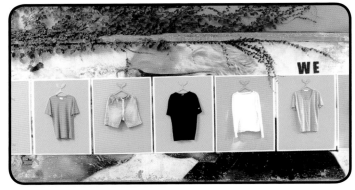

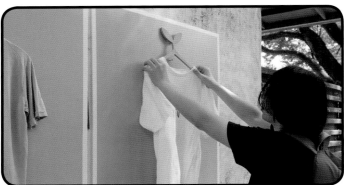

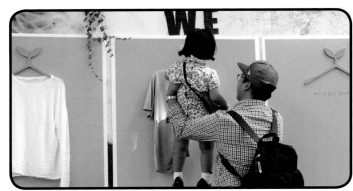

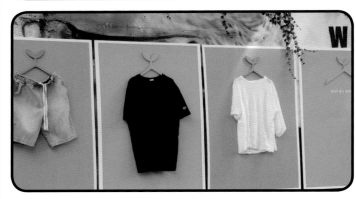

당신의 '헌 옷'이
누군가의 '새 옷'이 됩니다.

Students: Hyun Cheol An, Sun Young In | Eulji University

When fur coats are lifted in this pop-up shop, motion sensors trigger speakers in hangers.

Students: Ji Yeon Kim, Sookhyoun Kim | School of Visual Arts

Student: Krissy Beck | Temple University

Student: Simon Dekoninck | Miami Ad School

Students: Mariam Elias, Nellie Santee | Miami Ad School

Students: Jisoo Hong, Ji Hoon Kim, Minyoung Park | School of Visual Arts

INSTRUCTOR ABBY GUIDO EDUCATIONAL

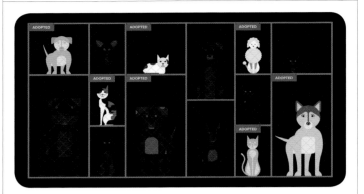

Student: Krissy Beck | Temple University

INSTRUCTOR RYAN RUSSELL FILM TITLES

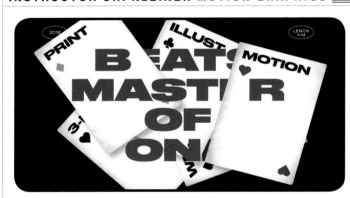

Student: William King | Pennsylvania State University

INSTRUCTOR RYAN RUSSELL FILM TITLES

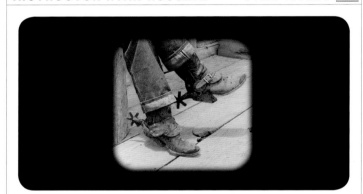

Student: Deric Silva | Pennsylvania State University

INSTRUCTOR ORI KLEINER MOTION GRAPHICS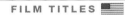

Student: Lemon Sanuk Kim | School of Visual Arts

INSTRUCTOR HYE SUNG PARK MOTION GRAPHICS

Student: Seong Yeop Sim | School of Visual Arts

INSTRUCTOR ORI KLEINER MOTION GRAPHICS

Student: Sung Yoon Lee | School of Visual Arts

INSTRUCTOR HYE SUNG PARK MOTION GRAPHICS

Student: Yonju Kim | School of Visual Arts

INSTRUCTOR DAVID CABESTRANY MOTION GRAPHICS

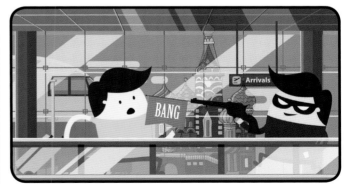

Student: Ksenia Gaman | Miami Ad School

INSTRUCTOR ORI KLEINER MOTION GRAPHICS

Student: Jimin Lee | School of Visual Arts

INSTRUCTOR HYE SUNG PARK MOTION GRAPHICS

Student: Jue Gong | School of Visual Arts

INSTRUCTOR ORI KLEINER MOTION GRAPHICS

Student: Young Gyun Woo | School of Visual Arts

INSTRUCTOR HYE SUNG PARK MOTION GRAPHICS

Student: Chusheng Patrick Chen | School of Visual Arts

INSTRUCTOR ORI KLEINER MOTION GRAPHICS 🇺🇸

Student: Lemon Sanuk Kim | School of Visual Arts

INSTRUCTOR HYE SUNG PARK MOTION GRAPHICS 🇺🇸

Student: Rachel Park Goto | School of Visual Arts

INSTRUCTOR HYE SUNG PARK MOTION GRAPHICS 🇺🇸

Student: Haelee You | School of Visual Arts

INSTRUCTOR HYE SUNG PARK MOTION GRAPHICS 🇺🇸

Student: Han Sol Ryoo | School of Visual Arts

Student: Ken Kwong | School of Visual Arts

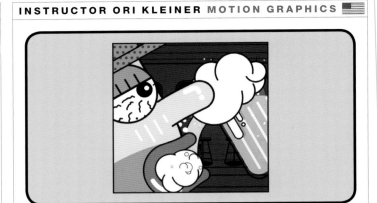

Student: Seong Yeop Sim | School of Visual Arts

Student: Theo Guillin | School of Visual Arts

Student: Chenyou Philip Lee | School of Visual Arts

INSTRUCTOR ORI KLEINER MOTION GRAPHICS

Student: Katherine Murnion | School of Visual Arts

INSTRUCTOR HYE SUNG PARK MOTION GRAPHICS

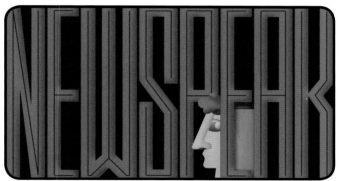

Student: Weixi Zeng | School of Visual Arts

INSTRUCTOR LEE WHITMARSH MOTION GRAPHICS

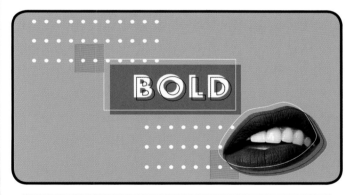

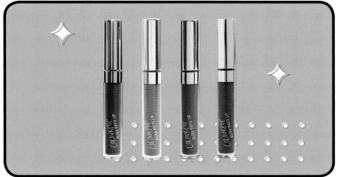

Student: Aliana Layug | Texas A&M University Commerce

INSTRUCTOR ORI KLEINER MOTION GRAPHICS

Student: Young Gyun Woo | School of Visual Arts

INSTRUCTOR ORI KLEINER MOTION GRAPHICS

Student: Young Gyun Woo | School of Visual Arts

INSTRUCTOR JUNGIN YUN MOTION GRAPHICS

Student: Yoon Sun Choi | School of Visual Arts

INSTRUCTOR ORI KLEINER MOTION GRAPHICS

Student: Hsiaopu Chang | School of Visual Arts

INSTRUCTOR ORI KLEINER MOTION GRAPHICS

Student: Hyejin Kim | School of Visual Arts

INSTRUCTOR ORI KLEINER MOTION GRAPHICS

Student: Jimin Lee | School of Visual Arts

INSTRUCTOR HYE SUNG PARK MOTION GRAPHICS

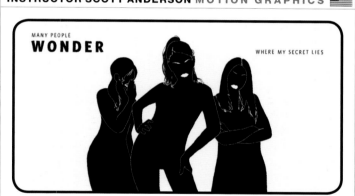

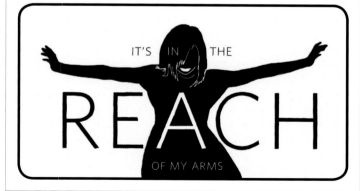

Student: Jue Gong | School of Visual Arts

INSTRUCTOR HYE SUNG PARK MOTION GRAPHICS

Student: Siling Zhao | School of Visual Arts

INSTRUCTOR SCOTT ANDERSON MOTION GRAPHICS

Student: Majesty Christian | Texas Christian University

INSTRUCTOR ORI KLEINER MOTION GRAPHICS

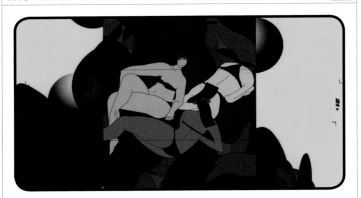

Student: Jane Inyeong Cho | **School of Visual Arts**

INSTRUCTOR MARK SMITH PROMOTIONAL

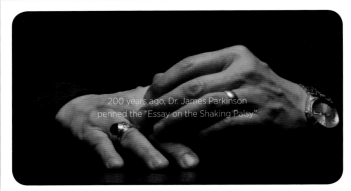

Student: Gian Marco Chavez | **Miami Ad School**

INSTRUCTOR FRANK ANSELMO PROMOTIONAL

Students: Mitchell Diercks, Jasper Vierboom | **School of Visual Arts**

INSTRUCTOR UNATTRIBUTED PROMOTIONAL

Students: Rohit John, Deep Chhabria, Dhanush Paramesh, Adithya Venugopal | **Miami Ad School, Mumbai**

INSTRUCTOR FRANK ANSELMO PROMOTIONAL

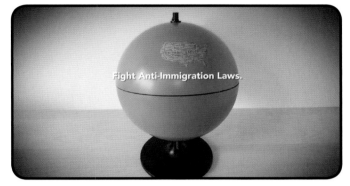

Students: Jake Blankenship, Yifei You | School of Visual Arts

INSTRUCTOR HOON-DONG CHUNG PROMOTIONAL

Students: Doohee Hong, Daeun Lee, Minhee Choi, Hyeri Kim
Dankook University

INSTRUCTOR UNATTRIBUTED PROMOTIONAL

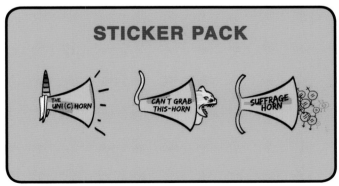

Student: Alejandra Chavez

INSTRUCTOR FRANK ANSELMO PROMOTIONAL

Students: Hae Ryeon Lee, Jihye Han | School of Visual Arts

INSTRUCTOR MARK SMITH TV/WEB COMMERCIALS

Student: Jon Gruber I Miami Ad School

INST. FRANK ANSELMO TV/WEB COMMERCIALS

Student: Students: Jens Marklund, Jack Welles, Jisoo Hong, Minyoung Park I School of Visual Arts

INST. ZORAYMA GUEVARA TV/WEB COMMERCIALS

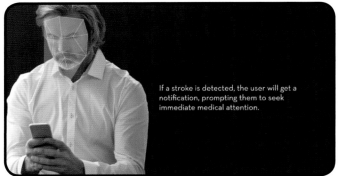

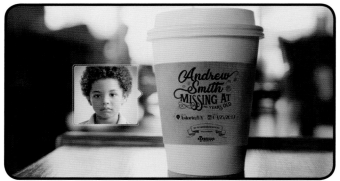

Students: Lorran Schoechet Gurman, Thomaz Jefferson
Miami Ad School New York / Miami Ad School São Paulo

INSTRUCTOR CHRIS DUMAS TV/WEB COMMERCIALS

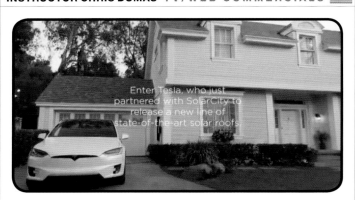

Students: Matt Tennenbaum, Jon Gruber I Miami Ad School

INST. FRANK ANSELMO TV/WEB COMMERCIALS

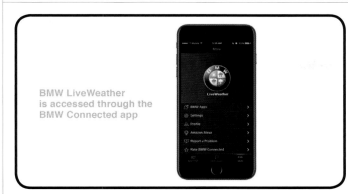

Students: Josi Matson, Seona Kim | School of Visual Arts

INSTRUCTOR JAKE REILLY TV/WEB COMMERCIALS

Student: Carolina Latorraca | Miami Ad School

INST. FRANK ANSELMO TV/WEB COMMERCIALS

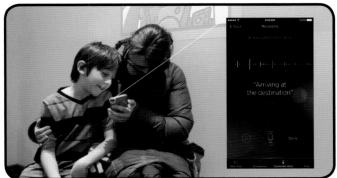

Students: Aiden Yang, Jiyeong Kim, Minyoung Park
School of Visual Arts

INST. FRANK ANSELMO TV/WEB COMMERCIALS

Students: Hunwoo Choi, Ein Jung | School of Visual Arts

INSTRUCTOR RYAN RUSSELL

Student: **Emily Cheng** | Pennsylvania State University

INSTRUCTOR RYAN RUSSELL

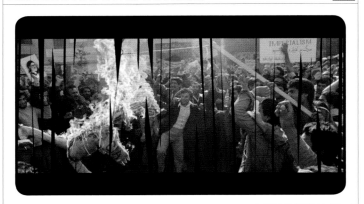

Student: **Ashley Card** | Pennsylvania State University

INSTRUCTOR ORI KLEINER

Student: **Axel Lindmarker** | School of Visual Arts

INSTRUCTOR UNATTRIBUTED

Student: **Jae Young Jang** | School of Visual Arts

INSTRUCTOR ORI KLEINER

Student: **Yae Nah Oh** | School of Visual Arts

INSTRUCTOR ORI KLEINER

Student: **Sohyun Lee** | School of Visual Arts

INSTRUCTOR ORI KLEINER

Student: **Weixi Zeng** | School of Visual Arts

INSTRUCTOR UNATTRIBUTED

Student: **Seongjin Yoon** | School of Visual Arts

INSTRUCTOR ORI KLEINER

Student: Jae Young Jang | School of Visual Arts

INSTRUCTOR HYE SUNG PARK

Student: Rachel Park Goto | School of Visual Arts

INSTRUCTOR VINCE SIDWELL

Student: Kyler Jones | Texas A&M University Commerce

INSTRUCTOR ORI KLEINER

Student: Kohki Kobori | School of Visual Arts

INSTRUCTOR ORI KLEINER

Student: Jonghoon Kang | School of Visual Arts

INSTRUCTOR ORI KLEINER

Student: Jae Young Jang | School of Visual Arts

INSTRUCTOR ORI KLEINER

Student: Jae Young Jang | School of Visual Arts

INSTRUCTOR GERALD SOTO

Student: Ye Hyun Lee | School of Visual Arts

INSTRUCTOR KRISTIN SOMMESE

Studs.: Nyomi Warren, Sean Merk, Emily Cheng, Stefan Pelikan, Rob Pitrovich | PSU

INSTRUCTORS ORI KLEINER, GERALD SOTO

Student: Ye Hyun Lee | School of Visual Arts

INSTRUCTOR HYE SUNG PARK

Student: Weixi Zeng | School of Visual Arts

INSTRUCTOR ORI KLEINER

Student: Ryoko Wakayama | School of Visual Arts

INSTRUCTOR RYAN RUSSELL

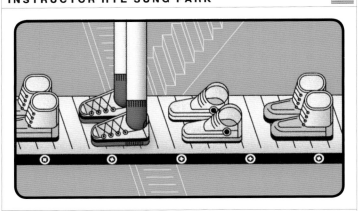

Student: Addie Ruston | Pennsylvania State University

INSTRUCTOR RYAN RUSSELL

Student: Turner Blashford | Pennsylvania State University

INSTRUCTOR E SLODY

Students: Diana Friedman, Jacob Altman | Miami Ad School

INSTRUCTOR FRANK ANSELMO

Students: Rogier van der Galiën, Robin van Eijk | School of Visual Arts

INSTRUCTOR MARK SMITH

Students: Hampus Elfström, Thomas Nguyen | Miami Ad School

INSTRUCTOR ZORAYMA GUEVARA

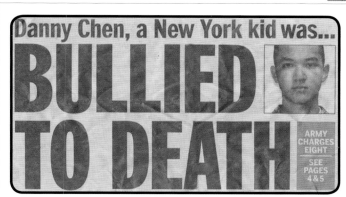

Student: Deep Chhabria | Miami Ad School

INSTRUCTOR LARRY GORDON

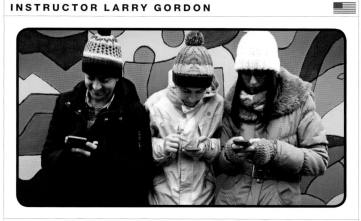

Student: Emily Kaufman | Miami Ad School New York

INSTRUCTOR FRANK ANSELMO

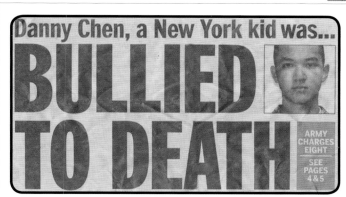

Students: Jaehyun Cho, Nobuaki Nogamoto | School of Visual Arts

INSTRUCTOR YVONNE CAO

Student: Anika Carlson | Texas Christian University

INSTRUCTOR ABBY GUIDO

Student: Leilei Lu | Temple University

INSTRUCTORS OLGA MEZHIBOVSKAYA, NADA RAY

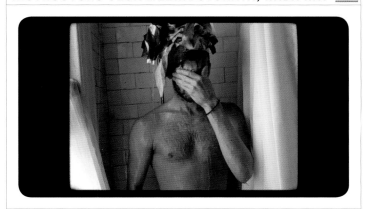

Student: Tim Trautmann | School of Visual Arts

INSTRUCTORS OLGA MEZHIBOVSKAYA, NADA RAY

Student: Koki Kobori | School of Visual Arts

INSTRUCTORS OLGA MEZHIBOVSKAYA, NADA RAY 🇺🇸

Student: Koki Kobori | School of Visual Arts

INSTRUCTORS OLGA MEZHIBOVSKAYA, NADA RAY 🇺🇸

Student: Woojin Chung | School of Visual Arts

INSTRUCTORS OLGA MEZHIBOVSKAYA, NADA RAY 🇺🇸

Student: Jonathan Frias | School of Visual Arts

INSTRUCTOR NIKLAS FRINGS-RUPP 🇩🇪

Students: Kushal Birari, Stefan Rotaru | Miami Ad School Europe

INSTRUCTOR BRENT WELDON 🇺🇸

Students: Emily Kaufman, Dana Goldstein | Miami Ad School New York

INSTRUCTOR BART CLEVELAND 🇺🇸

Student: Chris Ganz | Job Propulsion Lab

INSTRUCTOR MARK SMITH 🇺🇸

It only took you 5 seconds to read it.

Student: Jon Gruber | Miami Ad School

INSTRUCTOR MARK SMITH 🇺🇸

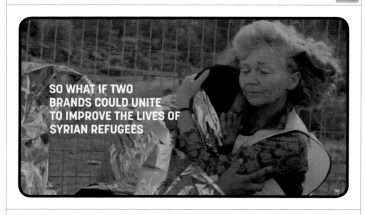

SO WHAT IF TWO BRANDS COULD UNITE TO IMPROVE THE LIVES OF SYRIAN REFUGEES

Students: Hampus Elfström, Thomas Nguyen | Miami Ad School

ADVERTISING PLATINUM WINNERS:

16 THE BMW COEXISTS WITH NATURE | School: Hansung University of Design & Art Institute | Instructors/Professors: Dong-Joo Park, Seung-Min Han | Student: Hyuk-June Jang
Assignment: The poster concept was created to deliver the message "BMW engine coexists with nature." At present, more people are suffering from fine dust. In addition, environmental prob lems are becoming serious. I hope that this engine will enable people and nature to live without any pain.

17 CHILD SOLDIER BILLBOARD | School: Syracuse University
Instructor/Professor: Mel White | Student: Nicole Framm
Assignment: Create an outdoor advertisement that raises awareness for Child Soldier International.
Approach: The innocence of childhood is something that is worth protecting. Unfortunately, for the 300,000 children who are currently being forced to participate in wars, violence has replaced the innocence in their lives.
Results: Designed as an open three-dimensional crayon box with bullets protruding from the top. I was aiming to visibly illustrate an innocent part of childhood being replaced by a horrific object from war.

18 OREO THINS | School: Miami Ad School Europe
Instructor/Professor: Patrik Hartmann | Student: Tania Shevereva
Assignment: Create an advertising campaign for new Oreo Thins.
Approach: For showing how thin the new Oreo Thins are, I made the thinnest ad in the world.

19 TABASCO | School: School of Visual Arts | Instructors/Professors: Jack Mariucci, Robert Mackall | Students: Tamara Yakov, Cindy Hernandez, Steven Guas
Assignment: The strategy for this assignment was "very hot."
Approach: We wanted to express tabasco in the hottest way possible, with literal flames as promotional items.
Results: We designed a lighter and box of matches that would be given out as promotional items from Tabasco.

20 PG A WEAKER AMERICAN | School: School of Visual Arts
Instructor/Professor: Frank Anselmo | Students: Hunwoo Choi, Ein Jung
Approach: Out of the many events that took place in the year 2017, one must acknowledge how the United States was an integral part of it all. This series of print advertisements was inspired by a prompt that read, "speak about the current political climate of America in a visually interesting manner." The given client—Partners Global—were advocates of peace and equality. As this piece was created during the time of the presidential campaign, it addresses the way other countries around the world started to view America. The United States was seen differently by the rest of the world, with Donald Trump at the center of discussion, and all the talk in politics and the various beliefs he stood by and advocated. In reaction to this phenomena, this print campaign revolved around a new image of America as perceived by many outside and inside of the country itself. The three images are visual metaphors of the diminishing power and strength of the United States and its 'upheld' belief in freedom. The odd proportions of the different symbols that represent liberty are almost humorous, hinting on how the claims made by the infamous presidential candidate were in fact ridiculous to many around the world.

21 PULL IT OUT | School: School of Visual Arts | Instructors/Professors: Jack Mariucci, Robert Mackall | Students: Bowook Yoon, Ha Jung Song, Woo Jae Yoon

22 WEIGHT WATCHERS | School: School of Visual Arts
Instructors/Professors: Jack Mariucci, Robert Mackall | Student: Han Sol Ryoo
Assignment: How to convince people to join the Weight Watchers visually.
Approach: Since people generally gain their weight because of their unhealthy habits, I tried to show the harmful effects of junk foods and lack of exercise.
Results: In this campaign, I combined each part of the body, specifically belly, arm, and hip with images of unhealthy foods such as a hamburger, hotdog, and donut to urge people to eat well-balanced foods and do some exercise with the Weight Watchers to have a healthy body.

23 SQUEEZING PIPE | School: School of Visual Arts | Instructors/Professors: Jack Mariucci, Robert Mackall | Students: Bowook Yoon, Ha Jung Song
Assignment: How can we induce people to exercise?
Approach: We thought that the first thing we needed to do is to catch people's eyes. Instead of explaining why they need to exercise, we approached with simple and strong visual of a muscular arm that squeezing a iron pipe to make people acknowledge the effect of exercising in Gold's Gym instantly while they are on the highway.

24 GOOGLE SEARCH BAR | School: Miami Ad School
Instructor/Professor: Indrajeet Chandrachud | Student: Shinyee Seet
Assignment: The idea is that we have too many things to learn and solve every day and that the Search bar is literally a tool in your toolbox to help you complete your tasks, solve your problems, and answer your questions.
Results: This results in a simple, compelling, and contemporary print ad that showcases the omnipresence of Google Search bar in our modern life.

ADVERTISING GOLD WINNERS:

26 SMARTCAR | School: Syracuse University | Instructor/Professor: Mel White
Student: Alexis Watson | Copywriter: Spencer Kolbert
Assignment: Create a Campaign for Smartcar using the following main message—Smallest car in North America.
Approach: Trying to park an SUV is like trying to park a large animal. Smartcars can park anywhere, even between two large SUVs—or wild animals.
Results: Big Idea: The car made for the urban jungle.

26 VOLKSWAGEN | School: School of Visual Arts | Instructors/Professors: Jack Mariucci, Robert Mackall | Students: Tamara Yakov, Cindy Hernandez, Steven Guas
Assignment: Show that the new Volkswagen mini has a lot of space.
Approach: Making it a "clown car" because there is so much room.
Results: Lots of room is in the car, even if you're unable to see it.

27 CHEVROLET MALIBU | School: Syracuse University | Instructor/Professor: Mel White
Students: Lan Zhang, Mikaela Thomas

28 THE TINIEST OF EMISSIONS | School: Miami Ad School
Instructor/Professor: Unattributed | Student: Emily Kaufman
Assignment: Draw attention to the Nissan Leaf's incredibly low fuel emissions.
Approach: We compared the tiny fuel emissions of the Nissan Leaf to the emissions of tiny animals, highlighting the environmental friendliness of the car.

29 HARLEY DAVIDSON | School: School of Visual Arts
Instructors/Professors: Jack Mariucci, Robert Mackall | Student: Tamara Yakov
Assignment: Harley Davidson helmets.
Approach: Tough bikers have more than just themselves to protect.

29 CLEARASIL | School: School of Visual Arts | Instructors/Professors: Jack Mariucci, Robert Mackall | Students: Tamara Yakov, Steven Guas
Assignment: Clearasil: Clears up your skin
Approach: Skin of a banana is both sensitive and tends to get spots.

30 CLEARASIL | School: School of Visual Arts | Instructors/Professors: Jack Mariucci, Robert Mackall | Students: Han Sol Ryoo, Yae Nah Oh

31 PROPEL: MAKE YOUR WORKOUT LAST THIS LONG (OUTDOOR)
School: Syracuse University | Instructor/Professor: Mel White | Student: Emily McMurray
Assignment: Create an outdoor execution for Propel flavored water. The main idea behind this campaign is that people want to self-improve and increase both the quality and duration of their workouts. Therefore, it is important to show that drinking Propel would achieve both of these goals.
Approach: The outdoor execution displays the copy "Make Your Workout Last This Long" on a route of the NYC subway map.

31 YETI OUTDOOR | School: Miami Ad School | Instructor/Professor: Anna Xiques
Student: Sean Rowland
Assignment: Create a billboard ad that features the YETI logo, a tagline, and a product. Emulate the YETI brand as a badass outdoor/camping brand.
Approach: I felt the ad should emulate what is important to YETI: the great outdoors and helping people get outside. It was important that the ad stood out, and what better way to do that than utilize nature's beauty as the ad itself?
Results: Visually, I felt a mountain is both intimidating and inviting, so I centered a clear billboard on Mount Rainier. The logo and tagline, "Ready When You Are," calls readers to get outside and enjoy the great outdoors.

32 AT&T | School: School of Visual Arts | Instructors/Professors: Jack Mariucci, Robert Mackall | Students: Tamara Yakov, Cindy Hernandez
Assignment: AT&T: Don't text and drive.
Approach: Everyone thinks they'e invincible and can do anything while driving.

32 DRAWING POPPYCOCK | School: Texas State University
Instructor/Professor: Bill Meek | Student: Salena Hu
Assignment: There were a number of students in Professor Bill Meek's class that chose to undertake a graduating political problem. ■ Personally, I had hoped that design and art schools would receive more attention following many kinds of crises that received big spending cuts and little financial attention toward crucial issues. Throughout time, this is one of the reasons we now know why students worldwide receive so little necessary creative education. ■ In proposing a playful challenge for Avaaz, we can make the most of our energy, time, and resources by knowing how to start the topic, rather than how to end it.
Approach: Draw the creative problem as an objective still life, versus subjective hazardous elephants, i.e., code #FF0000, and erupting elephant horns.

33 IT ISN'T A CHOICE | School: Syracuse University | Instructor/Professor: Mel White
Student: Yunxuan Wu
Assignment: GLAAD helps LGBT people fight for equal rights.
Approach: People think being gay is unnatural and want to know why people become LGBT. However, LGBT people can't choose their sexual orientation.

34 MOLESKINE | School: Syracuse University | Instructor/Professor: Kevin O'Neill
Student: Ting Peng
Assignment: Increase awareness and create a brand image. Moleskine is known as the high-quality travel notebook with a sense of luxury. According to research, the study shows that more high-tech CEO and employees prefer to use Moleskine to write their ideas. Therefore, we need to emphasize the concept behind the brand to reinforce its brand image to target audiences.
Approach: To establish the idea that Moleskine inspires ideas and thoughts, we looked for a metaphor, a light bulk that can relate Moleskine to inspiration.

35 PLAYSTATION VR | School: Syracuse University | Instructor/Professor: Mel White
Student: Ting Peng
Assignment: The campaign is to promote brand awareness by establishing the gaming atmosphere of PlayStation VR.
Approach: The campaign emphasizes the imaginary and fantasy world inside the one eyeball to extend the imaginary fantasy world.

35 AWF | School: Syracuse University | Instructor/Professor: Mel White | Student: Jingpo Li
Approach: The African Wildlife Foundation (AWF) is an international conservation organization. AWF's programs and conservation strategies are designed to protect the wildlife of Africa and ensure a sustainable future for Africa's people.

36 WWF - BALLOON ANIMALS | School: Miami Ad School São Paulo / Miami Ad School New York | Instructor/Professor: Alê Torres | Students: Bruno Giuseppe, Thomaz Jefferson, Eduardo Chaves, Gabriel Gakas, Lorran Schoechet Gurman, Adriano Tozin
Assignment: Forest fire, illegal fishing, global warming, and invasion of the habitat: those are all reasons for animal extinction and it happened because of humans.
Approach: We did a shooting of balloon animals that represent animals in danger because of those practices, showing how fragile they are to human greed.

37 OREO | School: School of Visual Arts
Instructors/Professors: Jack Mariucci, Robert Mackall | Student: Tamara Yakov
Assignment: Oreo.
Approach: Show a sophisticated Oreo that is for adults too.

38 THE RECEIPT | School: School of Visual Arts | Instructors/Professors: Jack Mariucci, Robert Mackall | Students: Bowook Yoon, Ha Jung Song

39 STEAMY HOT, SWEATING BOTTLES | School: School of Visual Arts | Instructors/Professors: Jack Mariucci, Robert Mackall | Students: Bowook Yoon, Ha Jung Song

40 4 BROTHERS | School: Miami Ad School | Instructor/Professor: Jerrod New
Student: Marcelo Shalders
Assignment: Create a campaign to release the new burgers and the new location of the Food Truck.
Approach: It's well know that there is no better burger than the American Burger, and 4 brothers is the only Brazilian Food Truck to provide the real taste of American burgers. Having that said, the poster shows that they provide well selected and homemade ingredients that give the American Burger a special taste.

41 DRAMAMINE AD | School: School of Visual Arts | Instructor/Professor: Jack Mariucci | Student: Fred T. Gaddy | Contributor: Angela Song

42 MOTION SICKNESS RELIEF | School: School of Visual Art | Instructors/Professors: Jack Mariucci, Robert Mackall | Students: Sujin Lim, Taekyoung Debbie Park

42 METLIFE TAGS | School: School of Visual Arts
Instructors/Professors: Jack Mariucci, Robert Mackall | Student: Young Wook Choi

43 RECORD STORE DAY UNCOMPRESS | School: School of Visual Arts
Instructor/Professor: Frank Anselmo | Student: Mick Jongeling, Rick Gerrits

44 R&R HOF MEMORIAL CANDLES | School: School of Visual Arts
Instructor/Professor: Frank Anselmo | Students: Jake Blankenship, Yifei You

45 R&R HOF STAIRWAY TO HEAVEN | School: School of Visual Arts
Instructor/Professor: Frank Anselmo | Students: Joe Chong, Mo Ku

46 IT'S THAT SIMPLE. | School: Syracuse University | Instructor/Professor: Kevin O'Neill
Student: Yunxuan Wu
Assignment: Tide can remove stains.
Approach: It's difficult to remove stains in clothes.
Results: Removing a stain is as easy as removing a sticker.

47 NIKON COOLPIX P900 DIGITAL CAMERA | School: Syracuse University
Instructor/Professor: Mel White | Student: Justina Hnatowicz
Assignment: The goal of this project is to communicate the spectular zooming capabilities of the Nikon COOLPIX P900 digital camera in a visual and creative way through making three print advertisements. The camera is currently the most technologically advanced digital camera on the market, and can magnify objects with an impressive 83x optical zoom and a 166x dynamic fine zoom.
Approach: To showcase the product's benefits creatively, I paid attention to the insight that taking a photo with a Nikon camera will yield the same results as if you're standing right next to the object.

48 SAMSONITE OUTDOOR | School: Syracuse University
Instructor/Professor: Mel White | Student: Ting Peng
Assignment: Create an outdoor campaign and present the product benefit. Samsonite is famous for its travel luggage. For its newest backpack collection, the large volume in its backpacks is highlighted and promoted.
Approach: Samsonite backpacks can carry more items than other backpacks, so we need to emphasize and exaggerate its benefit in a creative way by thinking about what the target audiences are and in which category the brand falls. Since Samsonite is known as a high-quality travel backpack for different uses, we decided on an outdoor location, which fits with the purpose and uses.

48 EXERCISE MORE. LIVE MORE. | School: Miami Ad School
Instructor/Professor: Larry Gordon | Student: Ana Miraglia

49 EPSON CAMPAIGN | School: School of Visual Arts | Instructors/Professors: Jack Mariucci, Robert Mackall | Students: Han Sol Ryoo, Yae Nah Oh

50 GLAD FORCE FLEX EXTRA STRONG TRASHBAGS | School: Miami Ad School
Instructor/Professor: Mark Smith | Student: Simon Dekoninck
Assignment: Create billboards that have a visual impact while showing off the strength of the Glad Force Flex trash bags.
Approach: I used animals that are known to rip open trash bags and eat garbage in a comical way to show the strength of Glad Force Flex trash bags.

50 BUILT FOR ADVENTURE | School: Syracuse University
Instructor/Professor: Mel White | Student: Kylie Chase Packer
Image Source: License purchased from Shutterstock
Assignment: Create an outdoor experiential ad that was to remain consistent with previously made Herschel print ads. Using the same insights, main message, and big idea, I developed an integrated campaign going off of the idea that Herschel backpacks are "Built for Adventure."
Approach: I wanted this outdoor ad to give the consumer an experience that substantiated the idea behind the product.
Results: I wound up inventing chair lifts that are made from life-size backpacks. These customized Herschel backpack chair lifts would occupy ski mountains across the country and would show how the product has the ability to literally brace you on your skiing adventure. At the same time, the chair lifts demonstrate the main message that the backpacks are extremely durable.

51 PEDIGREE | School: School of Visual Arts
Instructors/Professors: Jack Mariucci, Robert Mackall | Student: Sewon Park

51 PROACTIVE DOG FOOD | School: School of Visual Arts | Instructors/Professors: Jack Mariucci, Robert Mackall | Students: Bowook Yoon, Ha Jung Song

52 SOLUBLE SCRRIBLES | School: School of Visual Arts | Instructors/Professors: Jack Mariucci, Robert Mackall | Students: Bowook Yoon, Ha Jung Song

53 REFRESHEN YOUR MARRIAGE | School: School of Visual Arts
Instructor/Professor: Corel Theuma | Student: Samuel Kim
Assignment: The objective of this assignment was to create a print ad for Febreze.
Approach: A juxtaposition of a serious painting with a sense of modern humor.

54 LOCTITE STICKS STUFF | School: Kutztown University of Pennsylvania
Instructor/Professor: Ann Lemon | Student: Abby Scheuerman
Assignment: A singleminded campaign for a product needed at back-to-school.
Approach: Strong visuals that metaphorically demonstrate the product strengths.

55 PARKING LOT | School: School of Visual Arts | Instructors/Professors: Jack Mariucci, Robert Mackall | Students: Bowook Yoon, Ha Jung Song

56 SONOS FOLLOW | School: School of Visual Arts | Instructor/Professor: Frank Anselmo
Students: Aiden Yang, Jiyeong Kim

57 DIAMOND MATCHES | School: School of Visual Arts
Instructors/Professors: Tal Shub, Joanna Crean | Student: Kevin Lai

58 DUCT TAPE | School: Syracuse University | Instructor/Professor: Mel White
Student: Nicole Framm
Assignment: Highlight the product as an easy solution to various problems.
Approach: Duct Tape is one of the most versatile products on the market, as it can be easily and effectively used as a substitute for other tools.

59 MIRACLE GRO | School: School of Visual Arts
Instructors/Professors: Jack Mariucci, Robert Mackall | Student: Tamara Yakov
Assignment: Miracle Gro.
Approach: Apples are a classic thing that teachers have on their desk.

59 GLUED AND SAFE. | School: School of Visual Arts
Instructors/Professors: Jack Mariucci, Robert Mackall | Student: Yoonseo Chang
Assignment: Design an ad poster for Crazy Glue.

60 ALL THE COLORS IN NATURE | School: Miami Ad School
Instructors/Professors: Florian Weitzel, David Herrmann | Student: Carolina Latorraca
Copywriter: Margherita Teodori | Art Directors: Henriett Zsemlye-Racz, Carolina Latorraca
Assignment: Show the wide color choice Pantone has.
Approach: Pixeling nature's images to show how Pantone provides the color's code, even for the smallest pixel.

61 ENGINEERED TO CANCEL | School: School of Visual Arts
Instructors/Professors: Jack Mariucci, Robert Mackall | Student: Woo Jae Yoon

62 MONTBLANC PENS | School: School of Visual Arts
Instructor/Professor: Eileen Hedy Schultz | Student: Jae Wook Baik
Approach: Inspired by similarity between NYC landmarks and Montblanc pens.

62 TATTOO REMOVAL COMPANY | School: School of Visual Arts
Instructors/Professors: Jack Mariucci, Robert Mackall | Student: Tamara Yakov
Assignment: Tattoo Removal.
Approach: Lots of people get tattoos that they regret, especially while intoxicated.

63 DON'T TEXT AND DRIVE | School: School of Visual Arts
Instructors/Professors: Jack Mariucci, Robert Mackall
Students: Sujin Lim,Taekyoung Debbie Park, Hyunjin Stella Kim

64 PG CHILD SLAVE COFFEE | School: School of Visual Arts
Instructor/Professor: Frank Anselmo | Students: Hunwoo Choi, Ein Jung

65 HUMAN TRAFFICKING PSA | School: Texas Christian University
Instructor/Professor: Bill Galyean | Student: Brooke Wong
Assignment: I completed this project in Ad Design as a contracted Honors course. I loved working with my professor to create a PSA for something so important to me.
Approach: Capture the brutality and dehumanizing nature of human trafficking.

66 PG MADE BY IMMIGRANTS PRODUCTS | School: School of Visual Arts
Instructor/Professor: Frank Anselmo | Students: Rogier van der Galiën, Robin van Eijk

67 SEXUAL ASSAULT ADVERTISEMENT | School: Texas Christian University
Instructor/Professor: Bill Galyean | Student: Justine Rendl
Assignment: Create a public safety advertisement focusing on any topic that has a radical impact on society. I chose to do my ad on sexual assault. The statistics for rape are exponentially high, especially on college campuses across America. I recognize that many efforts to stop sexual assault are not successful. To address this issue and to promote what many organizations believe is the best way to stop it, I decided to incorporate a rape whistle into my ad.
Approach: I incorporated the whistle into my ad because it is a representation of the lack of success in stopping assault. Rape whistles are not a realistic solution, and are even laughed at on many campuses because of their lack of reliability to the issue at hand. I wanted to bring light the fact that we need a new way to stop assault from happening. I used a naked model to bring a shock factor to the ad.

68 PG SEWING NEEDLES | School: School of Visual Arts
Instructor/Professor: Frank Anselmo | Students: Joe Chong, Mo Ku

69 CHILDREN IN MUMBAI SLUM | School: School of Visual Arts
Instructors/Professors: Jack Mariucci, Robert Mackall
Students: Bowook Yoon, Ha Jung Song

70 UNTIE HUMAN TRAFFICKING | School: School of Visual Arts
Instructors/Professors: Jack Mariucci, Robert Mackall
Students: Bowook Yoon, Ha Jung Song

70 AMNESTY CHOKE CUP | School: School of Visual Arts
Instructor/Professor: Frank Anselmo | Students: Jake Blankenship, Yifei You

71 TO WRITE LOVE ON HER ARMS AD SERIES | School: Kutztown University of Pennsylvania | Instructor/Professor: Summer Doll-Myers | Student: Christian Weber
Assignment: Create four successive print ads that work as a series for a nonprofit organization. Ads are intended to be viewed as successive magazine pages.
Approach: TWLOHA is a national mental health media and outreach organization that focuses on suicide prevention in high schools and universities. This series plays on a contrast of depression and hope with eye-catching and shocking imagery. The campaign features original art direction, photography, and hand-lettering.

72 THE SPRITUAL JOURNEY | School: School of Visual Arts
Instructors/Professors: Jack Mariucci, Robert Mackall
Students: Bowook Yoon, Ha Jung Song

73 EVERLAST POSTER | School: School of Visual Arts
Instructors/Professors: Jack Mariucci, Robert Mackall | Student: Young Wook Choi

73 EVERLAST - START LIVING | School: School of Visual Arts | Instructors/Professors: Jack Mariucci, Robert Mackall | Students: Sheung Cho, Bernise Wong, Joanna Yoon

74 NATIONAL GEOGRAPHIC | School: School of Visual Arts | Instructors/Professors: Jack Mariucci, Robert Mackall | Student: Tamara Yakov

115 ZINE | School: School of Visual Arts | Instructor/Professor: Olga Mezhibovskaya
Student: Ashley Law

116 'A' MAGAZINE | School: Brigham Young University
Instructor/Professor: Adrian Pulfer | Student: Dallin Diehl

117 LINK MAGAZINE | School: California State University, Fullerton
Instructor/Professor: Theron Moore | Student: Angela Godoy
Artist: Mural in Photograph "Wrinkles of the City" By JR

Assignment: Create innovative solutions to various design problems surrounding the production of an entire magazine.
Approach: "Link" is an editorial design based on the concept of immersing the inner artist of its readers, as well as exposing artists that are not well known. The magazine contains 80 plus pages of imagery, typography and engaging articles.

118 CRAZY SEXY COOL | School: School of Visual Arts
Instructor/Professor: Carin Goldberg | Student: Sungyoon Lee

119 EXHIBITION 'A TO Z' | School: Unattributed | Instructor/Professor: Unattributed
Student: Dongkyu Lee | Exhibition Director: Shinho Bae, Haein Won | Art Direction: Dongkyu Lee, Joohee Lee | Design: Dongkyu Lee | Promotion Director: Haein Won
Promotion Team: Hijo Kim, Dongmin Lee, Yeong Ha Lee, Byung Won An | Special Task: Hanul Kim, Erena Lee | Sponsors: Shinsegae Duty Free, Emart, Aimhigh Education
Location: Shinsegae Mesa | Photography: Ki Hun Han, Jeong-eun Lee

Assignment: Exhibition 'A to Z' was a collaboration between NY and Seoul-based Korean artists. As a design director of the exhibition, I had to make an exhibition design and identity system including brochure, banners, and poster.
Approach: The exhibition title 'A to Z' implies 'From beginning to end, the full range of arts.' Based on CMYK colors, which contain every range of physical colors, I created a visual language that represents all spectrum of arts.

120 SLIVERWARE DRESS AND BAG | School: School of Visual Arts
Instructor/Professor: Kevin O'Callaghan | Student: Filipa Mota

121 KIDULT TAROT | School: Hongik University | Instructor/Professor: Marvin Lee
Student: Sol Bi Doo

Assignment: Kidult (Kid+adult) is the name for adults with interests seen as suitable for children, like games and comics. Aiming at this group, the illustrations reinterpret a set of Tarot cards, a wooden mobile, and a roulette game.
Approach: The objective is to convey each card's meaning through the setting of games, objects, and characters.

121 SULLIVAN CABIN PLAYING CARDS | School: Concordia University
Instructor/Professor: John DuFresne | Student: Matthew Sullivan

Assignment: Within a single media/medium, create and design editions, or a series of items espousing a notion, conception, abstraction, theory, hypothesis, or conviction that I am knowledgeable and passionate about. My project must have at least four components, clearly communicate my intentions, and work together conceptually and visually as a series.
Approach: My family has owned an all seasonal cabin on Lake Washburn in northern Minnesota for over 15 years, and card and board games are one of the corner stones to the cherished memories shared at the Sullivan cabin. In order to create a totem to celebrate these memories, I created playing cards commemorating the four seasons and the activities that take place within those seasons.

122 "CARPENTERS CHESS SET" | School: School of Visual Arts
Instructor/Professor: Kevin O'Callaghan | Student: Christopher Mourato

123 CASIO'S OCEANUS CLOCK | School: Hansung University of Design & Art Institute
Instructors/Professors: Dong-Joo Park, Seung-Min Han | Student: Jung heejin

Approach: Looking at the Casio's Oceanus clock, it was able to recognize the polish and the sophistication of the clock in the metal material. First of all, after painting the entire silhouette of the clock, using a pen tool, divided the segment and used the divider of the pathfinder to divide the sides. I enlarged the portions of this divided area so that I could approach the details more elaborately. I used various layers and lines to enhance the texture and depth of the natural colors.

124 ADIA VICTORIA | School: Watkins College of Art | Instructor/Professor: Dan Brawner
Student: Natalie Briscoe | Department Chair: Dan Brawner

Assignment: Adia Victoria, a local musician, participated in a live drawing session with the Illustration I class. During the session, Adia sang and shared information about her life.
Approach: The illustration exaggerates the features of this individual to emphasize the qualities that make her unique. Emphasis is brought to her hands to recall this movement as well as her emotion that she communicated when she performed. In terms of her outward appearance, Adia was quite tall, thin and wore all black. To emphasize this quality, her form is depicted as a defined, expansive black shape. The figure references Gustav Klimt's portrait paintings and incorporates his elongated figures and their contrast between a flat pattern and the modeled face and hands. Additionally, Adia discussed her complex relationship she carries with her identity as an African American woman from the South. In reference to her southern roots, patterns found on Gee's Bend quilts are included, which were also made by southern African American women. Furthermore, in the background, the presence of Spanish Moss Oak trees, which are native to the southeastern United States, further references her home.

125 MURIEL COOPER IN CONTEXT | School: School of Visual Arts
Instructors/Professors: Joe Marianek, Dinah Fried | Student: Dongkyu Lee

Assignment: Make an accordion formatted book visualizing the timeline of pioneering designer Muriel Cooper's life with historical context and her influences.
Approach: To emphasize her initiating works, I gave this timeline a three-dimensional look to represent her new approach in infinity world inside a computer. Each diagonal lined texts represents her life, surrounding histories, and influences.

126 DINER EN BLANC | School: Texas A&M University Commerce | Instructor/Professor: Katie Kitchens | Student: Hayley Green | Photographer: Morgan Crabtree

Assignment: Develop an invitation for Diner en Blanc. Guests dress in elegant whites and rendezvous to a secret location for an exclusive dining experience.
Approach: The concept referenced such words as white, secret, and exclusive. The goal was to create an interactive piece that elicited engagement, excitement,

and anticipation for the event.
Results: The invitation is screen printed in an elegant script set in Charlize with the details set in Fox and Bower. Pieces of the typefaces are printed on two separate sheets of clear acrylic. When the two pieces are placed on top of each other they reveal the message.

127 OCEANIC INSTITUTE BRANDING SUITE | School: Portfolio Center
Instructor/Professor: M.C. Coppage | Student: Alex Minkin

Assignment: Create a branding element for a non-profit of your choice.
Approach: When researching the Oceanic Institute, I discovered that they really have a deep understanding of not only the world's oceans but also of the microscopic.

127 LOGO DESIGN FOR HARRY'S SHOE REPAIR SHOP | School: School of the Art Institute of Chicago | Instructor/Professor: Mark Stammers | Student: Stephanie Yueyang Wang

Assignment: Identify an entity that either has no identity mark or has an unremarkable one in need of replacement.
Approach: Established in 1907, Harry's Shoe Repair is a three-generation shoe repair shop located in River North, a bustling neighborhood in the heart of Chicago. The inspiration for this logo design came from my observations of the heel repair process, in-depth interviews with the owner, studies of shoe constructions, and the architectural scene in the Chicago River North neighborhood skyline.
Results: The logo is an upside down heel, which reflects the shop's routine practice of fixing the tip of the heel by flipping the shoe upside down. The triangular form of the logo is intended to convey a stable, reliable, and professional persona to potential clients. The logo draws connections between the upside down heels and the architectural buildings in the Chicago River North neighborhood, in particular, the John Hancock Center.

127 BAUHAUS TOYS LOGO | School: Portfolio Center
Instructor/Professor: Hank Richardson | Student: Luke Romig

Approach: Designed a logo for Bauhaus Toys. It uses a unicorn to emphasize the powerful imagination of children.

127 SYDNEY OLYMPICS LOGO | School: Woodbury University
Instructor/Professor: Behnoush McKay | Student: Galia Gharabeg

127 BEAR | School: Universidad Católica de Santiago de Guayaquil
Instructor/Professor: Anais Sánchez Mosquera | Student: Eduardo Piedra Quiroz

Assignment: Test conceptualization skills by branding/logo design according to the diverse topics the students came up with at the beginning of the course.
Approach: Why a bear? Because it is an animal that transmits strength, security, is rude and agile, able to climb over obstacles, with thick fur to withstand varied climates. ■ Based on their thick fur, on the mountain peaks by which they usually climb, I decided on this style of illustration with thick edges. ■ In addition to referencing anatomy, the thick edges convey security and seriousness. ■ This is the monochrome version of the brand; there is a blue version and another coffee, which function to represent two types of bears, mountain and polar. ■ In the logo, the bear falls from a slope that can be interpreted as rock or ice, depending on the chromatic that it handles, which gives dynamism and movement to the composition. ■ Bear intends to be a mark destined to the care of mountain and polar bears, based only on the interest of helping them.

127 LUCULLIAN RISTORANTE LOGO | School: Portfolio Center
Instructor/Professor: Hank Richardson | Student: Luke Romig

Assignment: Create a logo.
Approach: This is a mark I created for a Northern Italian restaurant known for its prominent use of beef in their dishes.

127 UNITED STATES ARMY CORPS OF ENGINEERS | School: Texas A&M University Commerce | Instructor/Professor: Josh Ege | Student: Solbinna Choi

Assignment: This logo is for the United States Army Corps of Engineers. This logo represents who they are, what they do, and what they work toward.
Approach: I thought about what represents the U.S. visually and I discovered the eagle. The eagle is a very strong and well-known symbol for the U.S. And I also researched what the United States Army Corps of Engineers do and thought the compass and bridge show a good visual representation of the work that they do.

127 FOUR PILLARS LIQUOR STORE | School: Texas Christian University
Instructor/Professor: David Elizalde | Student: Emma Holland

Assignment: Create a brand and brand identity.
Approach: Four Pillars is a theoretical family-owned liquor store founded in Providence, Rhode Island that combines tradition with modernity. The company was started by four brothers of Irish descent who would like to create strong relationships with customers and support local breweries, wineries, and distilleries.
Results: Draws inspiration from the history of drinking in The US in the prohibition era with Art Deco inspired line work. It also references Celtic knots to emphasize the family descent. The lines rely on each other for stability and create an asymmetrical structure to reference family dynamics, growth, and unity.

128 HIGHWIRE | School: Portfolio Center | Instructor/Professor: Hank Richardson
Student: Carter Tindall

Assignment: Design a liquor bottle label based on the story of a Victorian Era figure.
Approach: Highwire Whiskey is inspired by Charles Blondin, the most famous wire walker of the Victorian Era. On his first walk across Niagara Falls, he sat down on his cable and called for the Maid of the Mist to anchor beneath him. He cast down a line and hauled up a bottle whiskey. He took a swig and began to run after he passed the sagging center.

129 MAXA ABSINTHE | School: Portfolio Center | Instructor/Professor: Hank Richardson
Student: Caroline Skarupa

Assignment: Design a liquor bottle based on the story of a Victorian person.
Approach: I designed a red absinthe inspired by the Parisian actress Paula Maxa, leading lady of the Grand Guignol theatre in the early 1900s. Nicknamed the "Princess of Blood," her morbid fascination with horror and tragedy inspired her roles on stage as well as roles in her personal life.

130 MORPHIS BY CATERPY BREWERY | School: George Brown College
Instructor/Professor: Jerri Johnson | Student: Hana Lee

Results: Morphis by Caterpy Brewery is a new beer brand created for men—19 to 25 years—preferring traditional lager tastes. Motivated by a caterpillar, the name 'Morphis' originated from the word 'metamorphosis' to express a strong and classic tone-of-voice. Royal crests, Victorian typography and a subdued colour palette inspired the design composition.

131 VIDA LIQUIDA | School: Pennsylvania State University
Instructor/Professor: Kristin Sommese | Student: Saige Sommese
Assignment: Design promotional packaging for an alcohol bottle.
Approach: Inspired by a positive outlook on life, I created Lucky studios, a design agency based in California. The bottle and collateral were designed to be sent on The Day of the Dead to announce the expansion of the brand to Monterrey, Mexico. The holiday is not as morbid as it sounds and is actually about celebrating life and loved ones. I emphasized this by making the packaging colorful and bright, and adding postcards into the promotional piece so that the receiver can send them to their loved ones, while also spreading the brand's presence.

132 SOVEREIGN SPIRITS | School: Watkins College of Art
Instructor/Professor: Judith Sweeney O'Bryan | Student: Christopher Adams
Department Chair: Dan Brawner | Photographer: Mike Rutherford
Approach: Create a bourbon company that sets itself apart by presenting unique illustration, creative writing, and craftsmanship. Different tiers of bourbon would be sold: a 12, 15, and 20 year—which would accommodate the varying budgets of our customers. However, quality is always in mind, and this is distinctly shown in how the bottle rests within the box. A specific angle has been selected to ensure that the bourbon never touches the cork—our bourbon always retains its integrity.
Approach: Each illustration used on the different bourbon bottles is derived from varying royal figures throughout history. For example, The King's Bourbon (which is the twenty year bourbon) is based off of the identity of King Charles the 8th of France—who went mad in his old age and killed himself (so the legend goes). The packaging needed to reference this story, so to compliment the tale Blood Wood is utilized for the bourbon box and cigar box. The cigar's labels present illustrations of the King to tie their connection to the bourbon, which is that they have been infused with The King's Bourbon to enhance their flavor.

133 HEMPSTERS | School: Miami Ad School San Francisco
Instructor/Professor: Unattributed | Student: Hridaynag Kooretti
Assignment: Packaging design and formulation.
Approach: I wanted Hempsters to have a personal and organic feel to it. I decided to use water colors for the aroma/flavor artwork.
Results: Hempsters is currently selling successfully in Asia and is currently looking at expanding to other countries.

134 SPHINX | School: George Brown College | Instructor/Professor: Jerri Johnson
Student: Amanda Wong
Approach: The Tersa Sphinx moth was selected to base the concept for this hard cider brand. The moth has a distinctly attractive and angular body shape that inspired the design of the label. ■ The name Sphinx was chosen because of its connotation to mystery and the exotic and is designed to appeal to women ages 19 to 25. ■ An opaque white bottle gives the cider a sense of anonymity, while placing emphasis on the label where bright vivid colours are applied for rich contrast. Inspiration for design decisions was taken from the elegant Art Deco period.

135 ALPINE ALES | School: Syracuse University | Instructor/Professor: Michele Damato
Student: Jacqueline Akerley
Assignment: Ideate a unique product and produce packaging for it.
Approach: I was inspired by the beauty of Lake Tahoe, and wanted to celebrate popular locations on the lake through the creation of a craft beer. I created vector illustrations of each location to be featured on the labels as a way to directly show the variety of natural wonders that surround the lake.

135 ST. GEORGE WHISKEY | School: Academy of Art University
Instructor/Professor: Thomas McNulty | Student: Zahra Ilyas

136 COMMON GROUNDS | School: Temple University | Instructor/Professor: Abby Guido
Student: Brandon Whirley
Assignment: Senior thesis project.
Approach: I knew I wanted to design packaging and a website for a brand that was unique. I decided to create Common Grounds, a company that offers a variety of coffee from different countries around the world—each one prepared and served in a way that's traditional to its origin.
Results: Each coffee recipe uses unique brewing devices or ingredients that make it special. I created patterns that are influenced by traditional textiles and art and used them on the packaging. Last I designed a website, complete with an online shop and a page for each type of coffee that includes information about the history and tradition, as well as the meaning behind the patterns.

136 TASTEA BRANDING | School: School of Visual Arts
Instructor/Professor: Eric Baker | Student: Park JooHyun

137 HOLLÆNDER GENEVER | School: Westerdals Oslo School of Arts, Communication and Technology | Instructor/Professor: Margaret Rynning | Student: Kristofer Hoffmann Schärer
Assignment: My goal was to tell the story about my home, Hollendergata (Dutchman's Street), a street with historical ties to Dutch shipping and the export of lumber that goes back hundreds of years.
Approach: My idea was to tell this story through the design of four limited bottles of Dutch Genever. The text presented on the design serves as a tribute to the street's background history and the architect that designed it. ■ The bottles are painted by hand and the labels are printed on premium Scandinavian produced paper. The label design draws inspiration from the baroque designs of the Dutch Golden Age and classical Dutch typography. The labels are therefore mainly based on typography and this reference to Dutch tradition shows through the consistent use of Dutch Type Library's DTL Fleischmann. The focus on Dutch tradition shows through the use of a traditional Dutch color palette; red, white, blue, and orange, and through the use of a cross hatched illustration of the royal arms of the Netherlands, House of Orange-Nassau. ■ As the front labels are

meant as a tribute to Dutch-Norwegian trade ties, the back labels, bottle caps, and the bottle itself serves as a tribute to the proud building of Hollendergata and the architect Herman M. Backer.

137 PEPSI X JLA | AUGMENTED REALITY PACKAGING CAMPAIGN
School: Art Center College of Design | Instructor/Professor: Gerardo Herrera
Student: Jenny Joe | Student Website: www.jennyhjoe.com
Assignment: Create a packaging campaign using Augmented Reality.
Approach: Pepsi and DC Comics assembled a collection of cans featuring the characters from Justice League of America. By unlocking the pixel graphic on the can, Pepsi X JLA provides an engaging experience by revealing the hidden superheroes who can battle with other people at San Diego Comic Con.

138 19 FOR MEN | School: Pennsylvania State University
Instructor/Professor: Kristin Sommese | Student: Brandon Rittenhouse
Assignment: Develop an original concept for a bath and body line and design the packaging. Each product is based on a decade in which they were popular.
Approach: Using original collage, I created collateral and the brand 19 For Men.

138 KINSHIP | School: Academy of Art University | Instructor/Professor: Michael Osborne
Students: Nathania Frandinata, Carrisa The, Nicola Crossley, Seen Rongkapan

139 FILM NOIR COLLECTOR'S BOX | School: Texas Christian University
Instructor/Professor: Jan Ballard | Student: Anika Carlson
Assignment: Create a collector's edition box that would be sold at an expensive and exclusive Film Noir Film Festival.
Approach: The classic black and white Film Noir style originated in the 1940s in Hollywood and focused on American crime and detective films. It focused on the insecurities of the time period, including fear, paranoia and mistrust. There is often a disillusioned male character who falls for a femme fatale who is manipulating him to get what she wants.
Results: A special edition collector's box was created that highlighted the high contrast, stark lighting, and mystery of the style, while including 1940s Art Deco patterns to tie in both the film and art style of the decade. The pop of red references the velvet movie curtains of the time.

140 NATIVE - RETAIL STORE PACKAGING | School: Academy of Art University
Instructor/Professor: Thomas McNulty | Students: Alireza Jajarmi, Ray Dao, Peggy Chu, Kim Di Santo, Sofia Llaguno

140 CRAFTSMAN | School: Portfolio Center | Instructor/Professor: Brett Player
Student: Melanie Maynard
Approach: Craftsman prides itself on a love of American practicality and ingenuity. These tools are handed down from generation to generation.

141 ETUDES NO. 1, 2, 3 | School: Art Center College of Design
Instructor/Professor: Jean Rasenberger | Student: Charles Lin
Assignment: Investigate the utilization of graphic design to create a series of visual scores for performance; that, an exploration of systems of musical notation, composition, language, and writing, through the lens of graphic design, could yield for rich discourse on the exploration of design as performance. These performances seek to offer insight into how the vernacular of graphic design can be experientially translated through the body in space and improvised music.

142 CONCERT POSTER | School: School of Visual Arts
Instructor/Professor: Eileen Hedy Schultz | Student: Yun Lee

143 MANIC MAKERS | School: University of Cincinnati
Instructor/Professor: Reneé Seward | Student: Maggie Gibbens
Assignment: Create a series of 3 posters advertising a hypothetical exhibition about the life and work of 3 scientific visionaries at the Chicago Museum of Science and Industry. This ongoing exhibition consisted of 3 segments, each highlighting the work of either Samuel Morse, Nikola Tesla, and Elon Musk.
Approach: I worked with the concept of "Manic Makers." Each of these technical pioneers shook the world with their big ideas, and transformed their respective fields with one particularly influential invention. However, this genius came with a side of crazy. Their work and vast intellects began to cloud their sanity and blind them to who they are without their work. In other words, they are, or were, their work. ■ To communicate this idea, I juxtaposed black and white portraits of each person with a symbol that represented their most successful endeavors. ■ I then used clipping masks to create the effect of the symbols fading into their faces, which helps to communicate the idea of the visionaries "being" their work.

144 SOUND ASSERTIONS: CHARLIE "BIRD" PARKER | School: University of Cincinnati DAAP | Instructor/Professor: Reneé Seward | Student: Kayla Stellwagen
Assignment: Create a poster for an exhibition series of jazz concerts to commemorate several jazz icons.
Approach: Typographic manipulations, made with paper, photography, and scanners, provided a huge opportunity to quickly generate compositions. Inspiration came while listening to the jazz music of each musical legend. A bebop beat influenced the type manipulations of Charlie Bird Parker's name.

145 TYPE DESIGN COMPETITION POSTER | School: School of Visual Arts
Instructor/Professor: Eileen Hedy Schultz | Student: Ziwei Liu
Assignment: Invite the entrants to submit their work for the Type Design Competition held by the Type Directors Club.
Approach: The colors are overlapped to create new colors. "T,""Y," and "P" are combined in one, just like they are falling from the previous one's position.

146 TYPOGRAPHIC TEXTURE | School: School of Visual Arts
Instructor/Professor: Olga Mezhibovskaya | Student: Davina Hwang

147 DREAM MAKES ME COMPLETE | School: Hansung University of Design & Art Institute | Instructors/Professors: Dong-Joo Park, Seung-Min Han | Student: Sung Hyun Ha
Approach: Everyone dreams of their own color. Those dreams come together to complete human beings. A dream makes a person. A dream makes people perfect. This poster uses a Chinese character. The poster was expressed graphically in colorful colors. This colorful Chinese characters mean dream, and the luminous yellow Chinese character means a person. The background type shows the harmony between the Chinese character and English.

148 CHANGE BY MANY | School: University of Cincinnati DAAP
Instructor/Professor: Reneé Seward | Student: Codie Chang
Assignment: Create an effective visual design system for the exhibition at the Freedom Center for Idea Comets: 3 Social Pioneers. The exhibition explores the development and historical perspectives of these three extraordinary world social leaders.
Approach: The "Change By Many" poster series acknowledges that at the core of each social movement is the person's actions and words, and it is the efforts of everyone with the smaller movements that make a difference. The poster is meant to be read differently at three distances.

149 NYFF POSTER SERIES | School: School of Visual Arts
Instructors/Professors: Kenneth Deegan, Brankica Harvey | Student: Hanbyul Park
Assignment: Create a poster series for the 55th New York Film Festival.
Approach: I have approached each film as a piece of artwork such as painting. Considering the characters, colors, and meanings of the films.

150 LIFE AND DEATH | School: School of Visual Arts
Instructor/Professor: Richard Poulin | Student: Kyu Jin Hwang
Assignment: The project is to redesign the famous designer' poster.
Approach: Takenobu Igarashi's representative artwork is three-dimensional alphabetic sculptures. ■ I attempt to express the difficult things I experienced. Based on his technique, I tried to convey the connection between life and death by combining the Korean word '죽음 (Death)' with the English word 'Life.'

150 LIFE IS BEAUTIFUL | School: Hansung University of Design & Art Institute
Instructors/Professors: Dong-Joo Park, Seung-Min Han | Student: Chaewon Lee
Assignment: It is a poster of Mr. Brainwash's exhibition.
Approach: It is the sole exhibition of Mr. Brainwash in Seoul, the first in Asia. ■ Inspired by his words, "I will see the entire interior of the gallery as a kind of canvas. The art gallery itself would become art," I designed the poster to give a simple yet powerful message as street art's uniquely colored paint rolls down.

151 NATIONAL PARKS POSTERS | School: School of Visual Arts
Instructor/Professor: Richard Poulin | Student: Jun Yong Choi

152 SOUTH CAROLINA FESTIVAL OF FLOWERS | School: Portfolio Center
Instructor/Professor: Mike Kelly | Student: Caroline Skarupa
Assignment: Create a poster based on an event.
Approach: I chose to design a poster for an event that takes place in my home state; the event is called the South Carolina Festival of Flowers.
Results: The final poster displayed the Yellow Jasmine flower, layered with typography because it is the South Carolina state flower.

153 TDC POSTER | School: School of Visual Arts
Instructor/Professor: Eileen Hedy Schultz | Student: Tamara Yakov
Assignment: Design a poster for a type competition for the Type Director's Club.
Approach: I used all of the letters in "Type Director's Club" with various typefaces and sizes. I wanted to express the diversity and approaches to making designs with type by using design principles such a contrast of size, shape, etc.

154 SLOW DOCUMENTARY FILM FESTIVAL BRANDING | School: School of Visual Arts
Instructor/Professor: Eric Baker | Student: Grina Choi

155 HANSUNG UNI. DESIGN & ART INSTITUTE GRADUATION POSTER
School: Hansung University of Design & Art Institute | Instructor/Professor: Dong-Joo Park
Students: Chan Kyu Lee, Min Gi An, Bong Hee Park, Min Soo Kim
Assignment: Poster of the 9th Hansung University Design & Art Institute graduation exhibition held every November. It is a graduation exhibition poster, selected after the 3rd screening of the work that students learned in school.
Approach: "The time has come for us to get out of the world." First, I used a balloon as a metaphor for expressing this. This expressed, "As we breathe, the inflated balloon bursts, and the air in it goes out of the world." The meaning of such an expression is "ready to go out of the world."

156 SEOUL JAZZ FESTIVAL | School: Hanyang University
Instructor/Professor: Inyoung Choi | Student: Bokyung Ku
Assignment: Design a typography poster which express mood of music genre.
Approach: Jazz is a music genre that musician's ability affects a lot. Colorful alphabets represent the musician's unpredictable improvisation and creativity.

157 FLUX | School: Watkins College of Art | Instructor/Professor: Chris Thompson
Students: Derek Anderson, Chris Fornal, Elliot Hay | Photographer: Travis Commeau
Department Chair: Dan Brawner
Assignment: Design a show poster for the Watkins College of Art Spring 2017 graphic design senior exhibition.
Approach: Change can be difficult to process, but for students graduating college it's an exciting time of opportunity. As a class we decided to illustrate this change through a medium that is interesting and unexpected. Ferro fluid is a messy black substance that contains nanoparticles of magnetite that react to a magnetic field in a phenomenal way, producing dense spikes and fluid motion. The nature of the ferrofluid's viscosity provides endless shapes and visuals, mirroring our process as artists and designers.
Results: By strategically targeting the Nashville advertising and design community with large scale printed posters, and unleashing animated versions of the poster at Creative Mornings Nashville, over 300 professionals attended our senior show for seven students at St8mnt.

158 CHAIR OF HOPE | School: Portfolio Center | Instructor/Professor: Hank Richardson
Student: Madison DeFilippis
Assignment: Design a chair inspired by an art movement and a personal story.
Approach: My chair is inspired by the freedom of expressionism, and by my journey to healing after my father lost his battle with cancer in August 2016. After hundreds of sketches and hours of looking through design books, I was able to create a chair that is comforting and uplifting.

159 ELATION CHAIR | School: Portfolio Center | Instructor/Professor: Hank Richardson
Student: Laura McMullan
Assignment: Design a chair based on a personal narrative.
Approach: Elation represents the elegance, resilience, and boundless nature of perfectionism. Inspired by values of the art movement Suprematism, the design

centers on finding unlimited meaning in the arrangement of geometric forms.
Results: While many can identify with perfectionism, the resilience of weathered Brazilian walnut wood laced with cold, sleek brushed aluminum form a dynamic composition of geometric shapes, revealing the costly beauty and cyclical struggles of my personal journey to the other side of perfectionism: Elation.

159 I AND I CHAIR | School: Portfolio Center | Instructor/Professor: Hank Richardson
Student: Danner Washburn
Assignment: Design a chair based off of a design movement and a personal story.
Approach: After researching the Psychedelic design movement, I realized that personal expression and voice were paramount in the work made during this time. My personal story detailed my realization that we all deal with hardships that make us who we are and, when shared, allow us to truly be ourselves.
Results: By eliminating a specific sitting location, users of this chair are given the opportunity to sit, recline, or rest where they feel is proper in that moment.

159 JONAH'S CHAIR | School: Portfolio Center | Instructor/Professor: Hank Richardson
Student: Alessandra Rabellino
Assignment: Design a chair based on a personal narrative.
Approach: This chair is a tribute to my late friend, Jonah, who passed away too soon at the age of 19. The design is inspired by the British Vorticist movement, and represents the power of accepting someone into your life and allowing them to change your perspective, ultimately weaving new narratives into your own story.

160 AN IMPERFECT CHAIR | School: Portfolio Center
Instructor/Professor: Hank Richardson | Student: Anna Riethman
Assignment: Design a chair based on a personal narrative.
Approach: I examined my struggle with striving for unattainable perfection. I used asymmetry as a metaphor for imperfection, as asymmetry is often unsettling for perfectionists. This shows that imperfection is not only what makes this chair beautiful, but also what makes a great many things in life meaningful.

161 CELEBRATION OF FAMILY CHAIR | School: Portfolio Center
Instructor/Professor: Hank Richardson | Student: Alex Cohen
Assignment: Design a chair based on a personal narrative.
Approach: My family may not look or operate like other families but it is my family. With maturity I realized that if it weren't for the fracturing and splitting my family wouldn't be what it is today.
Results: The form represents parts of my family will never talk or interact ever again but no matter what, they love and support me and that is worth celebrating.

162 ISRAELI STAMPS | School: School of Visual Arts
Instructor/Professor: Eileen Hedy Schultz | Student: Tamara Yakov
Assignment: Design stamps for a heritage month in the United States for any country of your choosing.
Approach: As the child of an immigrant from Israel, cultural food was a big part of my life. I chose to incorporate 8 of Israel's common foods as a way to represent its state.

163 OPHELIA | School: School of Visual Arts | Instructor/Professor: Olga Mezhibovskaya
Student: Dash Wang

164 TYPEFACE PROMO | School: School of Visual Arts
Instructor/Professor: Olga Mezhibovskaya | Student: Xin Song

165 36 DAYS OF TYPE | School: Academy of Art University
Instructor/Professor: Thomas McNulty | Student: Juan Manuel Corredor

DESIGN SILVER WINNERS:

167 GUGGENHEIM BILLBOARD | School: School of Visual Arts
Instructor/Professor: Eileen Hedy Schultz | Student: Tamara Yakov

167 MEAT MEAT MEAT | School: School of Visual Arts
Instructor/Professor: Dan Cassaro | Student: Hanbyul Park

167 BETHINK | School: Pennsylvania State University
Instructor/Professor: Kristin Sommese | Student: William King

167 HYDRAULIC FRACTURING AND THE ENERGY INDUSTRY IN THE US_THESIS PROJECT | School: Academy of Art University | Instructor/Professor: Carolina De Bartolo
Student: Juan Manuel Corredor

167 UNREAD LANGUAGE | School: Academy of Art University
Instructor/Professor: Stanley Zienka | Student: Hsuan-Yun Huang

167 A GLIMPSE TO 24 GREAT THINKERS | School: Academy of Art University
Instructor/Professor: Thomas McNulty | Student: Juan Manuel Corredor

168 BOOK | School: School of Visual Arts | Instructor/Professor: Olga Mezhibovskaya
Student: Ti Tung Wang

168 BOOK | School: School of Visual Arts | Instructor/Professor: Olga Mezhibovskaya
Student: Huiwen Tan

168 FRESH EYES CUBA BOOK | School: Art Center College of Design
Instructor/Professor: Tracey Shiffman | Student: Ricardo Imperial
Website: https://designmattersatartcenter.org/proj/fresh-eyes-cuba-a-deep-immersion-and-cultural-exchange-in-havana/ | Printer: Clear Image Printing, Los Angeles
Photographers: Art Center College of Design Students | Design Director: Tracey Shiffman

168 BASELINE | School: Drexel University | Instructor/Professor: Sandy Stewart
Student: Max Kahn

168 POP-UP BOOK_TATLIN'S TOWER | School: Academy of Fine Arts and Design
Instructor/Professor: Eduard Cehovin | Students: S. Arko Strojan, P. Kostevc,
A. R. Tomšič Jacobs, M. Kladnik | Assistant in making maquette: V. Stojanovski,
Photo: D. Kocijancic

168 PROJECT A | School: Auckland University of Technology
Instructor/Professor: Dr. Alan Young | Student: Phoebe Ellis

168 PARK BOOKS | School: School of Visual Arts | Instructor/Professor: Unattributed
Student: Rose Maria Sofie

169 DESTRUCTIVE BOOK INTERIORS, FAHRENHEIT 451 | School: School of Visual Arts | Instructor/Professor: Carin Goldberg | Student: Misha Hunt

169 MALCOLM GLADWELL BOOK SERIES | School: Brigham Young University
Instructor/Professor: Adrian Pulfer | Student: Tyler Watson

169 THE EARTHSEA BOOK COVERS | School: Portfolio Center
Instructor/Professor: Hank Richardson | Student: Brendan Brines

169 MILLENNIUM SERIES | School: Portfolio Center
Instructors/Professors: Hank Richardson, Melissa Kuperminc | Student: Brennan Holloway

169 VERTIGO BOOK COVER | School: School of Visual Arts
Instructor/Professor: Eileen Hedy Schultz | Student: Tamara Yakov

169 THE MAN WHO DIDN'T SHOOT HITLER | School: Miami Ad School
Instructor/Professor: Jerrod New | Student: Marcelo Shalders

170 ROJIN SAKE | School: School of Visual Arts | Instructor/Professor: Eric Baker
Student: Erik Campay

170 LARANNE | School: Portfolio Center | Instructor/Professor: Hank Richardson
Student: Elle Oser

170 XIAN FAMOUS NOODLE BRANDING | School: School of Visual Arts
Instructors/Professors: Courtney Gooch, Paula Scher | Student: Ho Seok Lee

170 MARRIOTT REBRANDING | School: School of Visual Arts
Instructor/Professor: Eileen Hedy Schultz | Student: Tamara Yakov

170 REBIRTH OF ANTHORA | School: School of Visual Arts
Instructor/Professor: Dan Cassaro | Student: Hanbyul Park

170 3DAYS | School: Hanyang University | Instructor/Professor: Inyoung Choi
Student: Bokyung Ku

171 FULL CIRCLE MARKET | School: Brigham Young University
Instructor/Professor: Adrian Pulfer | Student: Gunnar Harrison

171 BANDIT RESTAURANT BRANDING | School: Miami Ad School
Instructor/Professor: Hank Richardson | Student: Carolina Lara-Mesa

171 A LITTLE EVERYDAY | School: School of Visual Arts
Instructor/Professor: Richard Poulin | Student: Hie Won Sohn
Assignment: A Little Everyday is a new chocolate and coffee brand that promotes the health benefits of both chocolate and coffee on a daily basis.
Approach: The brand's logotype communicates this unique duality with two distinct yet compatible typefaces, serif-Baskerville, and sans serif-Cera.
Results: This pairing is further reinforced by the use of a soft, warm color palette throughout the brand's packaging.

171 REBRANDING WEST ELM | School: Art Center College of Design
Instructors/Professors: Sean Adams, Chris Hacker | Student: Heejeong Seong

171 THE MODERN CHAIR | School: School of Visual Arts
Instructor/Professor: Carin Goldberg | Student: Nicole (Dong Hyun) Kim

171 WOODHILLPARK | School: School of Visual Arts | Instructor/Professor: Unattributed
Student: Rose Maria Sofie

171 MUSEUM OF VISION LOSS | School: Maryland Institute College of Art
Instructors/Professors: Ellen Lupton, Jason M. Gottlieb | Student: Ze Wang

171 HYDRO GREEN BRANDING PROJECT | School: School of Visual Arts
Instructors/Professors: Courtney Gooch, Paula Scher | Student: Qingru Joy Wu

171 PUBLISHER PROJECT | School: School of Visual Arts
Instructors/Professors: Paula Scher, Courtney Gooch | Student: Danbee Kim

172 U9 GERMAN INSTITUTES OF TECHNOLOGY BRANDING | School: School of Visual Arts | Instructors/Professors: Paula Scher, Courtney Gooch | Student: Grina Choi

172 ARTHOP! | School: Texas State University
Instructors/Professors: Holly Sterling, Tanya Freach | Student: Lauren Godwin

172 MUSEUM IDENTITY REBRANDING GYEONGGI CERAMIC MUSEUM | School: Chung-Ang University | Instructor/Professor: Se Ra Yoon | Student: Min Kyeung Kim

172 KOKO | School: Brigham Young University | Instructor/Professor: Adrian Pulfer
Student: Blake Myer

172 PORTER FREIGHT CO. | School: Portfolio Center
Instructor/Professor: Witt Langstaff | Student: Sarah Asip

172 PHAIDON PRESS | VISUAL IDENTITY | School: Art Center College of Design
Instructor/Professor: Brad Bartlett | Student: Tais Ghelli

173 CASIO BRAND SYSTEM | School: Academy of Art University
Instructor/Professor: Hunter Wimmer | Student: Hugo Ugaz

173 NOVEL SOCIETY: A POP-UP CONCEPT FOR KINDLE | School: Portfolio Center
Instructor/Professor: Devan Carter | Student: Rachel Eleanor Phillips

173 FREIGHT | School: Portfolio Center | Instructor/Professor: Devan Carter
Student: Brennan Holloway

173 PERRYBRASSBRANDING | School: School of Visual Arts
Instructors/Professors: Courtney Gooch, Paula Scher | Student: Ho Seok Lee

173 FRANK'S FULL SERVICE | School: Portfolio Center
Instructor/Professor: Melissa Kuperminc | Student: Carter Tindall

173 FLUX | School: Portfolio Center | Instructor/Professor: Melissa Kuperminc
Student: Cydney Schwartz

174 OFFF (OPEN FLASH FILM FESTIVAL) | School: Art Center College of Design
Instructor/Professor: Brad Bartlett | Student: Kuan Chiou

174 VIGILANTE PLUMBING | School: School of Visual Arts
Instructor/Professor: Scott Buschkuhl | Student: Hyunkyung Koh

174 FAHRENHEIT PRESS | School: School of Visual Arts
Instructors/Professors: Paula Scher, Courtney Gooch | Student: HyeRi Hyun

174 AFROPUNK FESTIVAL | School: Art Center College of Design
Instructor/Professor: Brad Bartlett | Student: Yuma Naito

174 UNITED STATES VETERANS' ARTIST ALLIANCE (USVAA) | School: Art Center College of Design | Instructor/Professor: Stephen Serrato | Student: Juan Karlo Muro

174 2017 NEW YORK ASIAN FILM FESTIVAL | School: Art Center College of Design
Instructor/Professor: Brad Bartlett | Student: Brian Liu

175 DELTA AIRLINES REBRANDING | School: School of Visual Arts
Instructor/Professor: Eileen Hedy Schultz | Student: Tamara Yakov

175 DELICIOUS POSTCARDS | School: School of Visual Arts
Instructor/Professor: Unattributed | Student: Joe Haddad

175 FRUIT CALENDAR | School: School of Visual Arts
Instructor/Professor: Jon Newman | Student: Hanbyul Park

175 OCTOBER CALENDARS | School: School of Visual Arts | Instructor/Professor: Richard Mehl | Student: Tamara Yakov

175 ENVIRONMENTAL STEWARDSHIP—US CURRENCY REDESIGN
School: Portfolio Center | Instructor/Professor: Brittany Baum | Student: Casey Lovegrove

176 NEW YORK TIMES BOOK REVIEW | School: School of Visual Arts
Instructor/Professor: Carin Goldberg | Student: Doyeon Lee

176 THE GOURMAND MAGAZINE | School: Brigham Young University
Instructor/Professor: Adrian Pulfer | Student: Walker Croxton

176 REFLECTION | School: California Institute of the Arts
Instructor/Professor: Michael Worthington | Student: Hong Won Choi

176 PERSONA MAGAZINE | School: School of Visual Arts
Instructor/Professor: Barbara deWilde | Student: Jae Young Jang

176 MUSH. FOOD QUARTERLY MAGAZINE | School: School of Visual Arts
Instructor/Professor: Shawn Hasto | Student: Kyongjun Lee

176 ALARM MAGAZINE | School: Brigham Young University
Instructor/Professor: Adrian Pulfer | Student: Brooke Pathakis

176 ZA MAGAZINE | School: George Brown College | Instructor/Professor: Jerri Johnson
Student: Sanja Pavlovic

176 MAGAZINE | School: School of Visual Arts
Instructor/Professor: Olga Mezhibovskaya | Student: Sihao Sun

176 FORTE MUSIC | School: George Brown College | Instructor/Professor: Jerri Johnson
Student: Yusuke Yamazaki

177 ENTITY GHOSTLY JOURNAL | School: Syracuse University
Instructor/Professor: Michele Damato | Student: Erin Reeves

177 EDITORIAL DESIGN | School: School of Visual Arts
Instructor/Professor: Eileen Hedy Schultz | Student: Tamara Yakov

177 OUTCAST | School: Pennsylvania State University
Instructor/Professor: Lanny Sommese | Student: Kyle Cernicky

177 CASABELLA MAGAZINE | School: Brigham Young University
Instructor/Professor: Adrian Pulfer | Student: Megan Eckersley

177 TWELVE | School: Temple University | Instructor/Professor: Abby Guido
Student: Julie Lam

177 BLACK AND WHITE MAGAZINE | School: School of Visual Arts
Instructor/Professor: Carin Goldberg | Student: Soojin Hong

177 MY FIRST PICTURE DICTIONARY | School: School of Visual Arts
Instructor/Professor: Carin Goldberg | Student: Han Jun Kim

178 BLACK & WHITE MAGAZINE SPREADS ALL : SHIRIN NESHAT [ACCORDION]
School: School of Visual Arts | Instructor/Professor: Carin GoldbergStudent: Hyejin Lee

178 LA BIBLIA MAGAZINE | School: California State University, Fullerton
Instructor/Professor: Theron Moore | Student: Marshall Dahlin
Photographer's Assistant: Amanda Dahlin

178 CRAZY SEXY COOL WOOD TYPE VER. | School: School of Visual Arts
Instructor/Professor: Carin Goldberg | Student: Doyeon Lee

178 CRAZY SEXY COOL TABLOID VER. | School: School of Visual Arts
Instructor/Professor: Carin Goldberg | Student: Doyeon Lee

178 CRAZYSEXYCOOL | School: School of Visual Arts
Instructor/Professor: Carin Goldberg | Student: Minzi Lee

178 A WIFE HAS A COW | School: School of Visual Arts
Instructors/Professors: Jessica Walsh, Timothy Goodman | Student: Soojin Hong

179 ELEVEN | School: Portfolio Center | Instructor/Professor: Devan Carter
Student: Carter Tindall

179 TYLER HISTORY WALL | School: Temple University
Instructor/Professor: Kelly Holohan | Students: Krissy Beck, Laura Sutphen, Ryan Hewlett

179 PIXEL FOREST | School: School of Visual Arts | Instructor/Professor: Richard Poulin
Student: Hie Won Sohn
Assignment: A poster series promoting 'Pixel Forest' a video installation exhibition on the work of Pipilotti Rist at the New Museum in New York City.
Approach: This poster series expresses the same visual experience that the artist has created for the exhibition through imagery, color, and movement.

179 KAREL MARTENS EXHIBITION | School: School of Visual Arts
Instructor/Professor: Unattributed | Student: Seungeun Heo

179 A BRIDGE ACROSS | School: Portfolio Center
Instructor/Professor: Hank Richardson | Students: Laura Capps, Elle Oser

179 365 NIKE | School: Drexel University | Instructor/Professor: Shushi Yoshinaga
Student: June Lee

180 OUTAGE: DON'T LET THE GRID GO DOWN | School: Temple University
Instructor/Professor: Joe Scorsone | Student: Krissy Beck

180 COEXISTENCE | School: Hansung University of Design & Art Institute
Instructors/Professors: Dong-Joo Park, Seung-Min Han | Student: Min Gyong Park

180 LIL SMILE/LIL LOOK | School: School of Visual Arts
Instructor/Professor: Unattributed | Student: Harlan Ballogg

180 ADIA VICTORIA | School: Watkins College of Art | Instructor/Professor: Dan Brawner
Student: Katherine Hansen | Department Chair: Dan Brawner

180 REVIVE | School: Temple University | Instructor/Professor: Melissa McFeeters
Student: Jacqueline Jensen | Art Director: Melissa McFeeters

180 STELLAR APP POSTER | School: Texas Christian University
Instructor/Professor: Yvonne Cao | Student: Marissa Merrill

180 YELP GENEROCITY APP | School: School of Visual Arts | Instructors/Professors: Thomas Shim, Richard Poulin, Willy Wong, Shannan Coghill | Student: Jun Yong Choi

181 PATCHED APP | School: Pennsylvania State University
Instructor/Professor: Ryan Russell | Students: Rob Pitrovich, Deric Silva

181 TALK BOX | School: Portfolio Center | Instructor/Professor: Melissa Kuperminc
Student: Laura Capps

181 ON AIR | School: School of Visual Arts | Instructor/Professor: Ryan Scott Tandy
Student: Han Jun Kim

181 INSITU - THESIS PROJECT | School: Academy of Art University
Instructor/Professor: Wioleta Kaminska | Student: Emilie Garnier

181 THE PEROT'S NIGHT AT THE MUSEUM | School: Texas A&M University Commerce
Instructor/Professor: Katie Kitchens | Student: Alex Flores
Photographer: Morgan Crabtree

181 PÓSTURINN | School: Brigham Young University | Instructor/Professor: Adrian Pulfer
Student: Camilla Aubrey

182 AQUA | School: Universidad Católica de Santiago de Guayaquil
Instructor/Professor: Anais Sánchez Mosquera | Student: Eduardo Piedra Quiroz

182 RAYTHEON LOGO | School: Portfolio Center | Instructor/Professor: John Hartwell
Student: Alex Cohen

182 NEPAL OLYMPICS LOGO | School: Woodbury University
Instructor/Professor: Behnoush McKay | Student: Samantha Deboda

182 FERN + SPRUCE LOGO | School: Texas State University
Instructor/Professor: Holly Sterling | Students: Callie Gabbert, Angela Rhys,
Courtney Whitehouse, Randy Gaytan

182 APORA LOGO | School: Texas Christian University
Instructor/Professor: Bill Galyean | Student: Marissa Merrill

182 STEAMWORKS BREWING COMPANY | School: Portfolio Center
Instructor/Professor: John Hartwell | Student: Caroline Skarupa

182 GOOD PEOPLE BREWING COMPANY | School: Portfolio Center
Instructor/Professor: John Hartwell | Student: Laura Capps

182 TELLURIDE FILM FESTIVAL | School: Portfolio Center
Instructor/Professor: John Hartwell | Student: Laura Capps

182 GRAYCLIFF HOTEL | School: Portfolio Center
Instructor/Professor: John Hartwell | Student: Caroline Skarupa

182 BAUHAUS TOYS LOGO | School: Portfolio Center
Instructor/Professor: Hank Richardson | Student: Katie Tynes

182 ONEHOOP LOGO DESIGN | School: Metropolitan State University of Denver
Instructor/Professor: Unattributed | Student: Lysander Romero
Design Firm: Ekstrand Creative

182 MOE'S CAFE | School: School of Visual Arts | Instructor/Professor: Gail Anderson
Student: Youn Jae Lee

183 TOTAL WINE LOGO REDESIGN | School: Portfolio Center
Instructor/Professor: Stefan Kjartansson | Student: Laura McMullan

183 BOOSTER FUEL | School: Texas A&M University Commerce
Instructor/Professor: Joshua Ege | Student: Kelsey Paine

183 INTERDISCIPLINARY LOGOS | School: School of Visual Arts
Instructors/Professors: Olga Mezhibovskaya, Nada Ray | Student: Nubia Jay Giraldo

183 LOGO LOGO LOGO | School: School of Visual Arts
Instructor/Professor: Gerald Soto | Student: Francisco Serrano

183 RUNNING OF THE BULLS LOGO | School: Portfolio Center
Instructor/Professor: Hank Richardson | Student: Katie Tynes

183 PAX SOUTH LOGO REDESIGNS | School: Fort Lewis College
Instructor/Professor: Paul Booth | Student: Victoria Barber

183 US FOREST SERVICE | School: Texas A&M University Commerce
Instructor/Professor: David Beck | Student: Cooper H. Weinstein

183 LAND O' LAKES LOGO DESIGN | School: Portfolio Center
Instructor/Professor: Stefan Kjartansson | Student: Madison DeFilippis

183 THE CONTAINER STORE BRANDING SUITE | School: Portfolio Center
Instructor/Professor: Stefan Kjartansson | Student: Alex Minkin

183 OREGON ZOO | School: Portfolio Center | Instructor/Professor: John Hartwell
Student: Alex Cohen

183 OKLAHOMA CITY THUNDER | School: Portfolio Center
Instructor/Professor: John Hartwell | Student: Caroline Skarupa

183 PÓSTURINN | School: Brigham Young University | Instructor/Professor: Adrian Pulfer
Student: Camilla Aubrey

184 ALBUM COVER DESIGN FOR CHROMEO'S "BUSINESS CASUAL" | School:
School of Visual Arts | Instructor/Professor: Bryan Farevaag | Student: Shuyue Chen

184 PECHE | School: Portfolio Center | Instructor/Professor: Melissa Kuperminc
Students: Elle Oser, Laura Capps, Savannah Colbert

184 LITEN ØRNÄS | School: Kutztown University of Pennsylvania
Instructor/Professor: Ann Lemon | Student: Christian Weber

184 FLAUNT PACKAGING DESIGN | School: Art Institute of North Hollywood
Instructor/Professor: Evanthia Milara | Student: Leah Stang

184 URBANE SHAVE | School: Pennsylvania State University
Instructor/Professor: Kristin Sommese | Student: Hayle Stoner

184 GAIA COFFEE | School: Portfolio Center | Instructor/Professor: Hank Richardson
Students: Elliot Cohen, Rachel Eleanor Phillips, Anna Riethman, Sarah Asip,
Cydney Schwartz

185 INFOGRAPHIC & BOX SET | School: Texas Christian University
Instructor/Professor: Lewis Glaser | Student: Michele Farren

185 RIOT COSMETICS | School: Pennsylvania State University
Instructor/Professor: Kristin Sommese | Student: Cassidy Walter

185 JETPACK BY JETBLUE | BRAND EXTENSION | School: Art Center College of
Design | Instructors/Professors: Andrew Gibbs, Jessica Deseo | Student: Paul Knipper

185 MOTHER OF PEARL | School: Pennsylvania State University
Instructor/Professor: Kristin Sommese | Student: Katelyn Nellis

185 HIGH WATER BREWING | School: Academy of Art University
Instructor/Professor: Thomas McNulty | Student: Hsuan-Yun Huang

185 WINE LABEL | School: School of Visual Arts
Instructor/Professor: Olga Mezhibovskaya | Student: Sou Young Ji

186 SOVEREIGN SCOTCH | School: Portfolio Center
Instructor/Professor: Hank Richardson | Student: Mary Elizabeth Morse

186 GOLDA KOMBUCHA | School: Brigham Young University
Instructor/Professor: Adrian Pulfer | Student: Dallin Diehl

186 SPIRIT WORKS WHISKEY | School: Academy of Art University
Instructor/Professor: Thomas McNulty | Student: Cory Shigeta

186 ON THE SLY | School: Pennsylvania State University
Instructor/Professor: Kristin Sommese | Student: Cassidy Walter

186 HOLY GHOST EPA | School: George Brown College
Instructor/Professor: Jerri Johnson | Student: Eunice Joaquin

186 SHIELD PILSNER BEER | School: George Brown College
Instructor/Professor: Jerri Johnson | Student: Nancy Gioffre

187 GR BOTTLE | School: Miami Ad School | Instructor/Professor: Jerrod New
Students: Marcelo Shalders, Christian Napolitano

187 VANISIE MOONSHINE | School: Portfolio Center
Instructor/Professor: Hank Richardson | Student: Brennan Holloway

187 ALCAZAR XERES | School: Portfolio Center | Instructor/Professor: Hank Richardson
Student: Dan King

187 SOLÉ | School: Brigham Young University | Instructor/Professor: Adrian Pulfer
Student: Alex Pynes

187 WINE BOTTLE DESIGN | School: School of Visual Arts
Instructor/Professor: Eileen Hedy Schultz | Student: Tamara Yakov

187 POP! | School: Texas Christian University | Instructor/Professor: David Elizalde
Student: Reo Nathan

187 HATCHET WHISKEY | School: Portfolio Center
Instructor/Professor: Juliet D'Ambrosio | Student: Averil Eagle Brannen

187 LAGUNITAS BEER | School: Academy of Art University
Instructor/Professor: Thomas McNulty | Student: Sofia Llaguno

187 VINCI SUSTAINABLE POWDER MIXED PAINTS | School: Academy of Art
University | Instructor/Professor: Thomas McNulty | Student: Hugo Ugaz

188 FROM US, TO YOU | School: Academy of Art University
Instructor/Professor: Michael Osborne | Students: Brandi Steele, Jay Jeon,
Jessica Sanjaya Wonomihardjo, Lisa Lindh

188 AURA: PACKAGING OF ALL FOUR ELEMENTS: FIRE, WIND, WATER, EARTH.
School: School of Visual Arts | Instructor/Professor: Scott Buschkuhl
Student: Klever D. Alvarado

188 THEORY | School: California State University, Fullerton
Instructor/Professor: Theron Moore | Student: Angela Godoy

188 BLOSSOM AND BLOOM | School: Watkins College of Art
Instructor/Professor: Judith Sweeney O'Bryan | Student: Natalie Miles
Photographer: Mike Rutherford | Department Chair: Dan Brawner

188 SCENARIO IN THE SHADE INVITATION | School: School of Visual Arts
Instructors/Professors: Nic Taylor, Brett Kilroe | Student: Ho Seok Lee

188 ANDO - SUSTAINABLE POWDER MIXED PAINTS | School: Academy of Art
University | Instructor/Professor: Thomas McNulty | Student: Zihang Jiao

189 BODPOD PACKAGING | School: University of Wisconsin–Stout
Instructor/Professor: Nagesh Shinde | Student: Kendra Wagner

189 QUARTET | School: Pennsylvania State University
Instructor/Professor: Kristin Sommese | Student: Katelyn Nellis

189 WAR CHILD POSTER | School: Texas A&M University Commerce
Instructor/Professor: Rick Gavos | Student: Brandi Hamilton

189 STOP THE ABUSE | School: California State University, Fullerton | Instructor/
Professor: Theron Moore | Student: Marshall Dahlin | Copywriter: www.dosomething.org

189 WHAT DRIVES YOU? | School: Portfolio Center
Instructor/Professor: Melissa Kuperminc | Student: Caroline Skarupa

189 SHOW YOUR TRUE COLORS | School: Miami Ad School
Instructors/Professors: Hank Richardson, Adriana Pellegrini | Student: Carolina Lara-Mesa

189 VERSE 55:38 | School: California State University, Fullerton
Instructor/Professor: Theron Moore | Student: Maaheen Malik

189 YESTERDAY, TODAY, TOMORROW | School: School of Visual Arts
Instructor/Professor: Peter Ahlberg | Student: Yoonseo Chang

190 NO MORE REPEAT | School: Hansung University of Design & Art Institute
Instructors/Professors: Dong-Joo Park, Seung-Min Han | Student: Jinah Yu

190 PAST, PRESENT, FUTURE COEXIST | School: School of Visual Arts | Instructor/
Professor: Richard Poulin | Student: Kyu Jin Hwang

190 PERFORMANCE ART POSTER — BRUNO ISAKOVIC: DENUDED | School: School
of Visual Arts | Instructor/Professor: Eric Baker | Student: Tung Chou

190 POSTER | School: School of Visual Arts | Instructor/Professor: Olga Mezhibovskaya
Student: Jiwon Yu

190 A NATION THAT FORGETS ITS PAST HAS NO FUTURE | School: Hansung
University of Design & Art Institute | Instructors/Professors: Dong-Joo Park,
Seung-Min Han | Student: Kyung Hwan An

190 "TYPE CLASSIFICATION POSTERS" SERIES | School: Art Center College of
Design | Instructor/Professor: John Nettleton | Student: Yi Mao

190 ANOMALOUS | School: Watkins College of Art | Instructor/Professor: Dan Brawner
Students: Jeremy Searcy, Christopher Adams, Natalie Miles
Department Chair: Dan Brawner

190 "SAN HAU" POSTER SERIES | School: Da Nang Architecture University
Instructor/Professor: Tran Thanh Binh | Student: Dang Thi Bich Ngoc
Advisor: Phan Hai Bang

190 EAMES | School: School of Visual Arts | Instructor/Professor: Peter Ahlberg | Student: Klara Kovac

191 THE NIGHT VIEW OF SHANGHAI | School: Hanyang University | Instructor/Professor: Inyoung Choi | Student: Bokyung Ku

191 ESSENTIAL VISUAL FORMS | School: Georgia Institute of Technology | Instructor/Professor: Unattributed | Student: Do Hee Park | Assistant: So Jin Park

191 MAKE AMERICA GREAT AGAIN POSTER | School: Portfolio Center | Instructor/Professor: Pippa Seichrist | Student: Laura McMullan

191 DOES GOD WET IN THE RAIN | School: Art Center College of Design | Instructor/Professor: David Tillinghast | Student: Ying Siu

191 MIAMI AD SCHOOL - DRIVE YOUR IDEAS | School: Miami Ad School | Instructor/Professor: Kimberly Capron Gonzalez | Student: Sofia Soldevila

191 SOUND ASSERTIONS: THE JAZZY TYPE | School: University of Cincinnati DAAP | Instructor/Professor: Reneé Seward | Student: Morgan Smith

191 WAR | School: Dankook University | Instructor/Professor: Hoon-Dong Chung | Student: Soobin Yeo

191 FLUXUS POSTER | School: School of Visual Arts | Instructor/Professor: Carin Goldberg | Student: Seoyoung Lee

191 DEAD MEN TELL TALE | School: School of Visual Arts | Instructor/Professor: Scott Buschkuhl | Student: Yoonseo Chang

192 POSTER | School: School of Visual Arts | Instructor/Professor: Eileen Hedy Schultz | Student: Sean Dong

192 CUBA INTERNET FREEDOM | School: Miami Ad School | Instructor/Professor: Jerrod New | Students: Carolina Lara-Mesa, Carolina Rabago

192 RESONATING RHYTHMS | School: University of Cincinnati DAAP | Instructor/Professor: Reneé Seward | Student: Christopher Enderle

192 THE SHINING | School: School of Visual Arts | Instructor/Professor: Ivan Chermayeff | Student: Han Jun Kim

192 THING/THOUGHT: FLUXUS EDITIONS | School: School of Visual Arts | Instructor/Professor: Carin Goldberg | Student: Axel Lindmarker

192 "EXTINCT" POSTER SERIES | School: Drexel University | Instructor/Professor: Mark Willie | Student: Emily Charniga

192 HAYDEN PLANETARIUM POSTER | School: School of Visual Arts | Instructor/Professor: Eileen Hedy Schultz | Student: Panini Pandey

192 FEELS BLIND | School: Purdue University | Instructor/Professor: Dennis Y. Ichiyama | Student: Nancy Sells

192 INSPIRATION LAB | School: School of Visual Arts | Instructor/Professor: Leta Sobierajski | Student: Bokyoung Kim | Creative Production Partner: Wade Jeffree

193 SELF-RELIANT CHAIR | School: Portfolio Center | Instructor/Professor: Hank Richardson | Student: Laura Capps

193 EQUILIBRIUM CHAIR | School: Portfolio Center | Instructor/Professor: Hank Richardson | Student: Sarah Asip

193 LIBERTÉ CHAIR | School: Portfolio Center | Instructor/Professor: Hank Richardson | Student: Katie Tynes

193 MISOPHONIA CHAIR | School: Portfolio Center | Instructor/Professor: Hank Richardson | Student: Caroline Skarupa

193 APORIA CHAIR | School: Portfolio Center | Instructor/Professor: Hank Richardson | Student: Carter Tindall

193 METATRON'S CHAIR | School: Portfolio Center | Instructor/Professor: Hank Richardson | Student: Dan King

193 FOUNDATIONAL CHAIR | School: Portfolio Center | Instructor/Professor: Hank Richardson | Student: Mary Elizabeth Morse

193 EMBRYO CHAIR | School: Portfolio Center | Instructor/Professor: Hank Richardson | Student: Alex Minkin

193 UNFOLDING CHAIR | School: Portfolio Center | Instructor/Professor: Hank Richardson | Student: Casey Lovegrove

194 MOCHI TAPE | School: Portfolio Center | Instructor/Professor: Ruth Fowler | Student: Savannah Colbert

194 SOLE SHOPPINT CART | School: Portfolio Center | Instructor/Professor: Hank Richardson | Student: Carter Tindall

194 NORA LAMP POST | School: Portfolio Center | Instructor/Professor: Ruth Fowler | Student: Kindall Palmer

194 RX PILL BOTTLE REDESIGN | School: Portfolio Center | Instructor/Professor: Hank Richardson | Student: Sarah Asip

194 ADIDAS X Y-3 LIFESTYLE/RUNNING SHOE CONCEPT | School: Belgrade's Polytechnic | Instructor/Professor: Maja Milinic Bogdanovic | Student: Strahinja Spasic

194 BARBER BART PRODUCT | School: School of Visual Arts | Instructor/Professor: Lain Greenway | Student: An Cho

195 RUN | School: Portland Community College | Instructor/Professor: Nathan Savage | Student: Christi D'Zurilla | Image Source: The New Nike+ Running Experience: Smarter, More Social, More Motivational. 2012

195 ALLIANCE OF CULTURES | School: Academy of Art University | Instructor/Professor: Ezster Clark | Student: Patricia Catangui

195 EVERYTHING THAT INSPIRES PROJECT CONCEPT BOOK | School: Hansung University of Design & Art Institute | Instructors/Professors: Dong-Joo Park, Seung-Min Han | Student: So Ra Jeong

195 FLOCK AND FEATHER | School: Portfolio Center | Instructor/Professor: Hank Richardson | Student: Savannah Colbert

195 JACKFISH | School: Portfolio Center | Instructor/Professor: Hank Richardson | Student: Laura Capps

195 ABATTOIR RESTAURANT BRANDING | School: Portfolio Center | Instructor/Professor: Hank Richardson | Student: Carter Tindall

196 MINIMUM TYPEFACE | School: School of Visual Arts | Instructor/Professor: Jon Newman | Student: Zuheng Yin

196 ABC 3D+2D PUBLICATION | School: University of Illinois at Chicago | Instructors/Professors: Felicia Ferrone, Sharon Oiga | Students: Jennifer Brott, William Dutton, Hyunji Kim, Kenneth Randall, Judith Pauly, Diana Mazurok, Elissa Lepoire, Christopher Fanelli | Class: Typography III: Dimension

196 TYPEFACE | School: School of Visual Arts | Instructor/Professor: Olga Mezhibovskaya | Student: Natalia Drobinina

196 MAIZIE | School: School of Visual Arts | Instructor/Professor: Richard Poulin | Student: Chng Elaine

196 BASTION DISPLAY FACE | School: School of Visual Arts | Instructor/Professor: Irina Lee | Student: Joe Haddad

196 TYPEFACE DESIGN | School: School of Visual Arts | Instructor/Professor: Olga Mezhibovskaya | Student: Darius Wang Dazhi

196 TYPEFACE | School: School of Visual Arts | Instructor/Professor: Olga Mezhibovskaya | Student: Dongjun Choi

196 TYPEFACE | School: School of Visual Arts | Instructor/Professor: Olga Mezhibovskaya | Student: Uchan Kim

196 SAXOPHONE | School: School of Visual Arts | Instructor/Professor: Olga Mezhibovskaya | Student: Daye Kim

PHOTOGRAPHY PLATINUM WINNER:
199 PURPLE | School: Art Institute of Atlanta | Instructor/Professor: Lynda Green | Student: KaTiah Byrd

Approach: It is a portrait of a unique young girl that has an expression and body language that captures genuine emotion. On behalf of this portrait, I used colored gels to add a splash of accent to the frame. Initially, I used three strobes total for this assignment. I mounted a blue, red, and purple color gel to each strobe. Because of the purple being subsequently light, the color lacked the intensity that I was initially seeking. Removing the purple gel and combining a red with a blue gave the beautiful purple tone that I was looking for. Although the color purple mainly represents royalty, it sometimes assists those who seek the meaning of life and a spiritual connection. Blue is associated with tranquility and calmness and red can signify longing and desire. I went with these colors imagining the audience thinking about such things. There were no light modifiers used on the strobes because the goal was to keep the lights hard.

PHOTOGRAPHY GOLD WINNERS:
200 CHANEL | School: Art Institute of Atlanta | Instructor/Professor: Lynda Green | Student: Myles Mays

Assignment: To create a product shot only using painting with light.
Approach: Start with a dark product with lighting to reflect the painting in the front of the bottle to add contrast and separate it from the background.
Results: The combination of reds and blues highlighted the product's face and made it come forward out of the darkness with the help of the added lines behind it.

201 ANNIE | School: Texas Christian University | Instructor/Professor: Dusty Crocker | Student: Claire Hargis | Model: Ann Wilson Reich

Assignment: Students were prompted with creating a portrait image or image series.
Approach: A naturalistic approach to portraiture was taken in this photoseries.
Results: Lighting, framing, perspective, and color balance were utilized in creating a high-drama photoseries that encapsulated the natural beauty of the model, and moreover reflects the natural beauty of all women.

202 BOXER | School: Art Institute of Atlanta | Instructor/Professor: Lynda Green | Student: Kristopher Burris

Assignment: Commercial portrait on location.
Approach: Find something that would not only show a place of business but also add some action to the scene to make it a more lively portrait. By using the boxing studio the idea of adding action to the scene was easily obtainable.

203 PHOTOGRAPHED | School: Miami Ad School San Francisco | Instructor/Professor: Unattributed | Student: Hridaynag Kooretti

Approach: Travel helps define who you are. On my travels to various places, I have often clicked pictures that have not only captured scenery but also my thoughts at that precise moment. Such is the beauty of travel and the human mind...taking you to places beyond the physical form.

PHOTOGRAPHY SILVER WINNERS:
204 WOMAN ON THE COUCH | School: Art Institute of Atlanta | Instructor/Professor: Taylor Bareford | Student: Cassandra Davis

204 GARAGE | School: Art Institute of Atlanta | Instructor/Professor: Lynda Green | Student: Curtisey Liggins

204 KYRA | School: Art Institute of Atlanta | Instructor/Professor: Lynda Green | Student: Aboubacar Kante

205 THUNDERSTORM ON SUNNY ISLES | School: Miami Ad School | Instructor/Professor: Ginny Dixon | Student: Ksenia Gaman

205 SMOKE IN COLOR | School: Texas Christian University | Instructor/Professor: Dusty Crocker | Student: Kahla Watkins

206 BLOND | School: Art Institute of Atlanta | Instructor/Professor: Nicole HA Jacobs-Licht | Student: KaTiah Byrd

206 BASEBALL PLAYER | School: Art Institute of Atlanta | Instructor/Professor: Lynda Green | Student: Curtisey Liggins

206 DIESEL | School: Art Institute of Atlanta | Instructor/Professor: Taylor Bareford | Student: Ashley King

FILM PLATINUM WINNERS:
210 HOLLABACK | School: School of Visual Arts | Instructor/Professor: Frank Anselmo | Students: Ji Yeon Kim, Sookhyoun Kim

211 PIXELS FESTIVAL OPENING TITLES | School: School of Visual Arts | Instructor/Professor: Ori Kleiner | Student: Jin Jeon

Approach: While I got inspiration from the original title of Pixels Festival by Jellycube Studio and Ricardo Pugin, I tried to make this from my point of view

with more high contrast between the model and surroundings in order to present the majestic feature of the festival.

212 SONDER | School: School of Visual Arts | Instructor/Professor: Ori Kleiner | Student: Luke Guyer

Approach: Sonder is the realization that each random passerby is living a life as complex and vivid as your own. Three spaces were created to represent past, present, and future realities and their relationship to Sonder. Each space contains a visual metaphor that relates back to the theme of Sonder. The passing of time, internal conflicts, and people coming in and out of your life are all major themes touched upon in this piece.

Results: Three unique spaces were created to show visual metaphors of Sonder.

213 PERSPECTIVE | School: School of Visual Arts | Instructor/Professor: Hye Sung Park | Student: Siling Zhao | Music: Yukihiro Takahashi - Something New

Assignment: I decided to visualize Milton Glaser's words from an interview. As one of my biggest inspirations, Milton is my teacher in using design to better the world as well as a guide through struggle.

Approach: To communicate the idea of the interview best, I needed a comprehensive understanding and a simple and clever idea to connect the audience to the content and help them understand. After doing research on philosophy and psychology, I realized my reality is constructed by my own mind, and all the struggles I have could be nothing if I look at them differently. That was when I really understood what Milton was talking about in the interview and decided to use optical illusions–what you see is not what you see–to communicate the idea.

214 GOOD HANGER CAMPAIGN | School: Eulji University | Instructor/Professor: Myoung Zin Won | Students: Hyun Cheol An, Sun Young In

Approach: Each year $90,000,000 of old clothes are wasted. We found a way to enhance the value of these "old clothes." The old clothes that you hardly wear in your closet could turn into someone else's brand new clothes. The main idea is to utilize this "good hanger" to represent a legitimate donation to the children of other countries that are in need. This can promote the idea of "OTCAN" title logo and also advertise non-profit organizations to fundraise more.

215 PG THE FUR SHOP | School: School of Visual Arts | Instructor/Professor: Frank Anselmo | Students: Ji Yeon Kim, Sookhyoun Kim

Approach: More than 50 million animals are tortured and slaughtered for their fur annually. However, regardless of continuous effort to promote against fur production, fur consumption has been increasing significantly. ■ To educate and have greater impact on fur consumers, we deiced to open up a fake fur pop-up store, "The Fur Shop." When fake fur coats are lifted in this shop, motion sensors trigger the screams of animals in pain from the speakers attached on the hangers.

216 SUSTAIN: REFLECTIONS OF A TIRED GRAD STUDENT
School: Temple University | Instructor/Professor: Kelly Holohan | Student: Krissy Beck

Assignment: Graduate Thesis project.

Approach: Sustain is a deeply personal video compilation in which Krissy looks back on her time as a design graduate student and on the creative process in general. The video features a series of poems derived from a wide variety of source material including The Education of a Graphic Designer edited by Steven Heller, Living and Sustaining a Creative Life edited by Sharon Louden, and a selection of sites and articles that provide advice on maintaining relationships in graduate school. Krissy created a series of videos that act as visual metaphors for each of the poems, stringing them together using silent film era typography, music, and effects to further emphasize the nostalgia of self-reflection.

217 JUST LABEL IT - PSA | School: Miami Ad School | Instructor/Professor: Mark Smith | Student: Simon Dekoninck | Copywriter: Dan Morris | Art Director: Simon Dekoninck

Assignment: There is no FDA regulation on GMO labeling. We brought light to this issue by creating a comical video.

Approach: In a way, the FDA is hiding what's in your food by not labeling food as GMO. We wanted to deliver this message by blurring and bleeping out the ingredients that are GMO.

218 SPOTIFY SAM | School: Miami Ad School | Instructors/Professors: Jerrod New, Marcos Lawson | Students: Mariam Elias, Nellie Santee

Approach: Spotify SAM is an interactive feature that will help patients with dementia or Alzheimer's with music. Using Big Data, the algorithm will be able to identify the specific song being remembered by the patient, and serve them a playlist with similar songs, that might trigger past memories and stimulate neurological functions. ■ Spotify SAM, as a software, could live in a device as ubiquitous as a smartphone, or a home device, that can keep listening to what they are saying at all times. A simple hum would trigger the software and initiate the playlist. We also thought it would be nice to integrate Spotify SAM with other smart home features, such as smart lights and smart picture frames, to create a whole experience.

219 GOOGLE ASSISTANT KIDS | School: School of Visual Arts | Instructors/Professors: Jack Mariucci, Robert Mackall | Students: Ji Hoon Kim, Jisoo Hong, Minyoung Park

FILM GOLD WINNERS:

220 OVERLOOKED | School: Temple University | Instructor/Professor: Abby Guido | Student: Krissy Beck | Voiceover: Eamon Goebel

Approach: Animal shelter workers across the United States report having greater difficulty placing dogs and cats with predominantly black coats into permanent homes. Inspired by her own experience adopting a shelter dog, Krissy looks at the disputed phenomenon of Black Pet Syndrome in this motion graphic.

220 WHIPLASH | School: Pennsylvania State University | Instructor/Professor: Ryan Russell | Student: William King

Assignment: Each student selects a film to create a unique title sequence. This assignment focuses on composition, typographic hierarchy, pacing and time and sequence of type and image.

Approach: The opening scene of the film Whiplash introduces the main character practicing drums in a small room. For this project I utilized simple shapes to create a path to this space for the viewer.

220 DJANGO UNCHAINED | School: Pennsylvania State University | Instructor/Professor: Ryan Russell | Student: Deric Silva

Assignment: Same as above.

Approach: Django Unchained is a film written and directed by Quentin Tarantino about a bloodthirsty slave trying to save his wife from a Mississippi plantation. This film doesn't have a title sequence, and as one of the best films in the 21st century it deserves one. Tarantino uses blood on white objects to represent defiance of white supremacy, and I created a title sequence to follow this.

220 JACK OF ALL TRADES | School: School of Visual Arts | Instructor/Professor: Ori Kleiner | Student: Lemon Sanuk Kim

221 ABOUT TIME | School: School of Visual Arts | Instructor/Professor: Hye Sung Park | Student: Seong Yeop Sim

221 MEMOIRS OF A GEISHA | School: School of Visual Arts | Instructor/Professor: Ori Kleiner | Student: Sung Yoon Lee

221 PPAP MUSIC VIDEO | School: School of Visual Arts | Instructor/Professor: Hye Sung Park | Student: Yonju Kim

221 ALL YOU WANT TO KNOW ABOUT RUSSIA | School: Miami Ad School | Instructor/Professor: David Cabestrany | Student: Ksenia Gaman

Assignment: Create a short animated video about something you really love.

Approach: I based my video on the stereotypes I've heard about Russia.

Results: An "A" in the Motion Graphics class.

222 SELF-PROMO | School: School of Visual Arts | Instructor/Professor: Ori Kleiner | Student: Jimin Lee

222 SELF-PROMO | School: School of Visual Arts | Instructor/Professor: Hye Sung Park | Student: Jue Gong

222 MARRIAGE | School: School of Visual Arts | Instructor/Professor: Ori Kleiner | Student: Young Gyun Woo

222 LIFE IS NOT A JOURNEY | School: School of Visual Arts | Instructor/Professor: Hye Sung Park | Student: Chusheng Patrick Chen

223 THE WAY WE DRESS | School: School of Visual Arts | Instructor/Professor: Ori Kleiner | Student: Lemon Sanuk Kim

223 HUMANAE | School: School of Visual Arts | Instructor/Professor: Hye Sung Park | Student: Rachel Park Goto

223 HISTORY OF BLUE | School: School of Visual Arts | Instructor/Professor: Hye Sung Park | Student: Haelee You

223 DO RE MI SONG | School: School of Visual Arts | Instructor/Professor: Hye Sung Park | Student: Han Sol Ryoo

224 HAIKU | School: School of Visual Arts | Instructor/Professor: Ori Kleiner | Student: Ken Kwong

224 BAD HABIT (LOOPABLE ANIMATION) | School: School of Visual Arts | Instructor/Professor: Ori Kleiner | Student: Seong Yeop Sim

224 ANGRY SEA | School: School of Visual Arts | Instructor/Professor: Ori Kleiner | Student: Theo Guillin

224 ILLUSTRATE A WORD | School: School of Visual Arts | Instructor/Professor: Ori Kleiner | Student: Chenyou Philip Lee

225 PERSEVERE | School: School of Visual Arts | Instructor/Professor: Ori Kleiner | Student: Katherine Murnion

225 1984: PRINCIPLES OF NEWSPEAK | School: School of Visual Arts | Instructor/Professor: Hye Sung Park | Student: Weixi Zeng

225 COLOURPOP AD | School: Texas A&M University Commerce | Instructor/Professor: Lee Whitmarsh | Student: Aliana Layug

Assignment: The goal of this project is to create an ad that matches the brand Colourpop cosmetics for their new product "Ultra Matte Lips."

Approach: I decided to go with fun and bright colors that capture the company's identity. Their target audience are younger people ranging from 15 - 29 years old, which is why the brand is all about fun, exciting, and bold colors.

225 SELF-PROMO | School: School of Visual Arts | Instructor/Professor: Ori Kleiner | Student: Young Gyun Woo

226 LIGHT | School: School of Visual Arts | Instructor/Professor: Ori Kleiner | Student: Young Gyun Woo

226 THE STORY OF CHOCOLATE | School: School of Visual Arts | Instructor/Professor: JungIn Yun | Student: Yoon Sun Choi

226 NIGHTMARES | School: School of Visual Arts | Instructor/Professor: Ori Kleiner | Student: Hsiaopu Chang

226 ANGELS AND DEMONS MOVIE TRAILER | School: School of Visual Arts | Instructor/Professor: Ori Kleiner | Student: Hyejin Kim

227 SUNNY PATH | School: School of Visual Arts | Instructor/Professor: Ori Kleiner | Student: Jimin Lee

227 TOO MUCH OF ME | School: School of Visual Arts | Instructor/Professor: Hye Sung Park | Student: Jue Gong

227 SELF-PROMO | School: School of Visual Arts | Instructor/Professor: Hye Sung Park | Student: Siling Zhao

227 BEAUTIFUL YOU | School: Texas Christian University | Instructor/Professor: Scott Anderson | Student: Majesty Christian

Assignment: Art Direct and create a video with a strong emphasis on typography.

Approach: Inspired by Lucille Clifton's poem, "Homage to My Hips," I wanted to animate visual poetry encouraging positive body image.

Results: The PSA visually represents the poem "Phenomenal Woman" by the late Maya Angelou with the use of imagery and kinetic typography.

228 ZYGZYGY | School: School of Visual Arts | Instructor/Professor: Ori Kleiner | Student: Jane Inyeong Cho

228 DOT FACTS | School: Miami Ad School | Instructor/Professor: Mark Smith | Student: Gian Marco Chavez

Assignment: Dot Facts, a project designed to reinvigorate the New York Times'

approach to journalism and transparency, was an idea born of the deteriorating relationship with citizens and the media.

Approach: A completely different website experience was the best way to help address the need for journalism to double down on transparency and accountability, especially vital at a time when politicians of a certain stripe are fomenting doubts about the honesty of the media. We landed on the domain extension facts as the web address and name of our idea. ■ Our redesigned version of the New York Times website offers greater detail on both the content of an article and who's writing it. Our idea maps the timeline, primary and secondary sources, and edits and revisions a piece took on the way to publication. It also includes a reimagined author page that helps you put a person behind a byline.

228 PLAY? | School: School of Visual Arts | Instructor/Professor: Frank Anselmo
Students: Mitchell Diercks, Jasper Vierboom

228 NOT A BOOMERANG | School: | Instructor/Professor: Unattributed
Students: Rohit John, Deep Chhabria, Dhanush Paramesh, Adithya Venugopal
Approach: To commemorate the 200th year since the identification of Parkinson's, Instagram along with the Michael J. Fox Foundation for Parkinson's sparks a new movement amongst millennials using the most used social platform for Parkinson's awareness.

229 PG AMERICAN GLOBE | School: School of Visual Arts
Instructor/Professor: Frank Anselmo | Students: Jake Blankenship, Yifei You

229 GOOGLE ART RESTORATION | School: Dankook University | Instructor/Professor: Hoon-Dong Chung | Students: Doohee Hong, Daeun Lee, Minhee Choi, Hyeri Kim
Assignment: It is difficult to preserve artwork because they are damaged over time or intentionally damaged. The problem is that restoring damaged artwork is a technical skill, so it takes a lot of time and money.
Approach: Google has machine learning algorithms that organized countless artworks by visual similarity and timeline.

229 NASTYHORNS | School: Unattributed | Instructor/Professor: Unattributed
Student: Alejandra Chavez | Developer: Aparajita Dighe Karnik
Copywriters: Alejandra Chavez, Aparajita Dighe Karnik | Art Director: Alejandra Chavez
Assignment: Create a digital action that helps women and men stand up to misogyny online.
Approach: The Women's March came up with really impactful signs to fight misogyny after Trump was elected president. We took the boldest signs from the Women's March and turned them into iMessage stickers.

229 PG DOMINOES | School: School of Visual Arts
Instructor/Professor: Frank Anselmo | Students: Hae Ryeon Lee, Jihye Han

230 ANDROID FIRST RESPONDER | School: Miami Ad School | Instructor/Professor: Mark Smith | Student: Jon Gruber | Copywriter: Matt Tennenbaum | Art Director: Oleg Pak
Assignment: Digital campaign that uses existing technology to help save lives.
Approach: We used the front camera of Android smartphones to automatically check for signs of stroke upon unlocking, giving the option to call an ambulance.

230 BMW DRIVE-LIVE | School: School of Visual Arts | Instructor/Professor: Frank Anselmo | Students: Jens Marklund, Jack Welles, Jisoo Hong, Minyoung Park

230 STARBUCKS - ESPRESSO SEARCH | School: Miami Ad School New York / Miami Ad School São Paulo | Instructor/Professor: Zorayma Guevara | Students: Lorran Schoechet Gurman, Thomaz Jefferson | Advisors: Raphael Taira, Lindsei Barros, Nick Maciag
Assignment: Every year, it is estimated that at least 8 million children worldwide go missing. The first three hours are most crucial for rescuing a missing child.
Approach: Using your daily coffee, a huge database, and innovative technology to help find missing children.

230 SOLAR ROOF TRADE | School: Miami Ad School
Instructor/Professor: Chris Dumas | Students: Matt Tennenbaum, Jon Gruber
Assignment: Use solar for good. We chose to focus our efforts on North Carolina after 100,000 roofs were destroyed during Hurricane Matthew.
Approach: The average solar home produces 20-40% extra energy than it can make use of. This excess energy is then sold back to the energy provider, but only for what it cost the home to produce the energy. The energy companies then resale the energy for triple the price. ■ By creating a mutually beneficial trade, all of North Carolina receives new solar roofs for free, but in exchange, Tesla and SolarCity own the rights to the excess energy and do not have to purchase any of it back. ■ North Carolina is restored, and after just 3 years Tesla and SolarCity don't only break even on their costs of installing the roofs, but they start turning a never ending profit for their part in restoring North Carolina.

231 BMW LIVE WEATHER | School: School of Visual Arts
Instructor/Professor: Frank Anselmo | Students: Josi Matson, Seona Kim

231 INSTA 911 | School: Miami Ad School | Instructor/Professor: Jake Reilly
Student: Carolina Latorraca | Designer: Enrique Aresti | Copywriter: Michael Crawford
Art Director: Carolina Latorraca
Assignment: Create a digital campaign that uses social media to help save lives
Approach: To get help where it's needed faster, we paired 911 emergency services with Instagram live video by adding a button to the Instagram app.

231 BMW CONNECTED-VOICE | School: School of Visual Arts
Instructor/Professor: Frank Anselmo | Students: Aiden Yang, Jiyeong Kim, Minyoung Park

231 LINKFLIX | School: School of Visual Arts | Instructor/Professor: Frank Anselmo
Students: Hunwoo Choi, Ein Jung

FILM SILVER WINNERS:
232 ARGO | School: Pennsylvania State University | Instructor/Professor: Ryan Russell
Student: Emily Cheng
232 THE WAVE | School: Pennsylvania State University
Instructor/Professor: Ryan Russell | Student: Ashley Card
232 EXIT THROUGH THE GIFT SHOP TITLE SEQUENCE | School: School of Visual Arts | Instructor/Professor: Ori Kleiner | Student: Axel Lindmarker

232 GREED | School: School of Visual Arts | Instructor/Professor: Unattributed
Student: Jae Young Jang

232 SHUTTER ISLAND | School: School of Visual Arts | Instructor/Professor: Ori Kleiner
Student: Yae Nah Oh

232 MY FAVORITE THINGS | School: School of Visual Arts
Instructor/Professor: Ori Kleiner | Student: Sohyun Lee

232 BRUTALISM GREY | School: School of Visual Arts | Instructor/Professor: Ori Kleiner
Student: Weixi Zeng

232 APP EXPLAINER | School: School of Visual Arts | Instructor/Professor: Unattributed
Student: Seongjin Yoon

233 STAY | School: School of Visual Arts | Instructor/Professor: Ori Kleiner
Student: Jae Young Jang

233 THE FALSE MIRRORS | School: School of Visual Arts
Instructor/Professor: Hye Sung Park | Student: Rachel Park Goto

233 HOW TO SURVIVE: VISCOM School: Texas A&M University Commerce
Instructor/Professor: Vince Sidwell | Student: Kyler Jones

233 WIND-UP TOKYO | School: School of Visual Arts | Instructor/Professor: Ori Kleiner
Student: Kohki Kobori

233 OPENING TITLE OF MADMAX | School: School of Visual Arts
Instructor/Professor: Ori Kleiner | Student: Jonghoon Kang

233 SUNDOWN | School: School of Visual Arts | Instructor/Professor: Ori Kleiner
Student: Jae Young Jang

233 SUNDOWN | School: School of Visual Arts | Instructor/Professor: Ori Kleiner
Student: Jae Young Jang

233 PATAGONIA CLIMBING | School: School of Visual Arts
Instructor/Professor: Gerald Soto | Student: Ye Hyun Lee

234 ALIAS | School: Pennsylvania State University
Instructor/Professor: Kristin Sommese | Students: Nyomi Warren, Sean Merk, Emily Cheng, Stefan Pelikan, Rob Pitrovich | Art Director: Kristin Sommese

234 PATAGONIA SKIING | School: School of Visual Arts
Instructors/Professors: Ori Kleiner, Gerald Soto | Student: Ye Hyun Lee

234 SELF-PROMO | School: School of Visual Arts | Instructor/Professor: Hye Sung Park
Student: Weixi Zeng

234 LOST IN TRANSLATION | School: School of Visual Arts
Instructor/Professor: Ori Kleiner | Student: Ryoko Wakayama

234 NASTY GIRLS UNITE | School: Pennsylvania State University
Instructor/Professor: Ryan Russell | Student: Addie Ruston

234 SPUTNIK 1 | School: Pennsylvania State University
Instructor/Professor: Ryan Russell | Student: Turner Blashford

234 RESTORE HAPPY | School: Miami Ad School | Instructor/Professor: E Slody
Students: Diana Friedman, Jacob Altman

234 WEATHER MUSIC | School: School of Visual Arts
Instructor/Professor: Frank Anselmo | Students: Rogier van der Galién, Robin van Eijk

235 DEADLY REVIEWS | School: Miami Ad School | Instructor/Professor: Mark Smith
Students: Hampus Elfström, Thomas Nguyen | Art Director/Student: Thomas Nguyen

235 PRINT MY PROTEST | School: Miami Ad School
Instructor/Professor: Zorayma Guevara | Student: Deep Chhabria
Copywriter: Deep Chhabria | Art Director: Laura Marie Mariel

235 POKÉMON GONE | School: Miami Ad School New York
Instructor/Professor: Larry Gordon | Student: Emily Kaufman

235 BULLIMINATE 1280 | School: School of Visual Arts
Instructor/Professor: Frank Anselmo | Students: Jaehyun Cho, Nobuaki Nogamoto

235 BOOST APPLICATION VIDEO | School: Texas Christian University
Instructor/Professor: Yvonne Cao | Student: Anika Carlson

235 TODAY, NO WAY | School: Temple University | Instructor/Professor: Abby Guido
Student: Leilei Lu

235 RAIN | School: School of Visual Arts
Instructors/Professors: Olga Mezhibovskaya, Nada Ray | Student: Tim Trautmann

235 VISUAL MUSIC | School: School of Visual Arts
Instructors/Professors: Olga Mezhibovskaya, Nada Ray | Student: Koki Kobori

236 STONED | School: School of Visual Arts
Instructors/Professors: Olga Mezhibovskaya, Nada Ray | Student: Koki Kobori

236 PERCEPTION | School: School of Visual Arts
Instructors/Professors: Olga Mezhibovskaya, Nada Ray | Student: Woojin Chung

236 CHANGE | School: School of Visual Arts
Instructors/Professors: Olga Mezhibovskaya, Nada Ray | Student: Jonathan Frias

236 BMW CONNECTED – SEAMLESS | School: Miami Ad School Europe
Instructor/Professor: Niklas Frings-Rupp | Students: Kushal Birari, Stefan Rotaru
Copywriter: Philip Ziegler | Art Directors: Kushal Birari, Stefan Rotaru

236 WE ACCEPT ALL TYPES | School: Miami Ad School New York
Instructor/Professor: Brent Weldon | Students: Emily Kaufman, Dana Goldstein
Art Director: Dana Goldstein

236 DARN TOUGH SOCKS | School: Job Propulsion Lab
Instructor/Professor: Bart Cleveland | Student: Chris Ganz | Copywriter: Wes Andrews

236 GREAT FILMS, FAST | School: Miami Ad School | Instructor/Professor: Mark Smith
Student: Jon Gruber | Art Director: Sterling Stovall

236 RUN FOR SYRIA | School: Miami Ad School | Instructor/Professor: Mark Smith
Students: Hampus Elfström, Thomas Nguyen

Academy of Art University
www.academyart.edu
79 New Montgomery St.
San Francisco, CA 94105
United States
Tel +1 800 544 2787

Academy of Fine Arts and Design
Drotárska 44
811 02 Bratislava
Slovakia
+421 2 6829 9500

Art Center College of Design
www.artcenter.edu
1700 Lida St.
Pasadena, CA 91103
United States
Tel +1 626 396 2200
frontdesk@artcenter.edu

Art Institute of Atlanta
www.artinstitutes.edu/atlanta
6600 Peachtree Dunwoody Rd. N.W.
Atlanta, GA 30328
United States
Tel +1 770 394 8300
aiaadm@aii.edu

Art Institute of North Hollywood
www.artinstitutes.edu/hollywood
5250 Lankershim Blvd.
North Hollywood, CA 91601
United States
Tel +1 818 299 5100

Auckland University of Technology
www.aut.ac.nz
55 Wellesley St. E.
Auckland City, NZ 92006
New Zealand
Tel +64 9 921 9999

Belgrade's Polytechnic
www.politehnika.edu.rs
Krfska 7, Beograd 11000
Serbia
Tel +381 11 2633127

Brigham Young University
www.byu.edu
Provo, UT 84602
United States
Tel +1 801 422 4636

California Institute of the Arts
www.calarts.edu
24700 McBean Pkwy.
Valencia, CA 91355
United States
Tel +1 661 255 1050

California State University, Fullerton
www.fullerton.edu
800 N. State College Blvd.
Fullerton, CA 92831
United States
Tel +1 657 278 2011
admissions@calarts.edu

Chung-Ang University
www.neweng.cau.ac.kr
84 Heukseok-ro, Heukseok-dong
Dongjak-gu, Seoul,
South Korea
Tel +82 2 820 6575
international@cau.ac.kr

Concordia University
www.csp.edu
1282 Concordia Ave.
St. Paul, MN 55104
United States
Tel +1 651 641 8230

Da Nang Architecture University
www.dau.edu.vn
Vietnam
+84 511 3879999

Dankook University
www.dankook.ac.kr
152 Jukjeon-ro, Suji-gu
Yongin-si, Gyeonggi-do
South Korea
Tel +82 1899 3700

Drexel University
www.drexel.edu
3141 Chestnut St.
Philadelphia, PA 19104
United States
Tel +1 215 895 2000
info@drexel.com

Eulji University
www.eulji.ac.kr
143-5 Yongdu-dong
Jung-gu, Daejeon,
South Korea
Tel +82 31 740 7419
inter@eulji.ac.kr

Fort Lewis College
www.fortlewis.edu
1000 Rim Drive
Durango, CO 81301
United States
Tel +1 970 247 7010
admissions@fortlewis.edu

George Brown College
www.georgebrown.ca
230 Richmond St. E., Room 116
Toronto, Ontario M5A 1P4
Canada
Tel +1 416 415 2000

Georgia Institute of Technology
www.gatech.edu
North Ave. N.W.
Atlanta, GA 30332
United States
Tel +1 404 894 2000

Hansung University of Design & Art Institute
edubank.hansung.ac.kr
Seoul
South Korea
Tel +82 02 760 5533/5534

Hanyang University
www.hanyang.ac.kr
222 Wangsimni-ro, Sageun-dong
Seongdong-gu, Seoul
South Korea
Tel +82 31 400 5114

Hongik University
En.hongik.ac.kr
94 Wausan-ro, Changjeon-dong
Mapo-gu, Seoul
South Korea
+82 2 320 1114

Kutztown University of Pennsylvania
www.kutztown.edu
15200 Kutztown Road
Kutztown, PA 19530
United States
Tel +1 610 683 4000
admissions@kutztown.edu

Maryland Institute College of Art
www.mica.edu
1300 W. Mt. Royal Ave.
Baltimore, MD 21217
United States
Tel +1 410 669 9200

Metropolitan State University of Denver
www.msudenver.edu
P.O. Box 173362
Denver, CO 80217-3362
United States
Tel +1 303 556 5740
askmetro@msudenver.edu

Miami Ad School
www.miamiadschool.com
571 N.W. 28th St.
Miami, FL 33127
United States
Tel +1 305 538 3193

Miami Ad School Europe
www.miamiadschool.com
Finkenau 35e, 22081 Hamburg
Germany
Tel +49 40 4134670

Miami Ad School Mumbai
www.miamiadschool.com/advertising-school/mumbai
Mumbai Rose Cottage Complex Dr
S.S. Rao Road
Parel, Mumbai, Maharashtra 400012
India
+91 98195 43376

Miami Ad School New York
www.miamiadschool.com/advertising-school/new-york
35-37 36th St,, Queens, NY 11106
United States
Tel +1 917 773 8820

Miami Ad School San Francisco
www.miamiadschool.com/advertising-school/san-francisco
1414 Van Ness Ave.
San Francisco, CA 94109
United States
Tel +1 415 837 0966

Miami Ad School Wynwood
www.miamiadschool.com/advertising-school/miami
571 N.W. 28th St.
Miami, FL 33127
United States
Tel +1 305 538 3193

Pennsylvania State University
www.psu.edu
Old Main, State College
PA 16801
United States
Tel +1 814 865 4700

Portfolio Center
www.portfoliocenter.edu
125 Bennett St. N.W.
Atlanta, GA 30309
United States
Tel +1 404 351 5055

Portland Community College
www.pcc.edu
12000 S.W. 49th Ave.
Portland, OR 97219
United States
Tel +1 971 722 6111

School of the Art Institute of Chicago
www.saic.edu
116 S. Michigan Ave.
Chicago, IL 60603
United States
Tel +1 800 232 7242
admiss@saic.edu

School of Visual Arts
www.sva.edu
209 E. 23rd St.
New York, NY 10010
United States
Tel +1 212 592 2000

Syracuse University
www.syr.edu
900 S. Crouse Ave.
Syracuse, NY 13244
United States
Tel +1 315 443 1870

Temple University
www.temple.edu
1801 N. Broad St.
Philadelphia, PA 19122
United States
Tel +1 215 204 7000

Texas A&M University Commerce
www.tamuc.edu
2200 Campbell St.
Commerce, TX 75428
United States
Tel +1 903 886 5102
art@tamuc.edu

Texas Christian University
www.tcu.edu
2800 S. University Drive
Fort Worth, TX 76129
United States
Tel +1 817 257 7000

Texas State University
www.txstate.edu
601 University Drive
San Marcos, TX 78666
United States
Tel +1 512 245 211

Universidad Católica de Santiago de Guayaquil
www2.ucsg.edu.ec
Av. Carlos Julio Arosemena Km.
1½ via Daule
Guayaquil
Ecuador
Tel +593 4 220 6950

University of Cincinnati DAAP
daap.uc.edu
2624 Clifton Ave.
Cincinnati, OH 45221
United States
Tel +1 513 556 4933
daap-admissions@uc.edu

University of Illinois at Chicago
www.uic.edu
1200 W. Harrison St.
Chicago, IL 60607
United States
Tel +1 312 996 7000

University of Wisconsin–Stout
www.uwstout.edu
712 Broadway St. S.
Menomonie, WI 54751
United States
Tel +1 715 232 1122

Watkins College of Art
www.watkins.edu
2298 Rosa L. Parks Blvd.
Nashville, TN 37228
United States
Tel +1 615 277 7453

Westerdals Oslo School of Arts, Communication and Technology
www.westerdals.no
Vulkan 19, 0178 Oslo
Norway
Tel +47 22 05 75 50
admission@westerdals.no

Woodbury University
7500 N. Glenoaks Blvd.
Burbank, CA 91504
United States
Tel +1 818 767 0888
info@woodbury.edu

Anyone can teach—but to truly inspire young talent, it's crucial that teachers find ways to awaken their souls. Only then will famous work be born.

Frank Anselmo, *Instructor, School of Visual Arts*

AWARD-WINNING STUDENTS

Talk, talk, and talk more. The more you discuss your work and others in crits, the more comfortable you become when it's time to face a client or boss.

Sean Adams, *Instructor, Art Center College of Design*

Create the kind of advertising that will make a Creative Director say, "Wish I'd done that!"

Mel White, *Instructor, Syracuse University*

Be passionate about what you do.
It will see you through your most difficult hours.

Eileen Hedy Schultz, Instructor, School of Visual Arts

Schools:
Academy of Art University
Academy of Fine Arts
Art Center College of Design
Art Institute of Atlanta
Art Institute of North Hollywood
Auburn University
Austin Creative Department
Brigham Young University
California Institute of the Arts
California State University, Fullerton
Dankook University
Drexel University
Fort Lewis College
George Brown College
Hansung University of Design & Art Institute
Hanyang University
Kutztown University of Pennsylvania
Metropolitan State University of Denver
Miami Ad School
Miami Ad School Europe
Miami Ad School New York
Miami Ad School São Paulo
Miami Ad School Wynwood
Minneapolis College of Art and Design
Pennsylvania State University
Philadelphia University
Portfolio Center
Portland Community College
Purdue University
Savannah College of Art & Design
School of the Art Institute of Chicago
School of Visual Arts
Syracuse University
Temple University
Texas A&M University Commerce
Texas Christian University
Texas State University
The University of Texas Arlington
University of Cincinnati DAAP
University of Illinois at Chicago
University of Oklahoma
University of Texas at Arlington
Watkins College of Art
Woodbury University

Instructors:
Abby Guido
Adam Kanzer
Addie Langstaff
Adrian Pulfer
Allison Truch
Amanda Brennan
Amir Berbic
Andrew Loesel
Ann Lemon
Anne Benkovitz
Annika Kappenstein
Ariel Grey
Aya Kakeda
Bill Galyean
Bill Meek
Brankica Harvey
Brett Player
Brittany Baum
Bryan Birch
Bryan Farevaag
Carin Goldberg
Cate Roman
Catherine Campbell
Chris Buzilli
Christine George
Corel Theuma
Courtney Gooch
Dan Brawner
Dan Cassaro

Dan Kenneally
Daniel Sumbang
Dave Dick
David Beck
David Elizalde
David Sandlin
Debbie Millman
Dennis Y. Ichiyama
Devan Carter
Dirk Kammerzell
Dong-Joo Park
Dusty Crocker
Eduard Cehovin
Eileen Hedy Schultz
Elizabeth Marsh
Eric Baker
Eric Karnes
Evanthia Milara
Ezster Clark
Fabio Nunes
Frances Jetter
Frank Anselmo
Gerald Soto
Gerardo Herrera
Greg Privett
Grizelle De Los Reyes
Hank Richardson
Hartmut Jordan
Holly Sterling
Hong Ko
Hoon-Dong Chung
Hoshi Ludwig
Hunter Wimmer
Hye Sung Park
HyungJoo Kim
Ian Gregory
Ivan Chermayeff
Jack Mariucci
Jaehee Yang
James Kaczynski
Jan Ballard
Jan Jancourt
Jeffrey Schmidt
Jerri Johnson
Jerrod New
Jessy Kennedy
Jim Schachterle
Joanna Crean
Jody Graff
Joe Scorsone
John Hartwell
Jon Newman
Joseph Newton
Josh Ege
Juan Carlos Pagan
Judith Sweeney O'Bryan
Judy Penny
Juliet D'Ambrosio
Jung In Yun
Karen Kresge
Kate Clair
Katie Kitchens
Kelly Bryant
Kelly Holohan
Kenneth Deegan
Kevin O'Callaghan
Kevin O'Neill
Kimberly Capron Gonzalez
Kristin Sommese
Lanny Sommese
Larry Gordon
Lauren Lowen
Lee Whitmarsh
Leslie Singer
Leslie Steiger
Lewis Glaser
Linda Reynolds
Lisel Jane Ashlock
Louise Fili
Lynda Green
M.C. Coppage
Manual Dilone
Marcos Chin
Marcos Lawson
Maribeth Kradel-Weitzel
Mark Edwards
Mark Smith
Mark Stammers
Marlon Koster-von Franquemont
Martin Mendelsberg
Marvin Mattelson
Matt Delbridge
Mel White
Melissa Kuperminc
Melissa Withorn

Michele Damato
Mikaela Buck
Mike Kelly
Mina Mikhael
Nada Ray
Nathan Savage
Nic Taylor
Nic Wehmeyer
Nick Bertozzi
Niklas Frings-Rupp
Olga Mezhibovskaya
Ori Kleiner
Paul Booth
Paula Scher
Pauline Hudel-Smith
Peter Ahlberg
Peter Hobbs
Phil Hamlett
Pippa Seichrist
Ray Sison
Reneé Seward
Renée Stevens
Richard Mehl
Richard Poulin
Richard Wilde
Robert Best
Robert Mackall
Ruth Fowler
Ryan Russell
Ryan Scott Tandy
Sam Eckersley
Samuel Rhodes
Sandra Isla
Sarah Angle
Savina Mokreva
Scott Buschkuhl
Sean McGuire
Seung-Min Han
Shawn Meek
Simon Johnston
Sohee Kwon
Spencer Charles
Stacey Fenster
Stanley Zienka
Steve Brodner
Steve Saiz
Stuart Smith
Summer Doll-Myers
T.M Davy
Tal Shub
Taylor Bareford
Theron Moore
Thomas McNulty
Thomas Shim
Vassoula Vassiliou
Veronica Vaughan
Virgil Scott
Will Chau
William Culpepper
Wioleta Kaminska
Witt Langstaff
Yuko Shimizu
Yvonne Cao
Zachary Vernon
Zorayma Guevara

Students:
A. Grablejšek
Aboubacar Kante
Adithya Venugopal
Adriana Toledo
Aerielle Karpinsky
Alana Vitrian
Albert Magaña
Alejandra Chavez
Alessandra Divizia
Alessandro Stella
Alex Cohen
Alex Pynes
Alexandra Floresmeyer
Alireza Jajarmi
Alyssa Coffaro
Alyssa Dosmann
Amaurys Grullon
Amber Lamourt
Ana Miraglia
Andrew Ciobanasiu
Andrew Cuevas
Andrew Cygan
Andrew Mikhael
Angela Rhys
Angelina Chiong
Anika Carlson
Anna Riethman
Anthony J Mottola
Ara Cho
Arjun Roy

Arnould Madeleine
Ashanti Boatwright
Ashlee Rice
Ashley King
Ashley Lopez
Austin Haas
Austin White
Autumn Heckard
Averil Eagle Brannen
Axel Lindmarker
Barbara Kocjančlč
Bea Catapang
Bernise Wong
Birdie Chen
Bo Gyun Kim
Bo Zhou
Bokyung Ku
Brendan Brines
Brennan Holloway
Brett Morris
Briana Pong
Britta Wichary
Brittany Rogers
Brooke Pathakis
Brooke Southerland
Brooke Wong
Bryan Allman
Byeongju Kim
Caleb Fils-Aime
Callie Gabbert
Carl-Hampus Valin
Carlo Accattato
Carolina Lara-Mesa
Carolina Latorraca
Caroline Skarupa
Carter Tindall
Casey Brill
Casey Lovegrove
Celine Chow
Chanyoung Yang
Chau Vo Truong
Chris Choe
Chris Foss
Chris Ganz
Chris George
Christa Griffith
Christian Baron
Christian Napolitano
Christian Weber
Christina E. Rodriguez
Christine Rhett
Christopher Adams
Chusheng Patrick Chen
Cindy Karina Setiadi
Claire Hagen
Claire Hargis
Cooper H. Weinstein
Courtney Whitehouse
Cristhian Sabogal
Cydney Schwartz
D. Kisenko
D. Kocijancic
Da In An
Dale Brogan
Dallin Diehl
Dan Ng
Danbee Kim
Danica Tan
Daniel Ziegler
Danielle Reeves
Danner Washburn
Danny Lian
Davina Hwang
Dayoung Hwang
Derrick Chang
Devin Fallen
Diana Friedman
Diego Mancilla
Doyeon Lee
E. Emerši
Eduardo Chaves
Ein Jung
Elaina Berkowitz
Elaine Chng
Elaine Chung
Elle Oser
Elliott Chambers
Emilie Garnier
Emily Beck
Emily Faler
Emily Hartung
Emma Holland
Emma Tak
Erica Mack
Eunchae Koh
Eunice Joaquin
Eunice Pang

Faith Koh
Felix Yifei Wang
Ga Hae Park
Gabriella Okuda
Garret Wheeler
Gisell Bastidas Jaramillo
Gretchen Potts
Gunjan Shah
Gurgen Aloian
Ha-Won Lee
Haebinna Choi
Haley Stoneking
Hampus Elfström
Han Jun Kim
Hana Lee
Hanan Nurul
Hanbyul Park
Hannah Murphy
Hayley Marks
Henry Jocelyn
Hie Won Sohn
Hong Won Choi
Hsuan-Yun Huang
Hugo Ugaz
Huixin Xian
Hunwoo Choi
Hyejin Lee
HyeonA Kim
Hyewon Lee
Hyojung Tak
Hyun Ji Kim
Hyun-jin park
Hyun-Kyung Ro
Hyunjin Stella Kim
J. Grom
Jack Brownson
Jacob Marcus
Jacqueline Day
Jade Babolcsay
Jae Young Jang
Jaehyun Cho
Jake Blankenship
James Harrill
Jansi Buckles
Jee Hyun An
Jeein Lee
Jennifer James
Jenny Mascia
Jeon Jeannie
Jessica
Jessica Dawson
Jessica P. Dawson
Jie (Jenny) Miao
Jingpo Li
Joana Carneiro Peixinho
Joanna Yoon
Joe Haddad
John Kim
Jonathan Wood
Jong Myung Kim
Jonghoon Kang
jongwoong Park
Joseph Hatfield
Josi Matson
Juan Manuel Corredor
Jun Yong Choi
Justin Joo
Justine Rendl
Karina Pérez-Fajardo
Karl-Raphael Blanchard
Kasey Chen
Kate Fitzgerald
Katherine Hansen
Katie Tynes
Katrina Jajalla
Katy Mobley
Kayla Velocci
Kee Wei Chin
Kelsey Paine
Kenya King
Kevin Hsieh
Kevin Lai
Khristina Cruz
Kimberly Wu
Kindall Palmer
Kirushanth Sriranjan
Klara Kovac
Klever Alvarado
Krissy Beck
Kristie Bocanegra
Ksenia Gaman
Kushal Birari
Landon Taylor
Laura Capps
Laura Jones
Laura Sutphen
Laurel Benzaquen

Lauren Johnson
Leonardo Cantoran
Lily Stamm
Lily Wang
Lindsay Graviet Greaves
Lindsay Weisleder
Lorelle Dewitt
Lorelle Pais
Lorenzo Della Giovanna
Lorran Schoechet Gurman
Lucas Cruz
Luke Romig
Madeleine Arnould
Majesty Christian
Marcelo Shalders
María Sanoja
Mariam Elias
Mariana Mora
Marianna Von Fedak
Marina Ferraz
Marinique Mora
Marissa Merrill
Mary Elizabeth Morse
Matt Iacovelli
Matt Tennenbaum
Matthew Sasaki
Max Cohen
McKenzie Martin
Meagan Seng
Meg Gleason
Megan Morris
Megan Pando
Meghan Yoshida
Melanie Maynard
Melissa Nanquil
Meredith Heydt
Michael Booth
Michael Ching
Michael Crawford
Michaela Keck
Michele Farren
Michelle Sadler
Min Jung Son
Mohan Wang
Morgan Searcy
Myles Mays
Nadienka Cisternas
Nancy Gioffre
Natalia Drobinina
Natalie Miles
Nathania Frandinata
Nick Ricciutti
Nicole Bosley
Nicole Chance
Nicole Framm
Nikki Welty
Ning Zeng
Nitya Isaacs
Nura Saadallah
Olga Khristoforova
Orion Schlosser
Oscar Gierup
Paige Graff
Panini Pandey
Patricia Hajjar
Patrick House
Patrick Huang
Paul Lee
Pedro Moreno
Personal Zine
Pierre Fort
Preston Thompson
Purun Chai
Qingru Joy Wu
Qiuyu Guo
Rachel Eleanor Phillips
Rafael Villasana
Randy Gaytan
Ray Dao
Reithna Chhoeum
Reo Nathan
Ricky Santos
Rob Pitrovich
Rohit John
Rose Maria Sofie
Ruohua Huang
Ruonan Hao
Ryan Hewlett
Sabine Formanek
Saenansul Chung
Salomée Souag
Sam Jenkins
Sam Nunez
Samuel Kim
Sanhui Yoon
Sanna Gu

Sara Strojan Arko
Sarah Asip
Sarah Ilustrisimo
Sarah Lafrinere
Sarah Vaccariello
Sarah Wasley
Savannah Colbert
Sean Dong
Sean Merk
Seona Kim
Seoyoung Lee
Seunghyun Shim
Sewon Park
Shao Tsai
Sheung Cho
Shinyee Seet
Shreya Gupta
Shu Ting Hung
Shuli Wang
Shuyue Chen
Sihao Sun
Sijia Zhang
So Hyun Park
So Jin
So Ra Jeong
Sofia Llaguno
Sofia Soldevila
Solbinna Choi
Soobin Oh
Soobin Yeo
Soohyun Hwang
Soojin Hong
Sophia Kardaras
Sou Young Ji
Stefan Pelikan
Stephanie Yueyang Wang
Steve Carcamo
Su Jin Choi
Suhyun Kim
Sungyoon Lee
Susan Huang
Susanna Palm
Taeyul Ko
Tamara Vagner
Tamara Yakov
Tania Shevereva
Tanya Finder
Taylor Burgess
Taylor Shipton
Thomas Lee
Thomas Nguyen
Thomaz Jefferson
Tim Amerine
Tim Cao
Trevor Goldberg
Tung Chou
Turner Blashford
Tyler Bantz
Tyler Conwell
V. Stojanovski
Veronica Itzkowich
Vinicius Chiconato
Viva Gallivan
Wang Linxi
Wanjiao Fu
William King
Woo Jae Yoon
Woo Young Kim
Woorim Lee
Xiaoyu Xue
Xingwei Huang
Xueming Hua
Ye Hyun Lee
Ye Ji Park
Yeiniz Nevarez
Yeun Kyung (Amber) Lee
Yi Mao
Yifei You
Yingying Yue
Yoonseo Chang
Youlho Jeon
Younghoe Koo
Youri Hwang
Youyang Li
Yuchan Du
Yuji Yang
Yujin Rhee
Yun Lee
Yunxuan Wu
Yuxin Xiong
Zahra Ilyas
Zoe Nelson
Zoey Liangzhang
Zuheng Yin

Advertising Annual 2018

Design Annual 2018

Poster Annual 2018

Photography Annual 2017

Logo/Letterhead9

Annual Reports 2014-2016